Women Writing Crime
Fiction, 1860–1880

Women Writing Crime Fiction, 1860–1880

Fourteen American, British and Australian Authors

KATE WATSON

McFarland & Company, Inc., Publishers
Jefferson, North Carolina, and London

LIBRARY OF CONGRESS CATALOGUING-IN-PUBLICATION DATA

Watson, Kate, 1984–
 Women writing crime fiction, 1860–1880 : fourteen American, British and Australian authors / Kate Watson.
 p. cm.
 Includes bibliographical references and index.

 ISBN 978-0-7864-6782-2
 softcover : acid free paper ∞

 1. Detective and mystery stories— 19th century — History and criticism. 2. Fiction — Women authors — History and criticism. 3. Crime in literature. 4. Women and literature — English-speaking countries. I Title.
PN3448.D4W37 2012
809.3'872 2012004925

BRITISH LIBRARY CATALOGUING DATA ARE AVAILABLE

© 2012 Kate Watson. All rights reserved

No part of this book may be reproduced or transmitted in any form or by any means, electronic or mechanical, including photocopying or recording, or by any information storage and retrieval system, without permission in writing from the publisher.

Front cover images © 2012 Shutterstock

Manufactured in the United States of America

McFarland & Company, Inc., Publishers
 Box 611, Jefferson, North Carolina 28640
 www.mcfarlandpub.com

For Sara and Barry

Table of Contents

Acknowledgments	viii
Preface	1
Introduction: Transformation, Transmission and Transportation	3

CHAPTER ONE: BRITAIN
Introduction	15
Catherine Crowe (1790–1872)	20
Caroline Clive (1810–1873)	22
Elizabeth Cleghorn Gaskell (1801–1865)	38
Mary Elizabeth Braddon (1835–1915)	43
Mrs. Henry (Ellen) Wood (1814–1887)	59
COLONIAL CONNECTIONS	64

CHAPTER TWO: UNITED STATES
Introduction	68
Harriet Prescott Spofford (1835–1921)	79
Louisa May Alcott (1832–1888)	85
Metta Victoria Fuller Victor (1831–1885)	99
Anna Katharine Green (1846–1935)	118

CHAPTER THREE: AUSTRALIA
Introduction	132
Céleste de Chabrillan (1824–1909)	151
Caroline Woolmer Leakey (Oliné Keese) (1827–1881)	153
Eliza Winstanley (1818–1882)	157
Ellen Davitt (c. 1812–1879)	158
Mary Helena Fortune (c. 1833–c. 1909/10)	172

Chapter Notes	191
Bibliography	222
Index	245

Acknowledgments

This book is based on a Ph.D. thesis I submitted at Cardiff University in 2010. Thanks and gratitude primarily go to my thesis supervisors, Dr. Heather Worthington and Professor Stephen Knight.

In Australia, to Dr. Lucy Sussex (the University of Melbourne) for help with research queries and to Dr. Bronwen Levy (the University of Queensland) for assistance with the Bicentennial Scholarship. To Professor John Sutherland and Sarah Waters for email enquiries; to Grant L. Stone (scholarly resources librarian, Murdoch University), Jillian P. Brown (audio visual department, Fisher Library, University of Sydney), the staff at gleebooks (Glebe, Sydney), and the staff at Serendipity Books (West Leederville, Perth). And to the team and collections at Cardiff University Arts and Social Studies Library (and special collections and archives), the British Library, Senate House Library, the Menzies Centre (King's College, London), the National Library of Australia (Canberra), the University of Western Australia, the UWA Crime Resource Centre, the J. S. Battye Library of West Australian History (Perth), the State Library of Australia, Murdoch University, Sydney University, the State Library of New South Wales, the State Library of Victoria, the University of Melbourne (Baillieu Library), Monash University, La Trobe University, and, in America, the UCLA Michael Sadleir Collection and Charles E. Young Research Library.

Acknowledgments must go to the Arts and Humanities Research Council for my doctoral funding and additional funding for my American research, without which this monograph may not have been possible. I also acknowledge the Menzies Centre (King's College London) for the Australian Bicentennial Scholarship.

Thanks to all of those important people in my life that have supported me unconditionally, especially Zola, Mia, Rose, Pete, Barry, and Shirley.

Preface

This work explores women's crime fiction writing in the mid- to late nineteenth century in three national contexts: British, American, and Australian. In examining the work of women writers in this field, and in focusing on the period from 1860 to 1880, it also opens up critical constructions and histories of the genre.

Arthur Conan Doyle has long been considered the greatest writer of crime fiction, and the gender bias of the genre has foregrounded figures such as William Godwin, Edgar Allan Poe, Wilkie Collins, Émile Gaboriau, and Fergus Hume. But earlier and significant contributions were being made by women in Britain, the United States and Australia, and identifying these is the purpose of this study. It seeks not only to resolve what was perceived as an absence of women's crime narratives, but also to uncover and rectify the indeterminacy that has surrounded the period between 1860 and 1880, years that have recurrently been perceived as an interstitial space, but actually were central to the formation of the crime and detective form. Equally, this work attempts to delineate the movements toward and creation of the genre as it is now known, with its initial generic mix of ballads, Newgate novels, *Newgate Calendars*, sensation fiction, dime novel stories, domestic fiction, and the Gothic.

While women writers and their presence both indicate the need for and are a part of a criminographic reformulation, some of the writers discussed were excluded from debate, and some were well-known, successful and even (in some cases, retrospectively) praised. Often, Anna Katharine Green and her best-selling work, *The Leavenworth Case*, have been taken as a starting point for female criminography, yet the historical significance of other early women crime writers is unacknowledged. Mary Fortune is an obvious example. Perhaps the first woman to focus on and specialize in crime. Fortune has nevertheless received scant critical attention, the few articles that have been published cropping up mostly in the past decade. The women who are considered in this analysis were all innovators. The primary female authors who

comprise this tradition in Britain, America, and Australia are Catherine Crowe, Caroline Clive, Elizabeth Cleghorn Gaskell, Mary Elizabeth Braddon, Mrs. Henry (Ellen) Wood, Harriet Prescott Spofford, Louisa May Alcott, Metta Victoria Fuller Victor, Anna Katharine Green, Céleste de Chabrillan, "Oliné Keese" (Caroline Woolmer Leakey), Eliza Winstanley, Ellen Davitt, and Mary Helena Fortune. By their very presence in the criminographic arena — particularly in the instances that they eschewed pseudonyms — and by the subversive character of their writings, these women challenge our understanding of the early history of the genre.

These early writers built the foundation for the better-recognized women who followed, and the importance of their work calls out for a feminine reconstruction of the canon.

Introduction

Transformation, Transmission and Transportation

Transformation, transmission and transportation are key concepts which form a framework for this book. Their ramifications include the transformations of one genre into another as well as generic differentiation and its implications: the transportation of people and texts, and the relationship between the "criminal" and the "colonial." Men have long been considered the progenitors of the crime fiction form, but what this study seeks to illustrate is that women were present in criminous discourse from the beginning. In addition to this, women were significantly adding to the corpus of crime and detective fiction as we now know it and are thus an essential (but often neglected) part of this construction. While this feminine exclusion indicates a limited outlook which, to some extent, is still upheld, crime fiction was also synchronic and appeared in many countries. Though the general and critical focus on crime and detective literature has traditionally been on British, French and American exponents, this book will examine British, American and Australian women's crime writing, considering agency, reception and the development and interplay between nations and voices: what can be said and challenged, and what cannot and why.

In his discussion of policing in nineteenth-century Europe, Clive Emsley has written that "any one study that focuses entirely on one national experience must be missing something."[1] This study may be "missing something" in terms of constructing a female canon of crime fiction that only inspects three countries, but, because of the limits of space, a worldwide investigation cannot be conducted here. No doubt women were possibly deploying the crime form in other countries at the same time. In recent times, critical work has tackled the massive size of international contemporary crime fiction, as in *Investigating Identities: Questions of Identity in Contemporary International*

Crime Fiction, edited by Marieke Krajenbrink and Kate M. Quinn (2009). There is also *Multicultural Detective Fiction: Murder from the "Other" Side*, edited by Adrienne Johnson Gosselin (1999), which again centers on contemporary crime texts, examining them in terms of postcolonial and queer literary theories. Comparatively, there is space for a similar book to be written on international women's crime narratives from the nineteenth century.

Critical texts have emerged which focus on one writer and his impact upon countries and regions, such as Lois Davis Vine's edited *Poe Abroad: Influence, Reputation, Affinities* (1999). In this study, Edgar Allan Poe's literary diaspora reaches twenty-one countries and regions including Estonia, Scandinavia, China, and India but, curiously, not Australia. The key word in this context is "reputation": perhaps had nineteenth-century women writers been accorded the same status as male authors such as Poe — or even been acknowledged — then similar texts detailing women's international influence may have materialized. It was not until 2010 that Lucy Sussex filled the previously unmarked space with her book, *Women Writers and Detectives in Nineteenth-Century Crime Fiction: The Mothers of the Mystery Genre*, which specifically looks at the many women writing criminographically, and includes those in Australia. Also published in 2010 was *The Penguin Book of Victorian Women in Crime: All the Great Detectives and a Few Great Crooks*, but this focused on the late nineteenth century and includes both detecting and criminal women figures, such as Loveday Brooke and Madam Sara.

This study will touch on crime literature produced in France and Germany in the course of discussion, but will not concentrate on them. That is not to say that there was not an interaction between countries outside of Britain, the United States, and Australia. Clearly, though, there was in these countries a colonization of both people and cultures. Moreover, there was the transportation not only of criminals, but of criminographic discourse/s: periodicals and magazines were available both from and to other countries, with issues of piracy and plagiarism (in pre-copyright days) arising as a result. These interconnections become apparent as the crime and detective fiction forms evolve and impact upon each other.

In Edgar Allan Poe's "The Purloined Letter" (1845), Chevalier C. Auguste Dupin describes street signs over shop doors to the unnamed narrator as "a game of puzzles [...] which is played upon a map."[2] He further comments on "the motley and perplexed surface of the chart" (p. 352). While it may seem ironic to use a quotation from a male paragon of crime fiction writing here, it is perplexing as to why Victorian women have not been acknowledged and placed upon the canonical or even their own national map. This work, then, calls for a feminine re-mapping and disinterment in order to demonstrate

how women played and participated in the game of crime and detection and, sometimes, toyed with conventions.

In more recent times there has not been the need for such reconceptualization; there has been a strong literary presence of female crime and detective writers: the Golden Age of crime fiction (1920–1940) has primarily been associated with women such as Agatha Christie, Josephine Tey, Margery Allingham, Ngaio Marsh, and Dorothy L. Sayers. Other well-known contemporary female writers include P. D. James, Sara Paretsky, Patricia Cornwell, Val McDermid, and Mo Hayder. In comparison to this well-known modern feminine proliferation, the women who were writing at the inception of the crime genre were not or could not be recognized and accredited as such. This non-acknowledgement to some extent extends to present-day critical crime work, a point to which will be returned to.

The period from 1860 to 1880 has been chosen because it was a "boom time" for narratives of crime. At this point, crime/detective fiction was embryonic and not a distinct genre identified as the crime or detective story proper. The title of "detective fiction" came later — R. F. Stewart proposes 1886 — but it was not firmly in place until 1900 in the wake of Sherlock Holmes.[3] Rather, the initial attempts at crime and detective narratives were polymorphous and many have only retrospectively been reclassified as crime and/or detective fiction. At the outset crime narratives were a coalescence of the Gothic, sensation fiction, the picaresque, the *Newgate Calendars*, ballads and novels. Despite the popularity of crime/detective fiction from the 1890s onwards, there was an evident preoccupation with and need to read and write about crime at mid-century: Fyodor Dostoevsky's *Crime and Punishment* (1866) testifies to this.

The decades from 1860 to 1880 have been continually perceived in terms of and misconstrued as a vacuous space; viewed in this light, women are doubly elided. The genre in its fully formed incarnation, however, did not appear in a vacuum or arise only with the appearance of Arthur Conan Doyle's Sherlock Holmes novellas and stories towards the end of the nineteenth century. Catherine Ross Nickerson has summarized this: it is "the period between Poe and Dashiell Hammett [which is presented] as 'a gap' or as 'fallow.'"[4] Julian Symons calls the period an "Interregnum" and states that there were "twenty years of mostly indifferent work, of a literary form awaiting its proper medium."[5] This is a masculine medium which was not fulfilled until 1887 with Arthur Conan Doyle's *A Study in Scarlet*. H. D. Thomson in *Masters of Mystery* not only extends this crime free space, glossing over Poe in the 1840s and taking Émile Gaboriau as a starting point twenty years later instead, but valorizes the masculine with its title.[6]

Such assertions are, however, far from the truth and, most notably, they

also exclude female writers. Other writers who dismiss this period between 1840 and the 1870s and on into the late nineteenth century include George N. Dove who, in *The Reader and the Detective Story*, comments that "[t]he term *detective story* [...] refers to the kind of narrative originated by Poe in the Dupin stories, further developed and enriched by Doyle in the Sherlock Holmes stories, and later modified in the novels of Hammett and Chandler."[7] Erik Routley in *The Puritan Pleasures of the Detective Story* completely neglects the period preceding Holmes.[8] Dorothy Sayers has remarked that "the detective-story has had a spasmodic history, appearing here and there in faint, tentative sketches and episodes, until it suddenly burst into magnificent flower in the middle of the last century."[9] Conversely, Peter Drexler's essay, "Mapping the Gaps: Detectives and Detective Themes in British Novels of the 1870s and 1880s," has addressed and to some extent redressed this critical fissure in Britain.[10] Rather than an abeyance, this period was productive: this book aims to show how women's international crime writing—both within this era and generally—importantly contributed to the establishment of the genre.

How to define crime and what constitutes crime and detective fiction and its origins are problematic and are a question of hermeneutics. Crime has often been represented in history, with its representations in discourse going right back to Homer and the Bible. Crime was more traditionally revealed by God, guilt, chance, or social agency. William Shakespeare's revenge tragedy, *Titus Andronicus* (c. 1590), included crime, rape, murder, much bloodshed, and the human emotions or reasons which are the catalysts for such actions, but no detective figure. Early novel writers such as Daniel Defoe and Henry Fielding clearly had crime at the centre of their novels. In the period discussed here the rules of generic crime fiction are not yet in place. The issue of crime fiction and its many genres is therefore vexed. This study will interchangeably use the terms crime fiction, crime narratives/criminography, and detective fiction.

This is the period in which the detective figure comes into being, and which is fully comprehended and consolidated in detective fiction at the end of the century. Crime fiction could loosely be defined as that which includes crime and, in almost all cases, its resolution and the consequent punishment of the perpetrator/s. Jacques Barzun and Wendell Hertig Taylor in *A Catalogue of Crime* have detailed what they see as Voltaire and *Zadig*'s eighteenth-century detecting or proto-detecting pre-eminence:

> It is in the third chapter of this tale that the hero after which it is named takes up the study of nature to console himself for his marital troubles and uses the observation of natural facts to infer events he has not seen. However implausible and "agrarian" his method, he is the first systematic detective in modern

literature, and that priority itself adds to his troubles in the story until his royal vindication.[11]

Detective fiction's codification could be said to consist of both crime and an amateur or professional figure who functions to mediate this and leads/concludes the investigation. And, when inquirers do appear, there are more women writing them than has been appreciated. The period demarcated by this book maps the development and rhetoric of the crime and detective story proper, with a female emphasis.

It is only much later in the twentieth century and beyond that crime and detective fiction can be and has been delineated in terms of structure and narratology as well as formulaic rules and regulations. Tzvetan Todorov has illustrated this, stating that crime/detective fiction is "constituted by the problematic relation of two stories: the story of the crime, which is missing, and the story of the investigation, which is present, and whose only justification is to acquaint us with the other story."[12] Such prerequisites were also invoked by "S. S. Van Dine" (Willard Huntington Wright), with his "Twenty Rules for Writing Detective Stories" (1928):

> The detective story is a kind of intellectual game. It is more — it is a sporting event. And for the writing of detective stories there are very definite laws — unwritten, perhaps, but nonetheless binding; and every respectable and self-respecting concocter of literary mysteries lives up to them. Herewith, then, is a sort of credo, based partly on the practice of all the great writers of detective stories, and partly on the promptings of the honest author's inner conscience.[13]

These definitional outlines were followed tongue-in-cheek by Ronald Knox with his *Ten Commandments* or *Decalogue* (1929) of Golden Age fiction.[14] However, this study aims to trace the beginnings of this journey, and situate women writers within it.

As stated earlier, crime/detective fiction has traditionally been perceived and lauded as a seminal master genre. There is an axiomatic conception of man as both a crime writer and as a textual paterfamilias. Edgar Allan Poe has recurrently been depicted as the archetype, with both his creation of the Dupin stories of the 1840s and innovative formulation of intellectual ratiocination. Equally totemic is Arthur Conan Doyle's Sherlock Holmes, appearing in his first novella, *A Study in Scarlet* (1887), and followed by short stories in the *Strand Magazine*, beginning with "A Scandal in Bohemia" in 1891. To this luminary masculine list can be added Charles Dickens' *Bleak House* (1853) and Wilkie Collins' *The Woman in White* (1860) and *The Moonstone* (1868). In France there was the famous figure of Émile Gaboriau who created the *roman policier* (police novel) in the 1860s, commencing with *L'Affaire Lerouge* (in *Le Pays*, 1865) and featuring the French detective Tabaret. This was

succeeded by his police detective, *M. Lecoq*, in 1868. There are other detectives across the period: William Godwin's *Caleb Williams* (1794)[15] is now retrospectively envisioned as the first detective novel.[16] Equally discussed are William Russell/"Waters'" short stories (inaugurated in 1849); these stories incited many followers in the casebook/memoir vein — who will be examined later — and the pseudonymous detective series of "Andrew Forrester Jr." In Australia, Fergus Hume's *The Mystery of a Hansom Cab* (1886) was and still is popular and critically recognized.

This masculine tradition is propagated and upheld in critical work. For instance, Ross Macdonald in "The Writer as Detective Hero" writes that "[t]hroughout its history, from Poe to Chandler and beyond, the detective hero has represented his creator and carried his values into action in society."[17] This description is overtly masculinist and conflates men, writers, history, and detectives, omitting women in any of these configurations. Again, Martin Priestman in *Detective Fiction and Literature: The Figure on the Carpet* (1990) emphasizes Poe, Gaboriau, and Sherlock Holmes. Critical titles alone again distinguish this masculine predication; these include Ian Ousby's *Bloodhounds of Heaven: The Detective in English Fiction from Godwin to Doyle* (1976), Clive Bloom's *Nineteenth-Century Suspense: From Poe to Conan Doyle* (1988), and Audrey Peterson's *Victorian Masters of Mystery: From Wilkie Collins to Conan Doyle* (1984). In *Detective Fiction: The Collector's Guide*, edited by John Cooper and B. A. Pike (1988), there is no mention under "Individual Authors" of any of the women writers who will be discussed here (across countries), implying that these women are not seen as contributing to detective fiction, if seen at all.[18]

Against this myriad of iconic and male crime-based writers were women, who were not only marginalized but subsumed under this seeming masculine ubiquity. Alison Light has described a "cultural squint" that was brought about by the literary establishment's "obsession with [...] elites," and this summation can be applied to this earlier period.[19] John Sutherland has collated individual Victorian novelists and made a gender comparison:

> Of these [novelists], 566 are men, 312 women. [...] Among the men, no less than 110 had law as either a concurrent or previous vocation. [...] Among the women, the vast bulk had no other recorded activity than being wives (167) or spinsters (113). Not surprisingly, perhaps, the Victorian spinster was the most productive single category of novelist, with an average lifetime output of 24 titles.[20]

While this is a general evaluation of novels and not a discussion of woman-written detection, the focus is on men and their connections with the law; conversely, women writers are only permitted by society to succeed and produce novels if they are a part of the delimiting and non-threatening category

of spinster or wife in a firmly domestic role. Perhaps the reason why female-authored crime fiction was stifled in the nineteenth century is precisely because of the concept of the genre as deviant; women writers seeking publication could not be seen to deviate from the norm. Sensation fiction was much criticized and, even there, deviant women were punished and contained. According to George Eliot "the happiest women, like the happiest nations, have no history."[21]

Yet it could conversely be argued that the low prestige of the genre was what allowed women to write. In writing in these criminous forms, the women who will be studied here transgressed the Victorian notions of decorum and propriety vindicated by Eliot and personified by the fictional upholder of virtue and disapproval, Thomas Morton's Mrs. Grundy.[22] But this book contends that while mostly not overt in their challenges, a form of mediation is evident in the writings of the women discussed; as Luce Irigaray elucidates, women can "convert a form of subordination into an affirmation, and thus ... begin to thwart it."[23] While the presence of these women writers alone testifies to their right to be included in the (non-criminalized) history of the genre and also contests the purportedly masculine synecdoche, this investigation suggests that these women can and do enact (to varying ends) subversion through and within gendered publishing and social orthodoxies.

There has been critical work by women on women crime and detective writers and epochs, although coverage differs. Critical attention has predominantly been on Mary Elizabeth Braddon and Anna Katharine Green, and, more recently, Metta Victoria Fuller Victor ("Seeley Regester"). In modern times, however, writing on individual authors has emerged, such as Alison Jaquet's "Domesticating the Art of Detection: Ellen Wood's Johnny Ludlow Series" (2007) and Rita Bode's "A Case for the Re-covered Writer: Harriet Prescott Spofford's Early Contributions to Detective Fiction" (2008) among others. Lucy Sussex and Stephen Knight have both written extensively on individual authors and the genre at this period, and these works will be consulted throughout. Knight's article, "Sherlock Holmes's Grandmother: An Untraditional Look at the Anglophone Crime Fiction Tradition" (2008), is indicative of the resituating and rectification of a long female tradition before the initiation of Sherlock Holmes in 1887.

Michele Slung has posited an antithetical and challenging feminine requisition of discourse though crime writing; speaking generally she writes: "Women *are* more lethal because of their historical camouflage, and when they put their minds to crime — as authors— the accomplishment has been enhanced by this surprise element."[24] *Feminism in Women's Detective Fiction*, ed. Glenwood Irons (1995) has no mention of women criminographic writers in the nineteenth century, with a concentration on the post–Sherlock Holmes

period. Other accounts which include women vary in their coverage of periods and nations; when nineteenth-century women writers have been included, the emphasis has tended to be on Anna Katharine Green. *Killing Women: Rewriting Detective Fiction*, ed. Delys Bird (1993) has also appeared, as has Jessica Mann's *Deadlier than the Male* (1981). Kathleen Gregory Klein's edited *Great Women Mystery Writers Classic to Contemporary* (1994) can be added to this list, as can Kathleen L. Maio's "Murder in Grandma's Attic," in *Murderess Ink: The Better Half of the Mystery*, ed. Dilys Winn (1979); also of interest are Victoria Nichols and Susan Thompson's *Silk Stalkings: When Women Write of Murder: A Survey of Series Characters Created by Women Authors in Crime and Mystery Fiction* (1988), Catherine Ross Nickerson's *The Web of Iniquity: Early Detective Fiction by American Women* (1998), and Martha Hailey DuBose's *Women of Mystery: The Lives and Works of Notable Women Crime Novelists* (2000).

Scholarship on women and crime/detection has tended to concentrate on the figure/s of women detectives. These articles and books include Birgitta Berglund's "Desires and Devices: On Women Detectives in Fiction" (2000); Fay M. Blake's "Lady Sleuths and Women Detectives" (1986); Dagni Bredesen's "Investigating the Female Detective in Victorian and Edwardian Fiction" (2007); Jeanne F. Bedell's "Amateur and Professional Detectives in the Fiction of Mary Elizabeth Braddon" (1983); Patricia Craig and Mary Cadogan's *The Lady Investigates: Women Detectives and Spies in Fiction* (1986); Lisa M. Dresner's *The Female Investigator in Literature, Film, and Popular Culture* (2007); Kathlyn Ann Fritz and Natalie Kaufman Hevener's "An Unsuitable Job for a Woman: Female Protagonists in the Detective Novel" (1979); Barbara Lawrence's "Female Detectives: The Feminist-Anti-Feminist Debate" (1982); Carla Therese Kungl's *Creating the Fictional Female Detective: the Sleuth Heroines of British Women Writers, 1890–1940* (2006); Jane C. Pennell's "The Female Detective: Pre- and Post-Women's Lib" (1985); Arelene Young's "Petticoated Police": Propriety and the Lady Detective in Victorian Fiction" (2008); Suzanne Young's "The Simple Art of Detection: The Female Detective in Victorian and Contemporary Mystery Novels" (2001); Kathleen Gregory Klein's *The Woman Detective: Gender and Genre* (1995); and Judith Flanders's "The Hanky-Panky Way: Creators of the First Female Detectives" (2010).

Yet although such female detecting figures are important (and will be considered in the course of this study), there were other writers who were innovative in their contributions to crime/detection but who are not as often (if at all) discussed in critical work on criminography and detective fiction. These women who created "firsts" include (but are not limited to) Metta Victor Fuller Victor who, as research has suggested, wrote the first American detective novel, and Harriett Prescott Spofford who wrote the first female

crime series; Spofford also boldly penned these stories using her own name. In Australia, Ellen Davitt wrote the first Australian murder mystery and Mary Helena Fortune created the first detective fiction book in Australia and simultaneously had an extremely long-running casebook series titled "The Detective's Album." Only today are the writers Louisa May Alcott, Catherine Crowe, and Frances (Fanny) Trollope becoming less obscure in terms of their crime content and involvement in the crime/detective genre. These writers and their criminous work will be considered at a greater length within the following chapters.

Alongside these writers in particular, this critical work will incorporate a sense of the more general context by mentioning the conditions which affected the dissemination of both these women's voices and their crime work. These revolve around changes in print culture and publishing and its distribution and format. Cultural developments and population expansion in all three countries led to a coterminous growth in literacy. Nineteenth-century journals produced a multiplicity of writing, with the dominant form/s being the short story or serialization. These narratives were avidly read and also were circulated internationally. Many periodicals included crime and detective content, serials and stories, for example *Chambers's Edinburgh Journal*, *Blackwood's Edinburgh Magazine*, *Harper's Monthly* (America), the *Atlantic Monthly* (America), and the *Australian Journal*. The more common pattern was for a serial to appear in a periodical, followed by its issue in book form, although this was not a certified path open to all. Equally, this formation or trajectory changed as short fiction usurped the three-decker Victorian novel in the 1880s—as evidenced by the *Strand* and other journals. There was a slightly different direction in Australia and America towards the end of the century, and this will be detailed in the course of the chapters.

Not only were there shifts in literature, but these are inextricably linked to the contextual background of social and historical changes and conception of how to interpret the world through the discourses of science and the legal system, as well as literature. The proto-detective and later police/private detective emerge as new figures that assist in this mediation as law-enforcement shifted from that of sovereign power to disciplinary power. In terms of theoretical positioning, this study is not heavily theory-based, although it does take a feminist perspective. The methodology of this study is to concentrate on the complex interaction of multi-voiced and multi-national criminographic and gendered conversation/s in the period, instead of reading these contributions through the lens of a particular literary theory.

Structurally, rather than a linear, rigidly temporal structure, this book and the chapters within it will be divided by and premised upon nation. The study does not purport to be comprehensive in that (international) sense, yet

equally it is not parochial. That is not to say there was not a crime interaction or conversation between countries: clearly British (and American) crime literature and theatre was influenced by France and its crime writing, as was Fergus Hume later in the nineteenth-century in Australia. Each chapter will begin by contextualizing the masculine literary and socio-political background and marketplace. This will be followed by a concentration on the women writers and woman-written detection in comparison with the men.

The women writers who will be examined are chosen because of their innovation/s in the form. While this invariably includes Anna Katharine Green's now well-known *The Leavenworth Case* and Mrs. Henry (Ellen) Wood's *East Lynne*, the study has also attempted to include less-known writing by now famous writers such as Mary Elizabeth Braddon and Elizabeth Gaskell in addition to writers who have hitherto not widely been written on or acknowledged. Attention will be on some major case studies in order to give a context to the less-well-known material, and for comparisons to be drawn. This will be done in part as a survey, but certain texts and special cases will be concentrated on which bring together the themes discussed and emphasize women's original crime fiction contributions. These particular titles are *The Trail of the Serpent* (Britain), *The Dead Letter: An American Romance* (America), and *Force and Fraud: A Tale of the Bush* (Australia). From a stylistic and more general perspective, any italicizing, capitalization, or anomalies within this study are as written from their original source. Quotations and emphases are also as taken from the text/s unless indicated otherwise.

Chapter One considers Britain. This is taken as a starting point due to its historical time span as a nation, and because it was a nation which transported both people and culture to North America and Australia. The female authors who dominate this section are Catherine Crowe, Caroline Clive, Elizabeth Cleghorn Gaskell, Mary Elizabeth Braddon, and Mrs. Henry (Ellen) Wood. These writers and their works are used to show how they both contributed toward the crime genre but ultimately found themselves restricted and contained. Braddon's *The Trail of the Serpent* (1861) is concentrated on in this chapter, not only because of date, but because it is special in its liminal treatment of sub-genre/s, and its boundary-pushing as well as its incorporation of both challenging and pioneering figures.

Chapter Two gives attention to the American proponents, and follows a similar pattern, developing this dyadic positioning of feminine voice/contribution and constraint. Yet these women and their criminal articulations are more extended and to some extent they contest the borders further than their British counterparts. Writers included here are Harriet Prescott Spofford, Louisa May Alcott, Metta Victoria Fuller Victor, and Anna Katharine Green. Within this chapter there is a particular deliberation on Victor's *The Dead*

Letter: An American Romance (1866–7), which can be read as a detective novel and has primacy as possibly the first crime novel written by a woman in America; this novel also works to create the discursive space for the later figure of the girl detective.

Chapter Three explores the usually overlooked criminography of Australia. Both Australian men and women have been eclipsed as this national element of the genre has not often been considered by crime/detective histories or critical work. Post–1880, though, a masculine imperative emerged, with men being or becoming perceived as synonymous with both Australia/nation and writing. Such positioning means that women generally, and, more specifically, women writers of crime and detection are doubly neglected. While this has proved limiting in the sense that these women's voices and impact have unfairly been not recognized or attributed the status they deserve, they were still both writing in this form and innovatively and significantly adding to it. The Australian women writers who comprise this chapter are Céleste de Chabrillan, "Oliné Keese" (Caroline Woolmer Leakey), Eliza Winstanley, Ellen Davitt, and Mary Helena Fortune. There is a detailed analysis of Davitt's *Force and Fraud: A Tale of the Bush* (1865), which was the first murder mystery in Australia. Comparatively, and also cumulatively, women who were writing criminographic narratives appear very strong in Australia.

This study will now turn to these mothers of crime fiction who were challenging conventions both in and through their criminous writing.

ONE

Britain

Introduction

> "[M]en and women are shown as being foreign countries to each other." — Lyn Pykett, *The Improper Feminine: The Women's Sensation Novel and the New Woman Writing*, 1992
>
> "Along with the criminal, criminology itself is deported elsewhere." — D. A. Miller, *The Novel and the Police*, 1988

This book focuses on women's criminographic writing from the mid–nineteenth century until the 1880s; it also aims to examine how this writing is restricted and contained. This period, however, was preceded by a plethora of female-authored material that incorporated crime in various ways but which was not what might be considered crime fiction. Crime has long been a popular subject for writers of fiction, but in the nineteenth century the genre was largely dominated by masculine epistemology and male exponents. Men have been, and to some extent still are, taken as a synecdoche for crime and detective writing. The dominance of masculine crime narratives reaches its zenith with Arthur Conan Doyle's Sherlock Holmes at the end of the nineteenth century. Crime fiction and its masculine authorship had eighteenth-century origins; these are seen in the picaresque concentration on criminality and the criminal in Daniel Defoe's *Moll Flanders* (1722) and Henry Fielding's *The Life of Mr. Jonathan Wild, the Great* (1743), while William Godwin's novel, *Caleb Williams* (1794), featured an early proto-detective in its eponymous protagonist. Factual crime was equally, if not more, prevalent, as demonstrated by Henry Fielding's *Covent-Garden Journal* newspaper (1752), the popularity of the criminal and execution broadsides, the *Accounts* of the Ordinary of Newgate and the later collected criminal cases of the *Newgate Calendar* series (with the first large collection appearing in 1773). These early narratives had a strong monitory function, warning against the consequences of crime. Social and demographic changes in the nineteenth century, in combination

with increasing industrialization and urbanization and the erosion of class boundaries led to the perception of an increase in crime and a consequent need for new forms of control, both within crime narratives and outside of them. This change, in Michel Foucault's terms, is from a demonstration of sovereign power to an ideological disciplinary power.[1] Foucault's work builds upon Jeremy Bentham's earlier *Panopticon; or, the Inspection House* (1791). This social shift brings with it a commodification of crime: not only were there new criminal and "policing" bodies and modes emerging, but attendant with this was the need for a new discursive format (and figures) to attempt to make sense of the world.

Crime writing in the early nineteenth century was again dominated by men, as many of the accounts of the development of the genre suggest. *Blackwood's Edinburgh Magazine* published Thomas De Quincey's satirical essay, "On Murder Considered as One of the Fine Arts" (1827), as well as many short stories and "Tales of Terror" from the periodical's inauguration in 1817 onwards; these were predominantly in the modes of horror and sensation, although they did incorporate crime. Another strongly masculine text that contributed towards the development of the crime/detective genre was the anonymously written, three-part *Richmond: Scenes in the Life of a Bow Street Runner, Drawn Up From His Private Memoranda* (March 1827),[2] which featured Runner Tom Richmond and his quasi-detecting adventures. Between 1820 and 1850 a series of novels appeared which featured a criminal protagonist, often based on actual felons, and which became known as "Newgate novels." Keith Hollingsworth selects Edward Bulwer Lytton's *Paul Clifford* (1830) and *Eugene Aram* (1832); William Harrison Ainsworth's *Jack Sheppard* (1839); Charles Dickens' *Oliver Twist* (1838) and *Martin Chuzzlewit* (1844) as exemplary of the sub-genre.[3] To this wholly male-authored list can be added Ainsworth's first novel—*Rookwood* (1834)—which had the highwayman Dick Turpin as a central figure. G.W.M. Reynolds equally contributed to this masculine crime output in the 1840s, with *Robert Macaire in England* (1840) and the later weekly *Reynolds' Miscellany of Romance, General Interest, Science and Art*, but he is best known for his serial tales of melodrama and crime—*The Mysteries of London* (1844–45; book 1846). The *Mysteries* were inspired by Eugène Sue's *Les Mystères de Paris* (*Journal des Débats*, May 1842–October 1843; in English in 1845). Contemporary and critical concerns over the factual and literary use of crime, which will be later echoed in the 1860s by Margaret Oliphant, are evident in these earlier incarnations by Sue and Reynolds; *Bentley's Miscellany* commented on the mystery form in 1845:

> Mysteries, it appears, are no longer to remain so. Authors ... start up and show to the world that at least to them there have never been such things as mysteries. The veil of France is torn from her by a Frenchman, who certainly pays no

high compliment to his country, by exposing vices of the most hideous character, and which are certainly much better hidden both from the young and old. The moral to be drawn from melodramatic vice and virtue is very questionable. This mysterymania has crossed the Channel. Authors are manufacturing vices by the gross.[4]

Both Sue and Reynolds had a prolific output with their respective series/ *feuilletons* and later novels.

There was, furthermore, a vogue for and proliferation of narratives in the form of memoirs and anecdotes in the 1850s and '60s, a pattern which is evident in crime writing after the mid-century and which was instrumental in the creation of detective fiction. This became so popular by that by the late nineteenth century, as Leslie Stephens noted, "[t]he intelligent detective is a drug in the market."[5] Such views were earlier expressed more negatively by Margaret Oliphant:

> We have already had specimens, as many as are desirable, of what the detective policeman can do for the enlivenment of literature; and it is into the hands of the literary Detective that this school of story-telling must inevitably fall at last. He is not a collaborateur whom we welcome with any pleasure into the republic of letters. His appearance is neither favourable to taste nor morals.[6]

Public interest in these detecting figures and their representation is apparent in Charles Dickens' journalistic pieces on the detective police in his periodical, *Household Words* (appearing between July 1850 and February 1853). Prior to this, Dickens' interest in crime was shown by his newspaper sketches— *Sketches by Boz*—in the 1830s. The curiosity surrounding proto- or quasi-detectives is also apparent in the anonymously-authored "The Experiences of a Barrister" (*Chambers's Edinburgh Journal*, 1849–50). These eleven cases deal with murder, forgery, theft, marriage, property, and inheritance. "Samuel Ferret Esq., Attorney-at-Law," a detective prototype, appears in "The Contested Marriage" (1849). He is described as:

> Indefatigable, resolute, sharp-witted, and of a ceaseless, remorseless activity, a secret or a fact had need be very profoundly hidden for him not to reach and fish it up. I have heard solemn doubts expressed by attorneys opposed to him as to whether he ever really and truly slept at all—that is, a genuine, Christian sleep, as distinguished from a merely canine one, with one eye always half open.[7]

"The Confessions of an Attorney" (*Chambers's*, October 1850–June 1852), featuring the attorney, Mr. Sharp, as narrator and protagonist, has also been credited to Samuel Warren. The author of both "Experiences" and "Confessions" is still unknown, although it has been assumed that Warren is the writer. Later there emerged a self-conscious play on Warren in the U.S. with a dime novel written by "Detective Warren": *The Whitechapel Murders: Or, On the Track of the Fiend* (New York: Munro's Publishing House, 1888). This

authorship may be a coincidence, but the deprecation of the British police in the text seems to suggest that this choice of name was intentional. In 1854, Wilkie Collins' short story, "A Stolen Letter," offers yet another male-authored foray into crime. William Russell, writing as "Thomas Waters," created "Recollections of a Police-Officer" (*Chambers's*, 28 July 1849–3 September 1853), which initially appeared anonymously.[8] Russell's mode of writing served as a catalyst for numerous other purported "real life," male-authored police memoirs.

The years from 1860 to 1880 are generally perceived as an interstitial period with reference to the development of the genre, yet this is far from the case; in the 1860s crime is relocated in the newly emergent mode of sensation fiction. The Gothic and melodramatic elements which were more pronounced in the earlier material are now disconcertingly reworked and brought into the Victorian home. The domestic settings made this an eminently suitable literary space for women writers, although there was still a strong masculine presence. Critical attention has predominantly been on the works of Wilkie Collins and Charles Dickens as well as Mary Elizabeth Braddon and Mrs. Henry (Ellen) Wood. But in such crime-centered fiction that did appear, male voices continued to dominate: the pseudonymous Charles Felix's *The Notting Hill Mystery* (serialized in *Once a Week* from 1862–63; novel form 1865), Irishman Joseph Sheridan Le Fanu's *Wylder's Hand* (1864) and *Checkmate* (1871), and even Collins's sensational fiction was considered as crime fiction. As Dorothy L. Sayers notes in *The Omnibus of Crime* (1929), "[m]ost important of all during this period we have Wilkie Collins. [...] Taking everything into consideration, *The Moonstone* is probably the very finest detective story ever written."[9] Dickens too is seen to be part of the crime fiction canon and Caroline Reitz claims that "seminal works in the tradition of detective fiction [are]: *Caleb Williams* (1794), *Bleak House* (1853), *The Moonstone* (1868), and the Sherlock Holmes stories," texts which are all written by men.[10]

It seems then, that the "seminal and influential" texts are all masculine in origin. Where Dickens or Collins are not claimed as the originators of the genre, "Charles Felix" is proposed; Martha Hailey DuBose suggests that the first English detective novel is not Collins's *The Moonstone* but *The Notting Hill Mystery*. Stephen Knight observes that Felix's text is "the first English murder mystery with detection throughout."[11] Julian Symons also has *The Notting Hill Mystery* as the first detective novel,[12] as does Michael Cox, whose discussion of "the first full-blown detective novel in English," includes *The Moonstone* and *The Notting Hill Mystery*, but also suggests that "Angus Bethune Reach's *Clement Lorimer: or, The Book with the Iron Clasps* [...] is a contender for the title."[13] The first fully developed police detective figure to feature in a novel has been declared variously to be Dickens' Inspector Bucket and/or Collins' Sergeant Cuff. Yet Bucket only appears in *Bleak House* from

Chapter 22, and Collins' Cuff fails to ascertain and accuse the true culprit in *The Moonstone*. Dickens' *The Mystery of Edwin Drood* (left unfinished at his death in 1870) has both caused and been the subject of much discussion with many solutions and endings postulated. The list goes on, and this plenitude and popularity of nineteenth-century male-authored crime-inflected writing suggests that it was considered to be a suitable subject for men but not, the masculine predominance suggests, for women. Bradford K. Mudge's investigation into the "feminization of popular culture" considers possible reasons for this feminine eclipse, emphasizing the threat that the female posed by participating in the literary arena as both readers and writers:

> Like eighteenth- and nineteenth-century prostitutes, who were both victims and perpetrators of entrepreneurial capitalism, women's novels enacted a transgression while upholding the very standard they transgressed: romance, domestic, and Gothic novels all competed successfully in a literary market that deplored market success as a criterion of value.[14]

And such statements will later be seen in the masculine reaction to women writers in the United States.

The traditional genealogy of crime features no women writers. Social and literary conventions seemed to prevent women from directly addressing crime in their fiction. Ann Radcliffe (1764–1823) and her works exemplify this; using the (feminine) Gothic and suspense/mystery form — as in *A Sicilian Romance* (1792), *The Mysteries of Udolpho* (1794), and *The Italian* (1797) — she can incorporate crime into her discussions of feminine and social persecution, and can construct men as villains. However, this commentary is permitted by distance: literally, in the foreign settings and characters of the texts and also by utilizing unconscious states and representations of the "other."

Earlier, Charlotte Smith's *Emmeline, the Orphan of the Castle* (1788) again articulated these concerns. In addition to Smith, other earlier Gothic women writers were Sophia Lee and Clara Reeve. The Gothic was not a feminine-only form. Well-known masculine examples are Horace Walpole's *The Castle of Otranto* (1764) and Matthew Lewis's *The Monk* (1796) — which was written as a response to Radcliffe and functions as a reversal: the focus is on the villain as protagonist. In 1824 there was also James Hogg's *The Private Memoirs and Confessions of a Justified Sinner*. While not crime-based, some women did voice proto-feminist discontent over their social positioning: William Godwin's wife, and Mary Shelley's mother — Mary Wollstonecraft — wrote *A Vindication of the Rights of Women* in 1792, followed by *Maria: Or, The Wrongs of Woman* in 1798.

This female-authored eighteenth-century form of the Gothic/suspense is reworked in the early nineteenth century, with Maria Edgeworth's *Castle Rackrent* (1800), Jane Austen's parody, *Northanger Abbey* (1818), and Mary

Shelley's *Frankenstein* (1818). In 1998 P. D. James presented to the Jane Austen Society: "*Emma* Considered as a Detective Story." In 1843, Henry Chorley Fothergill in a review of Catherine Crowe's *Men and Women: or, Manorial Rights* (1843), conflated Crowe, Fielding, and Austen with their use of clues in their respective productions of a novel: "If we turn to Fielding, or to Miss Austen — that master and mistress of the art — we find that their artifice was surpassed by their ease and nature in concealing it; that the incident which served as clue to the labyrinth, was rather remembered afterward, and turned back to, than watched or noted at the time."[15] In addition, the Brontës included elements of crime in some of their fiction; Charlotte Brontë's *Jane Eyre* (1847) is concerned with notions of social crime, madness and (post)colonialism, which are seen in the often-discussed figure of Bertha Mason, and these are tropes which are again seen later in the sensation fiction.[16]

Anthony Trollope's mother — Frances (Fanny) Trollope (1779–1863) — wrote thirty-five books. Paul Féval perhaps mockingly employed the pseudonym "Sir Francis Troloppe" for *Les Mysteres de Londres* (1844). Stephen Knight has commented that this was probably a way of "one-upping" Eugène Sue. Michael Sadleir recognizes Fanny Trollope's influence, comparing her with Mary Elizabeth Braddon in the comment: "As a dogged, courageous and finally triumphant bread-winner she may be paralleled with Frances Trollope and with Margaret Oliphant."[17] Rather than endorsing convention, Fanny was a challenging literary presence, addressing issues such as slavery, religion, love, the Poor Laws, and the position of women, while *Hargrave; or, The Adventures of a Man of Fashion* (1843) incorporates elements of crime and detection. Linde Katrizky in "The Intriguing Case of Hargrave: A Tragi-Comedy of Manners" sees this novel as a combination of detective story and romance.[18] In 1839 the *New Monthly Magazine* wrote "No other author of the present day has been at once so much read, so much admired, and so much abused."[19] Fanny Trollope, though, simultaneously uses the conventional trappings of sentimental romance in *Hargrave*; this incorporation suggests the social and literary limitations placed upon women writers; they had to conceal both crime in their fiction and the crime of writing about such an unsuitable subject. But women were writing crime, and it seems that their texts have somehow been repressed or dismissed in favor of the male canon.

Catherine Crowe (1790–1872)

An example of an early female exponent of crime fiction who achieved publication and popularity by concealing her identity was Catherine Crowe

(1790–1872). Crowe's initially anonymously published *Adventures of Susan Hopley; or Circumstantial Evidence* (1841) was at the time of publication very successful and, boldly, the sub-title draws attention to its crime status.[20] This novel appeared a year before Sue's *Les Mystères de Paris* (1842–3). Its contemporary popularity is evidenced by the inclusion of Crowe's protagonist as a minor character named "Susan Hopley" in one of Samuel Warren's "Experiences of a Barrister" stories: "The Writ of Habeas Corpus" (*Chambers's*, 9 June 1849, 354–58). Mary Elizabeth Braddon later references the play of *Susan Hopley* in her novel, *Aurora Floyd* (1863). It is in the modern day that Crowe's influence is not known. *Susan Hopley* features the eponymous Susan, a maid servant who has a detecting function, and this novel can be read as a crime or mystery story and one which influenced later writers such as Wilkie Collins (with "Anne Rodway" [1856] and *No Name* [1862]), and the lady detectives.

It incorporates an intricate plot, which reveals the truth and the villains at the end of the narrative, and a court scene is involved. This novel is known in later editions as *Susan Hopley, or the Adventures of a Maid Servant*. This sub-title locates the novel in the domestic rather than criminal milieu. In a later novel, *The Story of Lilly Dawson* (1847), Susan is saved from her life as a maid by the discovery that she is a Colonel's daughter. John Forster commented that "there is no end to the circumstantial plots and counterplots, of which [Susan] is first the unconscious and unhappy centre, and at last the quiet and triumphant unraveller."[21] Brenda Ayres views *Susan Hopley, or the Adventures of a Maid Servant* as Crowe's "female detective novel."[22] In addition to crime, Crowe wrote drama, domestic fiction, historical fiction, non-fiction, a juvenile adaptation of Stowe's *Uncle Tom's Cabin* (in 1853), and contributed regularly to *Chambers's* in many genres. Susan tracks down the murderer of wealthy wine merchant, Mr. Wentworth. Susan's brother—Andrew Hopley—has absconded with a servant, Mabel Jones, and is consequently suspected of the deed. He is later found murdered. Susan also functions as detective in smaller cases outside the main investigation and later works with Mabel (later known as Amabel).

Susan's status as servant seems a purposeful reworking of Godwin's *Caleb Williams*: Susan's role as servant and detective is similar to that of Caleb in Godwin's text, but it is now a woman who is narrating and speaking of crime as well as functioning and excelling in a detecting capacity. Susan is a successful detective figure; the contemporary reviewer Thomas Kibble Hervey suggested that: "Through all the intricacies of the story, [Susan] winds her way with preternatural ease—the Dea Vindex, who unties all its knots."[23] Additionally, a secondary female figure in the narrative demonstrates detective skills: Julie Le Moine is "born with the spirit of a heroine, the passions of a Medea and the temper of a vixen" and helps Susan with her investigations.[24]

Despite these clear detective elements, Crowe's text has received little attention as crime fiction. John Sutherland returns it to the romantic sphere, calling it "[a] simply written romance, which achieved considerable popularity and was reprinted throughout the century."[25] In fact, Susan defies this patriarchal placement: after her detecting actions are successfully completed she is not returned, in Romantic tradition, to reassuring domesticity through marriage in the closure of the text. Crowe's role in the development of crime fiction has been unjustly forgotten.

Crowe published a second crime novel — *Men and Women: or, Manorial Rights*, 3 vols. (London: Saunder and Otley, 1843). This novel involved the murder of Sir John Eastlake and the investigation of three suspects. A review of this novel in the *Examiner* declared that

> A great many persons are introduced, and all, with a wonderful constructive art, are made to serve some purpose in detection of the master-crime. Incidents with no visible connection, but of indefinable sympathy rise in almost every chapter: gradually the link is formed, the chain of evidence imperceptibly extends, and the murderer is enmeshed.[26]

Curiously, despite favorable reviews at the time, this novel has never been reprinted — appearing only in one edition — and has consequently been overlooked. There is no detective *per se*, but a host of amateurs and a Bow Street Runner — Scroggs — appear towards the end of the novel. Lady Eastlake — the mother of the murdered man — thinks Mr. Rivers is the murderer and sets out with "the determination of detecting what everybody else seemed resolved not to detect" (II, p. 173). Yet she is wrong in her convictions, and it is the use of ballistics which uncovers the real perpetrator in a fashion reminiscent of the earlier "Der Kaliber" (1828) by Adolph Müllner.

Caroline Clive (1801–1873)

Another woman to test the gendered and discursive boundaries of crime writing was Caroline Clive (1801–1873), writing under the pseudonym "V." Her first and probably best-known novel was the successful *Paul Ferroll* (1855), a text that was endorsed by Elizabeth Gaskell. Gaskell wrote that the novel was "more distinguished [...] by power, than by beauty [...] The great skill is in the working out of this plot. People here condemn the book, as "the work of a she-devil," but buy it, and read it."[27] While the novel's title locates it in the tradition of the Newgate novel, Clive's text was, lacking a detective figure, a murder-mystery. It was, though, controversial in that Paul Ferroll unrepentantly murders his wife, happily remarries, and then confesses twenty

years later when someone else is convicted for his murderous deed; he is not punished, and escapes from prison. There is, unusually and rebelliously, no moral message in this discourse. This novel was translated into French and, later, a prequel was released: *Why Paul Ferroll Killed His Wife* (1860). Clive also wrote poems and theological essays. Clive's novel is further evidence of women writers challenging convention and contributing to the nascent crime and detective genre.

There was, from the 1860s on, a proliferation of British women's voices which significantly added to and helped develop a canon of female-authored crime fiction. The sensation novel seemed to offer a semi-respectable venue in which women could write about crime. But these women are not completely free from constraints; this study suggests that the reason why female-authored crime narratives in Britain in the nineteenth century could not flourish is because of gendered literary conventions which dictated suitable subjects for the female writer and asserted that crime was, clearly, an unsuitable topic for a woman. A female author seeking publication had better present work that accorded with the conventions. Michael Sadleir commented that in the 1850s and 1860s "while editors, publishers and public wanted stories of high life and crime, they would not stomach highlivers and criminals as they really were,"[28] especially not when represented by women writers.

The passages that follow consider the ways in which the nineteenth-century women writers Elizabeth Cleghorn Gaskell, Mary Elizabeth Braddon, and Mrs. Henry (Ellen) Wood incorporated crime into their narratives and so contributed to the creation of a female canon of crime fiction. But as will be demonstrated, it is in their lesser-known or anonymously published texts that they dared to experiment with crime and even there, their writing was restricted and contained.

When these women were writing, crime/detective fiction was in the process of becoming a distinct and self-contained genre, and crime rather appeared as part of other genres of writing as in the Newgate novels of the 1830s and 40s. This insertion of crime narratives into other genres is particularly apparent in the sensation fiction that emerged in the 1860s, with its interest in crime within the domestic sphere and its frequent exploration of deviant femininity. This is, perhaps briefly, the dominant form of fictional criminography; its domestic settings and concerns provide a discourse in which women could express their preoccupation with crime. An anonymous writer commented in 1864 that "[o]f all forms of sensation novel-writing, none is so common as what may be called the romance of the detective."[29] The abolition of stamp duty in 1861 (newspaper tax was abolished in 1855) increased the sales of printed material generally and the reduction in cost meant that texts became cheaper and were more widely available across the

whole social stratum. While the three-decker novel was primarily found in the circulating libraries and considered to be for the middle classes, serialized sensation fiction was read by the poor as well as the rich. A famous example is Charles Edward Mudie's Circulating Library (1842–1894). W. H. Smith's Library was also popular. Critical responses to sensation fiction were not positive as is shown by the comments by an anonymous reviewer of Wilkie Collins' *Armadale* (*Harper's Monthly*, 1866) in the *Westminster Review* (October 1866):

> Just as in the Middle Ages people were afflicted with the Dancing Mania and Lycanthropy ... so now we have Sensation Mania. Just, too, as those diseases always occurred in seasons of dearth and poverty, and attacked only the poor, so does the Sensation Mania burst out only in times of mental poverty, and afflict only the most poverty-stricken minds. From an epidemic, however, it has lately changed into an endemic. Its virus is spreading in all directions.[30]

The population of the fiction resembled its audience; in 1863 Henry Mansel described the sensation novel as:

> a tale which aims at electrifying the nerves of the reader is never thoroughly effective unless the scene be laid in our own days and among the people we are in the habit of meeting [....] The man who shook our hand with a hearty English grasp half an hour ago—the woman whose beauty and grace were the charm of last night [...] —how exciting to think that under these pleasing outsides may be concealed some demon in human shape.[31]

The sensation novel functioned to shock, precisely to elicit physical sensations in the reader. While it is disconcerting to learn that both the male possessor of the "hearty English grasp" and the female owner of "beauty and grace" are potentially not what they seem, criminality and deviance in the sensation novel is most often gendered as feminine.

Lyn Pykett describes the women's sensation novel as representing "The "Improper" Feminine."[32] The conflation of the female and sensation can be seen by Henry James' declaration that sensation fiction started with Mary Elizabeth Braddon's 1862 *Lady Audley's Secret*.[33] Women are constantly labeled as criminal and "demonic" for disturbing societal values and for threatening the patriarchal status quo. The best-known female exponent of sensation fiction is Mary Elizabeth Braddon, whose *Lady Audley's Secret* (1862) has come to epitomize the genre; this text also has elements of detective fiction. As its title suggests, *Lady Audley's Secret* has at its centre a woman who proves to be the criminal in the narrative: bigamous as well as murderous, Lady Audley set the pattern for many subsequent anti-heroines of the genre. But, as with much of the fiction incorporating crime produced in this period, Braddon's earlier work is hard to classify.

Still harder to classify is the exact role of the British woman writer within

the bounds of criminography. As Gilbert and Gubar note, "[m]ost Western literary genres are, after all, essentially male — devised by male authors to tell male stories about the world."[34] Alison Young supports this contention, stating that "[w]ithin the discipline of criminology, Woman is secreted behind the borders of a discursive closet."[35] This statement refers not only to female characters within crime narratives, but also to the female writers of these stories who were confined by society, patriarchy, and convention. As Professor John Sutherland observes, women writers in the period who are now considered canonical were interested in crime and its representation: "Gaskell is obsessed with crime. As was Braddon."[36] Obsessed certainly, but constrained by convention and so unable openly to articulate their interest in crime.

The masculine bias of the emergent genre of crime/detective fiction is apparent in twentieth-century critical works on the subject. The title of Clive Bloom's collection, *Nineteenth-Century Suspense: From Poe to Conan Doyle*,[37] suggests the conventional masculine markers of canonical crime fiction, as does *Sherlock's Sisters: The British Female Detective*,[38] which seems to locate the feminine as secondary to and derivative of the strongly masculine Sherlock Holmes and as appearing only in his wake after the 1890s. *Roots of Detection: The Art of Deduction Before Sherlock Holmes*[39] again uses Sherlock Holmes as a pivotal point, but while it includes an excerpt from Mrs. Henry Wood's *East Lynne*, no other female authors are mentioned. Marty Roth takes a patriarchal perspective, writing of "the place of women in what is, classically, a masculine genre even when authored by women."[40] Sutherland, responding to a query about women writers in the 1860s and 1870s who were writing what could be interpreted as crime fiction in Britain, states that "the box is empty [...] Odd, isn't it, that Wilkie Collins could introduce the first canine detective, but an English woman detective (as opposed to a Keyhole Kate) was unthinkable."[41]

Female-focused literary criticism such as Victoria Nichols and Susan Thompson's *Silk Stalkings: When Women Write of Murder* (1988), states its specific aim to be "a book which listed only the women authors of crime and mystery fiction and titles of their works."[42] In the 522 pages, covering the period 1867–1987, apart from a very brief mention of M(ary) E(lizabeth) Braddon's Valentine Hawkehurst, a quasi-detective figure who featured in Braddon's *Birds of Prey* (1867) and *Charlotte's Inheritance* (1868), there are no British women represented as writing in this form between 1860 and 1880. In the United States only Anna Katharine Green is mentioned and given the title of "mother of detective fiction." In terms of literature generally, there is a plethora of critical material on women's writing in the United States in the 1860s, but little of this is specifically concerned with crime, and the pattern is the same in Britain.

Within male-authored novels and texts concerned with crime, women often play pivotal roles, more usually as criminals or victims, but at times they have a detective function. The portrayal of women within these texts, this study suggests, opens the way for women writers to begin to include overt depictions of crime within their own fiction. The creation of female detectives in male-authored criminography is of particular significance. Another European male creator of a female sleuth was the German Ernst Theodor Amadeus Hoffmann, whose "Das Fraülein von Scuderi" (1820), was a Gothic-related murder mystery/crime set in Paris in the reign of Louis XIV and was concerned with jewel theft and serial murders. But Fraülein Scuderi is a collator of information given to her, rather than an active detective/investigator. Christopher A. Lee sees this story as precursive of the detective genre; his article "E. T. A. Hoffmann's "Mademoiselle de Scudéry" as a Forerunner of the Detective Story" reinforces this.[43] Gilbert Adair sees this story as the first detective story in western literature.[44] Jeremy Adler locates "Hoffmann's innocent lady detective, Mlle de Scudery, [as] an ancestor of Miss Marple."[45] R. J. Hollingdale writes that this story is "a detective story embodying most of the tricks of the genre supposedly invented by Poe [...] twenty two years later."[46]

Although in Dickens' *Bleak House* (1852–3) the focus has tended to be on the policing figure of Inspector Bucket, Dagni Bredesen's work on female detectives considers Dickens's representation of Mrs. Bucket:

> [She is] "a lady of a natural detective genius, which if it had been improved by professional exercise, might have done great things, but which has paused at the level of a clever amateur." Dickens writes almost as if "professional exercise" of detective genius had been an option for Mrs. Bucket.[47]

Mrs. Bucket is here aligned with power and detecting ability, yet such positions for women were not realizable either in life or in literature until much later. Peter Haining states: "Nor must we forget the clever wife of Inspector Bucket who, in my estimation, deserves the title of the first female amateur detective in fiction."[48] A husband/wife detecting combination similar to Mr. and Mrs. Bucket can be seen earlier in William Russell's anecdotal "Recollections of a Police Officer." The story "Mary Kingsford" (1851) depicts how Waters' wife, Emily, assists his investigation by being able to differentiate between a fake and a real diamond in a stolen brooch. In America, William E. Burton's 1837 story, "The Secret Cell," features L—, a London police officer who is assisted by his unnamed wife in an abduction case.

This is again clear in Collins' short story, "The Diary of Anne Rodway" (*Household Words* 26 July 1856), which features a female investigator. Collins' fictional investigative female may have been influenced by the factual case of Anne Kidderminster and her investigation into her husband Thomas's mur-

der, which was fictionalized in pamphlet form in 1688: *A True Relation of a Horrid Murder Committed Upon the Person of Thomas Kidderminster*. Anne Kidderminster is unique in that she can collect evidence, travel, interview and find the real culprit, and see that justice is served upon him, all without the interception or usurpation by a male. Providence and chance, though, do play a role. The association of the two feminine detecting names in the Kidderminster and Rodway stories may have been a coincidence, but it is very probable that Collins had read this story.

In Collins' story the eponymous protagonist investigates the death of her friend, Mary Mallinson, and speaks out against the masculine and authoritarian Doctor, who claims that Mary had fainted and hit her head when she fell, causing her death. Anne argues that "I [was] not yet quite convinced" (p. 6). This contestation of the Doctor and his discourse is significant. Prior to 1859 there was an anecdotal sub-genre concerned with the overarching discourses of medicine and law. Examples of these are Samuel Warren's (?) "Passages from the Diary of a Late Physician" series (*Blackwood's*, 1830–37), "The Experiences of a Barrister" (*Chambers's*, 1849–50), and "The Confessions of an Attorney" (*Chambers's*, 1850–52). Yet, in this story, Anne directly contests this authority with her own narrative and by gathering evidence. Anne's narrative links with Julie's in Crowe's *Susan Hopley*. Sexual policing and its regulation via society has been summarized by Foucault: "Sexuality was carefully confined; it moved into the home. The conjugal family took custody of it and absorbed it into the serious function of reproduction."[49] However, women and sexuality were more specifically arbitrated by an amalgamation of medical and policing gazes; a female criminalization/sexual deviancy dyad is evident in the factual passing by parliament of The Contagious Diseases Acts of 1864–1869.

Her fiancé, Robert, eventually usurps Anne's control over the case; he returns her to a socially acceptable womanly stereotype. As Anne says, "I wanted to go with Robert to the Mews, but he said it was best that he should carry out the rest of the investigation alone, for my strength and resolution had been too hardly taxed already" (p. 14). Anne's initial investigations are dismissed: "Robert agrees with me that the hand of Providence must have guided my steps to that shop from which all the discoveries since made took their rise" (p. 14). While as a consequence of Anne's actions the case is correctly solved and the criminal — Noah Truscott — brought to justice and transported, modern literary critics are still ambivalent as to the extent of Anne's empowerment. Robert P. Ashley writes that

> Anne accomplishes more by chance and by perseverance than by the exercise of any particular detective skill, but the most brilliant detective could do no more than Anne does — she identifies the criminal and establishes his guilt.

Hence, there should be little objection to her being crowned the first of lady detectives.[50]

Bredesen comments that "[a]lthough some critics designate her "the first female detective," Anne Rodway does not identify herself or her activities in those terms."[51] The proto-detecting woman is still, in this instance, mediated both by the masculine writer and literary and social conventions. From a sensational point of view and to gain sales, Anne is granted both detecting and feminine autonomy, yet this is short-lived; she must be brought back into the "reality" of appropriate gendered placements before the close of the narrative.

A similarly complex and perhaps more challenging character is Collins's Marian Halcombe in *The Woman in White* (1860). She is an aberrant woman both generally and in the sense that she is masculinized in her textual representation:

> Never was the old conventional maxim, that Nature cannot err, more flatly contradicted — never was the fair promise of a lovely figure more strangely and startlingly belied by the face and head that crowned it. The lady's complexion was almost swarthy, and the dark down on her upper lip was almost a moustache. She had a large, firm, masculine mouth and jaw; prominent, piercing, resolute brown eyes; and thick, coal-black hair, growing unusually low down on her forehead.[52]

Her piercing eyes align her with the plethora of detectives that will follow possessing discerning and penetrative eyes. Marian's investigative function masculinizes her, but this is ended by her re-feminization: her later illness — a direct consequence of investigating activities — functions to recuperate and weaken her deviant body. Gill Plain, writing on Sara Paretsky's V. I. Warshawski, observes "the terrifying extent of the forces [that] ranged against any manifestation of the female agent."[53] Yet this response to women and their involvement in crime has a long lineage, and is seen much earlier in this Victorian period. In Collins' *No Name* (1862) and *The Law and the Lady* (1875), the quasi-detecting figures of Magdalen Vanstone and Valeria Macallan respectively replicate this empowerment/disempowerment nexus; Dorothy L. Sayers contends that Collins made "two attempts at the woman detective [but] [t]he spirit of the time was, however, too powerful to allow these attempts to be altogether successful."[54] Additionally, quasi-detecting capacity can be accorded to Braddon's Eleanor Vane in *Eleanor's Victory* (1863) and Jenny Milsom in *Run to Earth* (1868), both of whom solve the mystery surrounding the deaths of their fathers. Such feminine investigations, however, are ultimately inspired by a need to avenge the patriarchal father/male. Read in this way, the detecting female and her actions are still dictated — by proxy — by the man. Although these women do challenge the masculine hegemony of crime writing in the period, their presence and power is invariably curtailed by the end of the narrative.

It is only in 1894 that the parody/pastiche, Mrs. Julia Herlock Sholmes can appear. These were two stories, "The Adventure of the Tomato on the Wall" and "The Identity of Miss Angela Vespers," in *The Student*, Edinburgh University Magazine, under the genderless pseudonym of "Ka." The real author is still unknown. Mrs. Julia Sholmes, however, is carrying on her husband—Herlock Sholmes's work. This propagates the trope of female detectives who are only allowed into the detecting sphere when the dominant male/husband figure is deceased; this is enacted in the two 1864 female detectives, and seen and repeated later with P. D. James' Cordelia Gray in *An Unsuitable Job for a Woman* (1972).

In the 1860s two apparently male-authored texts appear which anachronistically depicted female "police detectives." While women could be guards in women's prisons in the 1880s, it was not until 1918 that they were fully allowed into the Metropolitan Police (and the CID in the early 1920s). These texts are Andrew Forrester Jun.'s Mrs. G—, in *The Female Detective* (London: Ward and Lock, 1864) and the figure of Mrs. Paschal by "Anonyma" (probably W. Stephens Hayward) in *Revelations of a Lady Detective* (1864).[55] Recently, Judith Flanders has made a case for the primacy of the penny-dreadful, *Ruth the Betrayer* (1862–3), by Edward Ellis (pseudonym of Charles Henry Ross), stating that "*Ruth* precedes what are frequently called the first fictional female detectives."[56] Stephen Knight has made the suggestion that Andrew Forrester is possibly "Mrs. Forrester," whose text, *Fair Women*, will be examined later. *The Female Detective* and *Revelations* were written in the mode of popular and prolific casebook/notebook/memoir/professional anecdotes of the 1830–60s; more specifically, these were in the style of the "Thomas Waters" police-detective anecdotes by William Russell. The inclusion of a female detective is perhaps an attempt to refresh the police anecdote sub-genre and boost sales and conceivably also, in a similar vein to the sensation novel, an attempt to "shock" the reader. Michele Slung emphasizes this commercial conception of the female detective:

> Actually, the notion of the female detective got off the ground in the mid–nineteenth century more as a capitalization on the public's desire for new and novel kinds of sleuths than it did out of any real urge to give equal time to women and their intuitive talents.[57]

These female detectives, apparently written by men, contribute to the creation of a new discursive space in which women writers could inscribe their criminal interests. With the exception of the police detective, however, it seems that it is not until the *fin de siècle* in Britain and the 1880s in America that such figures appear in definite form, and even then, these were not necessarily created by women writers.

Women investigators and their categorization have been themselves the

subject of literary investigation. Birgitta Berglund summarizes the more usual representation of women in nineteenth-century criminography:

> Women in detective stories have been victims, or they have been perpetrators, but they have not, on the whole, been detectives—that is, they have not been given the most important part to play. In novels written by men, women detectives are very few indeed (although they do exist) but even in books written by women, male detectives dominate.[58]

By contrast, Fay M. Blake, speaking of the later nineteenth century, claims that "[t]here are two very different kinds of fictional female detectives during the period, upper class ladies and working women."[59] Dorothy L. Sayers noted of the established detective fiction genre that:

> There have also been a few women detectives, but on the whole, they have not been very successful. In order to justify their choice of sex, they are obliged to be so irritatingly intuitive as to destroy that quiet enjoyment of the logical which we look for in our detective reading. Or else they are active and courageous, and insist on walking into physical danger and hampering the men engaged on the job.[60]

Jane C. Pennell, however, sees them from a feminist viewpoint, stating that "the women adventurers were more *avant garde* than their male counterparts."[61] This study puts forward that Andrew Forrester Jun.'s "Mrs. G—," and W. Stephens Hayward's (?) "Mrs. Paschal," despite being (apparently) masculine perceptions of female detectives, embody the tensions between women, writing and crime and explore in criminographical terms the reality of women's roles in a patriarchal society—in fiction and in fact. The existence of these figures begins the process of constructing a descriptive space that will later be inhabited by the woman writers of detective fiction and their female investigating protagonists.

From 1861 onwards, police detective stories similar to those by William Russell and "Charles Martel," had appeared under the name of "Andrew Forrester." These collections were *Revelations of a Private Detective* (London: Ward and Lock, 1863), and *Secret Service; or, Recollections of a City Detective* (London: Ward Lock, 1864). Stephen Knight has suggested that "Andrew Forrester" may have been the pseudonym of the brothers John and Daniel Forrester, who were actual private inquirers.[62] Published in May 1864 and comprising an introduction and seven tales/cases, Forrester's *The Female Detective* introduces Mrs. G—[Mrs. Gladden], who initially seems self-abnegating, even attempting to erase her female presence in the narrative by declaring to the reader that: "In putting the following narratives on paper, I shall take great care to avoid mentioning myself as much as possible."[63] These stories, like Hayward's, appeared in collections rather than in periodicals. Later, Collins would create a fictional female doctor in his short story "Fie!

Fie! or, the Fair Physician" in 23 December 1882, simultaneously appearing in *The Pictorial World Christmas Supplement* and *The Spirit of the Times*. This incarnation can be paralleled with the female agents (amateur and professional) of detection. This woman is portrayed in sexualized terms and the story is laden with innuendo. This serves to undermine the status and power of a woman in an explicitly deemed masculine profession. This happens with Mrs. G — she is imbued with power, yet is self-effacing. Mrs. G — is a believably feminine representation and conforms to the patterns of proper femininity; her investigations are located in the domestic as are her mannerisms and habits.

The narrative makes it clear that Mrs. G — has no male protector and so must take on what might be more usually considered to be the masculine responsibilities. As Klein comments:

> From the outset, Forrester hides the details of his protagonist's female existence [...] she declines to admit whether she is a widow working to support her children or an unmarried woman responsible only for herself, thus screening her parental status. These omissions and evasions deny the character's definition in societal terms. In refusing to clarify her identity as a woman, the author redirects attention to her position as a detective.[64]

Mrs. G — follows the pattern of William Russell's "Thomas Waters" in the sense that both are obliged to take up a detecting role after circumstances have left them disadvantaged. Mrs. G — works for the police, but she is not formally a member of this organization. This anomalous categorization is exemplified by Mrs. G —'s recurrent denigration of the detecting abilities of the police force; she constantly tells the reader that they dismiss her claims or do not ask the appropriate questions. This is most explicit in "The Unraveled Mystery," where her ideas, investigations and findings regarding a headless human body are dismissed and the masculine police detectives are depicted as lazy and incapable.

This story may have been inspired by the contemporaneous factual case in 1860: the Waterloo Bridge murder (four years prior to the appearance of Mrs. G —'s story). In the Waterloo Bridge murder, body parts were found in a carpet bag. Thomas Donnelly wrote of this event in the *Dublin University Magazine*: "We have now, as alleged, an improved police, electric wires, rapid communication, bright street lamps, and other aids to discovery which were wanting some years ago; and yet not the faintest gleam even of suspicion has been fixed on any one in connexion with this event."[65] Mrs. G — echoes both Donnelly and presumably the public's sentiments. This action and her insight thus place her above and superior to the masculine force, in a feminine rewriting, inscribing her knowledge and insight. Yet, even though Mrs. G — employs stereotypes in her classification of criminal and victim, she does not

have the authority to bring this case to a close on her own. Like the "detecting" female figures already discussed, the possibility of feminine investigative power and knowledge is suggested, but ultimately limited and contained.

Significantly, Mrs. G—states that: "Criminals are both masculine and feminine—indeed, my experience tells me that when a woman becomes a criminal she is far worse than the average of her male companions" (p. 3). This—to modern eyes—sexist view was commonly held in the period, as an American short story, "The Murderess" indicates: "But the mind of woman once tainted, and the corruption is irremediable."[66] Appropriately for a female detective and perhaps to keep the text within the bounds of possibility and convention, Mrs. G—'s cases deal predominantly with the domestic; women can also go where the male detective cannot.

"Tenant for Life" is concerned with fraud, inheritance and legitimacy.[67] Set in 1863, this story revolves around the sale of a child who is then substituted for another child which has died at birth and who would have been the heiress to some vast property.[68] Without the substitute child, the "life-possession of the property" (p. 61) would go to the rightful heir, the dissolute Sir Nathaniel Shirley. In order to investigate the case, Mrs. G— passes herself off as a milliner and dressmaker in the family house of Miss and Mr. Shedleigh, the dead child's aunt and father respectively, who substitute the child in order to obtain the fortune. Mrs. G—'s detecting methods match Tom Richmond's *modus operandi* in *Richmond: Scenes in the Life of a Bow Street Runner* (1827). Richmond transfers skills learnt from his early life with gypsies to his Bow Street position; like Mrs. G—, Richmond eavesdrops and covertly watches. Thomas Waters again acts in a similar way in his role as "police officer." In Dickens' earlier journalistic pieces on and actions of the detective police: in "A "Detective" Police Party" (*Household Words* 1850), the detectives are shown to employ the same approaches of disguise, deceit, overhearing conversations, and trailing suspects.

Upon discovering the substitution, Mrs. G— informs Sir Nathaniel who, in turn, wants to give the Shedleighs into custody for robbing him of his entitlement. Conveniently though, Sir Nathaniel dies of heart disease at the crucial moment. Regretting her actions upon realizing Sir Nathaniel's degenerate nature, Mrs. G— tells the police officers involved in the case that Sir Nathaniel was mad, and so the Shedleighs and the substituted child inherit.

This action of taking the law into her own hands is evocative of Hoffmann's Mademoiselle de Scudéry. Mr. Ferret in "The Experiences of a Barrister" series acts similarly in "The Writ of Habeas Corpus" (*Chambers's*, 9 June 1849), and Sharp, in "The Confessions of an Attorney" series, does the same in "The Life Assurance" (*Chambers's*, October 1850). By labeling Sir Nathaniel as "mad," Mrs. G— is empowered as she is reversing the

more typical action of the male denouncing the female as "criminal" and mad. Mrs. G — makes an ethical decision again in the longer, novella-length story/case, "The Unknown Weapon." She decides not to persecute the female housekeeper who accidentally murders the criminal/son of her employer when he conceals himself in a box in order to rob the house. This empathy Mrs. G — shows in this story to the female housekeeper could perhaps suggest that *The Female Detective* was actually written by a woman.

Returning to "Tenant for Life," Mrs. G — , however, cannot complete this case without the assistance of a man. As Lisa M. Dresner, commenting generally on the role of the female detective, declares: "No matter how strong her desire to investigate, and no matter how strong her linguistic and interpretive mastery, she is never allowed to bring her investigation to a successful conclusion through her own efforts."[69] This is shown when Mrs. G — has "to consult with my attorney" (p. 36) who is a "gentleman-at-law" (p. 36). Mrs. G — tells the reader that he "passed over my industry in the business as though it had never existed" (p. 39). This apparent textual refusal to acknowledge Mrs. G —'s investigative skills are again seen in Sir Nathaniel's confrontation with Miss Shedleigh: "So I have found you out at last?" he said. It was clear he had passed me [Mrs. G —] over in the matter as though I had never known of it" (p. 88). Mrs. G — , however, re-asserts her control of the case at the close of the story as she triumphs over Sir Nathaniel.

While Judith Flanders has recently posited that "'Andrew Forrester' is J[ames]. R[edding]. Ware,"[70] Stephen Knight suggests, and this study agrees, that *The Female Detective* may in fact have been written by a woman. Martin Kayman equates the female detective with Mrs. Forrester in his discussion of the impact of Doyle's detecting antecedents on the Holmes stories; he writes "it is Mrs. Forrester — recalling the name of the author of 'The Female Detective' — who rejoices in the 'romance' of the story in 'The Sign of Four.'"[71] The clear sympathy shown by the female detective towards other women in her cases supports this notion, as does the appearance of a three-decker novel, *Fair Women*, written by "Mrs. Forrester" in 1867–8. Stephen Knight argues this case in *Crime Fiction 1800–2000*. Here, he comments that

> [t]here may be a candidate for female authorship. It is noticeable that the Forrester detective stories stop after 1864, with only reprints appearing until 1868, then nothing. That is the year when an unidentified Mrs. Forrester starts to produce her three novels, *Fair Women* (dated 1868 but the British Library copy is stamped 8 November 1867), *From Olympus to Hades* (1868) and *My Hero* (1870). These are standard three-decker gentry romances, but it is notable that the first involves a man shot while poaching [...] It is easy to suspect a woman writer, perhaps connected to the Forresters, worked first in one lucrative and popular literary genre and then turned to another.[72]

Ostensibly this is a romantic novel that incorporates crime into its tangled love affairs rather in the manner of sensation fiction, and this inclusion of crime offers some support to the claim that Andrew Forrester, Jun. and Mrs. Forrester were one and the same. The criminal in *Fair Women* is a farmer, Mr. Tom Fenner, who attempts murder. The chapter which relates these events is clearly demarcated as crime-based, with the title "Shot in Cold Blood." Within the stereotypical romance plot there is a secondary story of crime.[73] Knight draws a parallel between Andrew Forrester's "The Unknown Weapon" story and its use of murder weapon and a chapter title in Mrs. Forrester's *Fair Women*, named "Drawing the Arrow Head."

Fenner combines attempted murder with blackmail as well as the social misdemeanor of attempting to rise above his proper station through marriage. In what this study will show is a recurrent trope in nineteenth-century criminography, the criminal in *Fair Women* is expelled from Britain and his threat displaced to Australia. As a female author, this chapter suggests that Mrs. Forrester cannot make crime the crux of her narrative but must keep it in the margins, serving to centralize domesticity and romance. And this will be recurrently seen with the women writers in the period. The real focus of Forrester's novel is an attack on the cruel treatment of women and forced marriages. Other examples include George Eliot's later realist novel, *Middlemarch* (1871–2), with its concentration on the dilemmas surrounding marriage, especially unhappy ones. *Fair Women* has a similarity to Catherine Crowe's *Men and Women*. Crowe's novel deals with crime but also gender and class relations, as the title suggests— as does Forrester. In *Men and Women* it is Sir John Eastlake's treatment of women and female servants which leads to his murder. In *Fair Women*, it is Fenner's treatment or mis-treatment of women which leads to him committing crime. But, as in *The Female Detective*, women are represented as battling against socially prescribed feminine roles; Mrs. G— performs a similar function in her role as detective, bringing the treatment of women into the open. The short crime narratives and the novel both use gossip as a medium of investigation. As Mrs. G— says, "women are in the habit of talking scandal" (pp. 9–10). *Fair Women* is satirical, playing with conventions and using intertextual references, with a main character named Winifred Eyre.

Equally, *The Female Detective* is self-conscious in its metafictional use of contemporary murder cases and literature, such as the June 1860 Constance Kent/"Road House Murder" case, referred to in the story, "A Child Found Dead: Murder or No Murder," and the 1860 Waterloo Bridge Murder in "The Unraveled Mystery." Both *The Female Detective* and *Fair Women* are similar in their use of crime and its simultaneous retraction. These texts offer social critiques: *The Female Detective* questions police efficiency, where *Fair Women* concentrates its attack on social structures and marriage. There are tenuous

connections between the two texts in that Mrs. G—finds sympathy for servants and families, and advocates that wicked or dissolute aristocrats should not inherit. Another tenuous similarity is perhaps apparent in Forrester's *Revelations of a Private Detective* series (1863), in which a story, "Arrested on Suspicion," has a constable named Birkley. He is described as: a "soft-looking, quiet, almost womanly man, with fair hair and weak, soft blue eyes, a man about thirty-five."[74] In this instance Birkley is represented as and literally embodies the notion of a "fair woman." Birkley, while understated in this initial impression is, in reality, astute and competent. *The Female Detective* centers on crime, while *Fair Women* is predominantly a romance which integrates crime. Despite these different forms, the affinities between the two texts suggest that Forrester and Mrs. Forrester are the same author, with the later incorporating mediated crime due to the assignation of her real, female name. Forrester/Mrs. Forrester, however, were not the only authors who incorporated crime and/or detection in this period.

Appearing later in 1864 was William Stephens Hayward's (?) *Revelations of a Lady Detective*. Hayward (?) wrote ten "revelations" or investigations featuring his female detective, Mrs. Paschal. Like Mrs. G.—, she works for the police, but in a limited and indeterminate form. Mrs. Paschal makes it clear that it is not a police job that she is performing in her role in "Incognita." There is no actual crime here, and the work is really surveillance. As she remarks: "I rather liked a case of the kind in which I was about to embark. There was more money to be made out of it than there was in the legitimate way, and generally less danger and fewer risks" (p. 269). She adds that "people always think that the "police" can help them out of every difficulty" (p. 269). While *Revelations* appeared in 1864, the exact dates of publication have been contested, as has the author's real name. This has been due to misreading by a number of critics of the British Library 1864 stamp as 1861. The UCLA Michael Sadleir Collection holding of this collection has *Revelations of a Lady Detective* on the outside hard cover, and *The Experiences of a Lady Detective* on the inside cover page.[75] For the first two pages the reader is unsure of her gender: in the first line of the "Introduction" Mrs. Paschal asks "Who am I? It can matter little who I am" (p. 1). Mrs. Paschal goes on to explain her role to the reader:

> It is hardly necessary to refer to the circumstances which led me to embark in a career at once strange, exciting, and mysterious, but I may say that my husband died suddenly, leaving me badly off. An offer was made to me through a peculiar channel. I accepted it without hesitation [...] at the time I was verging upon forty. [...] I was well born and well educated [p. 3].

Such a description locates her as a middle-aged widow and implicitly not sexually available or desirable; and so, unsupported by a husband or male relatives, she must work to earn a living.

The asexual construction of the female detective will continue into the twentieth century; as Kathlyn Ann Fritz and Natalie Kaufman Hevener comment: "Female detectives, in comparison to male detectives, have been few, famous ones yet fewer, and attractive ones the rarest of all."[76] Barbara Lawrence argues that "these sexless creatures' conversations [...] became more pronounced as the battle [between male and female creators of female detectives] accelerated."[77] The representation of Mrs. Paschal is, though, rather masculine, with very masculine ideas and actions embedded within it; she is "the cool and crafty female detective" ("Incognita," p. 296) with great expertise in opening soda bottles and no fear of entering public houses. To some extent Mrs. Paschal is more part of the police than was Mrs. G—. At the start of the final story of the collection—"Incognita"—she is collaborating with police chief Colonel Warner in his office: "we continued our conversation, which related to some clever and impudent frauds upon pawnbrokers, and arranged our plan of action as to the steps to be taken to discover the thieves."[78] It is in this meeting that Colonel Warner tells Mrs. Paschal about the case, "She [Mrs. Foster Wareham] knows very well that the law cannot assist her" (p. 267). In this instance, Mrs. Paschal and her abilities are implicitly placed outside of the law. In "Incognita," Mrs. Paschal says of her client, Mrs. Wareham, that she:

> held out her hand in a kind manner, as if she looked upon me more as a friend and ally than a Jonathan Wild in petticoats. I have met people who have turned up their noses at me for being a female detective or thief-taker, as they have thought fit to term me, but I never forget the insult, and have had my eye upon them, and have caught more than one tripping, which perhaps, the reader will observe, is not saying much for my acquaintances [p. 269].

This locates Mrs. Paschal in the masculine tradition, but as a woman, her depiction is, to some extent, contesting such gendered and detecting representations.

The first episode, "The Mysterious Countess," introduces Mrs. Paschal as "one of the much-dreaded, but little-known people called Female Detectives." (p. 3) Her claim is later disputed by a criminal, to which Mrs. Paschal replies that the female detective "in this country [...] is not so uncommon a thing." (p. 44) Mrs. Paschal is more active and less feminine in her actions than Mrs. G—. For example, pursuing a clue, Mrs. Paschal removes:

> the small crinoline I wore, for I considered that it would very much impede my movements. When I had divested myself of the obnoxious garment, and thrown it on the floor, I lowered myself into the hole and went down the ladder [p. 20].

While her descent into a hole suggests the subterranean recesses of the Gothic tale and invites perhaps a Freudian reading, it is rare in Victorian

fiction that a woman can openly shake off the restrictions of clothing, and implicitly of gender, which impede her movements. This action recollects those of Marian in Collins' *The Woman in White*. She actively challenges her "petticoat existence" by removing her clothing apart from her cloak and petticoat to walk on a roof to gain information, but she is subsequently punished for her action and becomes seriously ill, while Mrs. Paschal suffers no ill effects from the removal of her clothing. The dating of both *The Woman in White* and the Mrs. Paschal stories, with Collins' appearing 4–5 years earlier, could suggest that Collins's novel was both read and re-worked by Hayward. As Kestner observes, "Mrs. Paschal is tough, in ways not totally acceptable according to the patriarchy."[79] Mrs. Paschal's ability to don disguises and the ways in which she tracks criminals are reminiscent of those employed by the real-life French police detective Eugène François Vidocq, and are not appropriate to femininity. Michele B. Slung suggests that:

> The very essence of criminal investigation is antithetical to what was considered proper feminine breeding, involving as it does eavesdropping, snooping and spying, dissimulation, immodest and aggressive pursuit and physical danger.[80]

Yet an ambiguity over the boundaries of gender roles appears, as eavesdropping, snooping and spying might be considered feminine traits. In "Incognita" Mrs. Paschal subverts and reverses the Gothic conventions where a loyal lady servant assists the heroine. Mrs. Paschal's real purpose, like Mrs. G —, is as a spy, feigning the role of the domestic-servant. Perhaps this reworking was influenced by Elizabeth Gaskell's "A Dark Night's Work" one year earlier (1863): a loyal man servant assists the heroine, but this time he is complicit in concealing murder and hiding a dead body.

In "The Mysterious Countess," both detective and criminal are female. Mrs. Paschal literally embodies the "Keyhole Kate" figure when she puts her eye to the keyhole of the locked door to the basement in her pursuit of the villain, called the "black mask," who is later revealed to be the Countess of Vervaine in masculine disguise. The Countess's crime, which is the theft of gold, is made doubly transgressive by her masculine guise, a quasi-transvestism which recognizes the freedom of the male and the constraints of femininity. The Countess's transgressions are punished, although not by the law, when she commits suicide, reinstating Victorian ideals of moral self-regulation. In death she is returned to her "proper" passive role. These acts function to confine female criminality in the domestic, as in Braddon's *Lady Audley's Secret*.

In a later story, "The Stolen Letters," the text inscribes Mrs. Paschal within a masculine-dominated and European-wide detective tradition:

> [Joseph] Fouché, the great Frenchman, was constantly in the habit of employing women to assist him in discovering the various political intrigues which

disturbed the peace of the first empire. His petticoated police were as successful as the most sanguine innovator could wish; and Colonel Warner, having this fact before his eyes, determined to imitate the example [p. 2].

Finally defeated by Mrs. Paschal, the criminal's exclamation upon conviction in this story emphasizes the novel position of the female detective within Britain, he declares: "Sold, by Heavens! a female detective" (p. 130). The existence in fiction of Mrs. Paschal and Forrester's Mrs. G — is made possible by the supposed masculinity of their creators; fully-realized female detectives produced by female authors are not yet a viable literary figure in this period when women writers were still limited in their forays into crime. Neither Hayward (?) nor Forrester wrote any further female detective stories, perhaps because after the 1860s the popularity of the police-detective anecdote waned. It was not until 1894 that another venture into female detection appeared, in the form of Catherine Louisa Pirkis's *The Experiences of Loveday Brooke, Lady Detective* (in the *Ludgate Magazine*). Although the female detective is not yet part of the female-authored fiction concerned with crime in the 1860s, women writers brought crime into their fiction in different ways, as the next chapter will show.

Elizabeth Cleghorn Gaskell (1810–1865)

A well-known, middle-class author who, perhaps surprisingly, incorporated crime into some of her work was Elizabeth Gaskell. Gaskell wrote realistic novels of domestic, historical and social fiction. She was abundant in her output, producing seven novels, four novellas, and over forty shorter works, including her lesser-known and pseudonymously written sensational and Gothic short stories.[81] Soon after Gaskell's death in November 1865, her obituaries valorized both Gaskell and her work; Richard Monckton Milnes in the *Athenaeum* described her as being "if not the most popular, with small question, the most powerful and finished female novelist of an epoch singularly rich in female novelists."[82] David Masson in *Macmillan's Magazine* commented that the "world of English letters has just lost one of its foremost authors."[83] In the 1930s, however, Lord David Cecil dismissed her as a "minor novelist" with a "slight talent" who was:

> all a woman was expected to be; gentle, domestic, tactful, unintellectual, prone to tears, easily shocked. So far from chafing at the limits imposed on her activities, she accepted them with serene satisfaction.[84]

But this chapter contends that Gaskell's short stories precisely challenged this feminine stereotype.

Gaskell certainly read and was interested in crime; it has already been noted that Gaskell had read and was enthusiastic about and recommended that people should read Caroline Clive's *Paul Ferroll* (1855). She was also concerned with the status of women in society, and this is evident in much of her fiction. On January 1, 1856, Gaskell signed the petition to amend the married women's property law. "A Dark Night's Work" (*All the Year Round*, January–March 1863) incorporates crime, as does her novel, *Mary Barton* (1848). Gaskell's shorter work, though, cannot be defined distinctly as detective or crime fiction; it is rather a pastiche of the Gothic, fairy-tale, supernatural, crime, horror and sensation. This chapter suggests that Gaskell re-works earlier, masculine narratives in a feminized Gothic mode. There is an underlying tension of narrative control manifested within these short stories which offer innovative ideas involving crime, but which they cannot fully follow through or permit to be sustained. This chapter proposes that Gaskell's refusal to put her name to this short fiction is because writing stories involving crime might have been detrimental to the sales of her more conventional novels. Gaskell was aware of the conduct for proper and improper women in writing as in life. In a letter to her friend, Tottie Fox, she wrote: "I think I must be an improper woman without knowing it, I do so manage to shock people."[85] An important element of Gaskell's shorter creations and one that locates her writing as significant in the context of this study is her use of crime.

Gaskell's short stories which include elements of crime are: "Disappearances" (*Household Words*, June 1851), "The Old Nurse's Story" (Extra Christmas Number: *Household Words*, December 1852), "The Squire's Story" (Extra Christmas Number: *Household Words*, December 1853), "The Poor Clare" (*Household Words*, December 1856), "The Doom of the Griffiths" (*Harper's New Monthly Magazine*, January 1858), "Lois the Witch" (*All the Year Round*, October 1859), "The Crooked Branch" (Extra Christmas Number: *All the Year Round*, December 1859),[86] "Curious, If True" (*Cornhill Magazine*, February 1860), and "The Grey Woman" (*All the Year Round*, January 1861). These mostly appeared in Dickens' popular magazine, *Household Words* (later *All the Year Round*). Excepting "The Doom of the Griffiths," the rest of these stories were initially anonymously published. Yet Gaskell wrote her first three stories under the pseudonym of "Cotton Mather Mills, Esq." These were "Libbie Marsh's Three Eras" (1847), "The Sexton's Hero" (1847) and "Christmas Storms and Sunshine" (1848); they were all published in *Howitt's Journal*.

Elise B. Michie presents a succinct criminalized analogy relating to Dickens and Gaskell's relations, describing "the subtext which [...] runs beneath their editorial dealings from the very beginning: that *Household Words* is less a refuge for Gaskell's writing than its prison."[87] Her work is contained and

controlled by masculine hegemony. Patsy Stoneman argues a more positive view of Gaskell's publishing actions; she contends that "[w]hat looks like acquiescence in Gaskell may, however, also be pragmatic negotiation."[88] Yet, against this and at the same time, Gaskell still manages to voice some crime-related stories. This again exemplifies the concurrent limitations placed upon British women writers and their attempts to voice and include crime.

In the majority of the stories mentioned above, crime plays a minor role but they demonstrate Gaskell's familiarity with other crime narratives circulating in the period. "Disappearances" (1851) is about people who have vanished under mysterious circumstances and Gaskell mixes fact and fiction rather in the manner of the Newgate novels' appropriation of *Newgate Calendar* cases. For example, "The Squire's Story" (1853) is based on a house-breaker from the eighteenth century, Edward Higgins. The anecdotal structure of Gaskell's tales is also reminiscent of the masculine and professional/policing memoirs which appeared in the 1840–1850s. Moreover, in "Disappearances," Gaskell explicitly draws on and references both Godwin's *Caleb Williams* (1794) and the detective police. The opening lines of this story explicitly draw attention to this: "I am not in the habit of seeing *Household Words* regularly; but a friend, who lately sent me some of the back numbers, recommended me to read "all the papers relating to the Detective and Protective Police.""[89] The final sentence reiterates this: "Once more, let me say I am thankful I live in the days of the Detective Police; if I am murdered, or commit bigamy, at any rate my friends will have the comfort of knowing all about it" (p. 10). "The Poor Clare" (1856) features a male narrator who is a lawyer and, in Gothic mode, it deals with dangerous females and ghostly doppelgangers. "The Doom of the Griffiths" (1858), set in North Wales, is again based on history and curses. But the best example of Gaskell's foray into the hybrid crime/Gothic/sensational narrative is "The Grey Woman."

The limitations imposed on women writers in terms of the contemporary gender expectations are particularly evident in "The Grey Woman" (1861), published anonymously in Dickens's *All the Year Round*. It cannot be classified as crime fiction *per se* and it does not feature a detective, although its criminals are finally apprehended. Rather, it is in a sensationalized, Gothic/Radcliffean *Schauerroman* format; there is an eerie and isolated "foreign" castle, exotic landscapes, persecuted women, male villains, terror, escape and pursuit, and Anna—"The Grey Woman" of the title—is the classic imprisoned Gothic heroine. Dresner suggests that: "The female gothic [sic] novel is a genre rife with "almost-detectives"— investigating women whose attempts to discover a secret are only moderately successful."[90] In the context of this chapter's argument, then, Gaskell's text makes an important contribution to the development of the female authored feminine investigator. Anna in "The Grey

Woman" and Amante, her Norman maid, perform not-quite-detective roles when they accidentally discover the true identity of Anna's husband. This coupling is again evocative of the (Female) Gothic, where the loyal maid/servant assists the heroine. The criminal content of "The Grey Woman" is made acceptable by its being in the established modes of Gothic and sensation fiction, which frequently depict the female as victim and/or deviant/criminal.

In "The Grey Woman," the heroine is Anna Scherer who, at the start of the story, is "a young girl of extreme beauty; evidently of middle rank."[91] The reader is informed that "this pretty girl, with her complexion of lilies and roses, lost her colour so entirely through fright, that she was known by the name of the Grey Woman" (p. 289). Gaskell may have read or be playing on Collins' earlier novel, *The Dead Secret* (*Household Words*, January–June 1857). In this novel, there is a servant, Sarah Leeson, who prematurely has gray hair. Serialized at a similar time as "The Grey Woman" was Wood's *East Lynne*: in this, after Isabel's train accident in France, her hair turns white. Anna is made gray in pallor yet, to some extent, escapes the punishment of transgression which is a trope of Gothic fiction. Gaskell's work and title potentially influenced the American, Anna Katharine Green, who wrote "The Gray Madam" in 1889. Gaskell's story, from its opening, is couched in the conventions of the fairy-tale and the past rather than the present. This distances the criminal elements of the story from the nineteenth-century reader, as does its foreign location. Anna's "grayness" is blamed on her criminal husband, the French Monsieur de la Tourelle, who is "a chief of chauffeurs" (p. 313): a band of thieves and murderers. There are seven murders carried out in the course of the narrative, and it is implied that the gang have committed many more. Tourelle murdered his first wife due to her inability to keep silent; this act is not only an emulation of Clive's *Paul Ferroll* but is also indicative of the masculine need to have and retain control over feminine articulation. Finally realizing her husband's true nature, Anna and her maid Amante escape the castle and head for Germany; they are pursued by de la Tourelle and his gang. Anna escapes, subsequently has her villainous husband's child and, after his death, finally and happily re-marries.

The gendered struggle between criminal husband and victimized wife is also enacted in the control of language and writing. Tourelle withholds letters which arrive for Anna. This patriarchal control over Anna's writing can be seen as a fictional and metaphorical reflection of Gaskell's own position. The conflict of authority figured in control over the written word is reminiscent of the relations between Dickens and Gaskell, in which Dickens attempted to control Gaskell's writing and its publication/dissemination. An awareness of these gendered restrictions is seen when Gaskell writes in *The Life of Charlotte Brontë*:

> When a man becomes an author, it is probably merely a change of employment to him. He takes a portion of that time which has hitherto been devoted to some other study or pursuit ... and another ... and steps into his vacant place, and probably does as well as he. But no other can take up the quiet, regular duties of the daughter, the wife, or the mother, as well as she whom God has appointed to fill that particular place: a woman's principal work in life is hardly left to her own choice; nor can she drop the domestic charges devolving on her as an individual, for the exercise of the most splendid talents that were ever bestowed. And yet she ... must not hide her gift in a napkin; it was meant for the use and service of others.[92]

Gaskell rebelled against this by sending some of her work abroad for publication in America. So, although she was seen by her male contemporaries to espouse traditional womanly virtues and roles, Gaskell simultaneously undermined these in her short fiction.

Gaskell's dissent through her discourse is evident in the subversive relationship between Amante and Anna which can be read as romantic or even sexual; the name Amante means "female lover" in French, and the women are represented as very close. Amante disguises herself as a man and plays Anna's husband in their escape, and it is this bond — contrasted with Anna's criminal husband — which is depicted as loving and secure. Amante's skill in appropriating masculine identity is seen in her actions in concocting a disguise in the miller's loft:

> finding in one box an old suit of man's clothes, which had probably belonged to the miller's absent son, she put them on to see if they would fit her; and, when she found that they did, she cut her own hair to the shortness of a man's, made me clip her black eyebrows as close as though they had been shaved, and by cutting up old corks into pieces such as would go in her cheeks, she altered both the shape of her face and her voice to a degree which I should have not believed possible [p. 323].[93]

These actions imply deviant sexuality, and this is a surprising aspect of Gaskell, who was better known for her conventional writing of women; in terms of the Gothic novel, Judith Halberstam has commented that "[t]he secret buried at the heart of Gothic [...] is usually identified as a sexual secret."[94] But the anonymous publication of Gaskell's text and the death of Amante return the narrative and Anna to proper heteronormative and feminine roles. Eve Sedgwick has equated male homosexuality and the Gothic form: "The Gothic novel crystallized for English audiences the terms of a dialectic between male homosexuality and homophobia, in which homophobia appeared thematically in paranoid plots."[95] A feature, then, of this female-authored proto-crime narrative is its focus on female transgression both through and within discourse. Gaskell, in writing such stories, can hint at new ways of reading. In this sense, Gaskell's work can be read in terms of

Judith Halberstam's concept of "the cross-dressed word." In her discussion of *Dr. Jekyll and Mr. Hyde*, Halberstam writes that

> [w]e might almost say that the grotesque effect of Gothic is achieved through a kind of transvestism, a dressing up that reveals itself as costume. Gothic is a cross-dressing, drag, a performance of textuality, an infinite readability and, indeed, these are themes that are readily accessible within Gothic fiction itself where the tropes of doubling and disguise tend to dominate the narrative.[96]

However, Gaskell also attempts other "crossings" into the realm of crime. Yet, as with her female contemporaries discussed so far, she is limited in her approach to and inclusion of crime: Gaskell was ultimately trapped by convention.

"The Grey Woman" incorporates crime, yet like much other female-authored material which used crime in its construction it is not yet crime fiction. Gaskell's work is seen to conform to the crime fiction genre in some aspects: Jacques Barzun and Wendell Hertig Taylor's *A Catalogue of Crime* includes Gaskell in the short story section, with "Disappearances" In *Cranford and Other Tales*, ed. A. W. Ward, *Works*, vol. 2 (JM 1920) and "The Squire's Story" in *Works*, vol. 2 (JM 1920).[97] "The Grey Woman," though, is not mentioned but this chapter contends that it can be read in the context of burgeoning crime fiction. However, contemporaneously with Gaskell, Mary Elizabeth Braddon was writing what can be considered as an early female-authored crime fiction narrative in *The Trail of the Serpent*.

Mary Elizabeth Braddon (1835–1915)

Mary Elizabeth Braddon's early work is transitional in terms of genre, as it is post–Newgate/pre-sensation in its formation. While Gaskell's writing was also transitional, *The Trail of the Serpent* develops differently and therefore breaks new ground in women's writing of crime.[98] Braddon's work at this early stage in her writing career was, to some extent, less censored, as she was not yet an established author and so less bound by convention. Although most commonly known, now and in her own time, as a sensation novelist, Braddon was, at least initially (1861/2), writing something nearer to crime and/or detective fiction. As well as her role as a female writer, Braddon frequently challenges the privileging of masculinity. This chapter questions DuBose's contention that "Mary Elizabeth Braddon never dealt seriously with detection."[99] While there is no doubt as to the criminal content of Braddon's later fiction or as to her influence, this chapter proposes that her early work is equally important to the development of early crime/detective fiction and

to the role of women writing in this area. Rather than conforming to the boundaries of genre, Braddon's *The Trail of the Serpent* enacts change and opens new discursive possibilities.

Braddon, initially writing at the end of the period in which the Newgate novels appeared, bridges the gap between the Newgate novel and sensation fiction in *The Trail of the Serpent*. *Punch* satirized the Newgate novel in 1841, drawing attention to its stereotypical "ingredients," which were later reworked in sensation fiction:

> Take a small boy, charity, factory, carpenter's apprentice, or otherwise, as occasion may serve—stew him down in vice—garnish largely with oaths and flash songs—Boil him in a cauldron of crime and improbabilities. Season equally with good and bad qualities ... petty larceny, affection, benevolence, and burglary, honor and housebreaking, amiability and arson.... Stew down a mad mother—a gang of robbers—several pistols—a bloody knife. Serve up with a couple of murders—and season with a hanging-match.[100]

The Newgate novel was a male preserve, traditionally associated with established and famous authors such as Lytton, Dickens, and Ainsworth, but Henry James later located Braddon in this context, describing her, in masculine terms, as "a soldier in the great army of constant producers,"[101] while an article in the *Eclectic Review* (1868) directly associated her with crime: "Miss Braddon. The Illuminated Newgate Calendar."[102] Braddon was a devoted fan of Lytton, and his influence on her writing is very apparent; *Trail* clearly draws upon Lytton's *Paul Clifford* (1830).[103] In *Trail*, the name of the village in which much of the action takes place is "Slopperton," which is also the name of a hamlet in *Paul Clifford*. The title of one of Braddon's chapters in *Trail*—"The Last Act of Lucretia Borgia"[104]—perhaps pays homage to Lytton's Newgate novel, *Lucretia, or the Children of Night* (1846), a novel which, like *Trail*, has a criminal protagonist who uses poison as the murder weapon, although, more conventionally, Lytton's poisoner is feminine, and there are other textual connections, as this chapter will show.

Braddon is also purposeful in her use of other genres in *Trail*. The text's narrator mentions "the laws of polite literature" (p. 86) constraining what can be explicitly said to the reader; Braddon draws on literary references to Vidocq, the French criminal turned detective, and compares her character Mr. Percy Cordonner, who is "a distinguished member of the 'Cheerfuls'" (p. 268),[105] to the Newgate escapee Jack Sheppard.[106] *Trail*'s criminal protagonist, Jabez North, asks: "Who I am, and what I am! Oh, I dare say I shall turn out to be somebody great, as the hero does in a lady's novel" (p. 291). This comment draws attention to the text's own status as a lady's novel. Jabez's rise to eminence from a lowly background recalls earlier narratives featuring orphans or children of unknown parentage who subsequently obtain money and sta-

tus. Jabez's acquisition of wealth and position locates Braddon's narrative in a long rags-to-riches tradition seen from Henry Fielding's *The History of Tom Jones, a Foundling* (1749) to Brontë's *Jane Eyre* and up to the present day. Jabez, though, lacks the moral development usually seen in this tradition and so is not able to fulfill the "heroic" positioning required by its conventions.

Braddon's concentration on the masculine body in *Trail* implicitly questions and critiques masculinity and its role in mid-nineteenth century society. This subversive view contrasts with Oliphant's later 1867 assertion that:

> [with] all philosophy notwithstanding, and leaving the religious question untouched, there can be no possible doubt that the wickedness of man is less ruinous, less disastrous to the world in general, than the wickedness of woman. That is the climax of all misfortunes of the race.[107]

The "misfortunes of the race" are here and in the sensation novel frequently attached to the "wicked" female body. This more usual alignment of "wickedness" with the feminine is both inverted and interrogated in *Trail*, particularly in the figure of Jabez. The murder by poison which Jabez commits is traditionally seen as a feminine crime and is often associated with the French.[108] With a criminal who, the reader later discovers, bears a foreign name, who takes on a foreign identity and who employs a feminine and French mode of murder, *Trail* portrays a plurally deviant masculine body.

In some aspects *Trail* can be classified as a sensation text: it incorporates secrets, offers an element of psychological exploration of motive and character, features Gothic/sensational doubles, rejected women and orphan children. It concurrently demonstrates aspects of the Newgate novel. Braddon acknowledged her debt to Newgate and crime when, in a letter to Lytton in 1872, she wrote "I think [...] I shall once more make my dip in the lucky bag of the Newgate Calendar."[109] The *Calendars* were a source for crime writers from Lytton with *Eugene Aram* (1832) to Ainsworth's *Jack Sheppard* (1839); Dick Turpin featured in the *Newgate Calendar* and was later fictionalized in Ainsworth's *Rookwood* (1834), and Godwin references the *Calendar* in *Caleb Williams*. This Newgate format, which placed the criminal at the centre of the narrative, is personified in *Trail* by its protagonist, the apparently respectable Jabez, who is gradually revealed to be a criminal motivated by the pursuit of wealth and fame in typical Newgate novel fashion. To achieve money and status Jabez murders, cheats and lies, changing his character, name and nationality to suit the circumstances. But *Trail* departs from the Newgate pattern as it also features an unusual and innovative detective figure, Mr. Peters, who is lower class and mute, and who is initially dismissed both by the text and its characters. Mr. Peters could be read as the personification of the shift from the Newgate to the sensational or proto-detective narrative and, concomitantly, of the positioning of the detecting figure as shifting from

"criminal" and "other" associations to a more respectable figure. Kayman details this genealogy:

> Whereas the voice of the eighteenth-century criminal, like that of the lunatic at large, was still effectively their own, in the course of the nineteenth century, they will be notoriously *silenced*. In their place, it will be the "detective," master of observation and information, who has the last word, the word which masters the mystery and the monster and provides the retrospective meaning of the narrative.[110]

This study contends that the mute Mr. Peters physically enacts this transformation. Jabez is the antithesis of Peters: he is vocal (in various languages), socially mobile, and rejects his son, while Peters is dumb, limited by his profession and social class, and rescues and rears Jabez's rejected child, becoming a substitute parent.[111] *Trail*, then, is neither Newgate novel nor yet sensation fiction: rather, it looks forward to a genre which is in this moment, far from being fully formed — that of detective fiction.

Eclipsed by *Lady Audley's Secret*, *Aurora Floyd* (1863) and *The Doctor's Wife* (1864), *Trail* has been neglected by critics and has been out of print for many years. In light of Braddon's prolific output — "the author of approximately ninety books"[112] during her lifetime (1835–1915) — this could be excused but, significantly, many critical texts and essays on nineteenth-century crime narratives fail to mention Braddon's work, or make only a passing reference to *Lady Audley's Secret*. Chris Willis considers, and this study concurs, that "*The Trail of the Serpent* is probably the first British detective novel," giving Braddon an important place in the development of the genre.[113] Braddon, then perhaps marks the beginning of another, new presence in her early text: that of the detective.

Trail was first published as *Three Times Dead; or, The Secret of the Heath* (London: W. & M. Clark; and Beverley: Empson, 1860), although there is some uncertainty about the date.[114] As Braddon observed, "Three Times Dead" or "The Trail of the Serpent" was my first novel, and it appeared in the [Beverley] newspaper, with no circulation in London, and I believe, very little at Beverley."[115] Wolff comments that Braddon's "first novel, virtually stillborn at Beverley in 1860, and cut by ten thousand words [was] otherwise very little changed in its London revival in 1861."[116] *Trail* was revised under the direction of Braddon's soon-to-be-partner, and, as of 1874 husband, publisher John Maxwell, and was a considerable success, selling 1,000 copies in its first week in March 1861.[117] Maxwell changed the title to *Trail* in order to sensationalize it, drawing on the sexual and sensational connotations of the serpent. The serpent can be assumed to be a metaphor for Jabez, the villain, who not only leaves a trail of destruction in his wake, but is "trailed" both by the narrative and detective.

The change of title was calculated to sell the novel to a wider audience,

and George Eliot's comment suggests the success of this ploy: "I suppose the reason my 6/- editions are never on the railway stalls is ... [that they] are not so attractive to the majority as 'The Trail of the Serpent.'"[118] The history of the text proves just as complex as its contents of crime, sensation, and detection.[119] *Trail* was, after its issue as a novel in its revised form, serialized in the *Halfpenny Journal: A Magazine for All Who Can Read* (twenty-eight parts: 1 August 1864–28 February 1865). This is the same journal in which her serialized novel *The Black Band* (1861–62), appeared; the journal was also run by John Maxwell, but *Trail*'s novel version just preceded *The Black Band*. It is atypical in this period to have firstly the complete text and subsequently the serial, and this unusual later serialization was perhaps calculated to take advantage of the success of *Lady Audley's Secret*.

A comparison of the Modern Library edition of *Trail* with the original serialized version of *Trail* and the 1861 edition of *Three Times Dead* reveals a number of changes. *Three Times* differs from *Trail* not only in its title, but in the names of some of the characters and places. The protagonist and criminal in *Trail* is "Jabez North"; or "Ephraim East" in the original 1860 *Three Times Dead*, and "three times" is a reference to Jabez/Ephraim's triple change of identity.[120] As in the Newgate novel, criminal Jabez is central to the plot; Braddon possibly needed a criminal protagonist to act as a vehicle for her critique of society. As twentieth-century critic William K. Everson, notes:

> the activities of the bad guys tell us far more about the changing mores and morals of our times than a similar study of the good guys ever do. From time's beginning, the basic *virtues* have remained unchanged. But social, moral, and legal behavior is forever changing.[121]

Braddon, in her preface to *Three Times*, depicts Ephraim/Jabez as "one of those characters of which unfortunately there are too many in this present state of society," going on to say that "his vices exposed in all their hideous deformity [are] to the execration of the well-thinking portion of the community" and should "serve as a warning to the vicious."[122] Ephraim/Jabez has a less than promising upbringing: he is, in both *Three Times* and *Trail*, a "hapless and sickly offspring [thrown] into the river" (p. 8) by his mother.[123] Rescued, he is brought up in the town of Slopperton — which Sarah Waters describes as "a sort of English 'anywhere'"[124] — and, in *Trail*, given his name by the officers of Slopperton work-house:

> Jabez; first, because Jabez was a scriptural name; secondly, perhaps, because it was an ugly one, and agreed better with the cut of his clothes and the fashion of his appointments [...] The gentlemen of the board further bestowed upon him the surname of North, and because he was found on the north bank of the Sloshy, and because North was an unobtrusive and commonplace cognomen, appropriate to a pauper [p. 8].

Jabez is thus socially located as poor and lower class and is devoid of family identity. In the 1860 *Three Times* version his original name as "East," as well as the middle-eastern origins of the biblical name Ephraim, is suggestive of distant lands and, implicitly, the Bible and stories of crime and violence. This unpromising beginning suggests to the discerning reader of either text that the protagonist is set to be a criminal, although this proves to be less apparent to the other characters in the narrative.

In *Trail*, the narrative makes it clear that Jabez's origins are in part the cause of his criminality: born a nobody, he wishes to become a somebody, with high social standing and money; someone like "the *soi-disant* [self-styled] Count de Marolles" (p. 405). To achieve his desires, Jabez manipulates, and where necessary murders, those surrounding him. Valerie de Cevennes — a victim of his plotting and later his wife — tells Jabez that he is "the incarnation of misery and crime" (p. 179). Jabez's motives for crime are made evident: after his first murder (of Mr. Harding) he declares how he will "build his fortune in days to come" (p. 37) with the cheques stolen from Dr. Tappenden, for whom he works as assistant and usher.[125] His theft ensures that when he flees to Paris he is possessed of a sum of money and has "only one object — to multiply that sum a hundredfold" (pp. 172–3). He then persuades Valerie — a woman of considerable social standing and wealth — into attempting to poison her current husband in order for Jabez to marry her and acquire the social status and wealth he desires. This act is incited by Jabez, but the husband does not die; he reappears later in the narrative. Jabez, in his new French identity as Raymond Marolles, can become "Monsieur Marolles [...] the centre of a circle of the old nobility of France" (p. 177) and can extend his possessions in South America, as well as later opening a banking branch in London. Jabez, "'the eminent banker'; and [...] universally trusted," (p. 257) presents a disconcerting image of the masculine criminal whose empire traverses nations.

Dennis Porter's assertion that "detective writers are distillers of familiar national essences" is challenged by Braddon's creation of Jabez.[126] He crosses national boundaries in the interests of his criminal actions and changes of identity. The familiar social institutions of the family and marriage are also brought into question by his representation. Ostensibly he has no parents, although his parentage is later disclosed to both the reader and to Jabez himself, and we also discover he has a twin brother, Jim, whom he later murders, effectively severing himself from family and killing his past to secure his future. Crime infects and permeates the domestic space, and, implicitly the national space. Braddon's description of Paris — where Jabez primarily resides after committing his crimes in England — can be read as a commentary on the state of England at the time:

Paris, the marvellous; Paris, the beautiful, whose streets are streets of palaces—fairy wonders of opulence and art; —can it be that under some of thy myriad roofs there are such incidental trifles as misery, starvation, vice, crime, and death? [p. 120].

There is a tension in society between an apparently respectable façade and the threat that lies behind it which could equally be applied to England. The representation of Jabez himself contests normative masculine imagery and expectations; he is depicted in feminine bodily terms with "very beautiful blue eyes" (p. 7), and a "rather slender figure" (p. 73). Yet the attention of the reader is continually drawn to what is behind this initial impression, as Mr. Withers makes clear:

"this 'ere young man, as I thought at first vos Jim, caught me by the throat sudden, and threw me down on my knee. I ain't a baby; but, lor', I vos nothink in his grasp, though his hand vos as vite and as deliket as a young lady's" [p. 387].

Jabez deviates from the norm in the conflation of feminine physique and masculine strength. This resonates with the paradoxical state of Monsieur de la Tourelle in Gaskell's "The Grey Woman," who is feminized but has a coterminous "terrible will."[127] Moreover, the identities of Jabez's numerous victims undermine the coherency of the mid–nineteenth century text and of society: the later sensation novel's concentration on female victimization is, in *Trail*, absent, as Jabez's victims are predominantly masculine.[128]

Jabez's first victim is "Mr. Montague Harding — returned from the East Indies with a large fortune" (p. 11), and it is his wealth that leads to his death. His throat is cut, and his cabinet rifled for money. The narrator tells the reader that this "murder at the Black Mill was something out of the common. Uncommonly cruel, cowardly, and unmanly, and moreover occurring in a respectable rank of life" (p. 39). The use of the word "unmanly" is significant as Jabez has feminine qualities. Alarmingly for the contemporary reader, crime is shown to permeate the middle classes. In describing Jabez's first act after murdering Mr. Harding, Braddon again pays homage to Lytton, specifically to *Pelham; or the Adventures of a Gentleman* (1828). In Lytton's novel, the murderer cleans the blood from his weapon and then drinks the water.[129] In *Trail*, after Jabez has committed the murder of Mr. Harding he literally has blood on his hands, which he washes off, drinking the bloody water to consume the evidence:

He washes them very carefully in a small quantity of water, and when they are quite clean, and the water has become a dark and ghastly colour, he drinks it, and doesn't make even one wry face at the horrible draught [p. 22].

While this act destroys the visible evidence of blood on Jabez's body, it has savage and cannibalistic overtones. His white hands are literally and metaphorically covered with blood.

There is, sensationally, a second death shortly after the first. Even more shockingly, Jabez's second victim is a child, Allecompain Junior, who is a pupil at Dr. Tappenden's Academy. The child, ill with fever, is under the care of Jabez and has his bed in Jabez's room. Returning from murdering Mr. Harding, Jabez responds to the little boy's cry for medicine. The boy, however, sees a lingering blood stain on Jabez's hand and, now hysterical, refuses to drink. Jabez then

> throws the medicine out of the glass, and pours from another bottle a few spoonfuls of a dark liquid labelled, "Opium — Poison!" [...] The boy tries to remonstrate, but in vain; the powerful hand throws back his head, and Jabez pours the liquid down his throat [p. 22].

As it is women who tend to be victimized in the established sensation fiction novel, the representation of the murder not only of a child, which is sensational in itself, but of a boy, is doubly disturbing. In keeping with Jabez's feminized aspects, the method of murder — poison — is itself feminine as the contemporary factual case of Catherine Wilson, who was sentenced to death in 1862 for poisoning her best friend, suggests.[130] In Braddon's text, the boy's death is assumed to be the consequence of his illness and his death looks "natural." Jabez's actions in killing the child can be read as a subversion of the traditional mothering role, both in Jabez's appointment to the task of nursing the boy and in his abuse of the responsibility. Here, as in other parts of the novel, the proper female and/or mothering figure is curiously absent or dead.

Such absence is intrinsic to the third and fourth victims of Jabez's social ambitions: the unmarried mother, who has given birth to Jabez's child, and the child himself. The unnamed woman is neglected by Jabez, who refuses to marry her and only infrequently offers minimal financial support, leaving both his child and his partner to starve. Subsequently, she commits suicide, intending to take her child with her. Peters, the detective figure in *Trail*, unknown to Jabez and the woman, overhears them arguing about Jabez's cruel indifference to his child and its mother.[131] He observes how Jabez's voice:

> was a nice, soft-spoken voice too, and quite melodious and pleasant to listen to; but it was a-sayin' some of the cruelest and hardest words as ever was spoke to a woman yet by any creature with the cheek to cal hisself a man [p. 245].

The woman's response is to reject Jabez's offering of money, saying she would rather surrender herself to the river Slosh. As she says these words, she throws his sovereigns at his face. Peters states later that "[o]ne cut him over the eye; and I was glad of it. 'You're a marked man,' thinks I, 'and nothin' could be handier agen I want you'" (p. 246). Andrew Mangham associates Jabez's cut with sexual deviance:

> the scar on his eye brands him with a particularly feminine image. [...] It is a menstrual image echoed by the gushing slit in Jabez's forehead. Indeed, the

scar is also somewhat scarlet-letter-like in its indication of Jabez's sexual indiscretions.[132]

Nathaniel Hawthorne's *The Scarlet Letter* (1850) is the primary exponent of the sexual deviance/branding conflation, with Hester Prynne branded with the signifier of shame, a Scarlet "A." It is ironic that Jabez's own (and stolen) sovereigns haunt him as a marker of sovereign power (literally, with the head on the coin), yet this is intermixed with the new disciplinary power of the detective, attributed to Peters.

Jabez's son, however, is saved from the river by Peters, and later named after it–"Slosh."[133] With the scars on Jabez's face, Peters can, subsequently, "mark" and identify Jabez. This tracking is one in which Slosh is involved as he avenges his mother's death. The child's role in the narrative is to demonstrate how the past continually haunts the present, suggesting that, irrespective of how Jabez invents himself he will, finally, pay for his sins if not his crimes. The text implies that history repeats itself as Jabez, ironically, is also the product of a dysfunctional relationship, his own mother having thrown him into the river after she had similarly been abandoned by her lover. This is an implicit social critique and is indicative of the burgeoning awareness that crime is caused by social circumstance as much as innate wickedness; it also gestures forwards to Braddon's concerns with the role of women in society, as seen in *Lady Audley's Secret*.

Slosh's mother refuses the appropriate female position of subservience to hierarchical, money-controlled masculine rule. She does this by rejecting Jabez's offer, albeit with ill consequences to herself and her son. The text thus comments on the mid–nineteenth century fears of social unrest and domestic disruption. This is reinforced by the numerous characters in the text who are orphans and waifs. The absence of mothers in *Trail* is particularly noticeable, and can be read as a critical exposition of the laws in the 1860s which refused a woman the right:

> to education and professional training and to earning and keeping her own income and property, her ability to make her own decisions, her right to be recognized as an independent legal entity and British subject, her right to be able to petition for custody of her legitimate children.[134]

Socially deviant or missing mothers are a common feature in sensation fiction and, as Pykett comments, "sensation novels do not end in the courtroom or the prison. Crime is dealt with in and by the family."[135] *Trail*, on the other hand, has no such stable and secure notion of family and this is in part why this chapter suggests that it is not sensation fiction. Crime in *Trail* is, certainly, related to family connections and status, but is not dealt with in and by the family, but by forces outside this unit, and the term "family" itself seems to evade normative definitions.

Jabez's relatives, when they are discovered simultaneously both by himself and the reader, are equally a product of this society; characters are revealed increasingly not to be what they seem. Jabez's own life and the path in which it takes—bar the explicit criminal and murderous actions—imitates that of his father: Jabez's relationship with women and abandonment of his child replicate his paternal history. His father, once discovered, proves to be the French aristocrat, Monsieur de Cevennes, who had been exiled to England, but having since come into property had been allowed a safe return to France after the Revolution. He leaves England, deserting his family, leaving Jabez's mother thinking him dead and breaking all ties. Ironically, Jabez turns to crime in the pursuit of the wealth and social status which, unknowingly, he will anyway inherit from his father. Jabez only discovers this family connection when his grandmother tells "the golden secret," which is a wedding deed, concealed in her shoe, proving that a marriage between Jabez's penniless mother and his aristocratic French father had taken place. Jabez subsequently confronts his father, only to find him even more evil and uncaring than Jabez himself.

Jabez discovers that he has other living family. On a walk one evening, Jabez passes the entrance to Blind Peter, a slum district, and is accosted by his maternal grandmother who takes him to be his twin brother, Jim, whom he will later allow to die in order to facilitate his escape from England and his pursuers. Jim is ill and Jabez is with him temporarily, but when Jim signifies a need for his medicine, Jabez withholds the drug:

> There was no friendly hand, Jim, to draw you back from that terrible gulf. The medicine stood untouched upon the table; and, perhaps as guilty as the first murderer, your twin brother stood by your bed-side [p. 95].

The biblical reference to Cain's murder of his brother, Abel, locates Jabez in a long line of murderers who break sibling and masculine bonds. Jabez does not actively murder Jim; here, it is his passivity which causes death. In committing actions which are suggestive of but not quite fratricide, Jabez again breaks proper family ties. He then uses his brother's dead body to enable him to escape, placing Jim's on the heath in the hope that it will be taken to be that of Jabez and it will be assumed that he has committed suicide.

Murder is shown to disrupt society more widely; each of Jabez's killings directly or indirectly affect others in the narrative, creating "quasi-victims" of his crimes. Mr. Harding's nephew Richard Marwood is initially suspected of murdering his uncle and is falsely accused, put on trial, judged insane and incarcerated in an asylum. He is eventually proved innocent and sane with the assistance of Peters and returned to society; Peters uses sign language in Richard's trial to convey to him that he should act as if he were mad. A more significant "quasi-victim," however, is the main female character in *Trail*,

Valerie de Cevennes. Valerie has immense property in Spanish America and hence is a target for Jabez. In his drive to accumulate money and status, Jabez tries to make Valerie equally criminal: he seeks to convince her that Gaston de Lancy, her clandestinely married husband, is unfaithful, and incites her into, as she thinks, poisoning him in revenge for his infidelity. But her murderous intentions have been noted by Monsieur Blurosset, and she is sold a non-poisonous substitute. When she realizes that her husband is innocent of infidelity and has not died at her hand, Valerie declares herself to be a "vile dupe, pitiful fool, [...] a puppet in the hands of a demon!" (p. 289). Jabez uses his knowledge of Valerie's murder attempt to blackmail her into marrying him so that he can access her fortune.

This plot twist prefigures a common feature of the sensation novel which, once established, is preoccupied with women and secrets and especially bigamy. While Valerie seems a hybrid figure, combining aspects of victim and murderer, she is also clearly empowered in the narrative, apparent in her refusal to capitulate to Jabez:

> He knew his power, he knew wherein it lay, and how to use it–and he loved to wound her; because though he had won wealth and rank from her, he had never conquered her, and he felt that even in despair she defied him [p. 257].

Valerie is subsequently involved in the pursuit of Jabez once his criminality is known and, like his son, represents his past returning to haunt him. A strong woman who triumphs, Valerie cannot be fully controlled by the masculine or the criminal. This show of feminine strength prefigures Braddon's later criminal heroine, the sensational Lady Audley.

Other female figures in the text, apart from Valerie, are marginal in both their roles and textual location. In comparison to their masculine counterparts, minimal roles are played by Kuppins, a girl who cares for Slosh as a child, and who later will become Peters' wife; Sillikens, who is Jim's sweetheart; Richard's wife Isabella, Mrs. Marwood, who is Richard's mother; and Mr. Harding's sister and the two mothers of Jabez and Slosh. The only other woman who has a significant part is Jabez's grandmother, who is, unflatteringly, referred to as "the old woman" (p. 293), "old crone" (p. 86), and a "grinning hag" (p. 83). Jabez fears and hates her, but it is her knowledge of his father's identity which empowers her and prevents Jabez from inflicting violence on her. Her reasons for concealing this information even from her own daughter can be read in terms of the emergent capitalist culture: the secret is effectively a commodity, generating income through blackmail.

Mangham sees the generic figure of the old maid as "a haunting signifier of surfeit and excess on a national scale; on an individual level, however, they were seen, conversely as figures of deprivation."[136] Jabez's grandmother tells Jabez that she will not reveal her golden secret "till I'm paid. I must be paid

for the secret in gold — yes, in gold. [...] I should like to lie up to the neck in golden sovereigns new from the Mint" (p. 294). Her secret and the money are inextricably linked to foreignness and violence; she tells Jabez that his father:

> hadn't been married to her long before a change came, in his native country, over the sea yonder [...] A change came, and he got his rights again. One king was put down and another king was set up, and everybody else was massacred in the streets [...] So he got his rights, and he was a rich man again [...] and then his first thought was to keep his marriage with my girl a secret [p. 294].

The text directs its attention on men and their wealth or attempts to gain wealth, and women are positioned as either insignificant, functions of the plot, or as greedy, needy and emotional females who stand in the way of men and their goals. These masculine and feminine representations function as a commentary on the contemporary society which was increasingly preoccupied with money, status and wealth, and the importance of everyone knowing their place in society. But the acquisition of wealth allows the individual to become socially upwardly mobile and, the text suggests, crime can facilitate this unsettlement of proper social boundaries.

Jabez, finally, is a victim of both himself and his actions within the narrative. He is captured, put on trial and sentenced "[t]o be hanged by the neck!" (p. 395) — the traditional closure of a criminal career and of the Newgate novel. He attempts to escape his fate by pretending to be a dead American who is being sent by sea, in a coffin, to New York, but is apprehended by Peters and one of the principal members of the Liverpool detective police force.[137] Jabez, however, avoids the forces of the law, and, using a small lancet, commits suicide.

Ian Ousby's observation that crime narrative "attached itself to a literary figure, the detective, rather than to a single literary genre" is evident in Braddon's text with its multiple detecting figures.[138] As Winifred Hughes states, "Braddon mixes up the approved categories," and *Trail* clearly demonstrates this while a similar blending is equally evident in her detective figures.[139] The social mobility of the police detective in the nineteenth century was limited by social class. Braddon, speaking of her writing, commented that "I will give the kaleidoscope ... another turn."[140] This turning of set images is seen with the main detective figure in *Trail*, whose representation subverts the detecting norm: Mr. Joseph Peters, known as "[t]he dumb detective" (p. 43), communicates in the "dumb alphabet" (p. 29) of sign-language. Peters is initially a "scrub," before progressing to police detective. The reader is told that "he was dumb but not deaf, having lost the use of his speech during a terrible illness which he had suffered in his youth" (p. 29).[141] Peters' low social position and disability locate him in the disempowered feminine sphere and, while

there is little room for women in mid–nineteenth century crime narratives and detective fiction, the feminized Peters can perhaps represent the unrepresentable, that is, the female as detective.[142] This disabled detective, then, offers an innovative discursive possibility.

As Chris Willis notes, "[o]ne of the greatest strengths of *The Trail of the Serpent* is the figure of the detective. Peters is a rare creation,"[143] and indeed, he seems so "rare" that he has now been forgotten.[144] Jennifer Carnell suggests that "[i]n this early novel Braddon is less inhibited and more sympathetic in her treatment of the professional detective."[145] Gary Hoppenstand and Ray Browne observe that "[f]ictional detectives have always been a bit strange, even from the beginning," and that "nearly every detective character seems burdened with some sort of personal abnormality."[146] While their work looks predominantly at American pulps in the twentieth century, the trope they identify is evident in Braddon's work and suggests a long history of such figures:

> Throughout history, the maimed, the unusual, the deformed, the freaks have always been considered to have been especially afflicted by the gods, and therefore have possessed a kind of special divine dispensation and power. In the defective detective pulps use of the deformed dick was also an effort to associate him more closely with — or separate him less widely from — criminals who, because their bodies represent their souls have been deformed.[147]

Peters uses his deformity to his advantage in order to grant himself perhaps an almost god-like power. In this instance the detective himself disturbs the social status quo; as someone of a lowly social status he eventually rises through the social ranks and gains wealth and a London property by the close of the novel. This is achieved through his own endeavors rather than a benefactor or family or inheritance.

Peters' role is initially one of subservience and less-than-detective status: he is "[t]he dumb man [...] one of the very lowest of the police force, a sort of outsider and *employé* of Mr. Jinks, the Gardenford detective" (p. 29). But, as both the narrative and Peters' skills develop he moves from his position as Mr. Jinks's assistant into a stronger role:

> Mr. Peters has risen in his profession since last February [...] as to have won for himself a better place in the police force of Slopperton — and of course a better salary [p. 102].

In his correct and unrelenting detection of Jabez, Peters advances from a "scrub" to the position of a defined police detective. His undercover disguise and the part he plays respond in fiction to the reality of the detective's role. Making enquiries at the public house, Gus — Peters' detective helper — describes Peters as "a foreigner, [who] hasn't got hold of our language yet; he finds it slippery, and hard to catch, on account of the construction of it"

(p. 350). Peters' rather undefined role is like that of the police detective in reality and in their fictional representation in the sense that these figures are also yet to be fully defined, yet while it is inferred that Peters does not have control over police language, this is only feigned and part of his disguise.

Conversely, via his alternative medium, he gains both control and solution of the case. The interconnection of foreignness, language, detection and class can be seen through another language being a signifier of class and education. Indeed, Thomas Waters has ability to speak two languages: French and English. He employs this ability in his case, "Legal Metamorphoses." (*Chambers's*, 28 September 1850, 195–99). In America, Spofford's detecting figure/narrator in "In a Cellar" (*Atlantic Monthly*, February 1859) is an unnamed retired English diplomat in Paris. And later Allan Pinkerton's operative, an Englishman and gentleman named Blake, in *The Gypsies and the Detective* (1879), can speak many languages of which one is Romany. This multilingualism allows him to pose as a newspaper reporter. Yet, comparatively it seems that Peters cannot master one. However, he refutes the "equation between idiocy and childhood [that] was prevalent in mid–Victorian England."[148] Peters is not childish in his intellect, only his inability to convey his meaning/s through verbal discourse; he is the antithesis of the vocal and fluent Jabez, but Peters has skills and influence that Jabez lacks. Peters knows Richard Marwood is innocent; once Richard is arrested Peters tells Mr. Jinks of his conviction, repeatedly spelling out "Not guilty!" Mr. Jinks dismisses Peters' claim, but Peters is finally, rewarded for his persistence and, at the close of the text, is a man of independent property in London with a hundred pounds a year settled on him. He becomes "Mr. Peters, the hero" (p. 111) after he finds Jim's body, arrests Jabez and solves the case.[149]

Social mobility is essential to the detective and Peters, as a disabled/feminized detective figure, can move unnoticed across social strata and finally, upwards. As he gains recognition he locates himself no longer on the Slopperton or Gardenford margin, but in the nation's capital, London. This relocation to London has parallels with Russell's Thomas Waters in "Recollections of a Police Officer" who, in his second-to-last story, moves to London in semi-retirement in 1831.[150] Pensioned off by Richard's mother, Peters takes a house on Waterloo Road. What is evident in this shift of location is a reversal of conceptions; the capital city of London directly contrasts to the fictional and rural Slopperton. It seems that as Peters defines himself as a detective, he is aligned with or strengthened by geographical and cartographic definition. This notion is an overt reworking of earlier forms of surveillance and stability/crime control as the country and smaller communities enabled malefactors to be more easily identified, and offered a sense of comforting knowledge, with the city as its antithesis, brimming with deracinated criminal

potential. Braddon clearly links London with crime: Kuppins continually asks Peters if everything they pass is Newgate (p. 261), and Chapter II (Book the Sixth), is titled "Raymond de Marolles Shows Himself Better Than All Bow Street" (p. 328). Comparatively, Jabez is not better than Peters (as a double outsider inhabiting London), and it is in London where Peters draws the case together and (with Slosh) sees Jabez in his new and elevated incarnation leaving his "Anglo-Spanish-American Bank."

Another innovative detecting figure in *Trail* is the boy "Sloshy" (a name interchangeable with "Slosh" in the narrative), Jabez's illegitimate son.[151] Willis claims that Braddon's creation was the model for Collins's "Gooseberry" in *The Moonstone*: "Collins borrowed one of Braddon's cleverest character inventions — the juvenile detective."[152] Flanders has written that the anonymous penny dreadful, *The Boy Detective, or, The Crimes of London* (1865–6) was "driven by the success of *Lady Audley's Secret*."[153] However, its subject matter lends itself to both *Trail* generally and the figure of Slosh. The gender of the orphaned Slosh emphasizes again that *Trail* is not the sensation novel proper. According to Pykett, "[a]long with the mother, the motherless girl is the most important figure in the women's sensation novel."[154] If, as Pykett claims, in the 1860s there is "a panic about the nature of the feminine. Woman, womanhood and womanliness all became contested terms," equally contested in Braddon's text is masculinity.[155] Slosh, illegitimate, subsequently orphaned and finally relocated into a new "family" without a father, represents family disorder and disruption, responding perhaps to wider social anxieties in the mid-nineteenth century. He also inverts the proper familial duty of a son when, in his detective capacity, with Peters Slosh tracks down and arrests his own father, Jabez. Furthermore, when Jabez avoids execution, as Peters tells the reader, Slosh "bellow[s] for three mortal hours because his father committed suicide, and disappointed the boy of seein' him hung" (p. 404). Domestic and filial conventions are here reversed and overturned. Slosh is an odd combination of adult and child and his liminal positioning unsettles proper social definitions.

Like the half-child, half-adult Slosh, Braddon's *Trail* is not fully formed; it is a transitional text which appropriates and reworks the previously masculine-bound conventions of crime narratives. These issues are evident to a lesser extent in another of Braddon's early novels, *The Black Band; or, The Mysteries of Midnight*, serialized in Maxwell's *The Halfpenny Journal* (1 July 1861–23 June 1862) and probably written and edited at least in part concurrently with *Trail*. This magazine was cheap, and consequently had a predominantly lower-class readership; Braddon had noted to Lytton that "the amount of crime, treachery, murder, slow poisoning & general infamy required by the halfpenny reader is something terrible."[156] *The Black Band*

follows the feminized Gothic pattern established by the fiction of Anne Radcliffe and seen in Gaskell's "The Grey Woman," but Braddon is more daring than Gaskell with her challenging of boundaries—both socially and textually. As a middle-class writer with an established reputation, Gaskell was limited in her writing by public expectation as well as social and sexual conventions while Braddon, still at this stage in her writing career relatively unknown, had more freedom. And, in spite of it being written under the aristocratic-sounding pseudonym of Lady Caroline Lascelles, Braddon's text was aimed at the lower classes, an audience that, this chapter suggests, enabled Braddon to challenge the boundaries of social and literary convention. *The Black Band* is perhaps rather derivative in its use of the feminine Gothic where *Trail*, aimed at a middle-class audience, is more radical in its appropriation of the masculine tropes and themes of the Newgate novel. Both modes of writing, however, can be seen as experimental and as intrinsic to Braddon's later mastery of sensation fiction.

The Black Band's plot rotates around a secret criminal political society—The Black Band, or "the Companions of Midnight" a name that signals the Gothic influence.[157] By contrast to Gaskell's "The Grey Woman," with its classically Gothic male criminals and female victim/protagonists, Braddon includes criminal women in her narrative:

> The Black Band did not reject the aid of women. There were women who took, in fear and trembling, those terrible oaths which gave their lives into the keeping of the Companions of Midnight. In many capacities women were useful to this band—as spies, to decoy, to ensnare, to blind, to creep into places where men could never penetrate, to obtain confidences, accorded to them on account of their sex [p. 109].

The most significant of these are Lady Edith and the French murderess, Rosine Rousel. Lady Edith makes several attempts at murder and possesses a "masculine nature" (p. 370), rather in the manner of Collins's Marian Halcombe in *The Woman in White* and of some of the later female detectives. *The Black Band* also features a number of investigating figures, including two police-detectives, Inspector Martin and Sergeant Boulder, but it is not until relatively late in the narrative that they make an appearance.[158] Their inclusion, though, locates the text more as crime/detective fiction than Gothic literature and *The Black Band* incorporates many of the elements of what will later be visible and recurrently used in the established crime genre. There is, for example, a private investigating figure, Joshua Slythe, clerk to the lawyer, Mr. Weldon.[159] Slythe is more active in the search for the Black Band than the police detectives. Equally, his social status associates him by proxy with the criminal class against which he pits himself. Single handedly, he infiltrates the den of the Black Band, using his initiative and risking his own life. He helps capture

some of the Black Band and adopts two children who had been forced to live in the criminal den. He is rewarded for his actions with both wealth and social elevation. In reality, of course, it would not have been so easy to traverse from the lower to the higher classes in the nineteenth century. While the lower-class audience of the periodical in which *The Black Band* was published enabled Braddon to experiment, nonetheless much of the text is derivative and peopled by stereotypes.

Trail and *The Black Band* have, this study suggests, been overlooked in favor of Braddon's later sensation fiction. But the study's contention is that these texts make an important contribution to the creation of a female canon of crime and detective fiction. Although Braddon's best-known text, *Lady Audley's Secret*, is clearly in the sensation mode, she still challenges literary conventions in her depiction of a devious and cunning criminalized woman. As Willis notes: "She knew what her readers liked, and was never afraid to change her style and subject matter to suit the changing demands of the literary marketplace."[160] *Lady Audley's Secret* has the feminized figure of Robert Audley in the detective role and Braddon wrote other proto-detective narratives, including *Eleanor's Victory* (1863). An experimental writer, Braddon's challenging stance against literary and social conventions can be contrasted with her contemporary, the rather more conventional and established writer of sensation and other fiction, Mrs. Ellen Wood. However, despite her conventionality and her respectable literary reputation, Wood's fiction, like that of Braddon, often incorporated crime and she too makes an important contribution to the establishment of the crime fiction genre.

Mrs. Henry (Ellen) Wood (1814–1887)

Mrs. Henry (Ellen) Wood and Braddon both had their first novels published in 1860. Wood had written over 100 short stories prior to this, while Braddon was still pursuing her acting career. Appearing a year before *Lady Audley's Secret*, and following Wood's first (temperance and prize-winning) novel, *Danesbury House* (1860), *East Lynne* appeared in W. Harrison Ainsworth's important and popular middle-class *New Monthly Magazine* (January 1860–September 1861). It epitomizes what would come to be called sensation fiction, with its seductive villain, a criminal element and, at its centre, a socially and briefly sexually transgressive heroine, the foolish Lady Isabel Vane. There is little detection as such in *East Lynne*, although the criminal sub-plot is important. Wood's work is moral, advocating and supporting the proper female values of the time, while Braddon's work tended towards the

subversive and might be considered to be proto-feminist in its questioning of the position of women in society. Wood had a long and prolific writing career, as a retrospective review in *The Times* in 1914 suggests. *The Times* article, "The Secret of Mrs. Henry Wood,"[161] recognized the combination of domestic and melodramatic elements in her fiction. While *East Lynne* has no detective *per se*, Wood clearly understood the relevance and significance of such figures and, in *Mrs. Halliburton's Troubles* (1862), included the figure of police-detective Sergeant Delves.[162]

Rudimentary elements of the later crime fiction genre are evident in *East Lynne*, particularly in the quasi-detective figure of Barbara Hare, who never ceases to believe in and try to prove her brother to be innocent of the crime of which he is accused. As Stephen Knight notes, not only does the novel have aspects of crime fiction, but:

> more interesting is the effect of the doggedly inquiring nature of Barbara Hare: finally given more scope than Marian Halcombe, she is perhaps even a source for the soon-to-appear lady detectives, Mrs. G — and Mrs. Paschal.[163]

Knight further comments that "*East Lynne* may have itself given Braddon the idea for a criminal heroine,"[164] while Murch proposes that "Mrs. Henry Wood [can be linked] with many later writers of detective fiction in her appreciation of what constitutes evidence, her accurate knowledge of the law. [...] Within this extensive framework of [*East Lynne*] is a well-constructed murder mystery."[165] Although the text allows Barbara Hare some investigating agency, the masculine conventions surrounding the use of crime in fiction remain and in the female-authored *East Lynne* criminal elements are contained in what is, despite its romantic aspects, a strongly didactic story.

East Lynne was a popular success and Wood's book sales equaled those of Braddon and Collins, as Margaret Oliphant observed, declaring in 1895 that Wood was "the best-read writer, perhaps in England."[166] In the twenty-first century, Martha Hailey DuBose states that "*East Lynne* eventually sold more than one million copies during Mrs. Wood's lifetime."[167] While *East Lynne* has criminal elements, it inscribes a firm moral message about female transgression. Because of this, as Emma Liggins remarks, "Mrs. Wood [...] seemed to pose no [...] problems, identified as she was with the nation at large, and specifically with its solid 'middle class.'"[168] Sayers sees Wood similarly, but in more sensational terms:

> That voluminous writer, Mrs. Henry Wood, represents, on the whole, melodramatic and adventurous development of the crime-story as distinct from the detective problem proper. Through *East Lynne*, crude and sentimental as it is, she exercised an enormous influence on the rank and file of sensational novelists, and at her best, she is a most admirable spinner of plots.[169]

Sayers here acknowledges Wood's contribution to the crime fiction genre, but glosses over its contribution to detective fiction. This chapter would argue, however, that although Braddon and Wood were bound by the literary conventions of their time and so limited in their representation of crime, their writing and their innovative proto-detective figures helped to shape what would become the detective novel proper.

East Lynne examines the ramifications of the socially "criminal" woman. Lady Isabel Vane/Mrs. Carlyle's "crime" is to allow herself to be seduced into committing adultery with the criminal in the text—Francis Levison, alias Captain Thorn. The novel includes a sub-plot of murder, committed by Levison. Isabel's husband, Mr. Archibald Carlyle, functions, with Barbara, as semi-investigative figures in the novel, seeking the truth about Barbara's brother who has been accused of the murder of George Hallijohn, which Levison has in fact committed.[170] Barbara and Archibald meet to discuss the case; Isabel's misinterpretation of their meetings as romantic trysts leads to her seduction by Levison and her consequent removal to "the Continent—that refuge for such fugitives."[171] She is subsequently, as the title of Chapter IX suggests, "Never to be Redeemed" (p. 203). Because of her infidelity, Isabel is repeatedly punished by the text and society for her non-adherence to feminine norms—a train crash disfigures her face and mars her beauty, her illegitimate child is killed in the same accident and, now unrecognizable as the beautiful Lady Isabel, she returns to England as Madame Vine, the governess to her own children. Wood is specifically commenting on the proper role of the woman within society, inscribing middle class and didactic values and suggesting the unpleasant consequences of straying from that role. The real criminal in the text, Levison, is eventually socially humiliated for his anti-social acts and legally punished for the murder he committed. *East Lynne* is, finally, more romance, sensation fiction and moral story than crime narrative, but it is nonetheless evidence of the ways in which women brought crime into their fiction despite literary and social convention. But while Barbara Hare offers only a limited and curtailed detective figure, Wood later wrote a series of short stories featuring a male investigating figure.

Mrs. Henry (Ellen) Wood's "Johnny Ludlow" stories are quasi-detective fiction, although the stories are embedded principally in the domestic.[172] The stories have a male proto-detective and they predominantly center on puzzling events which require explanation and resolution, but which include crimes such as pick-pocketing, kidnapping, and stealing. Johnny is endowed with the detective's "eye"; in "Losing Lena" he comments that "I was always reading people's faces, and taking likes and dislikes accordingly. [...] but it seemed to me that I could read people as easily as a book. Duffham, our surgeon at Church Dykely, bade me *trust to it* as a good gift from God."[173] The stories

also contain elements of the supernatural: in the *Johnny Ludlow First Series* collection (1874), for example, "Reality or Delusion?" (*Argosy*, December 1868) involved a woman who sees the ghost of her lover at the moment that he commits suicide.[174]

In the Johnny Ludlow stories, the age of the protagonist, the domestic setting and the minimal criminal elements suggest that the stories were calculated to appeal to a juvenile audience and so might reasonably be described as an early example of children's crime fiction.[175] The series ran from January 1868 to 1891, appearing monthly in the sixpenny *Argosy* magazine (1865–1901), which Wood edited. The time span of their production and publication suggests the popularity of the stories: "In total one hundred and twenty issues of *Argosy* over twenty-three years contain tales supposedly written from the viewpoint of a young Worcestershire lad."[176] The *Argosy* is described by Jennifer Phegley as a "family literary magazine," suggesting that children would have been part of its audience.[177] The stories being told from the perspective of Johnny Ludlow and Wood's refusal to append her name to them concealed the female identity of the writer.[178] Ellen Wood's declared reason for this was that:

> When I began the stories—for the *Argosy* magazine—my only motive for not putting my name to them was that they appeared to be told by a boy; and to append my name as the Author would have destroyed the illusion; or, at least, have clashed with it. [...] And now, having said thus much, it only remains for me to thank the public, as I do heartily, for the very great favour they have accorded to these simple and unpretending stories.[179]

Wood took over editorship and ownership of the magazine from Alexander Strahan in October 1867 and prior to this there had been a public outcry in response to the magazine's inclusion of Charles Reade's tale of bigamy and sexual passion, *Griffith Gaunt, or Jealousy* (1865). Perhaps the magazine and its new editor needed to include seemingly "simple and unpretending" tales to quell these objections to a challenging or shocking narrative. In this sense, the Johnny Ludlow series are depicted as non-threatening and simple.

The stories deal with the escapades of the eponymous Johnny, who is an orphan living with Squire Todhetley, his second wife and their family. The stories are mainly set in the counties of Worcestershire and Warwickshire, with the background occasionally changing as Johnny journeys around England, London, and France, but these locations all relate back to Worcestershire. Alison Jaquet connects these locations with the stories' blend of genres; she defines them as "fictional recollections of English rural life [which] are a generic mix of detection, romance, mystery and crime."[180] Crime, then, is here located outside the more usual criminal hub of London. The Johnny Ludlow stories oscillate between genres and are not holistically crime or detec-

tive fiction and critics read them in a number of ways. For example, Lucy Sussex, while not explicitly mentioning the Johnny Ludlow stories, exposes the multiplicities of Wood's writing while also specifically locating her within the emergent crime genre; she writes of "Ellen Wood and her works—the multilayered, powerful *East Lynne* (1861), her family sagas and intricate crime narratives."[181] Jaquet places Wood as a major female contributor to the detective genre, as a literary link between Poe and Doyle, in contrast to the more usual masculine tradition: "Ellen Wood's Johnny Ludlow tales form part of this "bridge" between Poe and Conan Doyle."[182] This comment, though, ignores the difficulties facing women writing crime narratives. This chapter contends that this is, seen retrospectively, evidence of a female-authored attempt at crime narratives and a contribution to the genre as we now know it, but still in an embryonic and hybrid form.

An overview of the stories shows that each is complete in itself, although they tend to interconnect, mainly because of their central character, Johnny, but also with other characters as well as criminals and crimes reappearing in subsequent stories. Additionally, a mystery or predicament introduced in one may be solved in another. Jaquet, rather than seeing these connections as contributing towards a totality suggests that "[t]he recurrence of characters [...] and constant shifts in time and place demonstrate how the series structure itself hints at an excess, an incompleteness, which can never be completely contained or represented."[183] This incompleteness can be related to the stories as nascent crime narratives, part of a genre in flux. When crimes occur, they are usually the sensation staples of bigamy, poisoning, theft, mistaken identity, disappearances/abduction, fraud, and murder or in a ghostly/Gothic form.[184] Crimes, in these instances, are sometimes clear and, at other times, submerged within the domestic discourse of the home.

As Wood's short stories are prone to moralizing, the contemporaneous critical responses to these works are largely positive; the Johnny Ludlow stories' first appearance as an anonymously authored collection in 1874 received a positive response from *The Academy*, which stated that "anybody who has not yet read them had better do so without loss of time."[185] In 1880 *The Saturday Review* praised the stories: "Johnny Ludlow's character is very well drawn.... No less well drawn is his half-brother, Joseph Todhetley, or his stepfather, Squire Todhetley, with all the strong prejudices and the kindliness of an English squire."[186] By the third collection of the series in 1885, however, *The Saturday Review*'s opinions changed, indicating that these quasi-crime texts had a limited shelf-life as the crime/detective genre had, by this time, become a recognizable entity. *The Saturday Review* commented that:

> these chronicles of petty crime and misadventure are at the best but painted photographs which do not deserve the name of works of art. 'The conversa-

tion,' as was lately said by one who had looked into the volumes, 'is that of the second-class railway carriage' ... the quintessence of British mediocrity.[187]

From a modern perspective, Bruce F. Murphy describes the Johnny Ludlow stories as Wood's "best work."[188] In *East Lynne*, Wood incorporated crime into her narrative as part of her novel's moralistic message; in the Johnny Ludlow series the focus was more openly on crime and detection, but the femininity of the author was concealed. Women could and did write crime in 1860s Britain, but it was always contained and constrained in some way.

While women continued to write and produce sensation fiction after the 1860s, in Britain there is a dearth of women producing works in the 1870s and 80s which may be considered to contribute to the genre of crime/detective fiction. Women were around, as is clear in the case of L. T. Meade (pseudonym for Elizabeth Thomasina Meade Smith [1854–1914]), who, with various collaborators, wrote a series of stories in the *Strand*. Her first two series were entitled "Adventures from the Diary of a Doctor," with a protagonist named Dr. Halifax. Meade was also the co-author of many mysteries with Robert Eustace. The proliferation of female attempts at crime writing in the mid-nineteenth century was, comparatively, not as plentiful towards the end of the century. British women's crime fiction contributions and subsequent containment and "start/stop" nature discussed in this national part title are perhaps likewise enacted or replicated in this temporal gap. As Hugh Greene has noted:

> there is a twilight world of neglected, but not completely forgotten, writers like Dick Donovan, Bodkin, Mrs. Pirkis and Mrs. L. T. Meade who wrote the occasional story which deserves to be resurrected, if not for its literary quality, then for some ingenuity of plot, some sudden flash of imagination, some light on the late Victorian and Edwardian world.[189]

This can be contrasted with the many American and Australian women writers who produced crime narratives over the decades of the 1860s, 1870s and 1880s and beyond and whose work drew upon and surpassed that of the conventionally constrained female British authors.

Colonial Connections

The women writers discussed here must, this section suggests, be considered as contributing to the development of crime fiction generally and detective fiction in particular. But while male writers and their criminous narratives freely and openly circulated across nations in this period, British women writers and their criminography were metaphorically criminalized in their often anonymous transportation to America and Australia.[190] Gaskell's

short story, "The Grey Woman," is set in France and Germany, while her other work and short stories are set around Britain and New England (U.S.), and she included the American Civil War in her writing.[191] Gaskell's short, non-mainstream fiction was also published in an American journal, *Sartain's Union Magazine*; this was "an American periodical which contained sentimental and moral tales and light sketches, as well as essays on literary subjects."[192] Gaskell was aware of the difficulties facing women writers producing non-mainstream fiction; in a letter to Charles Eliot Norton in 1859 Gaskell notes:

> If I try to keep my story as my own property for a month longer, will you send me word what any body will give for it in America, & how it may best be kept out of England.[193]

As publishing remained largely in the hands of men, this could have been the only route open to Gaskell. As Michie notes, "[e]ven when Gaskell sought to sever her connection with Dickensian periodicals and to publish elsewhere, she still experienced herself as having almost no control over her work."[194] Michie also associates Gaskell's writing with emigration:

> So, too, in the arena of professional writing, by getting her stories out of England and sending them to America, she is, in effect, choosing "emigration" for her writing. But the only place she can imagine sending her work is also the place where [in relation to "Lizzie Leigh"] it was originally most fully coopted. As a professional woman writer, Gaskell finally finds little or no way for her stories to remain her own property.[195]

In addition to being published in American periodicals, Gaskell had associations with Australia. She includes Australian emigration and fallen women in her writing; Nancy Henry comments that: "The complexity of her attitudes to change may be seen in the matter of emigration to the British colonies as a solution to poverty, disgrace, or discontent with society at home."[196] Further to this, her story, "The Heart of John Middleton" (*Household Words*, December 1850) features an escaped convict, Dick Jackson. Dick is a common name for Australian criminals in nineteenth-century Australian crime-based literature. Foster summarizes this story as one which "anticipates other short pieces in which Gaskell works out themes of vengeance and fate. The narrator feels he is of a "doomed race," branded by the sins of his criminal father, and although he eventually comes to accept the New Testament creed of forgiveness, his dark passions take a terrible toll on all around him."[197] In "The Moorland Cottage" (1850) the narrator, Frank Buxton, thinks he lives in a dishonest "nation whose god is money"[198] and wishes to escape to Australia or Canada, which are both depicted as a "newer and purer state of society" (p. 62). Gaskell's short story, "The Doom of the Griffiths" was published in America in *Harper's New Monthly* (January 1858). Henry asserts that it was "[i]n the late 1850s Gaskell began to take an interest in America" and that "[m]omen-

tous events such as the Crimean War and the American Civil War led Gaskell to think about the personal dimensions of broader social transformations and to situate her characters in actual historical events."[199] Her October 1859 piece, "Lois the Witch," considers the seventeenth century Salem witchcraft trials, and in 1863 she wrote a eulogy for Robert Gould Shaw, who was a Union army colonel. Elsie B. Michie writes that: "In contrast to Dickens, Gaskell did not view emigration as a solution to the problem of prostitution, instead insisting that the "fallen" woman could be redeemed by being taken into the domestic sphere."[200] Such recuperation can be seen in Wilkie Collins's *The Moonstone* (1868), where Lady Verinder allows Rosanna Spearman, a reformed thief and servant, into the domestic milieu.

Braddon's *The Black Band* was also transported abroad to America, but against her will. There is an 1877 George Vickers version, but this is an abridged edition, which omits details and some of the plot.[201] Jennifer Carnell describes this as an "American pirate edition."[202] Braddon's fictions were circulated widely in Australia. While it is uncertain whether *Trail* traveled to Australia in any form, Toni Johnson-Woods has undertaken comprehensive research into the Australian serialization of Braddon's other works, beginning in 1872 and concentrating on newspapers in Victoria, Queensland, and New South Wales.[203] It seems, therefore, that not only did Braddon become "woven into England,"[204] but was the author who "appeared most frequently in Australian periodicals," and was called the "Queen of the Colonies" by Woods.[205]

This study suggests that Braddon's texts are made doubly deviant given Australia's nineteenth-century criminal origins. The perceived British contemporary critical nineteenth-century victimization of Braddon and the response to her texts can also be questioned: Pykett queries "whether Braddon is the woman writer as victim of the nineteenth-century commodification of literature, or the woman writer as an entrepreneurial agent exploiting market conditions."[206] Braddon's texts, in their divergence from the rigid, class-inflected and realist Victorian novel, seemed to appeal to colonial inhabitants; an appeal of which Braddon took advantage. As Woods states:

> It is the layering of [Braddon's] stories that allowed exploration of working-class/middle-class, imperialist/colonist, man/woman contradictions that appealed to the burgeoning Australian middle classes.[207]

The testing of these social and national boundaries are seen as somehow criminal in Victorian Britain. Braddon's literarily criminal texts then literally migrate to the nation of Australia, with its criminal associations consequent upon transportation.

As noted earlier, the original incarnation of *Three Times Dead* can be found in America in the UCLA Michael Sadleir collection, curiously dated as 1854, six years before it was said to both appear and rapidly be forgotten in

Beverley in 1860. The Sadleir collection also holds 1866, 1867, and an 1890 editions of *Trail*. Braddon had set some of her work in colonial America. Her first published literary work included a poem called "Under the Sycamores," which was set in the seventeenth century and featured Menamenee, an American-Indian princess. While this text deserves a full analysis in itself, its existence connects Braddon, albeit tenuously, with America as well as with Australia.[208]

In *Trail*, the characters of Valerie, her original husband, De Lancy, and Richard, his wife and mother travel to "South America, where, far from the scenes which association had made painful to both, they might commence a new existence" (p. 405). South America, as opposed to Australia, which still has criminal connotations, or North America with its colonial and British associations, can serve as neutral ground on which these people can re-shape both their lives and, as British nationals, potentially the country. Jabez's surviving victims say "Farewell to England" (p. 397) and leave for South America in order to escape the criminal memories which they associate with "home."[209]

Back in Britain, after the 1870–1880 period, fiction largely seems to say "goodbye" to women writers working in the crime form, though Braddon and Wood were still producing fiction into the early twentieth century, with Wood's "Johnny Ludlow" series running until 1891. Ellen Miller Casey's discussion of the numbers of women novelists writing in the mid-century argues that towards the end of the century women novelists became more accepted.[210] Yet this was not within the crime genre, or what was soon to become the crime/detective genre proper, even though the crime and detective form was becoming popularized and plenty of this type of fiction was circulating. Changes in economic and printing practices in the 1880s/*fin-de-siècle* enhanced this crime and detective fiction dissemination: this period saw the decline of the sensation novel and rise of short fiction; there was no longer a privileging of the three-decker novel, and consequently it disappeared. In terms of crime fiction, Sutherland has commented that "[b]y the mid–1890s, it has been estimated that of the 800 weekly papers in Britain, 240 were carrying some variety of detective story."[211] In the 1880s, Arthur Conan Doyle took over the world of crime fiction, with his soon-to-be ubiquitous detective, Sherlock Holmes. Male authored crime and detective fiction which featured women detectives also appeared, such as George Sims's Dorcas Dene and Grant Allen's two series for the *Strand*, which both had female detectives: "Miss Cayley's Adventures," and "Hilda Wade."

This study will now move from an assessment of British women writers and relocate itself to America, providing a consideration of their counterparts, the American women writers. This chapter will examine the crime fiction they produced, the development of their crime writing and how they diverge and/or converge with their British sisters in their ways of incorporating crime into their fiction.

TWO

United States

Introduction

> "The world of crime and punishment may be something of a foreign country, one with strange customs, language, and manners" — Lawrence M. Friedman, *Crime and Punishment in American History*, 1993

> "Women, like men, are shaped by the country they inhabit, by their nation's language, history, literary canons, cultural mythologies, ideologies, and ideals." — Elaine Showalter, *Sister's Choice: Tradition and Change in American Women's Writing*, 1991

> "The woman writer. She has entered literary history as the enemy." — Nina Baym, *Feminism and American Literary History*, 1992

Criminography in North America developed in parallel with that in Britain but, as this national part title will suggest, with some important differences and innovations. This mode of writing has its roots in the late eighteenth century and it has generally been misperceived as a masculine tradition; accounts of American crime fiction have perhaps more commonly been seen as synonymous with the masculine, hard-boiled crime writers of the 1920 to the 1940s such as Raymond Chandler and Dashiell Hammett. Yet, prior to this there were many criminographic precedents including women writers of crime.

Initially there seems to be a symbiosis between British and American crime writing, perhaps a given, as much of America was initially colonized by the British. American writing in the seventeenth century was mainly of a religious nature, in sermon style, although when crime was committed it was punished by public execution and represented in printed form in the pamphlets, broadsides and ballads which appeared in the eighteenth century, as did their British counterparts. As in Britain, the Gothic influence on the novel was strong in eighteenth-century America and, more specifically, influenced the shaping of crime and detective fiction. What materialized was a national

Introduction 69

take on this form. This interaction of nations is evidenced by Edith Birkhead's commentary of America both in and from 1797; she writes that "[b]oth dairy-maid and hired hand amused themselves into an agreeable terror with the haunted houses and hobgoblins of Mrs. Radcliffe."[1] The American Gothic was not a straightforward national imitation of the European exponents, nor were there distinct polarities between the two: they impacted upon each other.

Variations between the two nations' criminographic writing become more evident after the American War of Independence/Revolution (1775–1783). Karl Miller suggests that "America is an orphan of a kind. [...] The New World began when romance began in literature, and it entered upon a divided relationship with the Old [European], rejecting the past which it was nevertheless to resume and perpetuate."[2] In general comparative terms Stephen Knight — discussing crime-focused writing circa 1840 onwards — comments that "a full historical pattern of American crime fiction can be constructed, which draws very little on the English tradition, to a substantial degree on the French tradition, and shapes its patterns of threats and value differently, and with national ideological impact."[3] This is apparent in the early American pioneer novels and what becomes very clear is that the early development of the crime fiction genre in America was strongly dominated by male writers.

Of these, Charles Brockden Brown (1771–1810) is a major figure. Brown was a significant influence on the development of the American novel, writing seven works of fiction between 1798–1801. He trained as a lawyer, wrote in many genres, was involved in politics (writing political pamphlets), and contributed to, edited and founded magazines. He is, however, best-known for his distinctive mode of writing, which has come to be known as American Gothic. The European settings and staples of architecture, those decaying labyrinthine castles, monasteries, and mansions with their hidden passages, are transposed onto the dangerous wilderness of the American landscape/frontier and, later, the city. Brown had written that the American writer should "adapt his fiction to all that is genuine and peculiar in the scene before him" so that the writer can be "entitled at least to the praise of originality."[4] In the Preface to *Edgar Huntly*, Brown wrote that the tale would not use the "Puerile superstition and exploded manners; Gothic castles and chimeras" of British Gothic (such as Radcliffe, Lewis, and Walpole), and that his story rather "exhibit[s] a series of adventures, growing out of the condition of our country." And, for this, Brown "would admit no apology," as he includes "the incidents of Indian hostility, and the perils of the western wilderness."[5] American Gothic conditions were concerned with the frontier, racial inflection, and relations with the Native Americans. Brown's novels feature disturbed mental states, suicide, murder, and crime. In *Wieland; or,*

The Transformation. An American Tale (1798) the murderer's mind and thoughts are central. The story is set in the wilds of Mettingen, Pennsylvania. Doubling is a strong trope; here it involves Wieland and Clara (his sister), and Catherine (Wieland's wife) and Henry Pleyel (her brother).[6] Wieland and Clara's father has died by spontaneous combustion and, spurred on by an unknown and persistent voice, Wieland goes mad and strangles his wife and five children, attempts to murder his sister and eventually commits suicide. These cataclysmic events are initially attributed to the supernatural, yet the cause is actually the unknown outsider Carwin, who penetrates their circle and produces the "unknown voice" using ventriloquism. He is apparently motivated only by "some daemon of mischief."[7]

The interconnection of madness, crime and the Gothic are again evident in *Arthur Mervyn; or, Memoirs of the Year 1793* (1799).[8] This story follows Mervyn and incorporates the real-life case of the yellow fever epidemic in Philadelphia in 1793. Mervyn retrospectively tells his story to Dr. Stevens, in whose house he is staying after Stevens has found him on a bench, afflicted with yellow fever. He details his arrival in Philadelphia and tells how he meets a man named Wallace who, after offering him lodgings, locks him in a room from which he subsequently escapes. With no money he begs, and unluckily meets and is then hired by a man named Thomas Welbeck who, it transpires, is a thief, forger, seducer and murderer, as well as the cause of Mervyn's recurrent troubles throughout the narrative. He is made well again, and Welbeck dies in a debtor's prison. Mervyn assists the ill-treated female figures of the tale, marries and then takes up an apprenticeship with Dr. Stevens.

Another important text by Brown, and one which Robert E. Spiller sees as the first American detective novel, was *Edgar Huntly or The Memoirs of a Sleep-Walker* (1799).[9] When Huntly's friend Waldegrave is murdered, he pursues the suspected Clithero Edny — although it transpires that Edny is a sleepwalker, not a murderer. The concentration on the chase and psychological relationship between Huntly and Edny is similar to and probably influenced by William Godwin's characters Falkland and Caleb in *Caleb Williams* (1794). Crime in Brown's text acts as the catalyst for the characters' actions and the focus is on them rather than on the criminal acts.

Brown's literary successor, James Fenimore Cooper (1789–1851), takes the American Gothic and adventure form further than Brown and, while his work is still not crime fiction as such, it has elements of the genre, especially in its hero, who has what might be seen as an early detective function. Cooper's "Leatherstocking Tales" (1823–1841), featuring frontiersman Natty Bumppo, are set in the wild landscapes of the mid–eighteenth century. Bumppo appeared in *The Pioneers; or, The Sources of the Susquehanna* (1823); *The Last of the Mohicans* (1826)[10]; *The Prairie: A Tale* (1827); *The Pathfinder;*

or, *The Inland Sea* (1840); and *The Deerslayer; or The First Warpath* (1841). Bumppo is an expert tracker, and this ability to follow individuals will become the mainstay of the detective. Cooper's writing influenced the contemporary French writers, including Eugène Sue with his *Les Mystères de Paris* (1842–3).

And, in turn, this discursive transatlantic relationship spoke back to and influenced writing and writers in America; the impact of Sue's and Reynolds's works inspired a host of imitators in America, especially of Sue.[11] The British/American interaction is also apparent in narratives such as William E. Burton's short crime stories/series, "Leaves from a Life in London," in the *American Gentleman's Magazine* (1837), or the "Pages from the Diary of a Philadelphia Lawyer" series (also in the *American Gentleman's Magazine*, 1838). Washington Irving (1783–1859) — historian, novelist, and essay writer — drew on the Gothic form in his short stories, as in "The Legend of Sleepy Hollow" (1820), with its headless horseman. Herman Melville's novella, "Benito Cereno" (serialized in *Putnam's Monthly* 1855; revised and collected in *The Piazza Tales* (1856)), can be classed as forming a part of the American Gothic, with its incorporation of terror, slave subterfuge, and murder upon a Spanish ship. Elements of protean detection are also seen in William Leggett's story, "The Rifle" (1827), which included ballistics as evidence, and Nathaniel Hawthorne's "Mr. Higginbotham's Catastrophe" (in *Twice Told Tales*, 1837). True crime accounts were represented by the *National Police Gazette* (from 1845), and a detective division within the New York police was inaugurated in 1857. Samuel Walker states that "it is difficult to pinpoint exactly the exact date of the first American police department. Historians generally cite the establishment of a day watch in Boston in 1838. Philadelphia, however, had experimented off and on with temporary arrangements between 1833 and 1854."[12]

Perhaps the best-known, and considered to be of great importance in the development of crime fiction, is the American author Edgar Allan Poe (1809–1849). Most of his work was published in the 1830 and 1840s, and he has retrospectively been considered to be the "father" of the crime/detective genre. According to LeRoy L. Panek, Poe is synonymous with "the detective story, [which is perceived as] something originally and fundamentally American."[13] This position is continually propagated in critical accounts of the genre. Charles E. May supports the valorization of Poe and American crime writing, adding that detective fiction had "its formal beginnings as a short story in America with Poe's Dupin [which] is well known, as is its adoption in that form in England."[14] Ordean A. Hagen's crime fiction genealogy also traces the inception of the crime genre from Poe in America back to Britain, then across to France with Émile Gaboriau's Monsieur Lecoq stories, but returns it to America and to a woman writer, Anna Katharine Green. In Tony Magistrale and Sidney Poger's work there is a chapter titled "Poe Feminized:

Daughters of Fear and Detection" which, by implication, suggests that women crime writers owe their existence and are subservient to the masculine originators of the genre. Such accounts of crime fiction, however, can be read in a more powerful sense, indicating that, while Poe began the genre, women writers in the United States quickly appropriated it.

Poe was editor of *The Gentleman's Magazine* from 1839 and, before the creation of his now-famous character of the French detective, Chevalier C. Auguste Dupin, published a collection of stories: "Tales of the Arabesque and Grotesque" (1840). Poe's intentional divergence from British paradigms is exemplified in his two-part satire of British Gothic "tales of terror" and the sensational, "How to Write a Blackwood Article" (*American Museum*, November 1838). This piece was originally entitled "The Psyche Zenobia." The second part, "A Predicament," shows how Psyche — in her search of a basis for a *Blackwood's* story — ironically becomes trapped by the hands of a tower clock. This description is grotesque: her eyeballs pop out, and she then loses her entire head. In terms of crime fiction, three interconnected stories primarily earned Poe his title of "father" of the genre: these were his tales of "ratiocination." Analytical and mathematical, they reworked the Gothic. Combining the psychological and apparently supernatural with the insightful, intellectual Dupin, who is assisted by his unnamed friend/narrator, this set in place a crime fiction format that is still in existence today.[15] These tales of ratiocination began with "The Murders in the Rue Morgue" (*Graham's Lady's and Gentleman's Magazine*, April 1841), which introduced the idiosyncratic investigator, Dupin. The unnamed narrator explains that "[t]his young gentleman was of an excellent, indeed of an illustrious family, but, by a variety of untoward events, had been reduced to such poverty that the energy of his character succumbed beneath it, and he ceased to bestir himself in the world, or to care for the retrieval of his fortunes."[16] Since the genre is not yet formed, Dupin is not a detective although, retrospectively, he is deemed as such. The setting is Paris and the crimes are the murders of an old lady, Madame L'Espanaye, and her daughter, Mademoiselle Camille L'Espanaye. Poe may have been influenced by the Gothic, German writer Hoffmann and his story "Mademoiselle de Scudéry," which is set in Paris. The culprit is, bizarrely, an escaped orangutan. Dupin is drawn into the case by newspaper reportage and by the later established crime fiction trope that an acquaintance has been wrongly accused; he uses his insight to solve the case where the police fail.

The second tale, "The Mystery of Marie Rogêt" (*Snowden's Ladies Companion*, 1842–3), blends the factual and the fictional. Poe draws on the real 1842–3 New York case of Mary Cecilia Rogers, known as "the beautiful cigar girl," whose dead body was found in the Hudson River.[17] Poe's account of the crime and his own attempt to find its solution is transposed to Paris. This fiction-

alization was problematic as, by the third installment of Poe's version, an article in the New York *Tribune* (26 November 1842) suggested that perhaps Rogers's death was consequent upon the botched termination of an unwanted pregnancy.

The final Dupin story, "The Purloined Letter" (*The Gift*, 1845), is the most critically explored of the three. It involves blackmail, with an important letter stolen from the royal apartments. The Minister D is known to be the culprit, but the most diligent searches of the police fail to discover/recover the letter. It requires the sagacity of Dupin to reveal that Minister D has hidden the letter in plain sight, in a card-rack. As Dupin observes of the police search: "The measures adopted were not only the best of their kind, but carried out to absolute perfection. Had the letter been deposited within the range of their search, these fellows would, beyond a question, have found it."[18] Dupin plays with ocular preconceptions when he complains of "weak eyes"; his spectacles function as an ironic antithesis: they form a guise so that his gaze is able to survey the apartment and ascertain where the letter is. The three stories of ratiocination prefigure Arthur Conan Doyle's Sherlock Holmes narratives and set in place many of the definitive elements of the established genre.

Poe's innovative Dupin stories did not immediately lead to any further developments in American criminography. It was apparently in the wake of the American Civil War (12 April 1861–9 April 1865) that further crime narratives began to appear. Imitators of the British "Waters"/casebook form emerged, such as the anonymously written *Strange Stories of a Detective; or, Curiosities of Crime, by a Retired Member of the Detective Police* (1863), which were set in New York.[19] This materialization is also exemplified in *Leaves from the Note-book of the New York Detective* (1865). The "Notebook," another male-authored narrative which continued the masculine dominance of writing associated with crime, was anonymously authored, but was purported to be edited by the fictional "John B. Williams, M.D." in order to lend it authenticity.[20] Sarah Weinman has John B as a real life person and author; she writes that "The memoirs, of course, are wholly made up, originating from the mind of John Babbington Williams (1827–1879), about whom we know little save that he was a medical doctor and contributed stories to the dime magazines of his time."[21]

It is perhaps the first sustained collection featuring a single investigating protagonist after Poe's three Dupin stories. The tales recount the adventures of investigator James Brampton, also known as "Jem," who is "known among thieves and rogues as J.B."[22] He is described as

> a man of extraordinary sagacity [who] had succeeded in discovering the perpetrators of crime, where to ordinary men all clue appeared to have been lost. His faculty in this respect was evidently owing to his keen observation, his acute mental analysis, and determined perseverance [p. 4].

In this description, Poe's Dupin can be seen to influence the representation of Brampton; in his cases he analytically reasons and observes.[23] Heather Worthington has suggested that Jem Brampton is "perhaps the first American urban detective."[24] J.B.'s reasons for his occupation are reminiscent of the contemporaneous British lady detectives, Mrs. G— and Mrs. Paschal, as well as Thomas Waters and Dupin; financial matters outside J.B.'s control force him to enter into a detecting occupation: his father's death by burning is the reason why he quits the study of medicine. This is frequently the way in which a detective figure can be introduced into narratives aimed at a middle-class audience and made acceptable to the reader: the investigator is shown to be middle class but fallen on hard times and so forced into what might otherwise seem a lower-class occupation. J.B., however, is different from the two (1864) British lady detectives and Waters in the sense that although he is initially an amateur detective and then a "detective-police officer," he does not acquire his cases through the police but through personal connections. The interconnection of J.B. with the superior positioning of Poe's Dupin is seen in the "Introduction": J.B.'s school friend, John Millson, approaches him for assistance, commenting that "I would rather trust the case in your hands than in those of the best detectives in New York" (p. 6). Where women appear in J.B.'s stories it is usually as victims in that they are wrongly accused of crime.[25]

A real-life American writer and professional detective at this time was Allan Pinkerton, whose British connection is apparent in his being the son of a Glasgow police sergeant. Pinkerton was eventually the "Chief of the U.S. Secret Service." His accounts blend the factual and the fictional but overall offer a more realistic story of crime and detection than the so-called police memoirs of the 1860s on both sides of the Atlantic. Pinkerton wrote eighteen crime/detective stories, starting in 1866, supposedly based on real experiences with his Pinkerton National Detective Agency (founded in 1852), which was the first of its kind in America. Worthington states that these "were possibly ghost-written but were published under his name."[26] The Pinkerton logo of an all-seeing eye is the point of origination for the later term "Private Eye." Pinkerton's novels included *The Expressman and the Detective* (1875) and *The Gypsies and the Detective* (1879). In 1889 Pinkerton would write *The Whitechapel Murders; Or, An American Detective in London* (Chicago: Laird and Lee, 1888). This was set in London, was based on the factual figure of Jack the Ripper, but made "the Ripper" a Native American woman. This story draws on the circulating anxieties of crime and identity, and displaces them onto women.

Pinkerton's impact is evidenced by the appearance of later variations. American Mary Roberts Rinehart's only series character is a thirty-eight-year-old called Nurse Hilda Adams. Adams is otherwise known as "Miss

Pinkerton" (1932–42, three books). She bears a resemblance to the British lady detectives (1864) in her ability, reasons for becoming a "detective," and domestic duplicity. "Miss Pinkerton" comments:

> And then I had made that alliance with Inspector Patton and the Homicide Squad. By accident, but they had found me useful from the start. There is one thing about a trained nurse in a household: she can move about day and night and not be questioned. The fact is that the people in a house are inclined pretty much to forget that she is there. She has only one job ostensibly, and that is her patient. Outside of that job she is more or less a machine to them. They see that she is fed, and if she is firm that she gets her hours off-duty. But they never think of her as a reasoning human being, seeing a great deal more than they imagine, and sometimes using what she sees, as I did.[27]

A Welsh, masculine version also appears, named Evan Pinkerton (1940–50, appearing in fourteen books). These were written by the English writer David Frome (Zenith Jones Brown). Pinkerton was not alone in exploiting this increasingly popular sub-genre of writing; in 1872 *Old Sleuth, the Detective; or, the Bay Ridge Mystery* by "Tony Pastor" appeared, while the pseudonymous "Ned Buntline" (real name Edward Zane Carroll Judson, c. 1822–1886) was a prolific producer of adventure and dime novel stories.

In parallel with this strongly masculine domination of the nascent crime fiction genre, American women writers were also taking to crime in their fiction and pushing the boundaries further and more firmly than their British sisters-in-crime, whose criminographic contributions were heavily restricted by social and literary conventions. American women began to write what might loosely be termed crime narratives, initially very much in the British sensation mode, but they quickly began to produce what are clearly crime/detective fiction narratives, constructing a distinctly American, female-authored crime fiction form by the end of the 1880s. Unlike their British counterparts, their influence extends beyond the 1860s. The most important of these women writers in terms of their role in the development of the genre and in their open challenge to male dominance were Harriet Prescott Spofford, Louisa May Alcott, Metta Victoria Fuller Victor, and Anna Katharine Green.

Women were writing and being published before the 1860s in America. As early as 1827 Catharine Sedgwick (1789–1867) — in her novel, *Hope Leslie* (1827) — strikes a feminist and nationalistic tone: "our new country develops faculties that young women in England were unconscious of possessing,"[28] but the proliferation of distinctly criminal narratives seems to begin just after the mid-century.[29] Modern critics such as Elaine Showalter, Hope Norman Coulter, Lee R. Edwards and Arlyn Diamond, and Judith Fetterley also advocate a distinctly American focus and argue for a separate American female

literary identity. Women were writing about their lives and their specific American experiences, mediated in the forms of domestic novels or moral/instructive handbooks, romance, and historical novels; these forms dealt with the treatment of Native Americans and could and did have feminist overtones. The appearance of such works contradicts Dr. Benjamin Rush, a University of Pennsylvania Professor of Medicine, and his "Thoughts Upon Female Education..." (1798), in which he asserted that women should read only moral essays, history, poetry, and travel writing.[30] Rush writes that

> [t]hese studies are accommodated, in a peculiar manner, to the present state of society in America, and when a relish is excited for them, in early life, they subdue that passion for reading novels, which so generally prevails among the fair sex. I cannot dismiss this species of writing and reading without observing, that the subjects of the novels are by no means accommodated to our present manners. They hold up *life*, it is true, but it is not yet *life* in America. Our passions have not yet "overstepped the modesty of our nature," nor are they "torn to tatters," ... by extravagant love, jealousy, ambition, or revenge. As yet the intrigues of a British Novel, are as foreign to our manners, as the refinements of Asiatic vice [p. 81].

Not only were American women reading narratives outside these gender-prescribed bounds, but they were equally writing, or beginning to write, alternative, sometimes crime-inflected narratives themselves.

The 1850s was an important decade in terms of U.S. women's writing. Yet there is still, at this point, a British influence which is evident; Elizabeth Stoddard has called this "a *Jane Eyre* mania,"[31] a trend that is apparent in Louisa May Alcott's work, which will be discussed later. Fred Lewis Pattee's book, *The Feminine Fifties* (1940), reveals how women in this period dominated the literary marketplace. Equally, David S. Reynolds's *Beneath the American Renaissance* conflates the 1850s with a "flowering" of American women's writing. In the 1850s the main literary form used by women was that of the domestic novel, although female-authored historical and Gothic novels appeared at this time. This fictional mass-market and the domestic novel's popularity and monetary value is evidenced by Susan Warner's *The Wide, Wide World* (1851), which sold one million copies worldwide. Well-known (and now canonical) exponents of the domestic novel include Mrs. E.D.E.N Southworth, Maria Cummins, Fanny Fern, Harriet Beecher Stowe and Julia Ward Howe.[32] Of these, perhaps the most famous is Beecher Stowe, with her seminal anti-slavery narrative, *Uncle Tom's Cabin* (1852). Showalter has noted that "[h]er fiction played a major role in the shift from American dependence on British and European literary models to acknowledgement of distinctively American subjects and forms."[33] These domestic texts could and did investigate gendered, social and racial "crimes." Masculine reactions to these female voices were less than favorable; Nathaniel Hawthorne has infa-

mously commented about the domination of the American novel by women in the 1850s:

> America is now wholly given over to a d___d mob of scribbling women, and I should have no chance while the public taste is occupied with their trash and should be ashamed of myself if I did succeed.³⁴

Further, he declared that "ink-stained women are, without a single exception, detestable."³⁵ This disparaging comment is reminiscent of Bradford K. Mudge's work on British women writers and readers and the "feminization of popular culture"; Mudge writes that the female "threat" has interconnections with the novel, capitalism, prostitution, and consumption.³⁶ While women writers were clearly seen to pose a threat to masculine literary dominance, their work was still, at this stage, secondary in output and importance to that of their male counterparts. Literature in mid-nineteenth century America seems to be concerned with, or eclipsed by, masculine writers of the "American Renaissance," primarily the literary figures of Walt Whitman (1819–92), Nathaniel Hawthorne (1804–64), and Ralph Waldo Emerson (1803–82). But as women came to dominate in one area of fiction (the domestic), other topics also become available to them, including crime.

This appropriation of a previously very masculine genre of writing begins in the 1860s, when Mary Andrews Denison (1826–1911) wrote the sensational *The Mad Hunter; or, the Downfall of the Le-Forests* (1863) which, while not yet quite detective fiction, incorporated crime into its narrative quite openly.³⁷ Panek, however, writing of nineteenth-century female-authored crime fiction, observes that:

> As literature, they are significant only because they are early. [...] Their popularity derived from the fact that their authors did something first, not from the fact that they did something well³⁸

Yet many of the crime narratives produced in the 1860s were well-written and innovative and provided a springboard for later female authors to develop the genre further.

Like their British counterparts, U.S. women writers still faced difficulties in writing. The Fifteenth Amendment of the Constitution in 1870 enfranchised black voters, but not women. It was not until the nineteenth amendment that women were allowed the right to vote. Lisa Marie Hogeland and Mary Klages suggest that "if national identity requires a recognition by the state of one's existence as a political and economic entity, then women writers were never "American" until well into the twentieth century."³⁹ Susan Coultrap-McQuin couples this duality — of women's presence and concomitant silencing — with a real life literary event:

> The prominence of women writers and their absence from the *Atlantic* [Whittier] dinner [17 December, 1877] reveal a major paradox confronting literary

historians of the nineteenth century: How can we explain women's persistence and success as writers in the face of attitudes and behaviors that could render them invisible?[40]

Despite this attempt at effacing women's discourse, which was still evident in 1877, women were persistent. The U.S. women writers discussed rectify this invisibility in their use of the traditions/practices open to them in order to challenge male dominance and move towards creating a female discursive space in the emergent genre of crime fiction.

As in Britain, there were no actual women police or detectives in this period (1800–1880). The first police matrons appeared in the late nineteenth century and this is similar to the restricted roles that British women could undertake in the same sphere, "policing" other women and juveniles in a limited, non-threatening capacity. In 1893 a Chicago patrolman's widow, Marie Owens, was first given the title "police officer," yet her actions were the same as her predecessors: socially based with no real power.[41] There is some argument over the date of the first women's entry into American law enforcement: Gloria E. Myers has forty-eight-year-old Lola Greene Baldwin in Portland, Oregon (1 April 1908) as the first policewoman in America (calling her "A Municipal Mother"),[42] while Barbara R. Price has thirty-seven-year-old Alice Stebbins Wells as the first policewoman, hired to work for the Los Angeles Police Department in September 1910.[43] Fay M. Blake in "Lady Sleuths and Women Detectives" writes that "[i]n the United States, a few women were hired as matrons in women's prisons and a few individual cases of women detectives are on record — one in Chicago in 1893, one in Portland, Oregon, in 1905 and one in Los Angeles in 1910 — but on this side of the Atlantic, too, the number of real women detectives in the police was minuscule."[44]

Other American women were moving into different areas of life and masculine spheres, and this kind of behavior and its attendant threat were conflated with the figure of the policewoman. While not a policewoman *per se*, there was the factual case of the female suffragette, Susan B. Anthony, who was arrested for civil disobedience after voting in the presidential elections in an attempt to attain a political voice.[45] In response to Anthony's actions, the *New York Daily Graphic* featured a front-page picture of "Miss Anthony Telling the Story of Her Arrest to the Woman Suffrage Convention" (8 May 1873). The following month (5 June 1873) the front cover of the same paper described Anthony as "The Woman Who Dared," with the editorial satirically predicting an imminent gender role reversal: "the female policeman will be a terror to male nurses and marketers. Oratorical women will hold the public rostrum and then a torch-light of procession of dazzling beauties will prove a wonderful sensation in coming elections."[46] While this comment emphasizes the threat which women posed in their attempts for gender equality, it equally

encapsulates the limited and denigrated position of the female policeman. The same commentary did, however, add more positively that "[w]henever women rule the hour, they must acknowledge the person of Miss Anthony, the pioneer who first pursued the way they sought."

There were also few representations of fictional women detectives. Fay M. Blake hypothesizes that "[t]he only American fictional police detective is Denver Doll, the heroine of four of Edward Lytton Wheeler's dime novels appearing in 1882 and 1883 and repeatedly reprinted after that. [...] Doll is also entirely a figment of Wheeler's imagination."[47] More generally, Lisa M. Dresner notes that "in all media, at all time periods, the Anglo-American female investigator is presented as in some measure fundamentally flawed, that she serves as a marker of the incompatibility of the cultural categories of 'woman' and 'investigator.'"[48] In 1885 there appeared *Helen Elwood, The Female Detective; or, A Celebrated Forger's Fate* by B. and R. (Chicago: G.W. Ogilvie, 1885). The text and its authorship are both hard to track down. Yet, despite the lack of actual role models in the field of crime and detection, women writers in America were much earlier imagining and writing about crime, as the work of Harriet Prescott Spofford demonstrates.

Harriet Prescott Spofford (1835–1921)

Harriet Prescott Spofford was a prolific and popular writer who initially contributed anonymous works to the Boston story papers, before writing for the *Atlantic Monthly* and *Harper's Bazaar* as well as numerous other periodicals; she also wrote hundreds of stories, poetry, children's fiction and essays.[49] Spofford tended more towards the Romantic and the Gothic forms in her writing, using these to explore the role of women in the contemporary American society. These gendered concerns are seen not only in the more obvious story of "Circumstance," but are also taken up in "Her Story" (*Lippincott's Magazine*, 1872) as well as in her writing in general. More importantly, a number of her works specifically concentrated on crime/detective fiction, pointing forwards to the later criminographic works of Metta Victor and Anna Katharine Green. Marvin Lachman's *Guide to the American Novel of Detection* includes Anna Katharine Green but omits Victor and Spofford, implying that he does not class these writers' works as "detection" narratives.[50] It is this aspect of Spofford's writing which has, until recently, been overlooked.

Spofford shared with the later Anna Katharine Green an educated background: she attended the Pinkerton Academy. Spofford's radical literary status

is evident in the tongue-in-cheek title of an early article about her: "Harriet Prescott Spofford: A Flaming Fire Lily Among the Pale Blossoms of New England."[51] This perhaps suggests that she did not concede to or was not afraid to push the boundaries of social and literary convention or incorporate shocking material in her writing, including, as this chapter will show, an emphasis on crime which made her a female pioneer in the creation of the female-authored American detective fiction genre.

Spofford is perhaps best-known for her story "Circumstance" (*Atlantic Monthly*, May 1860), which deals with threats and "crimes" such as scalping/murder, domestic destruction and, implicitly, gender "crimes" in its portrayal of the interaction between a wild beast and a trapped woman, a relationship perhaps most provoking because of its implied sexual subtext. "Circumstance" is a story of a pioneer woman in the wilds of Maine. Walking home to her husband and infant son she sees an apparition and is then captured and imprisoned in a tree by a wild male beast known as "the Indian Devil." The name of the beast may have derived from and be a feminine reworking of an episode in Brockden Brown's pioneer/Gothic novel, *Edgar Huntly*, where Huntly kills a panther in a cavern with a tomahawk and then eats its carcass and drinks its blood.

The woman in Spofford's story can only quell the Indian Devil's threats of violence and save her life by continually singing songs to it throughout the night. The impact of this story is evident in the reactions of Spofford's contemporaries. Emily Dickinson's shocked response was to declare that "I read Miss Prescott's 'Circumstance,' but it followed me in the Dark — so I avoided her."[52] Dickinson further noted that "it is the only thing I ever read in my life that I didn't think I could have imagined myself."[53] Sophia Peabody Hawthorne reacted to the physicality of the story, writing that "I wish she would spare the *Atlantic* her crudeness and her bald passion!"[54] These comments demonstrate both Spofford's originality and the rejection of convention in her writing. This is apparent in her openness about the authorship of her three crime stories, in contrast to the majority of her literary contemporaries, who kept silent about the authorship of their work. Spofford's criminal stories are "In a Cellar" (*Atlantic Monthly*, February 1859), "Mr. Furbush" (*Harper's New Monthly Magazine*, April 1865), and "In the Maguerriwock" (*Harper's New Monthly Magazine*, August 1868).[55]

"In a Cellar" was popular and well-received, bringing Spofford to the attention of the American public; however, initially it was assumed to be a translation from the French and presumably to be a male-authored narrative. The contemporary responses to Spofford indicate her ingenuity. Thomas Higginson considers that Spofford's first crime work is "so brilliant and shows such an extraordinary intimacy with European life that the editors seriously

suspected it of being a translation from some first-class Frenchman; as Balzac or Dumas." He adds: "Do you remember a Newburyport girl named Harriet Prescott ... whom I think a wonderful genius? She has just sent to the "Atlantic" a story, under an assumed name [...] I had to be called in to satisfy them that a demure little Yankee girl could have written it: which, as you may imagine, has delighted me much."[56] The story is set in Paris, and the crime is the theft of a large diamond from the Marquis of G —. There is an investigating figure who is an unnamed, retired English diplomat. He is similar to Thomas Waters in "Recollections of a Police Officer"; in the story "Legal Metamorphoses," Waters speaks French and uses this ability to work on a case.[57] This Parisian setting may have been influenced by Poe. Spofford's story is reminiscent of Fanny Trollope's earlier *Hargrave* (1843) in which Charles Hargrave, an Englishman and mugger in Paris, attempts to obtain diamonds and find a wealthy marriage for his daughter. Trollope's novel also includes a Parisian policeman, M. Collet. Spofford's detecting figure/narrator plays an amateur role; asked to help recover the stolen diamond he states that "[i]t is not often that I act as a detective."[58]

Chance and coincidence play a part in the narrative, as in the accidental meeting between investigator and a man wearing the chain belonging to the stolen jewel. Although the "detective" recovers the diamond, he in turn is subjected to theft but fails to realize that his valet, Mr. Hay/Ulster, is the thief.[59] The date of Spofford's narrative disputes Ross Nickerson's claim that Louisa May Alcott's novelette, "V.V.: or Plots and Counterplots" (February 1865), is the first detective story in American women's writing. While Spofford's "detective" is not yet fully-fledged, his manifestation is nonetheless important, while the date of publication, this chapter suggests, locates Spofford as the first in what will be a strong tradition of American women crime writers.

Spofford next created a more fully-formed detective in "Mr. Furbush" (1865).[60] While the detecting figure in "In a Cellar" is unnamed, Mr. Furbush definitely reappears in "In the Maguerriwock." Bendixen adds that "[s]he may have had plans for a series of stories featuring this detective and may even have published other Mr. Furbush stories that have not yet been located and identified."[61] Mr. Furbush is connected with the New York police and is "[a] man of genteel proclivities, fond of fancy parties and the *haut ton*, curious in fine women and aristocratic defaulters and peculators."[62] Rita Bode compares Mr. Furbush's function and insight in both "Mr. Furbush" and "In the Maguerriwock," to that of a camera lens.[63] In this she follows Ronald Thomas, who suggests that Poe and Dickens' detectives — Dupin and Mr. Bucket — both look and function as a camera.[64] In this sense, Mr. Furbush is allocated the supreme eye/vision of the detective. By contrast to "In a Cellar," Spofford's

second crime fiction has an American setting and is written in a third person narrative. Mr. Furbush is called in response to "an extraordinary murder that occurred at one of our fashionable hotels, under peculiar circumstances and in broad daylight, and without affording, as it appeared, the slightest clew to motive or murderer" (p. 623).

The murder victim is Agatha More, a legal ward who has been "strangled in her own handkerchief" (p. 623). Providence and chance play a major role as, opposite the hotel where the murder takes place, there is a photographic studio which Mr. Furbush coincidentally visits with his daughter. The photographer has pictures taken on the day of the murder which, Mr. Furbush discovers, upon closer inspection reveal "a speck [...] that would perhaps well reward them" (p. 624). The speck, enlarged, proves to be the hand of Agatha's guardian, Mrs. Denbigh; the photograph reveals a clearly identifiable ring.[65] This enlargement functions as a parallel to detection as detecting enacts the progress from *camera obscura* ("dark chamber") to *camera lucida* ("light chamber").[66] A reading of photography in terms of national advancement is illustrated by an article on "Photography" in *Household Words* (19 March 1853). The anonymous writer acknowledges that:

> Photography, out of England, has made its most rapid advances, and produced its best results in the United States and in France; but although both the French and the Americans have the advantage of a much purer and more certain supply of sunlight, it is satisfactory to know that the English photographers have thrown as much light of their own on the new science as any of their neighbours.[67]

The application of this new science in crime/detective fiction, however, seems to mainly make its advances in America and Australia, and this will be seen in Mary Helena Fortune's "The Dead Witness; or, The Bush Waterhole" (1866), which will be discussed later.

Mr. Furbush solves the crime "on his own account and in a kind of amateur way" (p. 624). The exact reasons for the crime/murder are not fully explained, although a love triangle between the guardians—Mr. and Mrs. Denbigh—and Agatha More is inferred. As in Forrester's British Mrs. G— story, "Tenant for Life" (published a year earlier), where crime (heart disease) literally kills Sir Nathaniel Shirley at the crucial moment, Mrs. Denbigh dies of shock when her crime is discovered. The story ends with Mr. Furbush stating that he is giving up detecting to open "one of the largest and most elegant photographing establishments in the city" (p. 626). Yet he reappears in "In the Maguerriwock" (1868) as a private detective—whereas in "Mr. Furbush" he is associated with the New York police.

The continuity of the detecting figure—albeit slightly changed—across these three female-authored stories is pioneering: Spofford was the first

woman writer to create a quasi-series detective in America. In "In the Maguerriwock" (1868) Mr. Furbush looks into the disappearance of a pedlar, lost in the forests of the frontier. This regional backdrop is reminiscent of those in the fictions of Brockden Brown and Fenimore Cooper. Here, Mr. Furbush is seeking proof of a death which is assumed to have taken place some ten years previously in the Maguerriwock area of Maine. Taking up the themes seen earlier in "Circumstance" (1860), this story focuses on the criminals—Mr. Craven and his son—who have killed the missing man for his money and possessions. More specifically in the context of this study, the story concerns the treatment of Mrs. Craven.

Her husband presents her as having descended into madness ten years previously, after the birth of her daughter, Semantha [sic] and, coincidentally, the death of the missing man.[68] Mrs. Craven's main role in the story is to repeat the seemingly pointless phrase "Three men went down cellar, and only two came up."[69] This sentence, while ostensibly innocuous, is, as Mr. Furbush discovers, the key to the story, as she had been a witness to her husband's murderous actions. Her husband knows what she means but calls it madness. The phrase is used as the closure of the narrative, not only overturning Mrs. Craven's supposed emotional and mental instability but also covertly implying that she had understood the situation before the arrival of the detective and had sought a coded way to transmit the information. While such incarceration is a Gothic preoccupation, Spofford may have read British Catherine Crowe's *Susan Hopley*. In Crowe's novel, the quasi-detecting character Julie Le Moine manages to both infiltrate the villains' den and gain information, but she is then locked in the cellar with a corpse. Although later rescued, she permanently loses the ability to speak. She can be compared to Mrs. Craven. Julie later gains revenge by imprisoning the villains who incarcerated her in a cellar. Mrs. Craven also rebels against her attempted silencing. The use of Mrs. Craven's words as closure privileges the female voice over that of the men in the narrative, and this is important. Mrs. Craven's positioning is, this chapter suggests, analogous with that of the American woman writer of crime: despite the dominance of the masculine voice in the contemporary body of crime writing, this privileging of the feminine advocates that the female voice speaking of crime is worth listening to. Furthermore, Spofford's story avoids the traditional romantic and domestic closure of previous modes of women's writing and "In the Maguerriwock" is clearly located as crime fiction.

While Spofford was still producing work after the late 1860s, a shift in literary tastes may account for her criminographic writing becoming less popular and her consequent move away from the crime form. The movement towards realism in America was directly contrasted against the Gothic and Romantic modes that Spofford used, modes which opposed rationalism and

classicism. The Civil War (1861–5) also instigated a change in literary style; it acted as a catalyst in inciting the shift away from sentimentalism and towards realism with its steady perspective. As Spofford wrote in a letter to Fred Lewis Pattee:

> You wonder why I did not continue in the vein of "The Amber Gods." I suppose because the public taste changed. With the coming of Mr. Howells as editor of the *Atlantic*, and his influence, the realistic arrived. I doubt if anything I wrote in those days would be accepted by any magazine now.[70]

Henry James suggested that Spofford should "study the canons of the so-called realist school,"[71] and she seems to have taken heed, discarding her criminal narratives in favor of her New England sketches.[72] But while Spofford seems finally to have bowed to and obeyed male dictates, her contemporaries were increasingly and independently venturing into writing crime.

Louisa May Alcott (1832–1888)

Writing almost simultaneously with Spofford was the influential American author Louisa May Alcott. Katharine Rodier emphasizes a connection between Spofford and Alcott, writing that "Louisa May Alcott's [...] 1877 *A Modern Mephistopheles*, published in the anonymous "No-Name Series" by Roberts Brothers, would be widely guessed to be Spofford's creation."[73] It was not until this story was reprinted with *A Whisper in the Dark* in 1889, a year after her death, that Alcott's name was attached to it.[74] Alcott is not usually considered as a writer of crime fiction, being best-known for the perennial favorite, *Little Women* (1868), a novel very much in the domestic/sentimental mode that has become a classic text for young readers.[75] While the fame of this work has given Alcott the title of "The Children's Friend," this chapter will consider Alcott's earlier, lesser-known "thrilling" novelettes. *Little Women* was followed by *Little Men* (1871) and *Jo's Boys* (1866), all of which revolve around the March family. Ann Douglas draws an interesting parallel between these works and Alcott's sensational-esque stories: "Yet the little girls of Alcott's later work have something in common with the *femmes fatales* of her early books: they too undergo metamorphosis, not growth. In a sense, murder pervades the worlds of both."[76] Stern postulates that there are more stories than are known so far, yet they cannot be found. She states that "[i]t is certain that there are more such tales concealed in the now crumbling weeklies of the 1850s and the 1860s. It is equally certain that they will remain undiscovered."[77] Alcott commented explicitly about her 1860s stories and productivity when she said that she was "[s]pinning yarns like a spider."[78] Written between

1863 and 1869, they incorporate crime and interrogate the less cozy aspects of life and human relations, with controversial themes including drug use (opium and hashish), ghosts, violence, revenge, murder, insanity, manipulation, child-bride(s), and mental aberration. These stories have been until recently relatively neglected; they add another dimension to Alcott's corpus of writing and make an important contribution to the emergent crime genre.

While critics such as Margaret Strickland, Ann Douglas, Elaine Showalter, Elizabeth Lennox Keyser, Leona Rostenberg, and Madeleine B. Stern have re-evaluated Alcott in terms of feminism and have consequently considered her lesser-known shorter works, they have tended to concentrate on Alcott's biographical details and have located her writing precisely in the feminized domestic, sentimental, and sensational modes, not as crime narratives. Ruth K. MacDonald dismisses Alcott's non-children's work:

> Her adult fiction is less noteworthy and successful. [...] the potboilers gave an expanded sense of Alcott's potential as a writer. [...] While interesting experiments, the adult works pale in literary worth, longevity, and commercial success beside the fiction for children.[79]

This chapter, however, suggests that what MacDonald regards as "potboilers" were in fact radical narratives that make an important contribution to what will be a distinctly American female voice in crime fiction.

Alcott's sensational work contested literary and social boundaries more openly than that of her British counterparts: she inverted the domestic and sentimental novel and her crime-inflected stories do not efface her criminal/discursive tracks by conventionally punishing the (usually female) wrong-doer/"criminal." As she stated in a letter to Maria S. Porter:

> Let us hear no more of "woman's sphere" either from our wise (?) legislators beneath the State House dome, or from our clergymen in their pulpits. I am tired, year after year, of hearing such twaddle about sturdy oaks and clinging vines and man's chivalric protection of woman. Let woman find out her limitations, and if, as is so confidently asserted, nature has defined her sphere, she will be guided accordingly; but in heaven's name give her a chance![80]

There are, however, congruencies between British and American fiction in the 1860s. Elizabeth Lennox Keyser specifically defines Alcott's stories as sensation fiction and Alcott was certainly aware of British fiction, through Emerson's library and her travels to Europe; it is probable that she read Gothic romance, pulp fiction/ "penny dreadfuls" and sensation fiction — intertextual references in her short "crime" work suggest this. Writing to Alf Whitman in 1862, Alcott observed that:

> I intend to illuminate the Ledger with a blood and thunder tale as they are easy to "compoze" and are better paid than moral and elaborate works of Shakespeare so don't be shocked if I send you a paper containing a picture of

Indians, pirates, wolves, bears, and distressed damsels in a grand tableau over a title like this "The Maniac Bride" or "The Bath of Blood A Thrilling Tale of Passion."[81]

The Gothic elements in her early work have led Stern and Rostenberg to comment that "Alcott might have become the American Mrs. Radcliffe had she not at length been diverted from her gory, gruesome, and fascinating course."[82] This insists that while Alcott's writing demonstrated a distinctly American version of the Radcliffean Gothic, it is still precisely Gothic; Stern and Rostenberg ignore the criminographical elements of these works. Their definition is even more limiting than the more usual description of Alcott's work as sensation fiction, which at least recognizes the criminal content frequently found in that genre. More recently, critics such as Ross Nickerson have perceived the crime and detective aspects of Alcott's "thrillers"; Ross Nickerson has Alcott's pseudonymous "V. V; or Plots and Counterplots" (1865) as "the first appearance of a detective in American women's letters."[83]

Alcott's impetus for writing was from economic necessity, as was the motivation for her English sister in sensation, Mary E. Braddon. Alcott's father — Amos Bronson Alcott — did not provide for his family: his pursuits and preaching on American Transcendentalism were not lucrative but ensured that the whole family lived in debt and poverty. Alcott's fierce determination and independence were apparent from an early age; at only fifteen, she declared "I *will* do something by-and-by. Don't care what, teach, sew, act, write, anything to help the family; and I'll be rich and famous and happy before I die, see if I won't!"[84] She wrote in her journal: "I will make a battering-ram of my head and make a way through this rough-and-tumble world."[85] Her early deprivations and the resulting ambitions became material for her adult fiction and for *Little Women*.

Alcott wrote family sagas, poems, novels, drama, juvenile fiction, fairy tales, and short stories, as well as working as a magazine editor. Stern writes that Alcott wrote "a total of 291 novels, serials, short stories, poems, and articles."[86] At age 30, she joined the army as a nurse (in the Union Hotel Hospital, Georgetown); under the comical pseudonym "Tribulation Periwinkle" she wrote her *Hospital Sketches* before going on to produce many "thrillers" in her thirties. These were all either anonymous or written under the pseudonym "A. M. Barnard."[87] It was not until World War II that these intriguing stories were revealed to have been written by Alcott; it was Leona Rostenberg who announced her discovery in her 1943 article "Some Anonymous and Pseudonymous Thrillers of Louisa M. Alcott."[88] It was not until 1976 that Stern reprinted these stories. As Alcott herself indicated, "I think my natural inclination is for the lurid style [...] I indulge in gorgeous fantasies and wish that I dared inscribe them upon my pages and set them before the public."[89] Her

choice of the words "fantasies" and "dared" suggest an awareness of the restrictions placed upon the woman writer which go against her "natural inclination." Alcott (born in Germantown, Pennsylvania) permanently moved to Concord, Massachusetts in 1840, and she associates literary restriction with the social restrictions of that town:

> How should I dare interfere with the proper grayness of old Concord? The dear old town has never known a starling hue since the redcoats were there. Far be it from me to inject an inharmonious color into the neutral tint. [...] And what would my own good father think of me ... if I set folks to doing things that I have a longing to see my people do? No, [...] I shall always be a victim to the respectable traditions of Concord.[90]

But after the literary success achieved by *Little Women*, Alcott ceased writing her criminographic narratives. Yet, a year later Alcott did write her final thriller under her own initials ("L. M. A"): "Perilous Play" (*Frank Leslie's Chimney Corner*, VIII. 3 February 1869). This story involved a heroine, Rose St. Just and hashish experimentation and appeared as the second part of *Little Women* was completed. Once Alcott was famous she might not want to lose readers, and this also concerns the notion of "proper" literature versus cheap.

The volume of these early stories was impressive: she wrote nine "thriller" stories between January 1863 and February 1869, as well as a later novel in 1877. The first was the anonymously authored "Pauline's Passion and Punishment" (*Frank Leslie's Illustrated Newspaper*, 3 and 10 January 1863); for this story she won Frank Leslie's competition prize of $100. These stories were predominantly published by two firms: in New York, Frank Leslie and his weekly *Frank Leslie's Illustrated Newspaper* (inaugurated in 1855), and Messrs. Elliott, Thomes, and Talbot of Boston (*The Flag of Our Union*). *A Modern Mephistopheles* anonymously appeared in Roberts Brothers of Boston's "No Name Series" in 1877. Elliott, Thomes and Talbot issued a *Ten Cent Novelette* series (the first in 1863) to rival Beadle's dime novels. These have been described as "the handsomest and largest ten-cent books ever published."[91] Alcott is like Gaskell and Wood (and later, Victor), and to some extent Braddon, in the sense that a majority of her work was published either under one man or place; in Alcott's case it was with Frank Leslie. It has not been until 1984 that these stories have been collected by Madeleine Stern as *The Hidden Louisa May Alcott*.[92] While all of Alcott's crime-related stories are interesting and deserve an examination in their own right, this chapter will consider two which this study regards as central to the formation of the crime genre.

"V. V.: or, Plots and Counterplots" (*The Flag of Our Union*, February 4, 11, 18, 25, 1865), refers to the socially ambitious, beautiful and duplicitous Spanish *danseuse*, Virginie Varens.[93] The "V. V." of the title is a reference to a tattoo on her wrist to which the text draws attention and which functions as

a significant point of identification.⁹⁴ The tattoo is of two dark letters—
"V. V."—with "a tiny true-lover's knot" underneath. Virginie tells her lover,
Allan Douglas, that "that was years ago when I cared nothing for beauty, and
clung to Victor [her cousin who is obsessively in love with her] as my only
friend, letting him do what he would, quite content to please him" (p. 318).
When the story starts Virginie is aged 17, so her inscription/patriarchal brand-
ing happened before this. She conceals these marks by wearing a wide band
of enchased gold which has a slender chain attached to it and an opal ring.
While tattoos have criminal and convict associations, with Police Gazettes
often using tattoos to identify criminals and absconders, Alcott although
using Virginie's tattoo as a plot device and means of eventual identification,
also uses the tattoo in a different way: to also implicitly question "criminal"
and gendered social configurations in terms of Virginie. Of Alcott's story
Stern writes: "Before the Civil War, Louisa had heard tales of Jonathan Walker,
whose hand had been branded with the letters S.S for 'Slave Stealer.'"⁹⁵ Alcott
may have influenced H. Rider Haggard, who wrote *Mr. Meeson's Will* (1888);
in this narrative an important document is tattooed on the heroine's back.
Sutherland says this is "an early masterpiece."⁹⁶ Yet a woman—Alcott—was
using the tattoo much earlier. Alcott was not included in the *Companion*.⁹⁷

The plot is dense, with an interweaving of shifting identities and
schemes, which Alcott cleverly draws together at the end. Virginie's "crimes"
include—but are not limited to—pretending to be the wife of the dead Col-
onel Vane and driving another character, Diana, to madness and suicide. To
achieve this end, she purloins the iron signet ring of the Douglas family in
order to produce a counterfeit seal on a fake wedding certificate to show
Diana. The plot stems from Virginie's secret marriage to Allan Douglas. On
the night of their marriage, however, Allan is murdered by Virginie's cousin—
Victor Varens—who is both in love with Virginie and attempts to control
her. She has Allan's child, flees from Victor in Spain to France and meets Col-
onel Vane, who loves and wants to marry her, but dies suddenly; Virginie
then proclaims herself to be his wife. She then perfidiously reappears in the
text disguised as the widow of Colonel Vane; she has learnt about Allan's fam-
ily from Vane and seeks to woo and win another Douglas (Earl Douglas, the
heir to the title); in order to achieve this she has to disrupt the love between
Diana and Douglas. It transpires that Allan's cousin is Earl Douglas (Allan
was a year older, but they were often mistaken for twins). In her new guise,
Virginie manipulates events and the family, charming everyone except Doug-
las. Victor Varens also reappears as Mrs. Vane's deaf and dumb man—Jito-
mar—who is purportedly one of the colonel's Indian servants; Virginie has
promised she would be Victor's wife once her son was acknowledged.

Douglas, though, functions similarly to Robert Audley in *Lady Audley's*

Secret. He vows to find Allan's murderer and avenge his death; he tells Virginie that "[n]ight and day I labored to clear up the mystery, but labored secretly, lest publicity should warn the culprits, or bring dishonor upon our name" (p. 394). Douglas tells Mrs. Vane/Virginie that:

> She was *not* innocent—for she lured that generous boy [Allan] to marry her, because she coveted his rank and fortune, not his heart, and, when he lay dead, left him to the mercies of wind and wave, while she fled away to save herself. But that cruel cowardice availed her nothing, for though I have watched and waited long, at length I have found her, and at this moment her life lies in my hand—for you and Virginie are one! [pp. 395–6].

And he does find and have Victor Varens handcuffed, but not before Victor accidentally causes his own death. Similarly to Lady Audley's incarceration, Douglas intends to lock Virginie in a Scottish tower, but she commits suicide with poison in order to escape this fate.

More importantly in terms of locating this text as (a harbinger of) crime fiction, "V.V.," similarly to Spofford's "In a Cellar" (1859), included a proto-detective figure who, unlike Spofford's detective, has a name, and one that is overtly connected with Poe's Dupin: M. Antoine Duprès.[98] He is "a stout, gray-haired [Parisian] Frenchman, perfectly dressed, blandly courteous" (p. 373). He is an ambiguous figure, and not a professional police detective, while certainly an amateur detective of sorts. Duprès' potential is encapsulated when he comments: "But I shall discover her yet. [...] I adore a mystery; to fathom a secret, trace a lie, discover a disguise, is my delight. I should make a superb detective" (p. 382). Duprès' assistance is called on by Douglas to help with his investigation into his cousin's murder/disappearance. Yet, like Spofford's detective, he proves to be fallible; Douglas tells Virginie that "[i]n the guise of Arguelles he [Victor] met Duprès in Paris, returned with him, and played his part so well that the Frenchman was entirely deceived, never dreaming of being sought by the very man who would most desire to shun him" (p. 399). It seems that it is Douglas who is more in control of the ending and meting out Virginie's punishment. This study would argue this undermines Stern's contention that Duprès is a "surprisingly modern, pre-Sherlockian detective [...] introduced for the purpose [of crime punishment]."[99] Although Duprès is not quite a fully-formed detective, his representation and the narrative itself suggest that Alcott was moving towards an investigative figure and was clearly interested in crime narratives. Diana — Douglas' lover — espouses detecting and surveillance skills, but, as with Lady Isabel in *East Lynne*, she mistakenly suspects Douglas and Mrs. Vane of having a romantic connection; Diana soliloquizes that "[s]he [Mrs. Vane] knows his mystery, has a part in it, and I am to be kept blind. Wait a little! I too can plot, and watch, and wait. I can read faces, fathom actions, and play a part,

though my heart breaks in doing it." (p. 348) Ultimately, though, Diana is limited; she draws the wrong conclusions, is made mad, and commits suicide. As in Britain with the fictional figures of Anne Rodway and Marian in *The Woman in White*, Diana's actions suggest that women cannot be detectives and must be curtailed.

The parallels between Alcott's narrative and Braddon's *Trail* seem too numerous to be coincidental, while they also emphasize Alcott's development of Braddon's *Trail*. These include the scene where Victor stabs Allan — Virginie's secretly married husband — through the heart. The first line in "V. V." is reminiscent of Jabez's machinations when he is watching Valerie acting (although in Alcott's case it is Allan watching his lover, Virginie dancing). Victor then bribes Virginie by threatening to say that she murdered Allan as she was the last person seen with him; Victor possesses the marriage certificate as security to use if she does not obey him. Earlier this same gendered power struggle and use of bribery is seen with Valerie and Jabez (as Jabez knows she "killed" her husband). The criminal/snake motif is also evident; Douglas says to Major Mansfield about first meeting Mrs. Vane: "She reminds me of a little green viper" (p. 330). Braddon's text explicitly referred to the serpent, which is emblematic of the criminal, Jabez. Alcott's text includes an Indian servant — Jitomar — purportedly deaf and dumb (it transpires that this is Victor in foreign disguise): this persona is an amalgamation of *Trail*'s Mr. Harding's servant and Peters. "Twins" are used: the cousins Allan Douglas and Earl Douglas are seen as twins because of their similarities, and there are the real twins of Jabez and Jim in *Trail*. The female detecting role and impetus seen in Braddon's works, triggered by wishing to avenge a male family member's death, is also seen in "V. V.": Douglas tells Virginie: "Over the dead body of my dearest friend, I vowed a solemn vow to find his murderer and avenge his death. I have done both." (p. 395) Chapter VIII of "V. V." is sub-titled "On the Trail" (p. 373). While not indicative of Braddon, the persona which Virginie takes on in "V. V.," of Mrs. Vane, is an explicit contrast to Isabel Vane/Madame Vine in Wood's *East Lynne*. This reading suggests that the evidence implies that Alcott had read *Trail*.

Alcott's interest in and knowledge of the literature of crime and detection are again evident in her later foray into the arena with "Behind a Mask." The short story, "Behind a Mask: or, A Woman's Power," first appeared in *The Flag of Our Union* under the pseudonym A. M. Barnard (October–November, 1866).[100] The original of this story, as well as Alcott's other works, was published in both *The Flag of Our Union* and *Frank Leslie's Illustrated Newspaper*, which are rare. Rostenberg elaborates that

> [t]he exact number of stories written by Louisa Alcott for *The Flag of Our Union* and their dates of appearance cannot be accurately determined at the

present time. The most complete run of this periodical owned by the Library of Congress has now been stored away for safe-keeping with the result that a thorough investigation of these stories by A. M. Barnard is now impossible.[101]

Alcott received $65 for the story from James R. Elliott, the periodical's editor, who wrote, with reference to Alcott's story: "[I] have no doubt but my readers will be quite as much fascinated with it as I was myself while reading the Ms."[102] "Behind a Mask" exemplifies Showalter's declaration that "there were few novels by English women in the nineteenth century as radical or outspoken with regard to the woman question as those by their American counterparts."[103] The story is relevant to this study's argument, although it is concerned with social "crimes" within the domestic sphere rather than with the murder or bigamy seen in British sensation fiction. "Behind a Mask" vividly exemplifies Elizabeth Stoddard's naming of the British influence upon American writing as "*Jane Eyre* mania"; in conjunction with this, Alcott's story also has affinities with sensation fiction in its employment of the trope of theatricality.

The novels of Braddon's *Lady Audley's Secret* (1862) and Wilkie Collins's *Armadale* (1866) are also aligned with this story. Other British influences may have been Daniel Defoe's *Moll Flanders* (1722). The woman is presented in a new and controversial light in Defoe's Newgate-related novel: Moll finally escapes the law and has a happy ending. Moll becomes initiated into criminality because of her aspirations to move into the class of the "gentlewoman." Moll is like Jean in the sense that she achieves what she wants and then both behaves and assimilates as there is no need to continue her/their purported "criminal" actions. Two years prior to "Behind a Mask," in Forrester's *The Female Detective* (1864), a story titled "Georgy" portrayed how an embezzling nineteen-year-old, George Lejune — "boy-criminal" — escapes justice. This narrative combines "a deceived detective, a cunning boy, and a young criminal quite destitute of remorse."[104] Mrs. G — comments that "[h]is ability in deception was wonderful." (p. 107) In Hayward's (?) "Incognita," Fanny Williams/ "Incognita" escapes punishment and it is inferred that she replicates the same social crimes. Earlier, in Henry Thomson's "Le Revenant" (*Blackwood's*, April 1827), the criminal narrator eerily tells the tale of his death on the gallows. This deception, though, had been constructed by his partner: it was to appear as a death with his revival in time to survive. These women, however, do not feign such acts or façades. Alcott's text appropriates and reworks elements of sensation fiction and of drama to form something new; she reconfigures the literary and social/gender boundaries and, most importantly, incorporates crime into her narrative.

The title of the story, "Behind a Mask," refers specifically to Jean Muir, a former actress. Jean is initially represented as nineteen and Scottish —

although it is later revealed that her nationality, as well as her identity and age are indefinite. This acting and gendered performance is similar to British texts, such as *East Lynne*, where Isabel comes back from the dead with her face masked by scarring from a train crash. Hayward's (?) Mrs. Paschal story, "Incognita," features a "third-rate actress" who is a criminal. Similar to Alcott's "actress"/"criminal" is "Incognita" (real name Fanny Williams): "Fanny Williams, the "Incognita" of the story, continued a siren, and speedily found a fresh victim whom she turned to good account with her usual tact and artistic skill."[105] The actress/criminal equation is seen in the first Mrs. Paschal story, "The Mysterious Countess." Kayman writes that being "reduced to crime by the death of her husband, the Countess is, significantly, a traditional figure of popular fiction, the beautiful former actress who married into the nobility."[106] Yet, unlike her British counterpart, Alcott's "actress"/ "criminal" is not punished.

Jean's behavior and the setting of the narrative action within a wealthy household, albeit in England, locate the story as sensation fiction.[107] But it subverts the generic convention that "all the sensation fiction, no less than the domestic, centers on love and marriage, and its heroines usually conform in the end or are punished for their rebellion."[108] In "Behind a Mask," Jean neither conforms nor suffers punishment for her subterfuge; her marriage is strategic and the control she exerts over men in the narrative defies the normative contemporary literary and social conventions. Alcott's story has much in common with but builds upon an earlier work by an American woman writer, Lillie Devereux Blake (1833–1913). Blake's first novel, *Southwold* (1859), is both Gothic and melodramatic, and features a nineteen-year-old *femme fatale* called Medora Fielding: she commits murder and consequently goes mad. In a similar way to Jean Muir in Alcott's narrative, Blake's text states that "her [Medora's] vanity was gratified that she has roused his [Walter Lascelles] feelings and satisfied herself of her power."[109] Rather than retaining this power and female autonomy, Medora is instead driven into insanity, implicitly by her empowerment, but remains sane enough to commit suicide in order to avoid incarceration in an asylum. This novel prefigures and possibly influenced Braddon's *Lady Audley's Secret*. Medora asks her mother if there has ever been any insanity in their family. This is affirmed when her mother tells Medora that "after I was married I discovered that your father's mother died in a lunatic asylum" (p. 226). The female conflation of crime with madness becomes a traditional trope, yet Alcott eschews such traditional endings for aberrant or challenging women in "Behind a Mask" as Jean retains her power. Her purportedly "criminal" actions are the result of her past life in which she had been rebuffed and ill used by a man. But in contrast to her sensational sisters such as Braddon's Lady Audley or Blake's Medora, Jean

does not resort to murder to secure her own happiness; her crime is purely social as she deliberately manipulates and deceives those around her in her pursuit of social status and wealth.

The story is, this chapter suggests, not in the mode of classic sensation fiction but a more overtly feminist take on an established genre. Natalie and Ronald A. Schroeder define these generic conventions: "It treated titillating subjects sensationally, but made the obligatory bow to prevailing moral norms; rebellious women, for example, tend to pay dearly for their transgressions."[110] It does, though, connect the character of Jean with Valerie in Braddon's *Trail*. Valerie is granted the chance by the text to escape unpunished for her attempt at poisoning and unintentional bigamy. Valerie also is allowed to stay with her first husband. Jean's actions are additionally connected with the character of Edith in Braddon's *The Black Band*, as she "should always wear a mask."[111] As with *Lady Audley's Secret*, "Behind a Mask" represents a seemingly perfect "Angel in the House" figure, with an uncertain past, who infiltrates the upper middle classes.[112] Jean's position as governess is initially conventional in the mode of *Jane Eyre*. She is introduced as "a little black-robed figure"[113] who "meekly sat down without lifting her eyes" (p. 5). This, however, soon changes: "instead of being what most governesses are, a forlorn creature hovering between superiors and inferiors, Jean Muir was the life of the house, and the friend of all but two" (p. 26). Alcott (and by proxy the Americans) play with the conventional representation of the (British) governess in the contemporary fiction and society. In contrast to the usual fate of the governess in fiction at the time, Jean is shown to achieve a "victory, one notes, seldom granted her English counterparts. She has proved herself a heroine — if only of deception."[114]

Karen Halttunen positions Jean and her actions against the sentimental and domestic; she

> commands total sway over the lives of others by means of a monstrous perversion of the sentimental concept of woman's influence. Whereas influence works through sincere affections, Muir's power operates through calculated deception; while influence is the product of loving self-denial, Muir's power stems from selfish ambition. Most important, although the sentimental woman exercises influence through her vulnerability, Muir seizes power through her complete immunity to emotion.[115]

Jean is reminiscent of the "heroine," Becky Sharp, in William Makepeace Thackeray's *Vanity Fair* (1847–8). Sharp, like Jean, is a conniving and self-made woman. They are both almost anti–Victorian in representation and antithetical to middle-class values. In Anthony Trollope's *Barchester Towers* (1857) there is a *femme fatale*, Signora Madeline Vesey Neroni, who despite being crippled, still exercises power over men. Lytton's *Lucretia, Or The Chil-

dren of the Night (1846) included the murderous and criminal Lucretia Clavering who, although crippled in the course of the novel, is not abated in or repentant of her machinations, although she does go mad at the close of the novel. The last two novels mentioned contrast to Wood's *East Lynne* which had Isabel's didactic punishment and disfigurement. Also, at the same time that Alcott was in England, Wilkie Collins' *Armadale* was serialized in *Cornhill* (November 1864–June 1866). Alcott may have read this text/novel and re-worked it in her story. Collins' story featured a maid, or former maid, of Ozias's mother, Lydia Gwilt, who was a murderer and adulteress. Yet the aptly named Gwilt must repent for her "guilt" and she commits suicide by drinking the contents of her purple flask. Conversely, Alcott's character does not suffer this conventional fate.

Additionally, Jean can manipulate the image she presents to society. When she is alone she comments:

> "Come, the curtain is down, so I may be myself for a few hours, if actresses ever are themselves." Still sitting on the floor she unbound and removed the long abundant braids from her head, wiped the pink from her face, took out several pearly teeth, and slipping off her dress appeared herself indeed, a haggard, worn, and moody woman of thirty at least [p. 12].

An earlier cunning feminine representation or intentional misrepresentation is personified by Fanny Williams/"Incognita" in Hayward's (?) "Incognita" (*The Experiences of a Lady Detective*); Mrs. Paschal comments that:

> One of the first discoveries I made was that her beautiful golden hair was in reality of a dark brown colour. She had some expensive wash in her dressing-case, some of which she poured into a saucer every other day and put on her hair with a small sponge. This changed the colour without in the least injuring the hair; and from a semi-brunette she became a blonde of the loveliest description [p. 278].

Alcott may have read Hayward (?) as she was in Europe two years after its publication. Virginie in "V.V" also manipulates her image; the text comments that it is not known if she is twenty or thirty-years old. Jean's manipulation of appearance is empowering as it permits feminine deceit and allows her to avoid the containment of proper femininity, but the text must be seen to fix her identity.[116] After her marriage to Sir John, she declares that "now that her own safety was so nearly secured, she felt no wish to do mischief, but rather a desire to undo what was already done, and be at peace with all the world" (p. 90). Perhaps if Jean had not felt such conventional repentance, Alcott's story may not have had the positive reception it achieved.

Such a victorious and unpunished ending can be seen earlier in Britain in 1861 with the anonymously written short-story, "The Woman with the Yellow Hair.— A Tale." *The Wellesley Index* has attributed this story to Percy

Fitzgerald.[117] In this story a beautiful woman (the ironically named Janet Faithfull) kills her detective/spying pursuer—her unnamed and soon-to-be brother-in-law. This is notable not only because she literally removes (masculine) surveillance and discipline with this act, but for the triumphant ending which the female-author, Braddon, could not write. The story ends by saying that: "She, who drives about in that deep, dark blue brougham, one of the most "stylish" in the capital, is Mrs. St. John Smith. She leaves her cards. She is very beautiful and placid [...] her yellow hair is famous; and she has really nothing to trouble her."[118] In Alcott's story, however, while Jean does not murder, her freedom is more controversial as a woman is writing and envisioning such punishment-free endings.

Jean possesses some of the skills, power and knowledge traditionally accorded to male detectives. While the cousins—Lucia and Gerald—who live in the Coventry house are mulling over their first impressions of Jean, discussing her looks and conjecturing about her impact upon Sydney, her previous employer, she informs them that:

> I think it honest to tell you that I possess a quick ear, and cannot help hearing what is said anywhere in the room. What you say of me is of no consequence, but you may speak of things which you prefer I should not hear; therefore, allow me to warn you [p. 9].

Furthermore, she speaks of her "fatal power of reading character" (p. 58) and both her auditory skills and her quick perception are characteristic of the male detective. Stern associates Jean's unusual abilities with her obscure origins: "Her background is mysterious. She has lived in Paris, travelled in Russia, can sing brilliant Italian airs and read character. Her powers are fatal."[119] Jean must, this reading suggests, be seen to be strange or "foreign" because she refuses the normative passive position of the feminine and seeks to attain power in her own right:

> When alone Miss Muir's conduct was decidedly peculiar. Her first act was to clench her hands and mutter between her teeth, with passionate force, "I'll not fail again if there is power in a woman's wit and will!" [p. 11].

Jean's "crime" is to openly aver her desire for female autonomy and her belief that it is her right, but such desire for power locates her as deviant and threatening.

Rather than overtly condemn Jean, however, the text rather demonizes her by implication, using intertextual references, for example by referring to the witches in *Macbeth*. As Gerald observes in conversation with Jean:

> You make a slave of me already. How do you do it? I never obeyed a woman before. Jean, I think you are a witch. Scotland is the home of weird, uncanny creatures, who take lovely shapes for the bedevilment of poor weak souls. Are you one of those fair deceivers? [p. 89].

Here, Jean (and implicitly, Alcott) are also laying claim to literary heritage. It is the woman who is blamed for Gerald's desire. As Lennox Keyser notes "[l]ike Jane Eyre, Jean is adept at playing little woman and sexual temptress simultaneously."[120] Indeed, Alcott specifically wrote about and compared herself with Charlotte Brontë: "I may not be a C.B., but I shall do something yet."[121] Another dimension to Alcott's appropriation of sensation fiction is her incorporation of a railroad accident into her narrative, but in contrast to Wood's *East Lynne*, where the crash victim is Lady Isabel Vane, Alcott instead has Gerald's brother Edward as the putative victim (p. 93). Edward, similarly to Isabel Vane, survives the crash and is able to return to his family home, but in contrast to Isabel, he can confront Jean and demand that she leave the house. As in *Lady Audley's Secret*, the masculine pursuer/s refuse to disappear, despite life-threatening circumstances impeding their unveiling of the "criminal" woman.

Besides Jean's "criminal" representation in "Behind a Mask," there is another woman, Hortense, who silently works in partnership with her. Hortense is on the periphery of the events and the narrative; the reader is not privy to much information regarding her and she is never present physically. Hortense is "criminal" in her complicity and scheming for personal and financial gain. She only communicates with Jean via letters and is otherwise invisible throughout the narrative. This name could have been employed as a specific reference to the character of Hortense in Dickens' *Bleak House*, who is Lady Dedlock's French maid and a murderess. Towards the end of the story Edward explains to the family that Jean's "own letters convict her" (p. 99):

> To convince you, I'll read Jean's letters before I say more. They were written to an accomplice [Hortense] and were purchased by Sydney. There was a compact between the two women that each should keep the other informed of all adventures, plots and plans, and share whatever good fortune fell to the lot of either [p. 100].

Sir John, though, refuses to believe this evidence and, despite the knowledge of the "proofs" of guilt which crime/detective fiction usually demands, Jean is not convicted. Unlike other forms of "criminal" plotting in letters in crime fiction throughout the nineteenth-century and beyond, Jean and Hortense's letters defy convention in their refusal to employ a concealing cipher or code. Rather, their writing is boldly and literally italicized in the text; this communication between Jean and Hortense contests Karen L. Kilcup's statement that society "require[s] women — both as writers and characters, as participants in their own texts— to costume themselves in convention."[122] In one of these letters, Jean writes of both her plans and her impressions of the Coventrys: "*They are an intensely proud family, but I can humble them all, I think, by captivating the sons, and when they have committed themselves, cast*

them off, and marry the old uncle, whose title takes my fancy" [pp. 100–1]. She further admits that "*the uncle is a hale, handsome gentleman, I can't wait for him to die*" [p. 101]. On hearing this letter read out, Lucia, responds by saying "She never wrote that! It is impossible. A woman could not do it" (p. 101), an exclamation that demonstrates the strength of the conventions that constructed femininity in the period. Jean removes the threat against her position when she takes "the letters from the hand which [Sir John] had put behind him [...] and, unobserved, had dropped them on the fire. The mocking laugh, the sudden blaze, showed what had been done" (p. 106). The disintegration of evidence with fire will be evident again, but by a male in Green's *The Leavenworth Case*. In a J.B. case, "The Mysterious Advertisement" (1865), he explains how one of the criminals, Charles Norval, "placed his hands on the will, in order to cast it into the flames, but at that moment I burst into the room, and pinned the legal document to the table with my hand."[123] While J.B. can intercept this action, Jean is victorious in her wish to incinerate evidence. She triumphs over the social structure of the family which should rather, conventionally contain and punish her.

While there is no detective as such in "Behind a Mask," there are various figures who briefly take an investigative role in trying to discover more about Jean. Mrs. Dean, a servant, works for the family and also functions as spy and quasi-detecting figure. A servant figure in this role is not uncommon in literature of the period; as D. A. Miller has suggested, servants are part of the all-seeing, covert and regulatory surveillance which thrives in the domestic, disciplinary structures of society. In Hayward's (?) "Incognita" (1864), Mrs. Paschal offers and has her services accepted by Fanny Williams to become her lady's-maid. By doing this she can both spy and insinuate herself into a trustful position; she comments that "gaining access to people's houses in the capacity of a domestic servant was a favourite plan of mine, and one I very frequently had recourse to" (p. 275). Jeremy Bentham's *Panopticon; or, the Inspection House* (1791) encapsulates this conflation of inspection and the house: authority is invisible yet ubiquitous (yet with the case of Jean she can both see these powers at work and overthrow them). Alcott may also be drawing on the tradition of Godwin's *Caleb Williams*: Caleb is Falkland's servant/secretary and can't quite fulfill a detective function (although he is a spy on his master and both finds and opens Falkland's chest); this latter action parallels with Dean's active investigations in finding Jean and Hortense's letters; Edward relates, "Dean boldly ransacked Jean Muir's desk while she was at the Hall, and fearing to betray the deed by keeping the letter, she made a hasty copy. [...] This makes the chain complete" (p. 104). Crowe's *Susan Hopley* (1841) has a maid servant in a detecting function: Dean and a maid, Mabel (later known as "Amabel") assist Susan; Julie Le Moine's maid, Madeleine,

also assists with her separate investigations. In Crowe's *Men and Women* (1843), Lady Eastlake conscripts the help of her old servant, Nelly. Anna in Gaskell's "The Grey Woman" comments that "I had always the feeling that all the domestics, except Amante, were spies upon me, and that I was trammelled in a web of observation and unspoken limitation extending over all my actions" (p. 13). Later, Gabriel Betteredge, the butler in Collins' *The Moonstone*, famously claims to have contracted "detective fever"—although he concomitantly expresses disgust at being labeled a "deputy-policeman." There is a criminalized secretary in Green's *The Leavenworth Case*, and this will later become a staple figure in Golden Age crime fiction. The American Dean, though, is unique because she is not a side-kick.

While Mrs. Dean's actions are instigated by a member of the family she is serving—a coupling which harks back to the heroine/maid of the Female Gothic—her figure incorporates detecting autonomy and drive beyond her duty to the family; it is almost as if tracking Jean is her own vendetta. Mrs. Dean carries out her spying at the request of Lucia, but Jean discovers her carrying out her covert duties:

> "Yes, my dear Mrs. Dean, you will find that playing the spy will only get your mistress as well as yourself into trouble. You would not be warned, and you must take the consequences, reluctant as I am to injure a worthy creature like yourself" [p. 75].

Mrs. Dean, however, persists and confronts Jean:

> As the door closed behind him [Gerald], Dean walked up to Miss Muir, trembling with anger, and laying a heavy hand on her arm, she said below her breath, "I've been expecting this, you artful creature. I saw your game and did my best to spoil it, but you are too quick for me. You think you've got him. There you are mistaken; for as sure as my name is Hester Dean, I'll prevent it, or Sir John shall." (p. 77)

Jean asserts her authority over Dean by utilizing a falsehood; she invokes her superior social status by claiming that she is the daughter of Lady Howard:

> Dean drew back amazed, yet not convinced. Being a well-trained servant, as well as a prudent woman, she feared to overstep the bounds of respect, to go too far, and get her mistress as well as herself in trouble. So, though she still doubted Jean, and hated her more than ever, she controlled herself [p. 78].

Mrs. Dean nonetheless continues her spying activities. As Jean writes to Hortense, "[I] *must be careful, for she is on the watch*" (p. 104). But Mrs. Dean's "detective" role is limited and finally terminated as Jean destroys the evidence of the letters—Jean's purportedly "upper class" origins ensure that her explanation of her actions to Sir John is believed rather than that of the servant.

Lucia also takes a quasi-investigatory role as she recognizes Jean's deception even though she cannot clearly articulate what it is. She attempts to warn

Gerald: "Beware Miss Muir. [...] Her art is wonderful; I feel yet cannot explain or detect it, except in the working of events which her hand seems to guide" (p. 90). In this instance, Lucia explicitly describes her actions as associated with "detection." As a woman, though, her actions are limited and her instinct cannot produce any concrete proof. The men in "Behind a Mask" are briefly associated with detecting by proxy and description, but apart from Edward's limited enquiries and inability to persecute Jean, they do not actually detect at all. After Jean has destroyed the incriminating letters, she challenges masculine dominance in criminological terms:

> the proofs were ashes, and Jean Muir's bold, bright eyes defied them, as she said, with a disdainful little gesture, "Hands off, gentlemen! You may degrade yourselves to the work of detectives, but I am no prisoner yet. Poor Jean Muir you might harm, but Lady Coventry is beyond your reach [pp. 106–7].

Jean is triumphant and cannot be touched by the masculine "law"; rather than being expelled from the middle-class family, she can remain within it. By appropriating the conventions of the sensation novel and using an English setting Alcott can displace this literary challenge onto the distanced British "other," thus avoiding the alienation of her domestic audience.

Alcott, while not writing criminographic narratives as we now know them, challenged masculine dominance over the nascent genre of crime fiction. Like her own heroine, Alcott is in a sense a literary criminal, possessed of a dual authorial identity which allowed her to write conventional domestic novels such as *Little Women* and simultaneously produce sensation fiction with criminal elements. But while her contribution to women's writing of crime was considerable, this study now turns its attention to another female author whose impact was even greater.

Metta Victoria Fuller Victor (1831–1885)

Metta Victoria Fuller Victor was a productive U.S. writer in her time, but has since often been overlooked. She worked in many forms and genres, engaging with the domestic and sentimental tale, poetry, short stories, housewife's manuals, juvenile fiction, westerns, boys' adventure stories, humorous narratives; she additionally wrote what purports to be an autobiography, *Passing the Portal* (1876). Victor first started writing with her sister, Frances Victor in their juvenile years. When she was aged nine, her poem, "The Silver Lute," was published in 1840. Frances Willard and Mary Livermore comment that this was "reprinted in most of the papers of the West and South."[124] Victor's first novel appeared when she was aged fifteen: *The Last Days of Tul: a*

Romance of the Lost Cities of the Yucatan (1846). She contributed to *Beadle's Dime Cook Book* and *Beadle's Dime Recipe Book* and was the editor of *Beadle's Home* and *Beadle's Monthly*; *The Dead Letter* was serialized in the last and to some extent the work she had done for the publisher earlier enabled her to have control over her own work. Victor was also the editor of *Home: A Monthly for the Wife, the Mother, the Sister and the Daughter* from January 1859, published by Beadle and Adams. This associates her with her British contemporaries: for example Braddon's editing of *Temple Bar* (up to 1866) and afterwards *Belgravia: A London Magazine* (from 1866), and Wood's editorship of the *Argosy* (1867–87).

Victor published her work at times under her own name, as well as under various pseudonyms. She was a polemical writer who advocated reform, writing on Mormon polygamy, alcohol and slavery, and it is these texts for which she has been, until recently, best known. Victor's *The Senator's Son, or The Maine Law; a Last Refuge: A Story Dedicated to the Law-Makers* (1853) dealt with prohibition laws. Willard and Livermore say that this book sold over 30,000 copies in England but that Victor did not receive any of the money from this.[125] Copyright between Britain and America was a contentious issue and enabled the proliferation of piracy — this will be seen again in Victor's *The Dead Letter*. Victor's second novel, *Fashionable Dissipation* (New York: United States Book Co., 1853), was a temperance novel dealing with alcoholism and male/female relations. Victor's third novel, *Mormon Wives: A Narrative of Facts Stranger Than Fiction* (1856), addressed polygamy in Utah; *Passing the Portal: or, A Girl's Struggle. An Autobiography* (New York: G. W. Carleton, 1876) also examined gender relations. Her best-known work was the abolitionist dime novel, *Maum Guinea and Her Plantation "Children," or, Holiday-week on a Louisiana Estate: A Slave Romance* (1861).[126] Albert Johannsen notes that this was Victor's most successful commercial venture, selling over 100,000 copies in America.[127] Victor wrote a number of dime novels, of which the first was *Alice Wilde: The Raftsman's Daughter* (1860). This was followed by more dime novels by Victor in varying genres: *Uncle Ezekiel and his Exploits on Two Continents* (1861), *The Gold Hunters* (1863), *The Backwood's Bride: A Romance of Squatter Life* (1860), and *Jo Daviess' Client; or "Courting" in Kentucky* (1863). The figure of Susan Carter in *The Backwood's Bride* performs a quasi-detecting function which is not wholly unlike the female avenger/"detective" in Britain.

More important to this study is Victor's production of three tales featuring detectives: *The Dead Letter: An American Romance* (1866–7), *The Figure Eight; or, The Mystery of Meredith Place* (*The Illuminated Western World*, 1869), and the short story "The Skeleton at the Banquet" (1867).[128] These were published under the pseudonym "Seeley Regester." The anonymously authored

Too True: A Story of To-Day (*Putnam's Monthly Magazine*, 1868) was also written by Victor, and it featured two amateur detectives: a student, Robbie Cameron, and artist, Miss Bayles. Kathleen L. Maio recognizes that this story "features a good deal of detection by a woman artist."[129] Lucy Sussex draws a comparison with Anna Katharine Green's *The Leavenworth Case*; she writes that "Fuller Victor's detective novel *Too True* (1868) was also published by Putnam, but anonymously. Green differed in not being an isolated instance for the publisher, but rather a recognised, respectable 'brand' name."[130] While *The Figure Eight*, "The Skeleton at the Banquet," and *Too True* are of interest, they will not be discussed here; most significant in the context of this chapter is Victor's *The Dead Letter*, which was Victor's first and strongest foray into crime fiction.[131]

Research suggests that Metta Victor's *The Dead Letter* is the first crime novel written by a woman in America. Catherine Ross Nickerson goes further, stating that "Metta Fuller Victor was the first writer, male or female, to produce full-length detective novels in the United States with the publication of *The Dead Letter* [...] and *The Figure Eight* in 1869."[132] *The Dead Letter* was an innovative hybrid of domestic, sentimental, sensational and romantic fiction which incorporated significant elements of the newly emergent, masculine-dominated genre of detective fiction. This text could be perceived in terms of Suzanne Young's definition of the "domestic detection novels [which are] a forgotten tradition of American mystery writing that combined scrutiny of domestic family arrangements with the emotional registers of traditional Gothic fiction."[133] She adds that "[t]he domestic detective novel, in fact, tends to see the protected female world of the traditional domestic novels as anachronistic."[134] R. F. Stewart, discussing British Victorian writers and definitions of their crime works, writes: "but crime — fraud, bigamy, murder. Robbery — is the mainspring of their works, and "criminal romance" was one of the critics' favourite terms for it."[135] Leonard Cassuto has argued that the twentieth-century hard-boiled crime stories in America derived from the feminine, domestic and sentimental stories of the nineteenth century.[136] There are, therefore, differing opinions over the novel's generic definition, in contrast to the writing of Alcott, which mainly re-worked the sensation mode. Stephen Knight asserts that, apart from the inclusion of clairvoyance in the text, "*The Dead Letter* is effective and confident, with a reasonably surprising final revelation, and this must define the novel more as a detective novel than a sensational thriller."[137] Although DuBose comments that "*The Dead Letter* is now regarded as little more than a quaint historical footnote,"[138] this chapter considers that it makes an important contribution to the crime novel proper and is doubly significant because of its female author and the minor but important female character, Lenore, who has until now been largely ignored by critics.

In the 1860s in America, fiction featuring crime tended to appear in dime novels (which cost ten cents, equivalent to British "penny dreadfuls"/"yellowbacks"), and in the sensation fiction at the cheaper end of the market. Edmund Pearson defines this cheap criminography as "tales of dread suspense" dealing in "violent action; in sudden death and its terrors."[139] The publishing house of Beadle and Adams was the main exponent of this type of fiction. Victor's story initially appeared as the lead serial in *Beadle's Monthly: A Magazine of To-Day*, which was an imitation of and challenge to the upmarket *Harper's Monthly*, and was aimed at a new target audience of the middle and upper-middle classes rather than the lower-class audience of the dime novels and magazines. Ross Nickerson comments that the reprinted versions of *The Dead Letter* and *The Figure Eight* as Beadle Popular Fifty Cent Books are suggestive of a readership comprised of the upper and middle classes.[140] As Johannsen observes, it was "one of the high class magazines of the day, and compared very favorably with the contemporaneous *Harper's*."[141]

The title of Victor's story, *The Dead Letter: An American Romance*, draws attention to both its nationality and to its romantic aspects. While in *The Dead Letter* closure is based on traditional romance and marriage, and so locates the story in a recognizable generic framework, its content deviates from the romantic norm. The second half of the novel's title urged the public to read the story, despite what this chapter suggests is its criminal content. Yet this intermixing has proved a vexed subject for modern-day literary critics. Panek defines *The Dead Letter* and Green's later *The Leavenworth Case* as "two well known American sensation novels [...] that fall into the category of crime fiction."[142] He elaborates this sensational definition, placing the novels in such a category because they "both centre on self-less, tragic female heroes and palpitating male admirers who witness and describe the tribulations and heroism of the women, but who are also mostly clueless about discovering the causes or cures for their suffering" (pp. 10–11). While Panek does list the reasons why these two novels are "relevant to the evolution of crime fiction" (p. 11), seemingly mediating between the two categories of sensation and crime, he then settles on the belittling statement that "[i]n spite of all this, they're not detective stories, not by a long shot. They're sensation novels" (p. 11). Elizabeth Foxwell, speaking of *The Dead Letter* and *The Figure Eight*, classifies them as "rediscovered Gothic gems," before calling Victor a "a pioneer in American detective fiction."[143] Catherine Ross Nickerson posits that Victor launched a new category of fiction: "The close association of that tradition [detective fiction] with an earlier body of popular women's writing, the domestic novel of the 1850s, produced a style we can call domestic detective fiction because of its distinctive interest in moral questions regarding family, home, and women's experience."[144] But this study considers *The Dead Letter*

to be detective rather than sensation or domestic fiction, and suggest that Victor cleverly manipulates the conventions and trappings of domesticity as a cover for and to render respectable her criminal content.

The publishing history of *The Dead Letter*, like that of Braddon's *Trail*, is not straightforward. The relationship between Victor and her publisher was similar to that of Braddon and Maxwell, as Orville Victor was Metta Victor's second husband and also "the creator of the dime novel and an editor at Beadle."[145] The serialization of *The Dead Letter* ran from January 1866 to September of the same year in *Beadle's Monthly; A Magazine of To-Day*, New York. There is a confusion of dates similar to those surrounding Braddon's *Trail*; the date of publication in book form of *The Dead Letter* is hard to pinpoint, and is still not resolved. B. J. Rahn and Earl F. Bargainnier claim the publication date as 1867; Nickerson states that the book form is 1866. Comparisons with the original serialized version reveal no major variations apart from some additional illustrations. In an advertisement for the text in 1881, *The Saturday Journal* claimed that apart from *Uncle Tom's Cabin* sales of *The Dead Letter* exceeded that of any other American novel.[146] Despite this comment, details about the reception of *The Dead Letter* are confused; the multiple re-prints, varying print forms and prices suggest wide and continuing public interest. Yet Okuda — writing before the 2003 reprint — questions its early reception and popularity:

> The fact that *Dead Letter* may not have been very successful (what is lacking in its studies is the discussion of its popularity) is probably one of the reasons why scholars find it difficult to bring the book out of obscurity.[147]

Although exact numbers of copies of *The Dead Letter* are not known, a glance at Beadle's prolific output suggests that in serial form it sold well: Michael Denning notes that "Beadle and Adams alone published 3,158 separate titles"[148] and "had published four million dime novels by 1865."[149] This context was not always positive: the critical reception of the romance and detective stories which comprised the dime novel genre is reminiscent of Oliphant's denigration of the British sensation story; dime novels are described as being "aimed at the wallets and the tastes of America's increasingly rowdy working class."[150] This description succinctly sums up the difficulties facing the emerging crime genre in its struggle to gain respectability. Victor, however, to some extent overcame these difficulties by locating her criminal narrative in the framework of romance and domesticity.

Lucy Sussex has discovered a British-American connection involving *The Dead Letter* and its printing and multiplicity of forms. The British *Cassell's Illustrated Family Paper* plagiarized and reprinted *The Dead Letter*, altering it in order to appeal to their audience (serialized between 3 November 1866 and 9 March 1867). As Sussex notes of *Cassell's* appropriation:

It is a measure of how similar English and American modes of detective fiction then were that a text's setting could be so easily changed — there is little sense of national character in *The Dead Letter*, either in locale or speech, except in the exotic Californian section.[151]

She goes on to say that: "The English version of *The Dead Letter*, however, was crucial to the novel's circulation. Thanks to *Cassell*, English crime writers had the opportunity to read, and be influenced by *The Dead Letter*."[152] Earlier, Victor's "The Tempter" (written for the New York *Home Journal*) appeared in Britain; Johannsen remarked that it created "a decided sensation" in England.[153]

Victor also has Australian affiliations. Australian crime writer Mary Helena Fortune's first story, "The Dead Witness; or The Bush Waterhole" appeared in January 1866, the same month as *The Dead Letter*, but while it is not known whether Victor's text was ever published in Australia prior to the 2003 reprint (which can be found in the Sydney University Library), Victor's *Too True: a Story of To-Day* (1868), did appear in Australia. Sussex states that "[i]t is indicative of how fast and far contemporary crime fiction could travel that the story of Konisberg [the German villain in *Too True*] would be extracted and run as a short story, "A Mysterious Affair," in an Australian regional newspaper, the *Queanbeyan Age* (5 September 1868)."[154] Crime writing, then, transcends national boundaries and this intercontinental dissemination of crime fiction suggests an on-going literary and criminal dialogue, and possibly locates the USA as a pivotal point between Britain and Australia.

The Dead Letter is set in 1857 and the story spans seven years, ending circa 1864. The narrative begins two years after the murder at its centre has been committed, in 1859. The novel was actually published in the period in which the American Civil War took place (12 April 1861–9 April 1865); *The Dead Letter* is, then, both antebellum and postbellum. The story opens with the narrator, Richard, working in the Dead Letter Office, and then revisits the events leading to the murder. This is where the "letters [which] have gone astray" are collated and where Richard and his fellow workers undertake the act of "opening, noting and classifying the contents of the bundles [...] it was of the most monotonous character."[155] This is in contrast to the conventional plot structure of crime fiction — already familiar — which more usually begins with a crime followed by investigation and explanation. There are two criminals in *The Dead Letter*: George Thorley, also known later as Doctor Thorley and Doctor Seltzer, and James Argyll. The title of the novel refers to the letter which is discovered in the Dead Letter Office, a letter that details the correspondence between the criminals, who are, respectively, a hired killer and his employer.

The dead letter arrives in Washington, D.C.; it is here that the letter fell in a crack and lay undiscovered for two years. Thorley, in his "dead letter" to

James, cryptically tries to indicate where the murder weapon has been secreted. When these cryptic actions and discourse are considered in the light of Alcott's "Behind a Mask," Alcott's two criminalized/plotting women seem doubly bold in their rejection of discursive disguise and codes to conceal their criminal intent. Victor may also have been influenced by Poe's "The Purloined Letter," where appearance and reality are contested and a letter is stolen for financial gain. Dupin explains to the unnamed narrator:

> In scrutinizing the edges of the paper, I observed them to be more *chafed* than seemed necessary. They presented the broken appearance which is manifested when a stiff paper, having been once folded and pressed with a folder, is refolded in a reversed direction, in the same creases of edges which had formed the original fold. [...] the letter had been turned, as a glove, inside out, re-directed and re-sealed.[156]

Poe used cryptography in "The Gold Bug" (1843). In Andrew Forrester, Jr.'s "Arrested on Suspicion," a multiply coded letter is visually presented and the narrator explicitly references Poe.[157]

The criminals are not initially revealed to the reader, following the classical detective fiction structure, but eventually the man paid to kill Henry Moreland is revealed to be:

> George Thorley, of Blankville, who used to have an apothecary shop in the lower part of the village, and who left the place some three years ago, to escape the talk occasioned by a suspicious case of malpractice [p. 159].

Thorley assumes three different names in the course of the narrative and evades the consequences of his actions by continually escaping to new locations across America. The reasons for his murderous actions are twofold: firstly, financial gain and secondly, because he is infatuated with a woman, Leesy Sullivan, a customer at his drug store. Leesy refuses Thorley's advances because she has an unrequited love for Henry Moreland. It is this which, with the fee promised by Argyll, makes Thorley eager to assassinate Moreland. Additionally, Thorley later attempts to kill the detective, Mr. Burton, in order to prevent his investigative activities.

Thorley seeks to rise socially; his ambition is to open his own drug store. Leesy tells Mr. Burton and Richard: "[Thorley] got himself into the good graces of some of the leading citizens of Blankville. He had told me something of his history; that is, that his family were English; that he, like myself, was an orphan" (p. 161). The figure of the orphan is a recurrent trope in Victorian literature. Usually seen as a path to progress, as in *David Copperfield*, in this case it is a path to criminality. One of the criminals is English and so located as "other" to new American national progress. The choice of English nationality is perhaps deliberate, done to enhance Thorley's criminality. As in Braddon's *Trail*, where the criminal Jabez is an orphan who abandons his child,

so Thorley deserts his daughter, Little Nora, who after her mother's death is reared by Leesy. His criminality is flagged up to both the reader and the other characters in the novel; he is represented as being a dangerous presence, marked in ways which define him as "other": "his eyes were black, his complexion sallow" (p. 57), and his hand has "been injured by himself, in some of his surgical experiments" (p. 165). This identifiable scar is reminiscent of the "marked man," Jabez, in *Trail*. This accident and the medical malpractice he commits—which results in his running away from Blankville—make Thorley seem doubly dangerous, physically harming others and himself. Thorley is also, initially, a part of "[t]he male medical establishment" with the associated implications of power and dominance over women.[158] As Catherine Clinton notes:

> Male physicians at mid-century were preoccupied with female nervous disorders. Whether these illnesses were real or imagined, doctors treated them with increasing frequency and unfortunate consequences in the latter half of the century.[159]

The notion of "female nervous disorders," of hysteria, is reiterated in *The Dead Letter*. There are frequent descriptions of quasi-hysterical symptoms in the narrative, and these are not confined, as might be expected, to the women in the text: James Argyll, Mr. Burton, and Richard Redfield all exhibit a kind of hysteria at times.

The use of a medical figure is seen in earlier criminographic work, such as Samuel Warren's "Passages from the Diary of a Late Physician" (*Blackwood's*, 1830–37), and the "medical man" who recurs, and at times dominates the narrative with his ideas, in Forrester's Mrs. G— stories (1864). Worthington writes that "there are parallels to be drawn between the practices of medical science and detection: as the physician seeks out the agent of disease, so the detective will seek out the agent of crime; and the relationship between medicine and crime will develop into the discipline that came to be known as 'criminology.'"[160] Victor may have read Anthony Trollope's *Doctor Thorne* (1858), which was not a criminal novel; the similarities and resonance in names, though, suggest that Victor was self-consciously reworking prior British and masculine discourse. Joe Meredith, in Victor's *The Figure Eight* (1869), studies medicine and disguises himself as a physician as part of his investigation/s. J.B. in *The New York Detective Police Officer* (1865) studied and trained in medicine before becoming a detective. Yet Victor here inverts the conflation of discourse and medicine controlling misdemeanors and the "mad"/ill criminal. Rather than medicine controlling or attempting to control crime, it is the criminal who literally carries out the murder. In Braddon's *Trail*, Jabez withholds medicine which leads to his brother's death. This problematization is later seen in Robert Louis Stevenson's *The Strange Case of Dr.*

Jekyll and Mr. Hyde (1886). There is a criminal Doctor in Dickens's "Three Detective Anecdotes" (*Household Words*, 14 September 1850), Doctor Dundey. He had robbed a bank in Ireland and was followed to and arrested in America. This abberant figure is seen again in the factual case of Dr. William Palmer, known as "The Rugeley Poisoner"; he was a scientist who murdered his own family for life-insurance money and also killed some of his associates over racing debts. Dickens wrote an article on Palmer's trial, "The Demeanour of Murderers" (*Household Words*, 14 June 1856). In Russell's "The Tragedy in Judd Street" (in *Experiences of a Real Detective* (1862)), Inspector F deals with a doctor who feigns having hydrophobia in order so that he can be credited with finding a cure once he recovers; ironically, the doctor does later contract this disease. Perhaps Victor's character of Thorley later influenced British R. Austin Freeman's serial protagonist, Dr. John Thorndyke, who has a similar name. Thorndyke was a lawyer and forensic scientist (appearing from *The Red Thumb Mark* in 1907 onwards). He signifies a recuperation of the deviant medical criminal into the control of and figure personifying law and medicine. Dr. Watson also embodies this. Arthur Conan Doyle completed medical training in Edinburgh and later had a medical practice at Southsea, opening in July 1882. Later, Collins would create a fictional female doctor in his short story "Fie! Fie! or, the Fair Physician" in 23 December 1882 (simultaneously appearing in *The Pictorial World Christmas Supplement* and *The Spirit of the Times*). Yet, this woman is portrayed in sexualized terms and the story is laden with innuendo. In 1874 Sophia Jex-Blake made it possible for women to undertake medical training and, in 1877, women were allowed to practice as doctors. Lytton's supernatural tale, *A Strange Story* (*All The Year Round*, August 1861-March 1862) included Dr. Lloyd, a mesmerist.[161]

After Thorley has had a written confession extracted from him by Mr. Burton, his criminality is displaced outside the United States into Mexico. This is the antithesis of the traditional detective fiction closure, where the criminal is punished and/or safely expelled from society. Thorley, in his ability to traverse America and beyond, provides a more threatening prospect as he could potentially strike again anywhere and at any time. The middle-class prerogative of class preservation is again evident in the treatment of James, the other criminal in *The Dead Letter*. Mr. Burton tells the Argyll family that

> it is for you to decide the fate of this miserable man. I have kept all my proceedings a secret from the public; I even allowed George Thorley to remain in Mexico, for I thought your family had already suffered enough, without loading it down with the infamy of your nephew. If you say that he shall go unpunished by the law, I shall abide by your wish; this matter shall be kept by the few who now know it. For *your* sakes, not for his, I would spare him the death which he deserves; but he must leave the country at once and for ever [p. 199].

Equally, the general consensus of the village is one which unintentionally glosses over James's criminality with a more comforting story: "The sudden absence of James Argyll caused much harmless gossip in the village. It was reported, and generally believed, that he had gone abroad, on a tour to Egypt, because Miss Argyll had jilted him" (p. 205). This is seen earlier in Alcott's "V. V.," when Douglas says to Virginie: "I will not have my name handed from mouth to mouth, in connection with an infamous history like this. For Allan's sake, and for Diana's, I shall keep it secret, and take your punishment into my hands" (pp. 401–2). James is feminized; he literally swoons after admitting his guilt — a movement or action stereotypically associated with the Victorian woman. The criminal, ironically named Charles Goodfellow, in Poe's "Thou Art the Man" (*Godey's Lady's Book*, 1844) also faints in guilt.

The other criminal in *The Dead Letter* is the man who hires the murderous Thorley, that is, James Argyll, who is dependent upon his uncle, Mr. John Argyll, and lives in his house as well as working for him as a law student. As "an almost universal favorite" (p. 40), James is a typical example of Karen Halttunen's notion of the "confidence man" in America, post–1830. She observes that "nearly one out of ten professional criminals in New York […] was a confidence man" and that he was "a man of shifting masks and roles," and served to "sever the link between surface appearances and inner moral nature."[162] This dual nature is perhaps most evident in James's insistence on helping the detectives, Mr. Burton and Richard, in their investigation when he is actually involved in the crime. James is represented as being firmly and confidently embedded into the middle-class infrastructure of both the Argyll house and American society. James's motives for murder differ from those of his collaborator, Thorley. James gambles in New York and owes money to Bagley, a loan shark. He assumes that he can gain his uncle Argyll's daughter's hand in marriage and uses this prospect as collateral in order to secure money to pay his debts, effectively "gambling away his uncle's property upon the credit of a daughter's hand which he had not yet won" (p. 110).[163] James subsequently robs Mr. Argyll of two thousand dollars from a locked desk in his library and he uses this to hire Thorley to kill Moreland.

The main victim in the narrative is Henry Moreland; he is a gentleman, a New York banker, and the fiancé of Eleanor Argyll. He is murdered as he travels from New York to visit Eleanor in Blankville. His male gender contradicts Mabel Collins Donnelly's assertion that "the favorite victims in literature of the nineteenth century are females."[164] He is stabbed by what proves to be a thin surgical instrument — incidentally pointing the finger of blame at Thorley — and the weapon is initially concealed in an ancient monarch oak on the Argyll estate. Part of the instrument is found in Moreland's body. This is similar to Lytton's *Pelham* (1828), where a part of a broken knife is left in

Tyrrell's body. In Alcott's "V.V," Douglas finds part of the murder weapon used to slay his cousin: "The handle of a stiletto, half consumed in the ashes, which fitted the broken blade entangled in the dead man's clothes" (p. 395). The symbol of the tree might have been influenced by Brockden Brown's *Edgar Huntly* (1799), where Edgar's curiosity and consequent quasi-investigation is sparked when he finds Clithero Edny digging under an elm tree, which had been where Edgar's friend, Waldegrave, was killed. Spofford's "Circumstance" also rotates around a tree. Earlier, Shakespeare's comedies used the woods as a site to convey magical and carnival associations.

Another victimized yet simultaneously criminalized figure is the Irish, lower-class seamstress, Leesy Sullivan. She is in love with her part-time employer — Henry Moreland — who shows her kindness; she desires him from afar, and mourns him after his death. She is not actually a criminal, but it is her interest in and secret love of Henry, both in and after life, which causes Richard and Mr. Burton to believe her to be so: they initially suspect that she is complicit in Henry's murder. Much of the narrative is allocated to the investigation of Leesy and her function in the text is perhaps an example of the later "red herring" convention of the crime/detective genre. Leesy is granted some power to speak out against her treatment; finally found by Mr. Burton and Richard, she retorts:

> You want to drag me forth before the world, to expose my foolish secret, which I have hidden from everybody — to put me in prison — to murder me! This is the business of you two men; and you have the power, I suppose [p. 128].

Leesy can be seen as a prototype feminist figure in the sense that she both encapsulates and mocks the conventions of women, crime and incarceration in a manner not wholly dissimilar from that of Alcott's Jean Muir. Such challenges and female contestation can be seen earlier with Janet Faithful in "The Woman with the Yellow Hair"; Janet retorts to her unnamed detecting pursuer: "A strange creature," she said, almost fiercely — "that is your judgement — because I dare not think or choose for myself — because I am dragged a fashionable slave to the market, set up and sold."[165] Yet the female voice, at this point, still has limitations: while Leesy oscillates between empowerment and disempowerment throughout the novel, ultimately she dies and so is removed from the narrative.

There are multiple detecting or quasi-detecting figures in *The Dead Letter*. The principal exponent is Mr. Burton; he is clearly marked in the narrative, in contrast to the liminal figure of Peters in Braddon's text. Mr. Burton is, though, like Peters, associated with the police. Chapter V is titled "*Mr. Burton, the Detective*" (p. 38). Peters in *Trail* is initially part of the police, yet later his status is indeterminate and more as a private detective. Mr. Burton's

detecting services are found at the New York detective police office, yet his affiliations with them are not public knowledge: Mr. Burton actively dissociates himself from the New York police force; speaking to Mr. Browne in relation to enquiries into Mr. Argyll's stolen money at the bank, Mr. Burton explicitly expresses: "I do not wish to be known there as belonging to your force" (p. 45). He is attached to "the secret detective-police" (p. 52) but works in an indefinite, unpaid capacity. Unlike Peters, he comes from the business class and is aligned more as a business man than a police officer. Mr. Burton is rather like the British female detectives—he works with the police but is not one of them. It is a change in fortune which leads him to this profession. This social elevation is the same as the British lady detectives, Tom Richmond, "Thomas Waters," and J.B. Richard notes that Mr. Burton is "intelligent, even educated, a gentleman in language and manner — a quite different person, in fact, from what I expected in a member of the detective-police" (p. 46). Mr. Burton could be seen as an advancement of the British Thomas Waters in his investigations and methods of investigation as he analyses, watches, and moves around. His reasons for detecting are again similar to Waters: they have both been deprived by criminals of their fortune and prior economic stability. Waters writes that "adverse circumstances [...] compelled me to enter the ranks of the Metropolitan Police, as the sole means left me of procuring food and raiment."[166] Like Waters and Mrs. Paschal, Mr. Burton has an attempted murder made upon himself (by Thorley). Ultimately, though, Mr. Burton is murdered at the end of the narrative by another, unnamed criminal.

Richard describes Mr. Burton's first appearance and explains to the reader "the expression of his small, blue-gray eyes, whose glance, when I happened to encounter it, seemed not to be looking at me but into me" (p. 44). The focus on Mr. Burton's eyes and his skills in perception bears comparison with the sharp gazes and penetrating, panoptic eyes of many detectives in nineteenth-century British criminography. These examples include Dickens's police detectives in his "Detective Police Anecdotes" and the fictional Mr. Bucket with his ubiquitous "unlimited number of eyes."[167] Gaboriau's Père Tabaret has "little grey eyes,"[168] and the anonymously authored stories in *Chambers's* featured Mr. Ferret with his gray eye and disciplinary surveillance. Equally, Mr. Burton incorporates elements of Cooper's Natty Bumppo; Richard states that "He was like an Indian on the trail of his enemy—the bent grass, the broken twig, the evanescent dew —[...] to him were 'proofs as strong as Holy Writ'" (p. 52). From another perspective, Mr. Burton is almost exactly like J.B. in his perpetuation of gendered assumptions which are interconnected with his detecting conclusions: Richard tells the reader that "[h]e said that the blow which killed Henry Moreland was given by a professional murderer, a man, without conscience or remorse, probably a hireling. A

woman may have tempted, persuaded, or paid him to do the deed [...] but no woman's hand, quivering with passion, had driven that steady and relentless blow" (p. 71). Mr. Burton also belittles Leesy; he comments that

> Women are like mother-birds, when boys approach the nest. They betray themselves and their cherished secret by fluttering about the spot. If this Miss Sullivan had been a man, she would have been in Kansas or California by this time; being a woman, I ought to have looked for her exactly the place it would seem natural for her to avoid [p. 130].

But these are not the only interconnections evident in the text.

Victor locates her narrative in the British tradition of literary detectives, with particular reference to Dickens's *Bleak House* (1853). The disintegration of the Dedlock family and the effect of Chancery in Dickens' novel are most evident. Mr. Burton speaks directly to that text when he comments: "'The wind is changing,' said Mr. Burton, speaking like the old gentleman in Bleak House. 'I see how the land lies. The goodly and noble Argyll ship is driving on to the rocks. Mark my words, she will go to pieces soon! you will see her ruins strewing the shore'" (p. 122). While Mr. Burton may share some of the characteristics of Dickens's detective, Victor develops Mr. Bucket's seemingly supernatural ability to appear and disappear at will by giving her detective, Mr. Burton, powers beyond the merely human. This is in marked contrast to Braddon's detective in *Trail*, Peters, whose skills are all too prosaic and consequently more realistic, in the tradition of the many police detectives featured in fiction in the 1860s. As Ross Nickerson observes: "*The Dead Letter* features a detective who is markedly different from Poe's rational expert and from real detectives in the postbellum period."[169] Rahn comments that:

> Seeley Regester has contributed to the development of the crime novel by extending the character of the detective. [...] Ms. Regester has augmented the abilities of the sleuth to include intuitive insight and extrasensory perception.[170]

Mr. Burton's "supernatural" skills are perhaps a response to the need for a superhuman American detecting presence which will comfort society by solving crimes. His talents are many; he tells Richard that "[w]hen I meet people, I seem to see their minds, and not their bodies" (p. 122), and he can ascertain details of Thorley from the dead letter "through the medium of his chirography" (p. 141).[171] He modestly states that:

> there is about me a power not possessed by all — call it instinct, magnetism, clairvoyancy, or remarkable nervous and mental perception. Whatever it is, it enables me, often, to feel the presence of criminals, as well as of very good persons [p. 201].

This boast of acumen is ironic; despite his avoidance of death, Mr. Burton finally is murdered through the mode of poison.

The narrator/protagonist, trainee lawyer Richard Redfield, additionally takes on a detective role; it is Richard who initially finds the "dead letter" of the title and subsequently works with Mr. Burton on the case, although Mr. Burton withholds information from him, as Sherlock Holmes will from Dr. Watson. This occurrence could perhaps be evidence that Doyle read Victor's work, and this novel in particular. Doyle was a fan of America and travelled there in the latter part of the nineteenth century. Yet Alcott did this a year previously in "V. V." with her characters of Duprès and Douglas. Duprès tells Douglas: "It would be well to leave all to me, for you will act your part better if you do not know the exact program, because you do nor perform so well with Monsieur as with Madame" (p. 389). As a consequence of his detective activities, Richard is framed by James Argyll, resulting in his exile from the house and the loss of his chance of employment with Mr. Argyll's law firm. Rahn notes: "The manipulation of his character is most ingenious and anticipates Agatha Christie's famous experiment with narrative viewpoint in *The Murder of Roger Ackroyd* by over half a century."[172] Richard's alignment with the law is evident in his assertion that "I'm a lawyer, you know, and demand the proofs" (p. 99) and, in speaking of the supposed "ghost," who turns out to be Leesy hiding in the summer house, declares that he "would ascertain the truth or explode the falsehood" (p. 116). While the ghost is a staple of Gothic fiction, perhaps Victor is drawing on Brockden Brown's *Wieland* (1798), where it is thought that voices were coming from the elder Wieland's Summer house are because the dead man is speaking. But despite his apparent stability of character, Richard has a nervous, not to say hysterical, aspect:

> I had sustained so many shocks to my feelings within the last forty-eight hours, that this new one of finding myself under the eye of suspicion, mingled in with the perplexing whirl of the whole, until I almost began to doubt my own identity and that of others [p. 42].

The comforting notion of stable masculine identity is, in this case, clearly destabilized; men are shown to be losing control.

This is not the only example of loss of control in the narrative. Richard seems to be an orphan, relying, after the death of his father, on Mr. Argyll's patronage. Yet Richard's mother is still living and, when he is temporarily exiled from the Argyll house, he returns to his mother and home, a move which metaphorically relocates him as a child and so allows his weakness to become physically evident: "Before I had been at home a fortnight, the unnatural tension of my mind and nerves produced a sore result — a reaction took place, and I fell sick" (p. 138). Such masculine reactions were seen earlier with the unnamed lawyer in Gaskell's short story "The Poor Clare" (*Household Words*, December 1856). The lawyer states: "I had an illness, which, although I was racked with pains, was a positive relief to me [...] my life seemed to slip

away in delicious languor for two or three months."[173] Gaskell had been published in America, in *Harper's New Monthly Magazine*. Braddon's Jabez is feminized as is Gaskell's M. de la Tourelle in "The Grey Woman" (*All the Year Round*, January 1861). The mother fulfils a healing role, enabling Richard to recuperate and to recover his proper masculinity after his fall into childlike and feminized weakness. Richard later reasserts his proper masculinity in his renewed pursuit of the criminal and his eventual incorporation into the Argyll family when he marries; in this action Richard is reminiscent of Robert Audley in Braddon's *Lady Audley's Secret*. Mr. Burton initiates Richard into what might be termed a "detective family"; on his return from his mother's house, Richard notes that Mr. Burton's "expression was as if he had said– 'Welcome, my son'" (p. 140). The unspoken words suggest a crime narrative lineage in which "detective" sons carry on the work of their metaphorical or surrogate "detective" fathers.

But there is another member of this "detective family," Lenore Burton, Mr. Burton's daughter. Lenore is accorded more space than the detective's unnamed daughter in Spofford's "Mr. Furbush" (1865). Mr. Burton's personal and family circumstances are described thus:

> he was a widower, with two children; the eldest, a boy of fifteen, away at school; the second, a girl of eleven, of delicate health, and educated at home [...] his heart was wrapped up in her [p. 72].

Curiously, despite the contemporary emphasis on the masculine in a patriarchal society, the reader is not told any other details of Mr. Burton's son: his name is never given nor spoken, and none of the characters in the novel meet him. Rahn suggests that Mr. Burton and Lenore are simply a conventional family unit: "Mr. Burton leads a normal family life and takes great delight in his children."[174] Mr. Burton's status as a widower enables a close relationship between father and daughter although, as this chapter will show later, this is a somewhat dysfunctional one. These curious family roles hark back to the dysfunctional families evident in Warren's "Passages from the Diary of a Late Physician" (*Blackwood's*, 1830–37) and "The Experiences of a Barrister" (*Chambers's*, 1849–50). These roles are also evident in Gaskell's shorter, hybrid/Gothic-style stories. This chapter contends that, in the creation of and focus on Lenore, Victor is working towards a female detective as well as claiming some kind of female agency within this masculine text and society.

Significantly, it is Lenore who actually possesses the clairvoyant skills for which Mr. Burton claims credit and which he turns to his own advantage in his detective work. DuBose comments: "The resilient Mr. Burton does his darnedest to solve the mystery rationally, but in the end, he must turn to his clairvoyant daughter for a resolution: a detective, yes, but hardly Poe's rea-

soning machine."[175] Ross Nickerson reads and perhaps dismisses Lenore as an old Gothic trope; she writes that *The Dead Letter* includes "several elements from the gothic novel, including the haunted house, the clairvoyant child, and the grieving widow-bride."[176] Panek emphasizes *The Dead Letter*'s status as detective fiction by making links between Victor's text and Poe's writing, claiming that Lenore "bears the nevermore name from "The Raven," Lenore."[177] Kathleen L. Maio recognizes the limited agency of Lenore, commenting that "[w]hen gentleman sleuth, Mr. Burton is stumped, he exploits the psychic powers of his daughter, Lenore."[178] Richard describes Lenore as:

> a lovely child [...] a vision of sweetness and beauty more perfect than I could have anticipated. Her golden hair waved about her slender throat, in glistening tendrils. [...] Her eyes were celestial blue—celestial, not only because of the pure heavenliness of their color, but because you could not look into them without thinking of angels [p. 73].

Presented as a conventionally angelic female child, Lenore is nonetheless implicitly sexualized by Richard's masculine gaze, and there is a clear conflict in the narrative between the conventional drive to depict Lenore as properly passive and the more subversive and potentially threatening possibility of the sexualized active female. This chapter wants to suggest that Lenore is a key figure in the text and that she is deserving of more critical attention than she has so far received.

Lenore's irregular talents are peculiarly feminine; her clairvoyance both suggests a clarity of vision and, equally, intuitive sensibility. Mr. Burton effectively displays his daughter to Richard, telling him that he wishes to "make [him] the confidential witness of an experiment" (p. 72) involving Lenore:

> I have told you how delicate her health is. I discovered, by chance, some two or three years since, that she had peculiar attributes. She is an excellent clairvoyant. When I first discovered it, I made use of her rare faculty to assist me in my more important labors; but I soon discovered that it told fearfully upon her health. It seemed to drain the slender stream of vitality nearly dry [p. 72].

Mr. Burton's statement suggests that it is really Lenore who has detective agency and that he relies on her talents for his success. Despite his recognition of the negative effects which such trances have on Lenore, he continues to draw on her psychic abilities. In the course of a clairvoyant search for Leesy, Lenore's "lovely face became distorted as with pain; the little hands twitched — so did the lips and eyelids" (p. 74). Lenore's detective agency comes at a price and is still within her father's control. As Mabel Collins Donnelly observes, "[a]fter a childhood in which the principal message to a girl was "Submit," the young woman was usually ready to regard father as the power in the household."[179] Lenore's submission to Mr. Burton demonstrates the strength of his authority.

Lenore's detecting manipulation/clairvoyance is reminiscent of the use of mesmerism and transference in *The Notting Hill Mystery* (1862–3; 1865). Many of Alcott's stories are concerned with the woman and alternate states of mind induced by opium and hashish. In "A Marble Woman: or, The Mysterious Model" orphan Cecilia Bazil Stein's guardian, sculptor Bazil Yorke, gives Cecilia laudanum. Feminine manipulation is seen again in "A Whisper in the Dark," which features another female orphan, this time named Sybil. Her purported "uncle" tries to coerce her into being his child-bride, but when Sybil resists he incarcerates her in a room in a manner not dissimilar to that experienced by Jane Eyre. He attempts to unbalance her mind via mind-control with the purpose of claiming her inheritance. In *A Modern Mephistopheles* (1877) mind control is again exhibited and hashish is given to the character of Gladys. In E. T. A. Hoffmann's "Der Magnetiseur" (written in 1813 and published in 1814 in vol. 2 of *Fantasiestücke* in *Callots Manier*), a character, Alban, is gifted with hypnotic powers; he stays with a baron's family, and subdues the daughter Marie to his will, and causes her death. A trance is included in *The Moonstone*, and Poe, in "The Facts in the Case of M. Valdemar" (1845), enables a suspension of consumptive death with a mesmeric trance. Suspended animation was earlier seen in Mary Shelley's "Rodger Dodsworth: The Reanimated Englishman" (1826).

Lenore's agency is limited by the sexualization implicit in her position as the object of the masculine gaze. She is further objectified as the focus of power struggles between James and Richard and between James and Mr. Burton when she temporarily resides in the Argyll house. Initially, she takes a dislike to James, but as Richard explains, James "had resolved to conquer Lenore. He paid court to her as if she were a "lady of the land," instead of a little girl" (p. 113). Richard's feelings for Lenore are made evident in his observation that he "was more hurt by her growing indifference to me and her increasing fascination for James than the subject warranted" (p. 113). This disturbing dynamic is seen in Brockden Brown's *Arthur Mervyn* (1799), where the villain/murderer and confidence man, Thomas Welbeck, defines Clemenza Lodi as his "daughter"; she is, though, in disturbing reality, his forced mistress. After tracing her to Mrs. Villar's brothel, Arthur eventually re-homes Clemenza with his friend, Mrs. Wentworth. Mr. Burton becomes jealous of James' power over his daughter, a power which detracts from his own; he is temporarily unable to put Lenore into a trance and tells Richard that "[s]he is under the influence of a counter-will; as strong as my own — and mine moves mountains" (p. 123). But in the fiction of this period, women seem to have little free will either in mind or body.

A similar narrative device can be seen in Ellen Wood's novel *Dene Hollow* (serialized in *Argosy*, January–December 1871): a servant to the Owen family,

Mary (daughter of Mrs. Barber) has visionary powers. Mary has prophetic dreams of the murder of Farmer Owen, and connects this act to a smuggler, Randolph Black. Mary recounts these dreams to the three male leaders of the village. While they initially mock such information, they also use it as a means of direction in their detection. The narrator states that "Mary Barber was superstitious in the matter of dreams. She did not have them often, but it must be confessed that two or three times in her life her dreams had appeared to foreshadow events that afterwards happened."[180]

Elements of the romantic novel can be seen in the many love complications in *The Dead Letter*, and romance is essential to the murder plot. The complex love relationships between Leesy, Eleanor, Henry, and Thorley are directly connected to crime, as are those between James, Eleanor, Mary and Richard. The first set of relationships lead to Henry's murder: Eleanor and Henry are engaged, but Leesy, who is employed by Henry, feels an unrequited love for him. Thorley, who is unsuccessfully pursuing Leesy, discovers her affection for Henry and, filled with motivation by jealousy, murders his perceived rival. The second complication rotates around Richard's initial love for Eleanor, which is soon displaced onto her younger sister, Mary. James too wants to marry Mary. Victor uses romance — love and sexual desire — to incite individuals to crime. While jealousy had frequently been the motive for murder in earlier crime narratives, Victor makes complex this simplistic approach by using a variety of relationships founded on love, creating a multiplicity of motive and perhaps prefiguring the many-layered narratives of the Golden Age "clue-puzzle" crime fiction.

Victor gave other female characters detecting roles in her text: the first is Mrs. Scott, the gardener's wife at the Moreland's summer residence. Richard declares that "Mrs. Scott was an American woman, and one to be trusted; I felt that she would be the best detective I could place at that spot" (p. 37).[181] But Mrs. Scott proves to be severely limited in her investigative abilities, concluding, in a very feminine and irrational way that "*The house is haunted!*" (p. 98). A second investigating female is "Mrs. Barber, the knitting detective" (p. 70), who is hired by Mr. Burton specifically to spy on Leesy:

> He had a person hired to watch the premises of the nurse constantly; a person who took a room next to hers in the tenement-house where she resided, apparently employed in knitting children's fancy woolen garments, but really for the purpose of giving immediate notification should the guardian of the infant appear upon the scene [p. 70].

Leesy, however, escapes her surveillance, suggesting again the very limited ability of the female detective. Mrs. Barber is more of an instrument for surveillance than an active detective.

The women in this novel cannot, finally, be allowed full agency. Their investigative actions are either curtailed or are used in the service of masculine detection by male detectives. But their presence and the clever combination of elements of romance and domesticity woven into the crime narrative demonstrate Victor's innovative approach to writing detective fiction. By contrast to the "female detectives" produced in British fiction in the period, Victor's female investigators are allowed to retain their feminine roles and content, and as a result have limited agency. *The Dead Letter* has affinities with contemporaneous British novels: Richard's legal profession is reminiscent of barrister Robert Audley; the partially criminalized Leesy, although deemed insane, like Lady Audley in Braddon's *Lady Audley's Secret* escapes her fate. Richard's nervous system and breakdown is reminiscent of Walter Hartright's fragility at the start of Collins' *The Woman in White*. Victor's serial/novel works to forge a distinct place for the American female writer of crime and contributes to creating space that will later be filled by the female detective in crime fiction. While using the trappings of the domestic, the romantic and the sentimental genres, it is clearly a narrative of crime. *The Dead Letter's* classification as a domestic, romantic novel may explain why it has never really been considered until recently to be part of the tradition of U.S. crime fiction. Its publication date is close to that of Anna Katharine Green's better-known and more firmly designated detective novel, *The Leavenworth Case*, and this might also explain why *The Dead Letter* has been overlooked. But elements of Victor's plot structures are revisited later in Britain, and her work may have influenced the French crime writer, Émile Gaboriau. Similar patterns where the male makes use of feminine intuition or clairvoyance are seen in William Busnach & Henri Chabrillat's *Lecoq The Detective's Daughter* (1886), a text that draws on Émile Gaboriau's famous fictional detective, M. Lecoq, who featured in Gaboriau's novels of the 1860s and 70s. *Lecoq The Detective's Daughter* was published in London but, following Gaboriau, is set in Paris. "Mademoiselle Jeanne Muret," or as she is revealed to be later in the text, Jeanne Lecoq is, this study suggests, an older version of Lenore: she is "a girl of eighteen or twenty — a brunette, whom one could adore, of energetical mien, but far from displeasing, agreeable to the eye, though hers is a somewhat masculine style of beauty."[182] Continually only referred to as "Lecoq's daughter" (p. 142), she possesses powers similar to those of Lenore and like her predecessor is both under and subservient to her father's power. It is possible that William Busnach had read *The Dead Letter* and been struck by the innovative figure of Lenore. And, almost certainly, Victor's work both contributed to and made possible that of her more famous sister in crime, Anna Katharine Green.

Anna Katharine Green (1846–1935)

In 1878 Anna Katharine Green's groundbreaking novel, *The Leavenworth Case*, was published; this work has gained her the title of "Mother of Detective Fiction" and international recognition. In this same year Victor published her serial, "Dora Elmyr's Worst Enemy; or, Guilty, or Not Guilty," in Street and Smith's *New York Weekly*. To attest to the text's ongoing popularity, *The Leavenworth Case* has recently been released as a Penguin Classic, with an introduction by Michael Sims (London: Penguin, 2010). The majority of critics tend to locate Green as the first woman to write detective fiction, glossing over those women who, as this study has demonstrated, had worked in criminography before her. A critic writing in 1910 went as far as to state that "no other American detective-story writer has rivalled her for a moment."[183] Ellery Queen wrote that Green was "the first woman to write 'pure' detective stories in any land or language."[184] Patricia D. Maida, while comparing Green's work to Poe and to America's European counterparts, neglects the U.S. women writers preceding Green:

> Green's novel was significant. Although the detective novel was flourishing in Europe, America had produced no significant heirs to Edgar Allan Poe whose short stories marked the beginning of the genre in the 1840s.[185]

Albert Johannsen observes that there was a significant shift in the subjects and themes of American fiction in the late nineteenth century:

> The year 1877 saw the introduction of five new Beadle series [...] With the introduction of the broad-leaves, the type of story gradually changed and deteriorated, for instead of Indian and pioneer tales, news boy, boot black, bad men, Western, and detective stories became the rule.[186]

This study suggests that this change in the rules made it possible for American women writers to produce crime narratives more openly once the focus was on the detective rather than the criminal, introducing a note of respectability to the genre and so making it a suitable subject for women. Moreover, Green's work encapsulates a shift from the emphasis on France and Britain as the criminographic models to emulate; her novel draws upon previous forms not only to produce detective fiction but to pave the way for later detective works. In Green's text New York is set up as a rival to the crime publishing centers of London and Paris.

Green, real name "Anna Catherine Green," was, like her predecessor Spofford, a college-educated woman — something still relatively rare in the period.[187] In 1863 she attended Ripley College, Poultney, Vermont, graduating

in 1866, and her academic and subsequent literary successes contradict Joyce Warren's assertion that "the most significant aspect of women's status in nineteenth-century America was their powerlessness."[188] However, despite her education, Green initially kept her writing activities a secret from her father, James Wilson Green. Indeed, after *The Leavenworth Case*'s publication, the Pennsylvania legislature would not believe the female authorship of the text, commenting that "the story was manifestly beyond a woman's powers."[189] Such contestation aligns Green's reception with that of Spofford's "In a Cellar," where Thomas Wentworth Higginson — Spofford's friend and literary mentor — had to satisfy the editors of its real authorship by a "demure little Yankee girl."[190]

In a long writing career, Green produced short stories, novellas, poetry and plays as well as novels. Like her female counterparts in Britain and America she was diverse as well as prolific in her output.[191] Best-known are her serial detectives, Mr. Gryce, Amelia Butterworth, and Violet Strange. Mr. Gryce first appeared in *The Leavenworth Case* (1878), Amelia Butterworth — spinster — first appeared in 1897 in *The Affair Next Door*, and Violet Strange first appeared in 1915 in *The Golden Slipper and Other Problems for Violet Strange*. It is in creating these series characters that Green again is highly pioneering and, in terms of *The Leavenworth Case*, is probably one of the first writers to create a series character, if not the first.

Cheri L. Ross writes about "The First Feminist Detective: Anna Katharine Green's Amelia Butterworth."[192] Nancy Y. Hoffman considers Violet Strange as the pivotal figure: "Strange was probably the first woman detective extant, with disturbingly few successors despite the numbers of women detective writers."[193] Barbara Lawrence posits the figure of the female detective as an element in the feminist/anti-feminist debate and comments that "[i]t is difficult to say when the war began; perhaps the first antagonist was Anna K. Green herself. By the time she wrote *The Woman in the Alcove* (1906), she had created a female detective and was consciously writing about the capabilities of women."[194] Lawrence then postulates that "[p]erhaps it is A. C. Doyle who is responsible for the beginning of the war. By the time *The Woman in the Alcove* was written, Sherlock Holmes, with his moody, anti-social personality, was well established."[195]

This study's contention is that the first challenges in this "war" were made not through the female detective but rather through the female writer of crime narratives: Green built on the works written by her predecessors and her contemporaries. Lawrence does not acknowledge *The Dead Letter* in any form, and seems to use *The Leavenworth Case* as a departure point, which also reinforces this shrouding of prior crime-based writing by women in America. An example of Green's "building" on antecedent work is perhaps

most overt in her 1883 work, *X. Y. Z.* (New York: G. P. Putnam's Sons). This shows a British influence: William Russell/"Thomas Waters" names "Part III: X. Y. Z." in "Recollections of a Police Officer" (*Chambers's*, 1849–1853). Thomas De Quincey's essay, "On Murder Considered as One of the Fine Arts" (*Blackwood's*, February 1827) also shows this: rather than using his own name, De Quincey anonymously wrote this essay as "X. Y. Z." Green's incorporation of ballistics could echo the earlier and innovative work of Crowe who, in *Men and Women*, used ballistics to eliminate suspects. An examination of guns, to a lesser extent, was shown in Andrew Forrester Jun's Mrs. G — story, "The Judgement of Conscience" (1864). She consciously avoided following the traditional literary path for women. Although she draws on some of the sensational and melodramatic tropes used by British women writers who essayed to introduce crime into their fiction, Green does not use these as the crux of her novel. Rather, she takes what this chapter suggests is a new, American, realist approach to crime writing, as had Spofford before her. Knight observes that Green "avoids the improbable events that Collins, 'Felix' and 'Regester' had relied on in their approaches to the novel of detection."[196] Green's skills were admired across the Atlantic in Britain, where Wilkie Collins remarked that:

> Her powers of invention are so remarkable — she has so much imagination and so much belief (a most important qualification for our art) in what she says.... Dozens of times in reading the story I have stopped to admire the fertility of invention, the delicate treatment of incident — and the fine perception of event on the personages of the story.[197]

Later, Arthur Conan Doyle would meet Green in a visit to New York in 1894. The then President Woodrow Wilson said that he "got the most authentic thrill out of Anna Katharine Green's books."[198] Green has been valorized as a writer and implicitly as the first widely-recognized female crime writer and her work is considered to make an important contribution to the British crime novel as we now know it; A. E. Murch writes that "in her work we can discern for the first time, in its entirety, the pattern that became characteristic of most English detective novels written during the following fifty years."[199] There is, with *The Leavenworth Case*, a perceptible reversal in the inter-continental literary exchange: United States crime fiction is now influencing British crime fiction instead of vice-versa. Ross Nickerson argues that "[d]etective fiction histories place [Green] as an intermediary figure, a writer who brought together the transatlantic influences of Gaboriau, Poe, and Collins."[200]

Green is frequently compared to Émile Gaboriau because of the similarities in the two writers' plots and narrative structures. As Knight observes, Green, like Gaboriau, "interweaves romances, manipulates the reader's expectations, and manages a surprise ending."[201] Barrie Hayne writes that "she owes much [...] to Gaboriau's descriptive realism — save that her subject is the salon

rather than the street."²⁰² These French connections are important to the developing crime fiction genre, but there are also significant structural, narrative and thematic variations evident in Green's text, its publication and its reception.

Green's text breaks away from the publishing format of the earlier narratives discussed here, rejecting cheap publication in serial form and appearing only as a novel, and this shift would start to occur more generally. A significant element in Green's popularity was the change in the reading public: book production had become less expensive, people had more leisure time, literacy was becoming more widespread and reading novels was beginning to be considered a respectable pursuit; the crime/detective story benefited from these changes. Symons comments that Green's novel:

> was immensely successful, perhaps partly because of her sex, partly because of the familiarity she showed with legal and criminal matters (her father was a criminal lawyer), and partly — one is bound to think — because there were so few detective novels being written. [...] There are one or two other interesting details in the book, like the use of mirror writing and the detailed medical evidence, but as a story it is extremely feeble.²⁰³

Symons admits Green's success while denigrating her skill: he uses the feminized adjective "feeble" to describe her plot. But sales of the book, its contemporary reviews and, retrospectively, its clear influence on the genre indicate that, contrary to Symons' opinion, it was not "feeble" at all.

As the *Publisher's Weekly* noted in its "Obituary" of Green in 1935, "[t]hough Miss Green was totally unknown at the time, response to the novel was overwhelming: it eventually sold over a million copies."²⁰⁴ Michael Mallory calls Green "the first bona fide American bestseller, selling a staggering three-quarters of a million copies over a fifteen-year period."²⁰⁵ That the novel was taken seriously is apparent in the decision of Yale Law School to put *The Leavenworth Case* on the syllabus.²⁰⁶ Its popularity is further demonstrated by the publisher announcing that by 1903 "its publishers announced that they had worn out two sets of plates reprinting the regular edition and were making another set,"²⁰⁷ and Green's novel was dramatized in 1891. Barrie Hayne adds that *The Leavenworth Case* "enjoyed a long run on the stage, and was also twice filmed: as a silent feature in 1923, which seems to follow the novel fairly closely, though dropping Gryce to leave the lawyer-narrator as the only detective; and in a sound version in 1936 which appears to bear little relation to the original."²⁰⁸ This can be compared with Crowe's earlier *Susan Hopley*, which was popular at the time and was adapted for drama.²⁰⁹ There can be no doubting the importance of Green's novel both in the development of the detective novel and as evidence of the increasing American influence on crime writing generally.

Curiously, Green preferred to think of herself as a crime writer rather than the creator of detective fiction. As she requested of a journalist in an interview in 1902:

> Please do not call my books "detective stories" ... I abhor the word detective. It is too often applied to atrocities. I choose crime as a basic subject because from it arise the most dramatic situations, situations which could be produced by nothing else.[210]

Green's reaction may have been inspired by a desire to raise the literary status of her text above the cheap dime novels in which detective fiction more commonly appeared. She describes her novel as "so passionate, so strong, so subtle, so dread, dark, and heart-rending it ought to be written with fire and blood. It will require all my enthusiasm, study, and power."[211] The *New York Times* obituary of Green retrospectively admired her skilful plotting:

> with the possible exception of "The Moonstone" it was not until the publication in 1878, of the Brooklyn young woman's "Leavenworth Case," that the art of sending the reader on a false track regarding the guilty person, and, at the end, of taking him completely by surprise with a convincing solution which had never occurred to his imagination, was developed into a fine art.[212]

Green, after her death, was given a writerly status matching that of the acknowledged master of detective fiction, Wilkie Collins, the author of *The Moonstone*, what T. S. Eliot suggested was the "first, the longest, and the best of modern English detective novels."[213]

Green's novel is very clearly set in America; in New York, to be precise, with occasional forays elsewhere. There is no attempt to relocate distasteful occurrences in the narrative to other countries, although there is a British connection. But more than its American setting or even its female author, it is innovative in the introduction of a number of themes and tropes, now familiar to the reader of crime fiction, but then new and exciting. *The Leavenworth Case* is original in its deployment of ballistics, science, medicine, and a coroner's inquest, the illustration of the crime scene, replica letters, and the inclusion of the locked room mystery. There is a diagram of the murder scene and the layout of the library, hall and bedroom, a ploy familiar to modern readers of the Golden Age detective fiction of Agatha Christie.[214] While some of these elements had appeared in earlier criminography, the way in which Green cleverly combines them locates her text as the forerunner of what Knight has called the clue-puzzle mystery. Éugène Vidocq, in a long story in Volume 3 of his *Mémoires*, both finds and reproduces a fragment of a letter found in the text. Green may have been influenced by this trope, yet she adds more and interweaves her clues within the puzzle and text. Textual incorporation was popular, as was newspaper reportage; these are seen in *The Mystery of a Hansom Cab* (1886), Poe's "The Mystery of Marie Rogêt" (1842–3) and

"The Purloined Letter," *The Notting Hill Mystery*, where a fragment of a letter is found in the Baron's room, and *The Dead Letter*, among many others. Sutherland, in his *Stanford Companion to Victorian Fiction* does not include an entry under Green and attributes the invention of the locked room murder mystery to Israel Zangwill (1892). Stephen Knight also has Zangwill's *The Big Bow Mystery* as "the first locked-room mystery novel."[215] In Le Fanu's story, "The Murdered Cousin" (1851), he included a doubly locked room where a murder had taken place. Green's text and detective both prefigures and directly influences one of the most famous masculine detective figures of the next century: Agatha Christie's Belgian detective, Hercule Poirot. Indeed, Gillian Gill's biography of Agatha Christie has shown that Christie had read Green, with Christie's sister, Madge Miller Watts, providing the initial impetus for Christie's crime-writing career by reading *The Leavenworth Case* aloud to the family when Christie was around eight years old.[216] Green's detective is Mr. Ebenezer Gryce of the New York metropolitan police; he is assisted by a gentleman, Mr. Everett Raymond, who is a junior member of the Leavenworth law firm and who narrates the tale. The use of a middle-class professional as narrator was perhaps a device that made the text and its police detective acceptable to its middle-class audience.

Her use of references from canonical and non-canonical British texts for the epigraphs that head each chapter suggests that Green was self-consciously positioning *The Leavenworth Case* in a specific, mainly masculine literary tradition, with writers such as Shakespeare, Spenser, Wordsworth, Coleridge, and Milton. By including these, Green not only displayed her literary knowledge and education but made respectable what had generally been considered literature suitable only for the lower classes. Green had stated that "[c]rime must touch our imagination by showing people, like ourselves, but incredibly transformed by some overwhelming motive."[217] In this, Green is following William Godwin, who declared that in writing *Caleb Williams* (1794), he first conceived a tale of pursuit and then sought a motive that would justify the pursuit.[218] Godwin also used the device of a servant betraying his master, and Green's narrative draws on this when the criminal in *The Leavenworth Case* proves to be (the ironically named) middle-class and respectable James Trueman Harwell, the secretary and murderer of Mr. Leavenworth. Similarly to Godwin's protagonist, Harwell breaks the bounds of the employer-employee relationship and the limits of class as criminality is associated with the lower orders. Ross Nickerson writes of "the mischief of a liminal class figure, the secretary who hovers between the ranks of servant and business professional."[219]

This social indeterminacy and the potential threat posed by such undefined figures are also present in Alcott's "Behind a Mask," represented

by the governess/"criminal" Jean Muir. Furthermore, Harwell is a double murderer, killing not only his employer but later Hannah Chester, the lady's maid and seamstress to the Leavenworth nieces/wards. Green may have been influenced by Crowe's *Men and Women*, where the double murderer Groves, (who is Sir John Eastlake's procurer and manservant) avenges his sister, who was ruined by Eastlake. Harwell's criminal motivation is his obsession with and unrequited love for Mary, Mr. Leavenworth's ward, and his criminal machinations are carried out with the intention of winning her hand. This "romantic" aspect and the sexual motive are similar to those in *The Dead Letter*, where murder is partly instigated by Thorley's jealousy of Moreland; in Green's text, Harwell believes that enabling Mary to receive her fortune from Leavenworth (as a result of his death) will make her indebted to him. The self-centeredness of the criminal and his motivation, in fact and fiction, led Green in 1919 to write that "the great truth I have learned through my study of crime and its motives is that evil qualities are inevitably those which center in Self."[220]

The murders in *The Leavenworth Case* are premeditated: one is a direct consequence of the other. The reader is informed of the death of a wealthy retired tea merchant, Mr. Horatio Leavenworth — the first victim — on page one. He is shot in the head while sitting at his library table, in a locked room, and with no apparent motive for the murder, as nothing has been stolen. The use of a pistol suggests a distinctly American method of murder; in European crime fiction, poison or stabbing are more common methods. Although pistols made appearances in earlier crime narratives, the gun used in this instance — which was Mr. Leavenworth's personal gun — not only shows that arms are both within the house and on the individual person in America, but it is a brand name: a Smith and Wesson. This suggests that guns are readily accessible and are almost a household name. The gun the murderer — Trueman Harwell — uses has been cleaned but he neglects to clean the cylinder. Murder among the wealthy and respectable provokes Mr. Raymond, the lawyer, to question the integrity of the domestic space: "What was the secret of this home?" (p. 95), placing Green's narrative in the tradition of sensation fiction in its focus on the domestic sphere, but which also gestures towards the later Golden Age crime fiction where the home becomes a place of danger rather than of safety and refuge. Furthermore, where in sensation fiction the lower-class police detective is shown to be ineffectual, in Green's text Mr. Gryce not only enters the middle-class home but succeeds in his detective work, albeit with the assistance of the middle-class Mr. Raymond.

Harwell kills his second victim, Hannah Chester, in order to prevent her from giving information that might lead to his arrest. She is made a suspect at the inquest because of her disappearance from the house on the same night

that Mr. Leavenworth had been murdered. Displacing suspicion onto an Irish serving woman in this way is reminiscent of the treatment of the lower-class figure of Leesy in Victor's *The Dead Letter*. This is ironic as criminal threat is located in the higher echelons, reworking conventional criminal assumptions. In the novel the paper — the *Herald*— writes about her disappearance and offers a reward. They also disseminate a description of her couched in criminal terms and descriptions of offenders not wholly dissimilar from descriptions in the police gazettes. They describe Hannah:

> Form tall and slender; hair dark brown with a tinge of red; complexion fresh; features delicate and well made; hands small, but with fingers much pricked by the use of the needle [...] Beside the above distinctive marks, she had upon her right hand wrist the scar of a large burn; also a pit or two of small-pox upon the left temple [p. 83].

As with Leesy, Hannah — for a majority of the narrative — evades capture by the detective/s. She is removed from the text when she is given poison, a white powder disguised as a love charm, in a letter from Harwell. While this gives the impression that she has committed suicide, the murder is in part a plot mechanism to prevent the disclosure of any crucial information pertaining to the case to the other characters in the text and, by proxy, the discerning reader. The women in this novel are generally, like their predecessors, subject to the manipulations of the men around them.

Mr. Leavenworth's two nieces, Mary and Eleanore, are also victims, although not of murder. The names are the same as the two sisters in Victor's *The Dead Letter*. In *The Dead Letter*, however, Eleanor is spelt without an additional "e." There are conflicting descriptions of both cousins throughout the novel as the plot incriminates each in turn. At one point in the narrative, Raymond declares of Mary, the sole heiress, "What an actress this woman was!" (p. 68), locating her in a long line of deviant women with dramatic skills such as Braddon's Lady Audley and Alcott's Jean Muir and Pauline Valary. Mary is represented as a conscious and charming manipulator of people and situations. Raymond later draws attention to Mary's instability of character; she is "[h]aughty, constrained, feverish, pettish, grateful, appealing, everything at once, and never twice the same" (pp. 123–4). However, when Mr. Gryce suggests that Mary might be complicit with the murder of her benefactor, Raymond struggles with this idea, considering it to be impossible for a woman to commit murder, and reiterates his convictions about Clavering as the perpetrator: "But he is a man. It does not seem so dreadful to accuse a man of a crime. But a woman! and such a woman! I cannot listen to it; it is horrible" (p. 193). In an era when women were almost universally denied autonomy and control over money, children and property Mary is, not surprisingly, motivated by money; she explains to Mrs. Belden why she conceals

her marriage to Clavering: "Mr. Clavering is not poor; but uncle is rich. I shall be a queen" (p. 243) and "I have been taught to worship money. I would be utterly lost without it" (pp. 243–4). Mary, though, is finally returned to proper femininity, renouncing her ambitions and donating her inheritance to charity; these actions are a consequence of her repent for her greed acting as an impetus for Harwell to murder her Uncle.

The other niece, Eleanore, is also suspected of the murder. Evidence, circumstantial and empirical, seems to point to her guilt. Eleanore refuses to divulge Mary's secret in order to protect her, but her position and innocence is established by the close of the novel and she is safely taken into masculine control as she becomes Raymond's romantic partner. This has parallels with *The Dead Letter*, but the love interest is reversed here: in *The Dead Letter* it is Eleanore who is initially coveted by Richard, and this love or admiration is then displaced onto Mary. In *The Leavenworth Case* it is Eleanore who is admired from the beginning, even though this admiration cannot be acted upon until she is wholly cleared from suspicion of her uncle's murder. In keeping with this, the final sentence of the novel takes the story away from crime and winds it back into romance, domesticity and sentimentality. Raymond explains that "we went out again into the night, and so into a dream from which I have never waked, though the shine of her dear eyes have been now the load-star of my life for many happy, happy months" (p. 331).

Perhaps Green's most radical move in her fiction was in her central detective figure, the lower-class New York detective, Ebenezer Gryce. This is unlike the previous American crime narratives and the work produced by women in Britain. Gryce appeared in her later texts and so was a serial detective. Crime fiction reader, critic, and writer, "S. S. Van Dine" (Willard Huntington Wright), defines him as being "as competent and convincing a solver of criminal riddles as America has produced."[221] Maida suggests that "it is possible that Doyle derived the concept of Watson from Green" and her figure of Gryce,[222] while DuBose observes that:

> There is a bit of Inspector Gryce in most of the fictional professional detectives that have followed. He was the first genuine series detective [...] More than any of its predecessors, *The Leavenworth Case* set the standard for professional police work in detective fiction.[223]

An initial description of Gryce emphasizes Green's intentional play with generic conventions in the representation of the detective:

> Mr. Gryce, the detective, was not the thin, wiry individual with the piercing eye you are doubtless expecting to see. On the contrary, Mr. Gryce was a portly, comfortable personage with an eye that never pierced, that did not even rest on *you*. [...] you might as well be the steeple on Trinity Church, for all connection you ever appeared to have with him or his thoughts [p. 5].

The omniscient sight, stressed so heavily in earlier crime fiction, is reworked in this context. Gryce's actions could be reminiscent of Peters' in Braddon's *Trail*; Raymond comments: "Turning my attention [...] in the direction of Mr. Gryce, I found that person busily engaged in counting his own fingers with a troubled expression on his countenance" (p. 66). Gryce — and Green — are also capable of creating new conventions; when Raymond asks Gryce who he suspects as Mr. Leavenworth's murderer, he answers: "Every one and nobody. It is not for me to suspect, but to detect" (p. 8). The impact of Green's work and this phrase is later seen almost verbatim in the phrase used in the Pink Panther films (beginning in 1963) by the French police detective, Inspector Jacques Clouseau. Although Gryce is "detailed as police officer and detective to look after this case" (p. 66), the constraints of class are still in place. As Gryce explains to Raymond: "have you any idea of the disadvantages under which a detective labors? For instance [...] you imagine I can insinuate myself into all sorts of society, perhaps; but you are mistaken. [...] I cannot pass myself off for a gentleman" (p. 106). Gryce, like his predecessors, is still subject to some of the limitations imposed by his social status, even in the allegedly less socially-stratified America. It is Raymond who makes Gryce's presence acceptable and mediates these limitations.

As a police detective officer, Gryce is in part at least, and realistically, motivated in his investigations by money; he tells Raymond "I have done the business; the reward is mine; the assassin of Mr. Leavenworth is found, and in two hours will be in custody" (p. 296). It is at this point in the novel that Gryce still lets both Raymond and the reader believe that Mary is the murderer. Socially inferior, Gryce wields power indirectly in his control over knowledge and information. Gryce says to Raymond about Mary when he finds out she is married to Clavering: "Are you so much surprised? It has been my thought from the beginning" (p. 192). This was seen earlier in *The Dead Letter* and will be replicated later with Doyles' Watson and Holmes. Gryce's depiction at the trial contrasts with that of Braddon's Peters at Richard's trial in *Trail*: "The coroner seemed satisfied, and was about to dismiss the witness [Eleanore] when Mr. Gryce quietly advanced and touched him on his arm. "One moment," said that gentleman, and stooping, he whispered a few words in the coroner's ear" (p. 63). These words are to ask Eleanore about the soiled handkerchief which was found in Mr. Leavenworth's room. Gryce's hands, in this instance, combine with his insight and make an impact upon the direction of and questions asked within the trial.

Peters, conversely, while assisting Richard through meanings conveyed by his hands is not allowed to directly interject or converse with the law and its proceedings. It is not until Chapter XXVI — "Mr. Gryce Explains Himself" (p. 193) that he reveals the extent of his knowledge and the results of his

investigations; he explains that he did not correct Raymond as that was the way for both theories to be tested. At the same time, though, Gryce is not infallible, and Green renders him realistically. For example, he suffers incapacitating rheumatism and his "helpless limbs" (p. 201) align him with the feminine, rather as Braddon's dumb detective, Peters is feminized by his inability to speak. By the end of the narrative, as the chapter title "Mr. Gryce Resumes Control" (p. 268) suggests, he is put back in charge of the text and the case. He successfully apprehends the correct culprit and gains his reward.

As in *The Dead Letter* there is quasi-detecting/investigative figure and lawyer who narrates the story through his personal perspective: Everett Raymond. The novel's first line sets up his presence and occupation as a respectable upper-class lawyer rather than a detective. In discussing the need to identify Henry Clavering, Raymond comments that "the part of a spy was the very last one I desired to play in the coming drama" (p. 108). Carnell's discussion of Braddon can, in this instance, relate both cross-culturally and to Raymond; she writes that "amateur gentleman detectives in three volume novels are reluctant to tell lies or adopt other identities."[224] Because of this class positioning, Raymond indicates that he is not interested in a share of the reward and says to Gryce that "[m]y reward will be to free an innocent woman from the imputation of crime which hangs over her" (p. 158). While this comment explicitly articulates earlier concerns about the surveillance element of detective work, it is simultaneously self-conscious in its commentary on melodrama and acting, which were previously connected with the Gothic and sensation sub-genres. By emphasizing these dramatic elements, Raymond (and his creator, Green) are purposeful in their divergence away from these prior forms and into the creation of the more fully defined detective fiction genre.

Additionally, Green incorporates curious and fleeting detective figures that are secondary to Gryce. Gryce has international connections: he has an informant, "Brown," based in London, who sends Gryce a telegram in cipher with information about Clavering. This is another instance of Green playing with prior criminographic conventions. In this case the detecting figures appropriate what has previously been a criminal means of discourse, used by such figures as Jean and Hortense in "Behind a Mask," the criminals in *The Dead Letter*, and Poe's "The Gold Bug." A further transitory detecting figure is Mr. Fobbs, who is "[d]etailed by Mr. Gryce to watch the movements of Miss Eleanore Leavenworth" (p. 71). He is the person who finds blood-stained "bits of partly-burned paper" (p. 163) under the coal on the day of the inquest and removes the coal from the fire until he finds a broken-handled key. Mr. Fobbs then disappears from the novel, yet Raymond suggests that he is a ubiquitous presence. When Raymond is discussing the newspaper accusation with Eleanore he "looked away, the vision of Mr. Fobbs, in hiding behind the cur-

tains of the opposite house, recurring painfully to my mind" (p. 96). This description reinforces the classed stereotype of the detective as a spy on the upper classes. In this respect, Mr. Fobbs and his surveillance can be compared with Mrs. Barber, "the knitting detective" in Victor's *The Dead Letter*. Mr. Fobbs, however, is more active.

The other assistant detecting figure is "Q," short for "query"; he is an agent employed by Gryce to track down Hannah. Q is introduced as "a brisk young man" (p. 179), and "the slyest and most successful agent in Mr. Gryce's employ" (p. 179). Despite this success, Q's function is to aid Raymond; Gryce tells Raymond that "the affair is a little too serious for him to manage alone. He is not equal to great occasions, and might fail just for the lack of a keen mind to direct him" (p. 201). Q's underhand spying tactics are akin to those of his predecessors in Britain and America, and, in Q's action of peering into Hannah's room, he is more specifically reminiscent of Collins' Marian Halcombe in *The Woman in White*, and Poe's orangutan; he explains to Raymond that: "I crawled up on to the ledge of the slanting roof last night while both you and Mrs. Belden were out, and, looking through the window, saw her moving around the room" (p. 226). Importantly, Q has an ability to disguise his appearance and transform his gender so well that he is not initially recognizable to Raymond. Raymond comments on Q's infiltration of Mrs. Belden's residence as a tramp woman:

> I saw, standing in the open door leading into the dining-room, the forlorn figure of the tramp who had been admitted into the house the night before. Angry and perplexed, I was about to bid her be gone, when, to my great surprise, she pulled out a red handkerchief from her pocket, and I recognized Q [p. 220].

Q and Mr. Fobbs are important figures as they fill in the detecting gaps; this emphasizes that Gryce cannot do everything, and so presents a realistic representation. Q, like Mr. Fobbs, having played out his role, subsequently vanishes from the text.

Unlike Q and Mr. Fobbs, however, Anna Katharine Green did not disappear after the publication of *The Leavenworth Case*: she and her text set a precedent for later crime fiction, and Green continued to develop the genre for the remainder of her writing career. While Green's work has (rightly) been valorized and often-discussed, little account has been made of those important American women writers whose contributions to the developing genre enabled in part Green's work. In comparison with their British counterparts, the American exponents showed themselves to be less restricted in what they could write; this is perhaps, to some extent, indicative of a new democratic and less socially-constricted country. Alexis de Tocqueville's writing on the adolescent American girl envisions this liberty:

> Long before an American girl arrives at the marriageable age, her emancipation from maternal control begins: she has scarcely ceased to be a child, when she already thinks for herself, speaks with freedom, and acts on her own impulse. The great scene of the world is constantly open to her view: far from seeking to conceal it from her, it is every day disclosed more completely, and she is taught to survey it with a firm and calm gaze. Thus the vices and dangers of society are early revealed to her; as she sees them clearly, she views them without illusion, and braves them without fear; for she is full of reliance on her own strength, and her confidence seems to be shared by all around her.[225]

British and American crime narrative writers shared common themes of crime and the treatment of women, both writers and characters; yet the American women authors seem able to break the boundaries without recrimination. These women were voicing their social dissent in their deviant crime narratives more freely than could their British counterparts. The American crime writing in this period is significant as it demonstrates the shift from America imitating Britain to America inaugurating new modes of writing which the British would later take up.

In the wake of Green, women writing crime became almost commonplace in America. A year after *The Leavenworth Case*, Emma Murdoch Van Deventer wrote the little-known *Shadowed by Three* under the masculine pseudonym of "Lawrence L. Lynch, Ex-Detective."[226] This novel is not mentioned often — if at all — in critical work,[227] although Panek writes extensively on Deventer under the sub-title of "The Other Woman."[228] Van Deventer wrote over two dozen detective stories, mostly appearing in the 1880s and 1890s. A significant amount of these titles signify their status by including "detective" somewhere in the title. *Shadowed by Three* included the feisty figure of Lenore Armyn and received a favorable contemporary review, which stated that: "The elements of "a detective story" are well known, and we say deliberately that none worthier of the name has appeared for some time." They add that "this book [...] is written with a good deal of force and spirit, and displays in its plan unusual powers of invention, and a thorough knowledge of 'the business.'"[229] A reason for the neglect of *Shadowed by Three* could be that the narrative is set in Chicago, where it was also published. Worth noting is Van Deventer's later novel, *Madeline Payne, the Detective's Daughter* (1883/4), which preceded by two/three years (and in all probability influenced) William Busnach & Henri Chabrillat's *Lecoq The Detective's Daughter* [*La Fille de M. Lecoq*, 1886].[230] The impact of Britain's Mary E. Braddon can be seen in Van Deventer's *Against Odds* (1894), when a female character comments that "[s]omehow I seem to have gotten into a new world, and I might very well pose for a Braddon heroine."[231]

Another woman novelist writing crime and detection in the period was

Bessie Turner. Turner first wrote *A Woman in the Case* (1875), which, as she commented, was purportedly "founded in fact," dealing with kidnapping and inheritance with the detecting figure, John Hardy, gaining both the inheritance and his romantic interest. Later, Turner wrote a short novel, *Circumstantial Evidence* (1884). Its premise is an exposé of and attack on "the shortsightedness of men, and circumstantial — the worst of all — evidence."[232] In 1887 New England writer and friend of Green, Mary R. Platt Hatch, would start a writing career, that included periodicals, poetry, articles, and five mystery novels, with her first novel, *The Upland Mystery: A Tragedy of New England* (1887). These figures attest to the lineage of women writers in America who contributed to the form after *The Leavenworth Case*.

This chapter has shown that American women were innovative in their crime writing, forging ahead as both advocators of women's rights and importantly contributing to a holistic view and conception of the genre, with its interconnections and diversions from Britain. But even more unheard of — and probably even more unfairly unheard of — are the women who were simultaneously writing important crime narratives in Australia.

Three

Australia

Introduction

> "'Faultlines' run from one point of intersection (of concurrence and conflict) to another, inscribing the lack of fit or harmony between codes of difference on the cultural map."—Susan Sheridan, *Along the Faultlines: Sex, Race and Nation in Australian Women's Writing 1880s-1930s*, 1995

> "To be down-under is to be, by cartographic definition, disorientated, upside down, inside out, lost."—John O'Carroll, "Upside-Down and Inside Out: Notes on the Australian Cultural Unconscious," 1999

So far this study has concentrated on the continents and crime narratives of Britain and America. Crime fiction, however, was itinerant and synchronic and also manifested itself in Australia. This formation has not usually been mapped, but that is not to say that Australia was a (literary) *terra nullius*.[1] Australia's purported "wilds" are an avatar of James Fenimore Cooper's and Charles Brockden Brown's American frontier, and the Australian urban literary landscape likewise functions as a transposition and doubling of Britain; as the *Australasian* reported in "A Suburban Study":

> In Bourke-street west we have Smithfield and the Barbican over again; Burlington-street and Saville-row find their doubles in Collins-street east; Cannon-street is reflected in Flinders-lane; Bourke-street is High Holborn, with a difference; Fitzroy-gardens and East Melbourne are Kensington in the bud; Lower Thames-street is the prototype of Flinders-street.[2]

While this extract is reminiscent of the London cartography seen in *Bleak House* and in Braddon's geographical reworking of the city in *Trail*, it also encapsulates the simultaneous mimesis and "difference" enacted in Australian literature and, as this chapter will show, specifically in Australian women's crime writing.[3]

In terms of literary critical focus and in comparison to Britain, America

or France, Australian crime fiction, while equally important and prolific, is not usually accorded the same status or critical attention as its cousins from the northern hemisphere. And when Australian crime fiction is discussed as part of the country's literary heritage, it has more usually been male Australian writers who are extolled as icons of national literary culture and identity. This is consequent upon the retrospective creation of a national myth (of "mateship," the outback, and the figure of the bushman) and the contributions of the *Bulletin* writers in the 1880s and onward. This masculinist viewpoint is seen in the valorization and anthologization of writers of the post–1880 period, such as "Rolf Boldrewood" (Thomas Alexander Browne), Hume Nisbet, Basil Farjeon, E[rnest] W[illiam] Hornung, Ernest Favenc, Guy (Newell) Boothby, Francis Adams, Edmund Finn, and Patrick Quinn. The most recognized and celebrated instance of Australian crime writing is Fergus Hume's best-selling *The Mystery of a Hansom Cab* (1886). This was published in Britain and America as well as Australia, so taking Antipodean criminography to the world. Anne Summers confirms this masculine emphasis, commenting that "there has existed throughout Australian history a systematic omission of women from what have been judged the highest achievements in any field."[4] But this "systematic omission" does not mean that women were not in actuality producing literature, including crime fiction.

Earlier, however, the Victorian gold rushes of the 1850s and the consequent influx of people raised issues about crime, identity, and a need for control; the goldfields and their attendant social heterogeneity were a site of anarchic and criminal potential. Simultaneously, there was a proliferation of literature about perceived increases in levels of crime and the possible measures that might be taken to regulate it. This in turn led to fictional accounts: A. W. Baker has noted that "1830–68: [signals] The End of Transportation; [and] The Beginning of Fiction."[5] More specifically, this mid–nineteenth century "beginning" also sees the beginnings of the genre of crime fiction in Australia. Curiously, there has been, as Stephen Knight writes, "[n]o place of any substance [...] found for Australian crime fiction in the national literary histories."[6] Furthermore, other countries' accounts of the genre ignore Australia. Alma E. Murch's *The Development of the Detective Novel* makes no reference to Australia, an oversight that, by extension, implies that the Australian woman crime writer is doubly forgotten. Murch, writing in and looking back from the 1950s, states that:

> A very considerable proportion of the popular novels and short stories written in England, France and America during the last hundred years are of the type known as Detective Fiction.[7]

Murch, though, is not alone in her exclusion of Australia as a producer of detective fiction. Ordean A. Hagen writes on the "Mystery Novel Abroad,"

yet does not mention Australia; Martha Hailey DuBose, in her analysis of mid–nineteenth-century detective fiction, only discusses that produced by the three countries of England, France and the United States and their impact upon one another.[8] Aaron Marc Stein ignores Australia as he traces what he sees as the traditional genealogies of the detective or crime novel:

> the detective story, despite its American birth, had its earliest post–Poe development in France. [...] it was only a short time before the word had crossed the channel and English authors avidly began to take up the detective story. From Britain it quickly made the return journey across the Atlantic to reroot itself lustily in the land of its birth.[9]

In the twenty-first century, *Investigating Identities: Questions of Identity in Contemporary International Crime Fiction*, while illuminating, considers many countries, but not Australia.[10] *Poe Abroad: Influence, Reputation, Affinities*, does not include a chapter on "Poe in Australia," although his impact was felt.[11] However, John Sutherland in *The Stanford Companion to Victorian Fiction* (1989) includes Australian criminography, but centers on male authors. By contrast, Knight not only draws attention to the proliferation of crime fiction produced in nineteenth-century Australia, but defines several social and historically inflected sub-genres of Australian crime fiction which came into being in the period: "Convict Stories," "The Goldfields Mystery," "Squatter Thrillers," and "The Criminal Saga."[12]

This neglect of Australian literature is related to colonial publishing and print culture practices. At mid-century the internal publishing climate of Australia was favorable. Elizabeth Webby comments that "[t]he discovery of gold in New South Wales and Victoria at mid-century led to a renewed interest in Australia from publishers, readers and writers."[13] The gold rush and its lucrative potential aroused public interest as well as creating crime; with this there also emerged factual reportage as well as fictional accounts of felony. Yet colonial writers were in competition with Britain; imported fiction and (pre-copyright) fiction by British and American authors could be obtained via international piracy. While this does not devalue Australia's output, it does somewhat impede the international dissemination of its literature and external circulation proved problematic. As Tim Dolin summarizes:

> the shipment of print products was largely one-way: it made one home — mid–Victorian Britain — more vitally present and real than the other, colonial Australia, which was either absent, hurried over, falsified, exoticised, or distorted.[14]

Knight, discussing Peter Temple and contemporary Australian writers, notes that this still exists today: "A double disadvantage operates against Australian crime writers. One is what historian Geoffrey Blainey identified as 'the tyranny of distance'— that is, a locale far away from the New York and

London publishing houses."[15] British and American authors whose work appeared in Australian publications included Charles Dickens, Wilkie Collins, Edward Bulwer-Lytton, Charles Reade, J. Sheridan LeFanu, Anthony Trollope, and later Arthur Conan Doyle and Thomas Hardy.[16] But the list was not entirely confined to male writers; Johnson-Woods writes that "[t]he most frequently appearing author was M. E. Braddon."[17] Margaret Oliphant and Mrs. Henry Wood were also featured,[18] while American women were represented by Metta Victor and Harriet Beecher Stowe.[19]

Toni Johnson-Woods has written that "[t]hough many periodicals published colonial writers in their earliest years, after 1870 imported fiction usurped the local material."[20] Woods compiled a table of imported and colonial serials in 1875, with the imported: colonial ratio being 17:5. In the *Australian Journal*, when Marcus Clarke was editor, he inaugurated "The Library Table" in March 1871, which comprised reprints; the *Australian Journal* explained:

> The Conductor of the *Australian Journal*, not being in a position to secure "original" contributions from Wilkie Collins, Mark Twain, Arthur Helps, Alfred Tennyson, and others, thinks that perhaps the public will not object to read a good thing because somebody else has read it before them, and in this hope intends for the future to set apart a few pages of the *Journal* for amusing and instructive matter, culled from the works of the most famous of all nations.[21]

These included Poe's short stories, Lytton's "The Haunted and the Haunters; or the House and the Brain," and Hoffmann's "Walpurgisnacht." This British printing predominance is echoed in H. M. Green's investigation into imported British magazines within Australia and their prominence in Sydney in 1866; he states:

> From Barton's figures it is clear that these periodicals were well read. The figures are worth analysis: *Good Words* sold 1750 copies a month and the *London Journal* 1500; *Punch* sold 690 and *All the Year Round* 335; among the heavier weights, the *Cornhill* sold 425, *Blackwood's* 92, *Macmillan's* 68 and the *Edinburgh* and *Quarterly* 40 and 46 respectively.[22]

This was the same for American fiction: Massina and Company's *Once a Week* (Melbourne) serials were comprised of "98% [...] written by American authors."[23] Woods, speaking generally of the impact of American writing on colonial periodicals, writes that "[m]ost of them came from the most popular American story-papers, the *New York Ledger* in particular. *Ledger* serials appeared in *Once a Week*, the *Australian Journal*, and the *Queenslander*."[24] The opening address of the Melbourne weekly, the *Australasian*, stated that "the colonists may, upon the whole, congratulate themselves that, if the press here and there partially fall short of the standard at home, it is, at any rate, many hundred degrees above the American."[25] In relation to American piracy,

the editor of the *Australian Journal*— discussing an unnamed story — wrote: "though we should not have taken the tale from its American source had we known that an English serial also took it, we see our own original papers— both stories and poetry — so frequently copied by American periodicals, that we never have any hesitation about extracting American productions that are worth copying."[26]

This material was circulated within Australia not only in the periodical press but by libraries. Samuel Mullen (1828–1890) inaugurated his bookshop and Select Library in Melbourne in 1859, based on Charles Edward Mudie's Circulating Library in London, while George Robertson had set up a bookselling and publishing company in Melbourne in 1852. From the mid-century onwards, there was a surge of production of Australian weeklies, daily newspapers and periodicals, many of which appeared initially in Victoria, Sydney and Brisbane. Of the many Australian authors writing in the period, J. S. Borlase was one of the few published in England, but this was not an avenue open to all. Borlase commented on the restricted publishing opportunities and lack of financial reward in Australia in an article for the British *Temple Bar* in 1870, calling the restriction a literary "semi starvation" and going on to say "[f]or ordinary writers there is not the slightest opening in any of the Australian colonies, least of all in Melbourne."[27] This "semi starvation" was not new, as another article, this time in the *Colonial Monthly* in 1869, demonstrates:

> As matters stand, we have practically no literary rewards, honours, or hopes of fame to offer colonial youth.... The local author in Victoria has been and is systematically kept down. It is appointed by law that he shall not write for popular serials, because the publisher's profit is so artificially restricted, that he cannot afford to pay for original composition, and he must not raise his price in the face of English competition artificially favoured.[28]

Knight, in his examination of early constructions of Australian fiction, observes that Australian "crime writers in general were overlooked and genre rather than gender was the major reason for disregard — Borlase was as much ignored as Fortune, Robert Whitworth quite as unknown as Ellen Davitt."[29] If this was the case for the Australian male writers, then the female criminographer is doubly distanced from the international publishing arena.

The magazine which published most of the authors discussed in this chapter was the *Australian Journal: A Weekly Record of Amusing and Instructive Literature, Science and the Arts* (hereafter *Journal*), which had a wide audience. Established in Melbourne in 1865 the *Journal* ran until 1962. A peer periodical described it to be:

> Based on the plan of the English Weeklies, such as the *Family Herald, London Journal, Cassell's Papers* & c, [and] takes up ground hitherto unoccupied, there

being no magazine in the Colonies devoted to the general reader; or to the entertainment of ladies and youth;-no publication wherein the literature of Australia may find a suitable abiding place.[30]

G. B. Barton estimated that in 1866 the *Australian Journal* averaged 5,500 weekly copies and that 1,750 of these were sold in New South Wales, equaling the English best seller, *Good Words*.[31] It was innovative in its concentration on crime writing, which was perhaps because its founding editor — George Arthur Walstab — had a personal interest in crime, writing a story, "Confessed at Last" (*Journal*, 25 April–8 August 1868), and a novel, *Looking Back* (1864), which recounted his experiences as a cadet in La Trobe's Victorian Mounted Police (1852–54). Walstab left the *Journal* and started editing his own magazine, the *Australasian Monthly Review*, in March 1866. Later in his career, Walstab translated some of the crime fiction of the popular French author, Émile Gaboriau.[32] However, Andrew McCann comments that "[t]oday the *Australian Journal* is itself all but forgotten but for [Marcus] Clarke's involvement with it and its publication of his masterpiece [*For His Natural Life*]."[33] But the recovery of many of the *Journal's* crime stories has been made possible by Victor Crittenden and the numerous reprints published by the Mulini Press under their *Australian Books on Demand* imprint.

As far as "real" crime was concerned there was in Australia, as in Britain and America, a perceived need for control in the form of policing/detecting figures. John Harris, the grandfather of John Lang (generally regarded as the first Australian-born and published writer), has been called "the first Australian policeman" by G. F. J. Bergmann. Harris functioned in a rudimentary, thief-taker capacity. As in Britain, such figures were met with suspicion and perceived to be *agent provocateurs*; a contemporary emigrant to Australia, Alexander Harris, wrote that these early police officers were men "who have crept up from their own ranks by cunning and sycophancy, and because they would do any dirty work rather than submit to bodily toil."[34] Mounted police appeared in the 1820s in Victoria and later, in 1842, Aboriginal men served under white officers, with the Native Police Corps established by Henry E. P. Dana. The indigenous "black trackers" were depicted as being in tune with the land in a way similar to Cooper's Natty Bumppo, even though Bumppo was a white American brought up by Native American Indians. In Australian fiction indigenous trackers feature in William Howitt's *Tallangetta* (1857) and J. B. O'Reilly's *Moondyne* (1879). They are also represented in contemporary iconography; the *Illustrated Sydney News* features an illustration of two clothed trackers: "Trackers Finding the Pistols. The Murder of Mr. T. Ulicke Burke, at Piggoreet, near Ballarat, Victoria" (No. 37, Saturday 15 June 1867, p. 185). Yet, on page 229 of the same number/volume there is an illustration of "Aboriginals Roasting Emu," in which the two figures are naked

(16 September 1867). Later, Arthur Vogan wrote a collection of short stories: *The Black Police* (London: Hutchinson, 1890). In the early twentieth century the internationally known and popular writer, Arthur W. Upfield, wrote a novel series (beginning in 1929 with *The Barrakee Mystery*) featuring part-Aboriginal Inspector Napoleon "Bony" Bonaparte. Bonaparte was both a graduate and a black tracker. These stories were set in Queensland and the outback. Knight has discussed more recent indigenous detective writing, including Mudrooroo Narogin's Detective Inspector Watson Holmes Jackamara of the Black Cockatoo Dreaming stories (beginning in 1990 with "Westralian Lead") and Philip MacClaren's *Scream Black Murder* (Sydney: HarperCollins, 1995).[35]

A detective force was inaugurated, also in Victoria, in 1844, comprising a sergeant and four constables.[36] This was augmented in 1862 (to 41 detectives) as a consequence of the gold rush and its attendant influx of population. Dean Wilson and Mark Finnane write that "The Detective Branch remained autonomous from the general body of police, having its own rank structure and recruiting civilians directly. By 1862, the Branch had expanded to 41 detectives distributed across the colony in detective districts, where one, two or three detectives were stationed."[37] Like their international counterparts, they were prone to corruption. In 1862, Charles Hope Nicolson, Inspector of Detectives, compared the criminal class in Victoria to that of England. Nicolson thought the numbers of criminals in Victoria were double that of England, a reason being that people perhaps turned to criminality as they were "more demoralized, owing to the convict element with which they come into contact."[38] Later, the real-life personage of John Christie, who has retrospectively been labeled as "Australia's Sherlock Holmes," appeared.[39] He wrote memoirs purportedly derived from real events in the 1870s which were later reported in newspaper articles in Melbourne in the 1890s. Christie was a hybrid figure, amalgamating the roles of detective and thief taker, having been fired for resorting to shady methods. The contemporary reception of policing figures displays a distinctly Australian shift that is reflected in fiction. "William Burrows," J. S. Borlase and initially Mary Helena Fortune portrayed positive representations of Australian police yet, as the 1854 Eureka Stockade with its insurgent gold miners indicated, an anti-authoritarian stance emerged and was prevalent post–1860. This alteration of perceptions contrasts with the United Kingdom, where the police were unpopular at their inception in 1829–30 but popular, at least in fiction, by the 1850s, and police anecdotes were still in vogue in the 1860s. The Australian shift of opinion with regard to the police paved the way for the anti-police Australian male of later fiction, typified in Banjo Paterson's celebrated song, "Waltzing Matilda" (1895).

Moreover, women featured within policing configurations. The role of women in Australia, in life and literature is summed up succinctly by the title

of Anne Summers's influential book, *Damned Whores and God's Police: The Colonization of Women in Australia*. Women were homogenized as "Damned Whores" and then subsequently as "God's Police" (from 1840 onwards), but they could be either in the same period. "Damned Whores" were initially categorized "based on the fact that virtually all of the white women to come here [Australia] in the first two decades of colonization were transported convicts, but it was continually reinforced by the social structure which evolved in the penal colony."⁴⁰ And Summers states that within this penal colony "women were assigned only one main function – they were there primarily as objects of gratification."⁴¹ The change from "Damned Whore" to "God's Police" was enacted in tandem with "[t]he 1840s [which] saw the first wave of Australian nationalism."⁴² The role of "God's Police" was predicated on wives and was ideological: to function as upholders of moral virtue.

And it seems that this gendered and delimiting template was a hard one to shake. While women were policing women and men, and the domestic milieu, it was a long time before the female policewoman appeared in reality in Australia. The first appointed policewoman in (South) Australia was Fanny Kate Boadicea Cocks (better known as Kate Cocks) in 1915; America had the first policewoman in Los Angeles in 1910, while the British were slow to appoint female constables, waiting until 1923. The Australian Women's Register has the first Australian policewomen in Queensland in the Roma Street Police Station in 1931, Ellen O'Donnell (1896–1963) and Zara Dare (1886–1965). These women were still limited in capacity and neither were officially sworn in; they performed tasks such as looking after lost children, escorting female prisoners, and assisting abused women.⁴³ The South Australian Register wrote in 1915 that "[t]he movement for women police is not a fad of ultra-moralists. Still less is it a freak development of the women's rights agitation. It represents a serious effort to remedy certain social conditions which cannot be alleviated by other means."⁴⁴ H. A. Lindsay outlines the duties of the first Australian women police:

> They did little in the way of tracking down criminals. Their work consisted mainly in patrolling dance halls, parks, beaches and other places where young people congregate, on the lookout for girls under age. They also watched railway stations, bus terminals and wharves. They developed a flair for detecting girls who were trying to appear over eighteen, or who had run away from home.⁴⁵

These limitations upon women in reality both extended to and were enacted in representations of female detectives in fiction: female detecting figures were not included as characters in Australian fiction. And these social and gendered restrictions extended to women writing fictional crime, as this national part title will discuss.

Because of its role as a location for transported criminals, from Australia's inception there has been a proliferation of writing which incorporated, and later specialized in crime. This study has already mentioned that the mid-century was a boom time for crime narratives, yet crime writing was circulating prior to this. Australia has had inextricable carceral connections since the arrival of the first fleet (Botany Bay, 20 January 1788). And with these convicts there came songs similar to or having their origins in the ballads which were sung in Britain; for example "Bold Jack Donohoe" (the Irish incarnation) became "The Wild Colonial Boy" (named "Jack Doolan" or "Duggan") in the Australian context. In the latter ballad, the eponymous figure is from Castlemaine, Victoria. The "Wild Colonial Boy" becomes a bushranger, and, to some extent, follows a similar path to Jack Donohoe in that he dies at the end of the ballad.[46] Initially, crime writing was concerned with dangerous convicts and was, for the majority, envisioned from a European perspective. These early texts include Thomas Wells' *Michael Howe, the Last and Worst of the Tasmanian Bushrangers* (1818) and the London-based hack writer Thomas Gaspey's *The Adventures of George Godfrey* (1828). In this latter text, the eponymous hero is transported to Botany Bay and the story features bushrangers, melodrama, corruption, ex-convicts, and the threat of cannibalism. At this moment in fiction, the action set in Australia is confined to an episode in the text as a whole and does not dominate the narrative. Rather, it is a chapter in the *Bildungsroman* of George Godfrey.

The first criminally inflected novel to be written and published in Australia was Henry Savery's *Quintus Servinton: A Tale founded upon Incidents of Real Occurrence* (1830–1; published in Hobart). Servinton was a convict, transported to Port Arthur for issuing pretend bills. Servinton's fictional crime of forgery parallels with the factual position of the writer, Savery himself. Knight elucidates that "[b]oth author and hero were involved in issuing fictitious bills—that is, commitments to future payments which can themselves be used as a form of security."[47] The emphasis at this point is still on England (where the novel both starts and finishes, with Australian content interpolated). Charles Rowcroft's works start off in a similar vein, containing fact and fiction in his three-volume *Tales of the Colonies, or The Adventures of an Emigrant* (1843). This initially endorses a British colonial/imperial perspective on Australia (Tasmania). Then there is a shift into fiction: in volume two there appears the voice and narrative of a head bushranger, Gypsey, who, in telling his tale, invites the readers' sympathy. Rowcroft's fictional follow-up book, *The Bushranger of Van Diemen's Land* (London: 1846), focuses on the bushranger of the title, Mark Brandon, who, with other escaped convicts, seizes a ship. Heroic elements—which will later be a staple in the construction of the Australian national myth—are introduced in his portrayal. Also appar-

ently written in 1846 was *Ralph Rashleigh,* the purportedly factual account of a convict. However, the literary self-consciousness and sensationalism of the narrative undermine this assertion and James Tucker — a criminal who wrote comic drama — has been suggested to be its author.⁴⁸ The facts surrounding *Ralph Rashleigh,* however, are still very dubious and its authorship is unconfirmed.⁴⁹

Born in Australia (Parramatta, New South Wales), John George Lang (1816–1864) is considered to be the first fully Australian novelist and both the man and his work signify how Australian crime fiction is now localized. Lang was a barrister; he worked in London and India and was also a writer of crime fiction. He wrote for Dickens' *Household Words* in the 1850s, including the popular story, "The Ghost on the Rail" (5 March 1853), and a novel, *The Secret Police, or Plot and Passion* (1859), which was set in Napoleonic England. "The Ghost on the Rail" was later reprinted in book form in 1859 in *Botany Bay*. Knight contends that "[i]f ghosts can be accepted as detectives [...], then it is also Australia's first detective story."⁵⁰ Lang's first foray into crime fiction proper was the novella, *Frederick Charles Howard* (1842), the first of an anonymous series entitled "Legends of Australia." Victor Crittenden claims that this novella is "the first truly Australian tale" and that is "unlike any that precede it."⁵¹ It is set in Sydney, where the protagonist Howard has been transported after the murder of his father-in-law in 1836. Australia is represented as a "country where tyranny and cruelty then raged throughout."⁵² Howard's beautiful wife, Isabella, follows him to Australia and traces him to his hut in the Shoalhaven country wilds. Yet the criminal element is somewhat ameliorated when Howard informally joins the mounted police. The happy couple, reunited, remain in Australia, a development from the more usual pattern where closure would be signaled by a return to England.

Lang later wrote *Barrington* (1859), a tale based on a real ex-convict, the Irish pickpocket, George Barrington, who was transported to Sydney in 1791 but later became a chief constable of Parramatta. A collection of stories by Lang, *Botany Bay or True Tales of Early Australia,* was released in 1859 (appearing in *Household Words, The Welcome Guest* and *Fraser's Magazine*). Crittenden also attributes the novel *Lucy Cooper* (*Sharpe's Magazine,* London 1846) to Lang.⁵³ Set in the 1830s, this novel realistically conveyed the threats the convict world presented for a woman. Cooper has been transported to Sydney for an unnamed crime; she subsequently endures various hardships until finally she obtains a ticket of leave, but remains in Australia.⁵⁴

In 1855 Lang published *The Forger's Wife or Emily Orford* (London: Ward Lock); this had similarities to *Frederick Charles Howard*— a devoted, pretty wife follows her convicted husband to Australia. Originally serialized in *Fraser's Magazine* (1853) and reprinted as a serial in *The Mofussilite* in 1855.

This text was reprinted in later editions as *The Convict's Wife: A True Tale of Early Australia* or *Assigned to His Wife*. In London (Bentley, 1860), Anne Beale wrote *Gladys the Reaper*: in this, Chapter XL was titled "The Forger's Wife." This was set in the U.K., but was possibly influenced by Lang as it is verbatim with his novel's title and appeared five years after Lang's narrative. H. M. Green has described *The Forger's Wife* as "crude and melodramatic," yet it should not be written off as such.[55] The novel begins in England but is then set, for the most part, in convict-era Sydney. It relates the tribulations of the heroine, Emily Orford, and the exploits of her ignominious husband, forger and confidence man Charles Roberts alias Reginald Harcourt, who eventually becomes a bushranger and dies; Emily subsequently returns to England. The novel features George Flower, an ex-convict, thief taker/proto-detective figure and self proclaimed "king of traps" (p. 94).

It later transpires that Flower is Emily's illegitimate half-brother. Nancy Keesing states that Flower was based on the real-life policeman in Sydney, Israel Chapman.[56] Both Chapman and Flower are endowed with a photographic memory for faces, and the representation of Flower was perhaps influenced by the earlier narratives such as the anonymously authored British text, the picaresque *Richmond: Scenes in the Life of a Bow Street Runner* (1827). While Flowers plays a deceptive role (he masquerades as a convict-bolter, "Teddy Monk," in Millighan's bushranger gang), employs violence and is financially driven, he is also discerning: he ascertains that Roberts' certificate of freedom is a forgery. While shown as proud, veracious and having morals, Flower oscillates in his representation. He pockets Roberts' little pistol, extracts £50 from Mr. Isaac Abrahams for receiving Emily's stolen writing-desk, and he purloins the gold and jewelry from the bushranger den. Flower's interaction with Nelson — the convict-informer — to obtain information about the receiver of Emily's writing-desk is violent: "striking Nelson on the bridge of the nose a blow which swelled up both his eyes and felled him to the earth. '*That* writing desk,' repeated Flower, placing the thick sole of his boot upon Nelson's neck. 'Gurgle up the receiver, or I'll squeeze out your poisonous existence.'"[57] Flower comments that the certificate of freedom found in Roberts' pocket "is uncommon *like* old Secretary Macleay's signature, but hang me if it *is* his—no, it can't be. I say, how comes the water-mark on the paper to be of later date than the pardon itself?" (p. 38). Equally, there is a sense of both (Gothic) doubling and respect between Millighan, the bushranger chief, and Flower. The novel describes Millighan: "In short, he was very like George Flower in disposition and accomplishments—as good looking, and as active" (p. 76). Flowers, though, advocates reformist ideas to Major Grimes (a settler who had been a major in the Royal Artillery and whom Millighan targets for his store houses full of supplies): "I wish to teach

you settlers, and the Gov'ment, and bushrangers, a great moral lesson. I want to make you more independent and secure — bushrangers less numerous and daring — and Gov'ment more economical and sensible" (p. 113).

This novel contests (pre)conceptions of Australia, as voiced by Emily, who suggests that it is an "uncouth and cruel land" (p. 31). While Flower has become prosperous by the novel's close and sails back to England, he ultimately returns to his home in N.S.W., Australia. This sense of grounding and national identity is enacted in Flower's language and Australian dialect; his Australian nationality is confirmed when, in his visit to England, he resists assimilation back into the mother country and the English find him difficult to understand. The characterization of Flowers challenges "[t]he idea that wherever Australian speech differs from that of England it must be corrupt and distorted."[58] While Emily is passively portrayed, used and prostituted by her husband and does not believe in his (repeated) guilt until very late in the narrative, there are other, intriguing criminal female characters. There is the unscrupulous "Enchantress," who attacks Roberts with a carving-knife, and a bushranger woman named Ellen Leger, who is later slain in the showdown with Roberts. Curiously, Flower, upon capturing Millighan's posse, makes the two escapee convict women in the gang ("Mother" — Elizabeth Norris — and "Sister Sall") dress as mounted police. Flowers states to Major Grimes that "[t]hese are ladies, you know, overseer, and capital police they make, too" (p. 95). The representation of these peripheral female characters in the Australian setting hints at potential for women in other arenas outside of those which the contemporary reader might have expected.

Following Lang, the pseudonymous and still unidentified "William Burrows" wrote the first tales about crime on the Victorian goldfields in *Adventures of a Mounted Trooper in the Australian Constabulary* (1859)[59] and *Tales of Adventure by a Log-Fire* (1859). Burrows' first novel interconnects with the plethora of procedural stories that appeared in Britain and elsewhere in the 1850s and '60s, yet the crimes committed are distinctly Australian, revolving around gold licenses, bushrangers, and "cattle-duffing" (cattle theft). Moreover, the location of the narratives is also firmly Australian in the goldfields/diggings and townships of Victoria. The crime/s represented here and the criminals are now Australian-born in contrast to the imported crime of transported convicts.

Examples of other male Australian crime writers and their native narratives include William Howitt's *Tallangetta: The Squatter's Home* (1857); Henry Kingsley's three-volume *The Recollections of Geoffry Hamlyn*, which has a bushranger as central character (London: 1859); "Robin Goodfellow" (pseudonym of Thomas Harrison, c. 1830–1901): "Was it Murder? Or, Passages in the Life of a Tasmanian Settler" (*Australian Monthly Magazine*,

December 1866–February 1867); "The Undiscovered Crime" by F. E. S (*Australian Journal*, 23 May–2 June 1866); and F. S. Wilson's "Broken Clouds! An Original Australian Tale" (*Illustrated Sydney News*, 16 May 1866–August 1867). An advertisement for the latter tale states that "[u]nlike many (so called) Australian novels, the whole action is confined to the Colony." It also purports to authenticity: "Being an Australian story, written by an Australian, many of the recorded incidents have come under the author's own observation, while the descriptions of scenery may be relied on as faithfully delineated — and not the mere imaginings of an inventive mind."[60] Set in N.S.W., it features a detective — "the little hard-featured [...] Mr. Keen" (p. 11), has a murder (of Mr. Dansby, who is strangled), a lawyer (Mr. Kenworthy), and a murderer (Harry Claston). As in "The Diary of Anne Rodway" (1856) a piece of cloth (part of a neck-tie/cravat) is found clutched and twisted around the dead man's fingers. Disguise is also employed: Mr. Keen tells Mr. Kenworthy of an old case of his on the diggings, where he "assumed the character of a doctor" (p. 11) in order to capture a murderer, Nick Marston, who had had his finger nearly bitten off. Keen humorously states that "[m]y first surgical operation was to slip a pair of handcuffs over Nick's wrists" (p. 11).

It seems that at least one Australian version of the British and American pseudo-autobiographical casebooks popular in the period appeared also, with the anonymous "Leaves from a Surveyor's Field Book."[61] Later texts were B. L. Farjeon's *In Australian Wilds* (1870); Robert P. Whitworth's *The Trooper's Story of the Bank Robbery* (1872), and a serialized crime novel, *Mary Summers: A Romance of the Australian Bush*, which included a detective — David Turner: "the best, sharpest, and most wary officer in the detective force"— and which appeared in the second issue of the *Journal* in September 1865.[62] There was also Campbell McKeller's *The Premier's Secret* (1872); and the first Western Australian novelist, J. B. O'Reilly, who wrote a convict story, *Moondyne: A Story of the Underworld* (1879).

Another writer of some importance was Charles (Edward Augustus) de Boos (1819–1900). Born in London and emigrating to Australia in 1839, he was a journalist, reporting on the goldfields, and later a mining warden and police magistrate. He is best-known for *Fifty Years Ago: An Australian Tale* (1867).[63] De Boos also wrote *The Stockman's Daughter* (1856), which involved two bushrangers — Rover and "Opossum Jack"— and is focused on the mystery posed by the titular stockman's lowly status. This was serialized in the Sydney newspaper, *The People's Advocate* and appeared three years prior to Kingsley's *The Recollections of Geoffry Hamlyn*. Victor Crittenden writes that "*The Stockman's Daughter*, the earlier novel by Charles de Boos, was lost in the files of the newspaper in which it was published anonymously and so never considered as either interesting or important."[64] His daughter works to clear her

father's name and, after he is murdered, not only confronts the bushranger and his gang but, with the assistance of an Aboriginal named "Quart Pot," bails them up. While Victor Crittenden comments that "[s]he is a real hero!," and while adding that "[s]he was certainly brave and determined and she faced a gang of violent men," he is also ambivalent about her.[65] The use of an indigenous assistant is an Australian parallel to Fenimore Cooper's "Leatherstocking Tales" featuring protagonist Natty Bumppo and his Mohican companion, Chingachgook. The representation of the stockman's daughter builds on that of the challenging women in Lang's *The Forger's Wife*, and is reminiscent of the avenging amateur female sleuths of Britain such as Collins' Anne Rodway, Magdalen Vanstone, and Valeria Macallan; Crowe's Susan Hopley and Julie Le Moine; Braddon's Eleanor Vane and Jenny Milsom; and Wood's Barbara Hare. But, as with Anne Rodway et al., it is the daughter's lover who appears and takes over, capturing the villains and seeing them hanged in Sydney, so implicitly restoring masculine control.

Mark Brown's Wife: A Tale of the Gold-fields was published in the *Sydney Mail* in 1871, with its narrative set in 1854. This is a very violent story and the criminal impetus and content arises from Ruggy Dick, the villain, and his actions. Mark Brown's wife, Cicely Drake, is made a fallen woman as a consequence of Dick's deliberate miscommunication of information. Dick intercepts Mark's letters to Cicely, and then anonymously and deceptively informs Cicely that her husband, Mark, is dead. This information leads her to be seduced by and bear the illegitimate child of "the Master" in whose house she was working. To add to this list of insults and unfortunate incidents imposed upon Cicely, she is then murdered by Dick. A similar fate awaits Mark: Dick shoots Mark through the shoulder, breaks his jaw, then strips his body and places it on top of an ant bed. Cicely can be aligned with Emily (in *The Forger's Wife*) in that she is the passive subject of male violence and deceit: her illegitimate baby dies, she is subjected to mental shock and falls into disrepute. But she responds actively when she meets Ruggy Dick and pushes back his black wig:

> Swiftly and suddenly she turned upon Jem, and with a spring like a tigress seized him by the black silk handkerchief which he wore around his throat. [...] her little hand became fixed like iron into the handkerchief she had seized, and was now twisting till she almost strangled him who wore it. "Murderer," she moaned out, "I know you now, and you shall never leave here till you go into the hands of the hangman!" [p. 105].

He subsequently kills her but, while at this point they are still victims of male violence, Australian women seem to assume more agency in these criminal narratives than their British sisters, and even take on a detective function at times.

Mark Brown's Wife features a detective figure — a miner and friend of Mark Brown, who is called Tom Drewe, and who for the most part retrospectively narrates the tale. As with Lang's Flower, Tom sounds authentically Australian in his use of colloquial language, but he also instills the values of "mateship," which will be central later in the century. Tom's painstaking detective work is contrasted to the corrupt and incompetent police. He mixes detecting modes by employing the methods of an indigenous tracker at the diggings to find Job Hicks and his dog. Tom's final confrontation with Dick is indicative of the retributive capacity of the Australian land itself; in attempting to escape, Dick falls down a shaft concealed by dry bushes:

> But though he still lived, he was completely crushed and mangled by his fall, legs and arms being broken, and every part of his body having suffered, except his head [...] He had injured his spine, and death within a few hours was inevitable. And so it was; amidst tortures unspeakable, and unable to move a limb, the murderer died before daylight [p. 131].

As Dick's death is not instantaneous, the land punishes and tortures him for his crimes. Perhaps de Boos was influenced by Borlase who, in his story, "The Night Fossickers of Moonlight Flat" (1867), includes a fossicker and criminal — Spider-legged Ned — who pushes his criminal partner, Tom, into the old Tolvadden shaft, which is the deepest on the Flat.

Marcus (Andrew Hislop) Clarke (1846–81) made a move towards the detective story in "Wonderful! When You Come to Think of It" by "M.C." (supplement to the *Hamilton Spectator*, 26 January 1865).[66] Lucy Sussex comments that not only was this Clarke's first story published in Australia but "the earliest Australian detective story so far discovered."[67] And this was perhaps the first Australian parody of the British 1860s casebooks: the narrator and detecting figure, Benjamin Bloggins, mentions reading Poe's mysteries ("The Purloined Letter") and explicitly cites Russell's "Waters," saying that he has "bought all the "Recollections of Detective Police officers" too, and studied them intensely."[68] In this sense, "Wonderful!" can be read as an anti-detective story, mocking "Waters" and the London "plodding" form of the 1860s: Bloggins is portrayed as a comical and bumbling figure, continually drawing the wrong conclusions and recounting "the process of making an ass of myself" (p. 2). The repetition of the title phrase, "Wonderful!," attests to this, and serves as the signifier of his incompetence.

Two months after "Wonderful!" came the still anonymous "Experiences of a Detective" by "E. C. M." (*Australasian*: 11, 18 March, 1865); this was clearly crime fiction in the casebook format with a police detective narrator. Clarke's work as a journalist also showed his interest in crime, with the "Night Scenes in Melbourne" series (*Argus*, February–March 1868) and the "Lower

Bohemia" sketches/series in the *Australasian* in 1869. These and his later sketches are both reminiscent and show the impact of Dickens's 1830s newspaper *Sketches by Boz*, but with an Australian context. Clarke's criminal emphasis also links to and follows the pattern of Dickens's *Household Words* police anecdotes on Scotland Yard detectives. Clarke lends his work verisimilitude by stating that he had police support for his night-time adventures in the criminal underworld. Additionally, he wrote historical sketches about transportation, violence and convicts (collected as *Old Tales of a Young Country* (Melbourne, 1871)); "The Doppelganger" (*The Australian Monthly Magazine*, July 1866), which harks back to earlier crime/Gothic configurations in its German setting, murder and ghostly/dead doubles, and the posthumously published *The Mystery of Major Molineux* (1881).

As were Walstab and Whitworth, Clarke was an editor of the *Journal* (between March 1870 and September 1871), but he is best known for his influential and retrospective accounts of the terrors and violence of the transportation system in *His Natural Life* (*Journal*, March 1870–June 1872; revised novel, 1874).[69] Andrew McCann writes that "Clarke's *His Natural Life* is perhaps the only nineteenth-century Australian text that enjoys the status of a classic and circulates as such beyond the confines of distinctly national boundaries and processes of canonisation."[70] And Stephen Murray-Smith has stated that "[f]orty years after its original publication a poll found it the most popular Australian novel."[71] The impact of Clarke can be shown by the fact that an American writer, Leon Lewis (1833–1920), wrote "Found Guilty; or, the Hidden Crime" (*New York Ledger*, 1878), which was about a wrongly accused British convict transported to Australia. *His Natural Life* is Gothic in its concentration on and relaying of psychology, is sensational, melodramatic and intertextual. Clarke's text concerns the plight of an English gentleman—Richard Devine (later Rufus Dawes)—who is expelled by his father and is then wrongly accused and convicted of murder and subsequently transported to the penal settlement of Macquarie Harbor in Tasmania. In contrast to earlier convict narratives, Devine is innocent of the crime for which he has been transported.

In the serial version he changes his name to Tom Crosbie and becomes a shop keeper on the goldfields before returning to England. The Gothic doubling of Flower/Millighan in Lang's *The Forger's Wife*, is again seen in the characters of Richard Devine and John Rex, the latter character being both a villain and Richard's enemy. The characterization of Sarah Purfoy in *His Natural Life* could suggest that Clarke had read Alcott's "Behind a Mask." Sarah has congruencies with the character of Jean: she is insurgent, and adept in her manipulation of older men (Captain Blunt). Sarah also has detecting affinities; she tells John Rex, her escaped husband:

> There is not a single act of your life, John Rex, that I do not know. I have traced you from the day you stole out of my house until now. I know your continental trips, your journeyings here and there in search of a lost clue. I pieced together the puzzle, as you have done, and I know that, by some foul fortune, you have stolen the secret of a dead man to ruin an innocent and virtuous family.[72]

The modification of the serial into novel form signified a change; the reduction in length refocused the text on the Australian context, with only a brief section devoted to the London beginnings of the story and without the return to England. Instead, Devine dies at sea protecting Sylvia, the child of the woman he loves but is never attached to. *His Natural Life* extends the convict theme earlier seen in Henry Savery's *Quintus Servinton* (1830–1), and this Australian concentration will be seen again and become more prominent and centralized with the work of J. S. Borlase.

J. S. (James Skipp) Borlase (1839-date of death unknown) was a crime writer who was later to co-author the first Australian detective series with Mary Helena Fortune.[73] Born in Truro, Cornwall, he emigrated to Melbourne in 1864. A practicing solicitor in Melbourne, this means of employment was closed to him after he was arrested for both deserting his wife (Rosanna) and fleeing to Tasmania in January 1865. Deprived of this source of income, he turned to writing and began writing children's literature, history/historical nouvelettes and crime fiction. In 1887 he would claim in an interview that he was first published in fiction papers at age nineteen, while he was studying for the law.[74] With Fortune, Borlase extended the goldfields format seen in "Burrows'" work; they created a Victorian goldfields version of "Waters" and the other police casebooks of the 1850s and '60s with their detailed accounts of the detection of crime by the mounted police. Borlase and Fortune's collaborative police procedural series in the *Journal* appeared almost simultaneously as "Memoirs of an Australian Police Officer" (September 1865–February 1866) and "Adventures of an Australian Mounted Trooper" (October 1865–February 1866). Borlase's featured a mounted policeman detective, James Brooke, but tracking who wrote what exact story becomes problematic as both writers interchanged police series; and this intermixing extended to detective figures—for example, Fortune used Borlase's detective, James Brooke, in her story "The Dead Witness." Speaking of these writers' two detectives (Borlase's James Brooke, and Fortune's Mark Sinclair), Knight asserts that Brooke and Sinclair are "two of the most simply engaging and least ideological of fictional detectives."[75] Fortune and Borlase's series and their imbrications have proved extremely hard to separate; Lucy Sussex and John Burrows have detailed this in "Whodunit?: Literary Forensics and the Crime Writing of James Skipp Borlase and Mary Fortune."[76]

Their computer-based textual analysis of unnamed fiction in the *Journal* found that rather than Fortune's first story being "The Dead Witness" (1866), she wrote "The Stolen Specimens" in October 1865. They have also found that number five of Borlase's initially anonymous "Memoirs of an Australian Police Officer"—the short story "The Dead Witness"—was in fact Mary Fortune/"W.W.'s." They established strong evidence that she had a hand in five other stories, including "Mystery and Murder," which were reprinted under Borlase's own name in the English magazine, *Reynolds's Miscellany* (27 January 1866), and then as part of his collection: *The Night Fossickers and other Australian Tales of Peril and Adventure* (London: Warne, 1867); this story ("Mystery and Murder") was again later reprinted in *Stirring Tales of Colonial Adventure* (London: Warne, 1894), and *Australian Tales of Peril and Adventure, told by an Officer of the Victorian Police* (London: Warne, 1870). "The Shepherd's Hut" was published again under "J. S. Borlase" in *Reynolds's Miscellany* in January 1866.

The inaugural issue of the *Journal* (September 1865) included the anonymous story (which was written by Borlase), "The Shepherd's Hut; Or, 'Tis Thirteen Years Since." This popular story included an unnamed detective and, after the pattern of Vidocq's *Mémoires*, declared itself to be true crime but, given the content, this is highly unlikely. While we know it as fiction, in relation to "The Shepherd's Hut" and its contemporaneous status as fact or fiction, the *Athenaeum* indeterminately wrote:

> Whether Mr. Borlase ever held in reality, as well as in imagination, a prominent place in the Melbourne police force, or whether, in claiming consideration for services which he rendered to the cause of order and efficient government in the character of a detective, he merely makes bold use of one of the licenses permitted to writers of fiction, we do not care to enquire. It is enough for us to know and report that the perilous, no less than strangely mysterious adventures described in his *well-written, though highly-sensational volume*, are just such adventures as the reasonable reader can believe to have fallen to the lot of a chief of police [...] Under ordinary circumstances, we are slow to commend books that invest crime and criminals with melodramatic interest; but *their dramatic art and unusual force place Mr. Borlases' tales of peril and adventure high above spurious revelations of London and Edinburgh police officers*, and vicious compilations from the annals of our criminal courts. Whether he be ex-policeman or not, Mr. Skipp Borlase is not to be ranked with those fabricators of 'Confessions' and 'Curiosities' [...] *Regarded as short tales written to rouse emotions of horror and intense longing for the result of atrocious circumstances, his stories will well endure comparison with things in the same way and for the same end by Edgar Allan Poe.*[77]

"The Shepherd's Hut" was followed by "The Missing Fingers" (No. II of "Memoirs"; November 1865). This story may have influenced Wilson's "Broken Clouds" (published a year later in the *Illustrated Sydney News*), where the

detective, Mr. Keen, relates how "the murderer [Nick Marston] had one of his fingers nearly bitten off. What does he do but tears a coloured pockethandkercher of most peculiar pattern into strips, binds up his hand with part of it, and leaves the remainder on the floor of the tent" (p. 11).

Borlase was fired from the *Journal* for plagiarizing Sir Walter Scott in 1866. Borlase's work was said by the *Australian Journal's* "Our Whatnot" column to bear "more than a mere "family likeness" to "Ivanhoe," and other obscure productions of an unknown Scottish baronet."[78] He then returned to England and reprinted his *Journal* short stories in English magazines and also in a collection, *The Night Fossickers and Other Australian Tales of Peril and Adventure*.[79] Stephen Knight has found evidence for Borlase having appropriated "William Burrows'" *Adventures of a Mounted Trooper in the Australian Cavalry* (1859); Borlase's story, "Pursuing and Pursued" (9 December 1865) has similarities to "Burrows" in a description of police barracks in Melbourne. Other connections arise between Lang's *The Forger's Wife* and "The Duel in the Bush" (11 November 1865). Additionally, portions of Ellen Clacy's *A Lady's Visit to the Gold-Diggings of Australia* (1853) are evident in "The Night Fossickers of Moonlight Flat."[80] Lucy Sussex summarizes that

> Precisely how many other borrowings are concealed within the pages of *The Night Fossickers* is unknown at this point in time. However, given the instances already cited, the text already seems a Stolen-Goods store.[81]

With this in mind, Borlase's description of his work, in a private letter to a publishing firm in May 1895 seems somehow ironic: he wrote "*I am very quick to gauge the taste of the reading public in such matters*" and "I have never written a story that I have been unable to sell, even though I have not a spark of true genius but merely a power of mechanical construction, which has perhaps served me in better stead."[82] Borlase also claimed that he had been "for a long period editor" of the *Australian Journal*.[83] This statement, however, has not been substantiated and it is still unclear who ran the magazine in the period between Walstab and Clarke. Sussex writes that "[h]e may have briefly taken over when Walstab left the magazine, perhaps in December 1865."[84]

His other collected work and novels include *Bluecap the Bushranger, or the Australian Dick Turpin* (1885); *Daring Deeds: Tales of Peril and Adventure* (1868); *Australian Tales of Peril and Adventure*, told by an Officer of the Victorian Police (1870); *Stirring Tales of Colonial Adventure: A Book for Boys* (1894); and *Ned Kelly: The Ironclad Australian Bushranger* (1881). Further to this, Sussex has interconnected Borlase and crime/mystery writing with another writer, Adam Lindsay Gordon (1833–1870)—a poet who had emigrated from England to Australia.[85] Mary Fortune and her stories/connection with Borlase will be examined in more detail later in this national part title.

While the discussion above shows the development of the crime form in the hands of Australian male writers, Australian women too were busy writing crime. As in Britain and America, Australian women were faced with similar impediments to their attempts to write crime and turned to other forms in the first instance. Mary Fortune, however, while writing in other forms and genres, was one of the first women to specialize in crime. Other Australian women writers achieved popularity: Ellen Clacy's *A Lady's Visit to the Gold-Diggings of Australia in 1852–3* ran to several editions. Australian-born Louisa Atkinson's writing includes the novel *Gertrude the Emigrant: A Tale of Colonial Life by an Australian Lady* (1857) and other works which were serialized in the *Sydney Mail*. But while they depict colonial and domestic life in the goldfields, there are no tales of murder and her narratives do not represent the harsh realities of such lives. Elizabeth Lawson defines Atkinson as writing "Victorian romance-melodrama" with "intrusive explicit moralizing."[86] However, this national part title wishes to focus on women's writing that incorporated crime in some way, and the rest of the sub chapters will concentrate on the crime and mystery work of Céleste de Chabrillan, "Oliné Keese" (Caroline Woolmer Leakey), Eliza Winstanley, Ellen Davitt, and Mary Helena Fortune.

Céleste de Chabrillan (1824–1909)

Australian women writers, although not initially writing crime fiction *per se*, were dealing with crime in their writing. Céleste de Chabrillan, or Céleste, Comtesse de Chabrillan (1824–1909) and her writing exemplify this; she was a Frenchwoman who moved to Australia with her husband (the French consul to the Victorian colony) in 1854. Chabrillan was also known as her nickname, "La Mogador." With a background as a dancer, prostitute, courtesan, and circus performer, Chabrillan challenged social convention in her life as well as in her literature. A. R. Chisholm writes that "Céleste, born in the slums and educated in a house of assignation, had a will strong enough to carry her through the most appalling tribulations and leave her name in the history of two countries."[87] The criminal content of her writing was perhaps informed by her stay in jail as a teenager, imprisoned for "moral danger."[88] As a consequence of Chabrillan's earlier life and her two popular pieces of autobiographical writing/memoirs (titled *Adieux au monde* (1854) and appearing in Melbourne newspapers), her reputation followed her to Melbourne and shaped the cold reception she received from its inhabitants.

Regardless of this ostracism, while in Melbourne she wrote a novel, *Les*

Voleurs d'Or (*The Gold Robbers*) (1857).[89] After the success of this novel, Chabrillan wrote many other novels, of which two were set in Australia: *Miss Pewell* and *Les Emigrés*. In 1877 she wrote some new memoirs: *Un Devil au Bout du Monde*. Post–1877, Chabrillan also tried her hand at writing plays and verse. Chabrillan writes a message "To the Reader" about *The Gold Robbers*, that "I started to write this book to amuse myself, but this caprice became a passion. I did not burn it because I love it; it has been my companion in exile, the confidant of my sorrows, the friend of my thoughts." She adds that "to console myself [from being away from France], I wrote. This is my excuse, if I can be excused."[90] The Sun edition of *The Gold Robbers* added a subtitle on the front cover to the effect that it was "Australia's weirdest literary curiosity 19th century lust, rape & murder."[91] The book, initially published in France, integrates elements of the French *feuilleton* into its potent mix of sensation, romance, and sentimentality; moreover, it is melodramatic and has crime and criminals, but no detective and it is not structured as a mystery as the criminals are made known to the reader. The dual identities of Max the convict/later "Mr. Fulton" do not converge until further in the narrative, but this information seems self-evident to the discerning reader today. Alexandre Dumas praised the book in a review and made it instantly famous. Unfortunately, this novel did not appear in an English translation until 1970. Consequently, the novel was adapted and dramatized for the theatre with the help of Dumas, but this was not initially as successful as its book counterpart. This success changed once the production moved to Belleville (on 28 May 1864), where it was met with enthusiasm. It was also performed in Belgium and Holland. Chabrillan was certainly aware of and read Sue's *Les Mystères de Paris*, which was similar in its mélange of melodrama, romance and crime.[92] This study contends that she had also read Lang's *The Forger's Wife* (appearing two years earlier than *The Gold Robbers*): in Chabrillan's *The Gold Robbers* Keltly — the mare Max steals from his owner in lieu of gold — reappears throughout the text, a feature that seems similar to Flower's "gallant little animal" (p. 111), "Sheriff," in *The Forger's Wife*. Furthermore, Flower's Australian wife, Susan Briarly, dies on the voyage from Australia to England. This is seen two years later in *The Gold Robbers*, when the character of Melida dies on board the ship which is returning her family from Australia to Britain.

Set in the Victorian goldfields and gold rush in the 1850s, Chabrillan's narrative deals with the initially parallel and then intertwined stories of an emigrant man named Joanne, the British emigrant family of Doctor Iwans, and two criminals, Max (pseudonym Mr. Fulton) and "the Cutter," who are both escaped convicts from Sydney prison.[93] They commit many crimes and murders on the goldfields in order to steal the gold discovered and recovered by others. In addition to their single thefts from the miners, they then attack

the escort transporting the gold to the bank; following this, Max kills his accomplice and starts a new life with the gold. It is in his new incarnation as Mr. Fulton that Max meets and develops designs on and an obsession with Dr. Iwan's daughter, Melida, kidnapping and raping her. Chabrillan's description of Max/Mr. Fulton's actions accords with Michael Sturma's comment that "[l]iterature about the colony [N.S.W.] and its penal background sometimes approached a subtle form of pornography."[94] Max is later hanged and, ultimately, the Iwans family and Joanne return to England. Australia as a nation, in this context, is represented as synonymous with crime, threats, and bad luck; as Dr. Iwans tells Joanne: "the air of Australia is fatal for us."[95] This novel, while not wholly crime or detective fiction, still serves as both an important historical commentary and as evidence that women in Australia were from an early moment, openly writing about crime and violence.

Caroline Woolmer Leakey (Oliné Keese) (1827–1881)

Another example of Australian women's crime narratives is the little-known *The Broad Arrow: Being Passages from the History of Maida Gwynnham, a Lifer* (London: Bentley, 1859), written by Caroline Woolmer Leakey (under her pseudonym of Oliné Keese). Knight considers Leakey's choice of pseudonym, suggesting that it is "as if she were hiding half her name."[96] Initially Leakey considered the *nom de plume* of "M. A. Dimond."[97] This novel was first published by Richard Bentley in 1859; it was unsuccessful and lost money. A Tasmanian reprint by Walch and Son followed in 1860. Alison Jane Rukavina has suggested of the original version that "Bentley may have delayed the publication of *The Broad Arrow* in order to capitalize on the other novel's [George Eliot's *Adam Bede* (January 1859)] success, presenting a sister novel to audiences who had read *Adam Bede*."[98] This claim can be supported by the fact that both *Adam Bede* and *The Broad Arrow* had been reviewed in *Bentley's Quarterly Review*, which stated that the two novels present different "pictures of life and society."[99] *The Broad Arrow* was then (after Leakey's death on 12 July 1881) abridged as a one volume second edition (1886); this version was popular and sold for 2 shillings, having an initial print run of over 2000 copies.[100] Jenna Mead has written of the 1886 cut version that it "aimed at producing a popular novel, romantic in temper, exotic in location and colonial in sensibility."[101] Bentley partnered with George Robertson to create "the Australian Library," which was targeted at an Australian audience and market, purporting to be that which "(an old colonist)

feels will be specially grateful to the Australian reader: the vernacular and idiom are Australian."[102] Yet these tales are still picked by a "colonist." Correspondingly, in Australia itself, the response to the treatment of transportation and the novel was not as welcome; *Walch's Literary Intelligencer* wrote that Leakey's narrative trod heavily on Australian "political and social conflict."[103] Miles Franklin's response to the abridged (second) edition supports this: "Mrs. Leakey fell short of Clarke's melodramatic fire in fusing improbabilities. Situations for an arresting novel remain unexploited and there are religious homilies tedious to a generation grown impatient with exhortation to submission to inhuman conditions," and that it had a "tedious" plot with romantic conventionality.[104]

Knight writes that *The Broad Arrow* is "[t]he most unfairly forgotten of the early colonial texts."[105] Debra Adelaide too recognizes this negation, observing that

> If [...] Caroline Leakey's *The Broad Arrow* (1859) is mentioned, it is usually to criticise its melodramatics and sentimentality, and to show that Marcus Clarke's later convict novel did a far better job of the subject all round. Yet *The Broad Arrow's* vivid details of convict oppression and brutality are extraordinary, coming from the pen of a gentlewoman of the 1850s. Not only is this never mentioned, the possibility that Leakey's novel paved the way for Clarke's *His Natural Life* (published some dozen years after hers) is never entertained: the Tasmanian setting, the innocence of the main character, the central role of a clergyman in the narrative, are common to both.[106]

An example of this is Stephen Murray-Smith's discussion of the popular interest in crime and punishment: "Henry Savery's *Quintus Servinton* (1830), had a convict theme, and successors included Charles Rowcroft's *The Bushranger of Van Diemen's Land* (1846) and Caroline Leakey's *The Broad Arrow* (1859). [...] None of these was of any significance as literature."[107] John Jordan has noted that Clarke held a copy of Leakey's novel in his library, despite Clarke's claim that he knew of no other writer discussing the penal system.[108] In *The Broad Arrow*, the fictional convict woman has two names: her real name is Maida Gwynnham, but once she becomes a convict she takes on the pseudonym of Martha Grylls. Maida is a gentlewoman by birth, but had been transported to Van Diemen's Land for forgery and child murder, even though she is innocent of the latter crime. In relation to the veracity of the novel, Lurline Stuart has noted that Leakey had seen convicts in Tasmania, and that she wrote her book upon her return to Britain in 1853.[109] A review of *The Broad Arrow* in *The Literary Examiner* wrote that it was written by "a lady, who feels strongly because she testifies of that which she has actually heard and seen."[110] *The Spectator* wrote that Leakey "speaks of what she knows, and testifies to what she has seen.... *The Broad Arrow* is ostensibly a novel;

but it is so full of such serious considerations, that we must look elsewhere if we only seek amusement and relaxation."[111] *The Athenaeum* (30 April 1859), *The Spectator* (14 May 1859), and *The John Bull* (23 April 1859) all compared Leakey's text to Charles Reade's penal system novel, *Never Too Late to Mend*, but gave her precedence due to her first-hand experience. The novel has affinities with *Lucy Cooper* (attributed to Lang) in that it tells the story of a convict woman. Leakey's work is moralistic and serious and in the vein of Maria Edgeworth and George Eliot; it has been described as "an immigrant's guidebook [and] ... an armchair tour with fitful fiction ... in addition [to] unusual material."[112] Leakey's novel is important as it is by a female writer and features a female protagonist in contrast to the male-authored texts that featured women in major roles, such as *Lucy Cooper*.[113] It is also significant for its attack on the institution of the convict system.

The Broad Arrow immediately locates itself in the convict-narrative tradition; the opening lines state "[s]o many attractive books on Australian and convict-life have appeared of late years."[114] Leakey elucidates on the title of her narrative, and conflates it with the diabolical: "the Broad Arrow ... showed itself— symbolic alike of Government's claim on the body, and the Evil One's claim on the soul of the poor sinner" (p. 94). The text has many scenes, and it introspectively concentrates on Maida's thoughts and feelings in relation to her convict experience/s, rather than the physical abuse of convicts in Clarke's novel. Maida's master, Mr. Evelyn (who was formerly a police magistrate), details that "[i]t is a colonial assumption that prisoners have no feelings, and a Government assumption that they ought to have none, save those known as physical" (p. 88). The narrative voice, speaking of Macquarie Harbor and Norfolk Island, more generally poses a moral question about the efficacy of the whole convict system:

> How is it that these places, focused for special reformation, have not only failed in their purpose, but have been evil in their effect on the felon, changing him from bad to worse, from a state of furious resistance to apathetic despair, from fear of death to hatred of life [p. 236].

And this systematic questioning and critique is the concern of the narrative.

As in de Boos's *Mark Brown's Wife* and Lang's *The Forger's Wife*, Maida has been ill-used by a man: (Captain) Norwell, "who ruined me, body and soul" (p. 62). She adds that: "He sent me money which I flung in the fire since I could not fling it back to him" (II. 62). Rejection of this masculine commodification and control would later be seen by Jabez's abandoned partner and mother of his child in *Trail*. Maida's seduction by Norwell and sexual fall is the catalyst for both her descent into disrepute and for her penal con-

viction; Maida allows herself to be sentenced in order to save Norwell from blame as a check forger. The narrative follows Maida's unfortunate life: it details her trip on board the prisoners' ship, the homes she is assigned to, her solitary confinement and eventual death. As the story progresses, in the second volume, Maida finds Christianity. This is induced by the occupants of the house that she is assigned to as a servant in Hobart — mainly inspired or incited by the dying invalid, Emmeline Evelyn and to a lesser extent by her Uncle, Mr. Herbert Evelyn. Yet despite this, the authority of men and God are still equated. Maida informs the reader that "[s]he sometimes found the thought, "What will Mr. Herbert say to this?" exerting a restraining influence on her actions" (p. 173). Maida dies in a convict hospital and Leakey's critique of inept and corrupt police is extended as this corruption is shown to permeate all facets of society, and is personified by Maida's nurse. Leakey describes the nurse: "The rod of office becomes a snake in her hand [...] a snake whose malice all must feel, whose subtilty [sic] all must dread, and whose fascination none can withstand" (p. 237). Williams Elliott has said of this figure, that "the nurse is an apt example of the way the System tries to turn convicts into suffering bodies and suppress their human sympathies and proclivities."[115] The conditions of Australian life, then, are initially shown to exacerbate and foster evil.

Maida's actions, though, are emblematic of the reappearance of feminine dissent as, at times, she rebels against her mistreatment. This feminine challenge is evidenced in an important episode in "Chapter VI: An Old Acquaintance": crime, past and present, England and Australia, all coalesce when Maida encounters the criminal, Bob Pragg. Maida recounts his role in her life: "It was only fitting that the man who had wrung her from her baby should be appointed to work her further woe; it was only to be expected that he should haunt her to this remote corner of the world" (p. 164). It was Bob who arrested Maida in England. Bob is in a graveyard with two fellow criminals, Sam and Giles. Initially it escapes Maida that there are others in the vicinity with her; when this is recognized, however, she reacts: "With a quick cry of impatience she sprang over the barrier and confronted two low-foreheaded, brutal-visaged prisoners, who were wantonly abusing their trust by kicking about and otherwise ill-treating two coffins that had been left them to inter" (p. 132). She confronts them: "The fire of bygone days flashed from her dilating eyes, and in a tone of haughty superiority she exclaimed — 'I'll report you! What dare you do? I remain by you until I have seen them decently buried'" (p. 132). Equally, she is not afraid to take physical action; when one of the prisoners, Giles, kicks a coffin, "[b]y a dexterous movement, Maida had collared and thrown him, whilst his foot was upraised to give a second kick" (p. 154). Unfortunately, this brave action results in physical violence and pun-

ishment as Giles knocks her senseless. It seems, at this point, that Maida/the woman is not able to fulfill a policing role. While the narrative offers glimpses of gendered power appropriation and contestation of the convict system, ultimately this cannot yet be overturned in fiction and Maida dies. And later, after transportation had ceased, other women were also preoccupied with and writing about such topics.

Eliza Winstanley (1818–1882)

As little-known as Caroline Leakey is Eliza Winstanley (1818–1882), who wrote *For Her Natural Life: A Tale of the 1830s* (London, *Bow Bells*, July–December 1876), which was a response to Marcus Clarke's seminal text.[116] She also wrote "Bitter Sweet—So This Is Life" for the *Sydney Mail* (1860) under the pseudonym "Ariele." English-born, Winstanley lived in Australia, working as an actress, between 1833–1846, taking up writing on her return to England as is shown in her memoirs, *Shifting Scenes in Theatrical Life* (1859). The theatre influenced her writing, giving it a melodramatic air, something that she perhaps shares with Mary E. Braddon. In addition to contributing to *Reynolds's Miscellany* ("Margaret Falconer; or the Steward's Daughter," 1860), she was editor of John Dick's penny magazine—*Bow Bells*—from 1876, publishing around forty novels in serial form in the periodical. Three of these have Australian backgrounds: *Twenty Straws* (1864), *What Is to Be Will Be* (1867), and *For Her Natural Life* (1876).

For Her Natural Life is a melodramatic history of a woman's experience of the harshness of the convict transportation system, and, as with Clarke, was written after the eradication of transportation. Comprising two books, the first details the life of the protagonist—Margaret Aubert (convict name, Margaret Nesbit)—in England, and her survival after the desertion by her husband, culminating in her trial for the death of her child; she is wrongly found guilty and sentenced to transportation. Speaking of *For Her Natural Life*, Knight notes that in literary terms "[t]he novel is quite short, and also deeply conventional."[117] The narrative events are similar to Maida in *The Broad Arrow*, except Margaret is wholly innocent of any crime and not a sexually fallen woman; also like Maida, Margaret was born a gentlewoman. It is her secret marriage to Nesbit Aubert which is the cause for her troubles and the presumption that she is fallen, but it is because of the scheming of the main villain of the narrative, Sir Dennis Wolfdene, that she is wrongly convicted, and this continual mistreatment is the crux of the narrative and its emphasis on the injustices of the convict system.

The second volume traces her journey to Sydney and her new life as a convict. The narrative details Margaret's many assigned placements as a servant, which fail and cause her anguish: firstly she is a servant for Mrs. Bromley (who discharges her due to gossip and fears that her husband is attracted to her) and then Mrs. Prusser (where she is dismissed due to her jealous daughter, Angelica). Margaret then achieves a happy and rewarding placement with her next mistress, Glenthora Cathcart. But this happiness is invariably transitory: as in *The Forger's Wife*, the heroine's problems stem from and are exacerbated by her conniving (and betraying) husband. Margaret's husband, Nesbit, reappears in Australia — engaged to Glenthora, and Margaret must denounce him and inform Glenthora that he is already married to her. Yet there are many wicked men in Margaret's life, for example the convict superintendent, Captain Dunmarra who both attempts to seduce and torments Margaret. Consequently, when Margaret attempts to escape with Joan Lopez — a convict and woman friend she had met on the convict ship on her voyage to Australia — and she dies at sea; this is the same fate suffered by the protagonist of Clarke's *His Natural Life* (book form) and Melida in Chabrillan's *The Gold Robbers*. Dorice Williams Elliott has commented that "both Joan and Margaret die in an effort to escape Dunmarra and the convict system he represents."[118]

Winstanley's narrator tells the reader at the conclusion of this story that "[m]y story has been a sad one, but it has been faithfully narrated, even as it was told to me in that far-off-land — that land of sunny brightness, to which my memory lovingly clings, and after which I yearn with a yearning which will never be gratified."[119] Nevertheless, she did return to Australia in 1880 and died in Sydney in 1882. While this text diabolizes the convict system and criticizes unjust gender conventions and purported social "policing," it does not feature a detecting/policing figure or sequence and it is not really crime fiction in the manner of the writing being produced by other Australian woman writers such as Ellen Davitt and Mary Fortune. Nonetheless, Winstanley and her contribution should still be noted. Almost a decade prior to Winstanley, however, Ellen Davitt was constructing the first murder mystery in Australia. *Force and Fraud* has been acclaimed by Lucy Sussex as Australia's first murder mystery novel.[120]

Ellen Davitt (c. 1812–1879)

Ellen Davitt is one of the most significant contributors, male or female, to Australian criminography despite only writing for about three years (1865–68). Although she does not figure in the criminographic canon, Davitt's crime

narratives preceded those of some of her more famous British contemporaries: *Force and Fraud* predated Wilkie Collins' 1868 novel *The Moonstone* by three years. But where Collins's text appeared in book form as well as in a periodical and so has remained in print, this chapter suggests that despite Davitt's work being published in a leading colonial journal, the ephemeral nature of such publications has resulted in her being forgotten in Australia and elsewhere. It was not until the 1990s that Davitt's writing received academic attention, with *Force and Fraud* published in book form in the *Australian Books on Demand* series in 1993. Her influence and importance have subsequently been recognized by Sisters in Crime (Australia) who have established "the Davitt award" for Australian women's crime writing.[121]

Recent research, mostly by Sussex, has revealed further details about Davitt and her female contemporaries. Born Ellen Heseltine around 1812 in Hull, Yorkshire, Davitt spent her early life in the United Kingdom, where she received an extensive education. This educational background aligns Davitt with the American criminographic writers Harriet Prescott Spofford and Anna Katharine Green, but while their tertiary education is a matter of record, Davitt's educational claims have not been validated. Davitt commented that she had "[s]tudied under Masters in England, spent some time in fashionable schools in Paris [...] have [illegible] honours in History, Modern Languages, Composition, and Elocution."[122] She later lived in France and Ireland with her husband, Arthur Davitt, before they emigrated to Victoria to take up positions respectively as principal and superintendent in the Model School in East Melbourne in the 1850s. Both she and her husband had a problematic relationship with the Model School and its administrators. Davitt lost her position as a consequence of the lack of school funds and went on to set up her own school for governesses, the "Ladies' Institute of Victoria," circa April 1859. But her business did not prosper and her husband died soon after from tuberculosis on 24 January 1860. Davitt then joined another school at Kangaroo Flat, Victoria, in 1874, from which she was also dismissed. She died of cancer in Melbourne on 6 January 1879.

Davitt was also Anthony Trollope's sister-in-law — a less-than-publicized fact then and now. Davitt was an elder sister of Trollope's wife, Rose. A regional Australian newspaper, the *Kyneton Observer*, reported in 1864 that Mrs. Arthur Davitt was "the sister-in-law of Mr. Anthony Trollope."[123] This information, though, was not widely broadcast and there is a definite sense of deliberate omission; Davitt is not mentioned in biographies of Anthony Trollope or in his accounts of his two visits to Australia (1871 and 1875). This is in direct contrast to Davitt's own account of Trollope's 1875 visit in which she related that "Mr. Trollope called on me" for an hour at her school in May.[124] The treatment meted out to Davitt by the Trollope family bears some

resemblance to that given to another unconventional and literary woman, Frances (Fanny) Trollope (1779–1863), who was Anthony Trollope's mother. In Davitt's own immediate family, her father, Edward Heseltine, equally led an unconventional life. Heseltine was a bank manager in Yorkshire who embezzled around £5,000 from 1830 to 1850; he absconded to France to evade capture and his criminal actions, as Sussex has noted, could have been part of the impulse behind Davitt's creation of *Force and Fraud*. From a tangential perspective, another Victorian writer had an embezzler in their immediate family: Charles Dickens' grandfather (on his mother, Elizabeth's, side) was a senior clerk who worked in the Navy Pay Office and who was, in 1810, exposed as an embezzler.[125]

In conjunction with her teaching career, Davitt was a progressive, proto-feminist figure. She was outspoken and voiced her opinions; she was a writer, an artist, and toured Victoria as a public speaker, offering lectures with titles such as "The Vixens of Shakespeare," "Women and her Mission," "Colonisation v. Convictism," and "The Influence of Art." Speaking of "Women and Her Mission," the *Hamilton Spectator* commented that:

> Mrs. Davitt's lecture [...] is a literary work of great ability, displaying a large acquaintance with history and both English and foreign literature. The style of composition too is both easy and pleasing, and the extracts remarkably well chosen. The lecturer whose delivery is effective and pleasing was repeatedly applauded in the course of the evening and, as far as we could gather, the audience were generally well pleased, both with the subject and the manner in which it was treated.[126]

In April 1861 she gave a public lecture at the Melbourne Mechanics Institute, "The Rise and Progress of the Fine Arts in Spain," and a report in the *Examiner* stated that it was by "a lady whose name will doubtless be familiar to many of our readers."[127] Davitt was making a name for herself; this lecture was, remarkably for a Victorian woman, followed by a lecture tour of Victoria. But art critic "Christopher Sly" was less enthusiastic about a painting (of Saint Cecilia) that she submitted for the first exhibition of the Victorian Society of Fine Arts in 1857, remarking that it was "a tremendous thing for a lady to do, but it had much better have been undone [...] please, Mrs. Davitt, don't do it any more."[128] Her interest in architecture is apparent in her participation in the remodeling of the school in which she was employed. In short, Davitt refused the role of a conventionally subservient woman, confined to the domestic sphere. Consequently, descriptions of her are often unfavorable: historian J. Alex Allan has branded Davitt as being possessed of "a certain harshness, priggishness, and overbearing self-esteem."[129] He added that she was "the power behind the throne" and had a "faculty of fault-finding."[130] And in the twentieth century, Victor Crittenden of the Mulini press remarks:

"Just imagine a woman in the 1850s daring to have a high opinion of herself and her capabilities."[131] But it is precisely these opinions and capabilities which enabled Davitt's writing of *Force and Fraud*.

The serialization of *Force and Fraud* began on the first page of the inaugural edition of the *Australian Journal* in 1865.[132] Later in the same year, the *Journal* published Davitt's novel-length serials "Black Sheep: A Tale of Australian Life" (25 November 1865–27 January 1866), and "Uncle Vincent; or, Love and Hatred. A Romance of Modern Times" (5 May–23 June 1866), as well as the novella, "Past and Futures: a Tale of the Early Explorers" (18–24 March 1866). Her first work, "Edith Travers," has not been traced.[133] Davitt's other fiction is more melodramatic than the mystery-based *Force and Fraud*. Her last serial, "The Wreck of Atalanta" [sic], which appeared in the *Journal* 6 April–20 July 1867, incorporated mystery elements, but they are not as central as those in *Force and Fraud*.[134] The *Journal* editor wrote that "The Wreck of Atalanta" was "certainly the happiest effort of Mrs. DAVITT'S pen, and we promise our readers a rich treat in its perusal."[135] The *Journal* featured much crime writing and fiction and included Australian writers such as Mary Helena Fortune and James Skipp Borlase, both prominent and prolific crime writers whose work also appeared in the periodical's first edition. Sussex, in discussing J. S. Borlase and his contributions to the *Journal*, compares his output with Davitt's: "He made at least 25 appearances in various genres; only Ellen (Mrs. Arthur) Davitt [...] rivalled him, with 22."[136] This information attests to Davitt's ability and flexibility, as well as her capability to keep pace with the *Journal*'s male exponents. *Force and Fraud*'s length is more like that of a novella — under 70, 000 words, with very short chapters — and, in this sense, Davitt was ahead of her time in eschewing the more traditional Victorian three-decker novel format. The cover of the Mulini Press book reprint of *Force and Fraud* (1993) features Davitt's own artwork in an 1837 sketch of her sisters. The writer again contested Victorian literary conventions by refusing to use a pseudonym for her criminal works, using instead her own name — "Mrs. Arthur Davitt." Once established as a writer, Davitt simply signed her work off as "by the author of."[137] After 1869 there is no sign of her literary work and, if she did write later, it has not been traced. While Davitt's *oeuvre* was small and published over a short period, she nonetheless made an important contribution to the development of Australian crime fiction.

Force and Fraud is pioneering in its status as the first murder mystery in Australia, and the first "whodunit." It was quickly imitated: Crittenden compares Robert P. Whitworth's serialized crime novel, *Mary Summers: A Romance of the Australian Bush* (which appeared in the second issue of the *Journal* after *Force and Fraud* in September 1865), with Davitt's work. He comments that "[i]t is not as successful a murder mystery as *Force and Fraud*

[…] as it does not focus on or have dropped into the story in a regular fashion the clues to the murderer."[138] Davitt's story starts with the murder of a wealthy squatter and station owner, originally from Scotland, named Angus McAlpin. Killed near his rural property, the positioning of his dead body and the consequent action of the plot explain the text's subtitle, "A Tale of the Bush." By contrast to the earlier convict-orientated narratives such as Clarke's *His Natural Life* where the initial crime occurs in England, the crime, here the criminals and the setting are all Australian.

McAlpin has an independent and headstrong daughter, Flora McAlpin, who is engaged, against her father's wishes, to an artist, Herbert Lindsey. McAlpin's agent, Pierce Silverton, however, is also in (unrequited) love with Flora. Herbert is painting in the bush one day when he becomes involved in helping a wounded Gaelic bushman (Evan Gillespie), in the process losing his knife and bloodying his clothes. This is later taken as evidence of Herbert's involvement in the murder of McAlpin and results in his arrest. Marcus Clarke may have read and been influenced by Davitt's story. There are parallels between Herbert and Richard Devine and their circumstances: Plain Joe (in the serial version of *His Natural Life*) contemptuously says to Devine: "Proof! warrant! Didn't we find your knife sticking in the poor old man's throat? The marks of your bloody hands on your own wainscot? Isn't the old man's handkercher round your wrist, and the old man's blood on your shirt? Warrant! There's warrant enough to hang yer, let alone arrest yer."[139] In fact, the murder has been arranged by Silverton. The text indicates that it was a common occurrence for McAlpin to bully others, and that he would often vent his rage on Silverton. In the crucial instance which incites murder, Silverton has been beaten by his employer (McAlpin) with a riding whip after quarrelling while out for a ride. Subsequently, Silverton chances to meet "Dick" Thrashem, an ex-convict and criminal, who agrees to assassinate McAlpin for a fee of a hundred pounds, giving Silverton his revenge for his ill-treatment at McAlpin's hands. Thrashem then blackmails Silverton, making him pay for Thrashem's silence. When Thrashem carries out the commission Silverton is shocked and suggests that he did not mean it literally. The fact that this deed is not premeditated and that Silverton is clearly middle-class is, in itself, threatening: the suggestion is that anyone can slip into crime. Meanwhile Silverton manipulates events in order to secure Flora's hand in marriage, but before he can achieve his aim, Thrashem kills him in an argument. Thrashem is apprehended and executed and Herbert is cleared, living happily ever after with Flora.

The story conforms to the now familiar generic crime and mystery pattern: it starts with a murder (of squatter Angus McAlpin), the body of the narrative is concerned with the discovery of the solution to the mystery and

the true culprits are not detected until the closure of the text. But in its period, the plot structure was innovative. What differentiates Davitt's text from other crime narratives circulating in the nineteenth century is its distinctly Australian flavor. The narrative action shifts between the bush, small townships, Melbourne, and, briefly, Queensland, and there is a tacit acknowledgement of the connections between Australia and Britain when Thrashem sails there. *Force and Fraud* incorporates sensational elements, but they are knowingly self-conscious. For example, there is a chapter titled "The Lovers of Sensation"[140]; Mary, a servant at the "Southern Cross," compares the murder of McAlpin to a popular sensational magazine, commenting that "[i]t's just like a story I am reading in 'Reynold's Miscellany'" (p. 40). While Davitt uses the conventions of sensation fiction, she re-works and extends them in an original way while paying lip service to the sensation genre in her intertextual references.

Davitt's originality can be seen in the characters within the text. Silverton and ex-convict "Dick" Thrashem work together, while Silverton is ostensibly a good friend of Herbert and pretends to act as a conduit of communication between Herbert and Flora. The title of Davitt's text refers specifically to the names of the two criminals: "Force" is Thrashem, who is the murderer, and "Fraud" is Silverton, who commissions the killing while giving the appearance of remaining loyal in intention and action. Knight has noted that "although this overtly a story about landed property, the villain's name, Pierce Silverton, reminds us that wealth now also lies in mining, piercing the land for gold and silver."[141] It is towards the end of the narrative, on the day before Silverton is to marry Flora, when the two criminals fall out and the title of the novel reveals its full significance. Thrashem demands a further 100 pounds from Silverton; the result is "*Force and Fraud*, contending with each other! The *two crimes* which so often unite in the destruction of mankind now striving for the mastery" (p. 129). The last line of the text again picks up on the dual elements of the criminal act. While simultaneously offering a conventional closure with the reunion of Flora and Herbert in happy domesticity, the narrative observes "they have passed through their ordeal — the power of the man of *force* having been destroyed — the arts of the man of *fraud* rendered unavailing" (p. 139). In a stylish twist, Davitt's sententious final words reiterate the significance of her title. This phrasing is similar to Reynolds' epilogue at the end of the novel in *The Mysteries of London*, which states: "Tis done: VIRTUE is rewarded-VICE has received its punishment."[142] While the repetition of a title for a story's closing line was a common motif, (such as M. C.'s earlier "Wonderful! When You Come To Think of It" (*Hamilton Spectator*, 26 January 1865) and Spofford's later story, "In the Maguerriwock" (1868)), Davitt's title/closing line is as mysterious as her mystery; she does not give any clues away as to its significance until the very last moment of the narrative.

Silverton not only commission's McAlpin's murder but seeks to better himself socially through his love for Flora and her fortune, behavior that conforms to *The Critic*'s definition of "Social Reform" in November 1873: "One of the most distinctive features in the social fabric of these colonies, and which must strike the eye of every observer, is the restless, craving desire to 'better one's condition.'"[143] In comparison to the criminal stereotype of Thrashem, Silverton is more covert in his criminal actions and intentions and he is, disconcertingly, from a higher social class. This cross-class criminal collaboration interconnects with the criminality in contemporaneous British crime fiction. In Andrew Forrester Jun.'s *The Female Detective*, female detective Mrs. G—comments "you rarely find educated men (I am referring here more generally to England), combine with uneducated men in committing crime. It stands evident that criminals in combination presupposes companionship."[144] Davitt, in her Australian context, refutes this assertion in her intermixing and crossing of preconceived class, criminal and literary boundaries. In doing this, she represents the reality of society in Australia with its mixture of classes, unknown identities, and convicts and ex-convicts.

Silverton, like Braddon's Jabez and Monsieur de la Tourelle in Gaskell's "The Grey Woman," is repeatedly described in effeminate terms. An instance of this is seen in Silverton's reaction to Herbert's "not guilty" verdict:

> Pierce [...] fell in a dead swoon on the floor! Such might have been expected from Flora, or indeed, from any woman in the court far less deeply interested in the result of the trial; but a *man* has no *right* to faint unless from physical exhaustion [...] poor Silverton was so extremely delicate! [p. 93].

Such fragile or feminine depictions also connect to the delicate Falkland in *Caleb Williams*, Squire Griffiths in Gaskell's "The Doom of the Griffiths," and James in *The Dead Letter*. These descriptions and figures are in fitting with the Gothic preoccupation with enfeebled men. In the concluding chapter Silverton is initially "borne with honour to the grave" (p. 135), with his role in the murder of McAlpin undetected; the truth, however, is revealed by Thrashem once he is captured: he confesses his own crimes and Silverton's involvement, so posthumously ruining his reputation.

Thrashem, as an ex-convict, embodies a disconcerting and polymorphous criminal identity; he worryingly appears under different names throughout the novel and seems beyond the containment of discursive boundaries. These are "Dick," "Maddox," "Jarvis," "John Smith" and "Smith." When he is captured, the landlord states that "I reckon he is all those blackguards, and a dozen more besides" (p. 131). It is later revealed when he is captured that his true name is Maddox. The name of "Dick" for a criminal is a recurrent one in Australian criminographic narratives, and is seen in *Mark Brown's Wife*. He is "a man of middle height, of a square build, with features that

might have been cast in an iron mould [...] all was physical" (pp. 24-25). This description conforms to the contemporary ideas concerning the physical appearance of a criminal. The September 1873 edition of *The Critic* observes that:

> The ordinary criminal is usually a being, so brutalised in appearance, that it is no wonder that the lawyer, to whom the type is so familiar, should come to regard him as a mere animal — deficient in reasoning power, but cunning, malevolent and pre-eminently selfish, and as a natural sequence influenced only by selfish animal considerations.[145]

Thrashem is known as "the greatest ruffian that had ever been known in the district" (p. 3) and is "suspected of having committed more than one crime of great enormity" (p. 126). The text details some of these crimes, but it is implied that there have been many more. In this respect, the representation of Thrashem accords with David Indermaur's contention that "[b]y all accounts, violence was significantly higher in [...] 19th century Australia than it is today."[146] Thrashem's criminal threat is, though, ultimately quelled: he is punished and executed for his crimes, an ending which is in line with traditional, reassuring accounts of crime where order is restored and the criminal — or criminals — punished.

Yet, from another perspective, Thrashem unsettles the conventional and predictable ways of reading the criminal body. He serves as a connection between nations, especially those of Australia and America, and Australia and England. In this sense, his figure embodies Knight's delineation of the literary progression of the Australian criminal sub-genres: as in Thrashem's representation they evolve from the "Convict Stories" (British/English focus) to the "Criminal Saga" (Australian/national focus). This chapter suggests that Thrashem's criminal being challenges national stereotypes. Davitt/the narrator reverses the contemporary British perception of Australia as wild and criminal: "From those rich Australian plains, smiling in peace and plenty, we must now turn to the "wild waste of ocean," and there we shall perceive a majestic ship drifting through a narrow channel" (p. 103). The trip on the "Robespierre" which Thrashem takes to England, functions as reverse transportation of the criminal body. Silverton pays him to leave the country, yet Thrashem ultimately returns. The name of the vessel is indicative of terror; it is a direct reference to the French Revolution and its period of "terror" and turbulence associated with Robespierre, the extremist leader. Silverton's dialogue with Thrashem emphasizes this juxtaposition of nations when he states "you will be safer and happier in England." Thrashem's reply is that he has "[n]o objection to have a look at the old country, but I fancy it's a slow sort of a place for a fellow who has lived ten years in the bush." Silverton then retorts "Suppose you go to America, *that* is not a slow place" (p. 25). In this

instance, America is depicted as a land of criminal possibility. Davitt's plot makes it clear that Australia is not the only land inhabited by criminals but that England and America are at least as, if not more, productive of criminality.

The catalyst for the mystery narrative is McAlpin's murder and the motives are money, inheritance, and love of a woman. The murder occurs in the bush; McAlpin is found "*dead — Murdered on the Plain!*" (p. 13), and his deceased body appears at the opening of the story. He has been initially stunned by a blow to the head but "[t]he *death-wound*, however, was in the centre of the throat, and had evidently been inflicted by a large knife" (p. 15). This bowie knife reappears in 1871 in de Boos' *Mark Brown's Wife*. In de Boos' text, Chapter V is entitled "The Bowie Knife." Where his body is found is distinctly Australian — it is marginal, both literally and metaphorically: "The scene where the incident had taken place was on the outskirts of an Australian forest [...] all around was wild" [p. 4]. This is continued: "No dwelling was in sight, neither was there any trace of a *made* road or fence, nor anything that indicated the work of man; but, though all around was wild, the scene was attractive" (p. 4). As Kay Schaffer notes:

> Landscape looms large in the Australian imaginary, although its infinite variety has been reduced to a rather singular vision — the Interior, the outback, the red centre, the dead heart, the desert, a wasteland. It is against this land that the Australian character measures his identity.[147]

And McAlpin's body is also peripherally placed. It is this placement, or need to place the crime, that enables McAlpin's dead body to set in motion the second narrative of how, who, and why the murder was committed.

Moreover, what stems from McAlpin's death is a host of quasi-victims. The most prominent of these is Flora, McAlpin's daughter. Her body and the body of land she will inherit are the objects of Silverton's desire. In this context it could be argued that she is representative of the land, shown by Schaffer's land/female conflation, where she posits that the land is gendered as female and that this can be perceived as a threat to the male. This endemic Australian construction is encapsulated by Schaffer's chapter sub-heading of "Landscape Representation: Woman as Other." She writes of the Australian woman that "[i]n the relationship of the Australian character to the bush, her presence is registered through metaphors of landscape." She adds: "in Australia the fantasy of the land as mother is one which is particularly harsh, relentless and unforgiving."[148] Flora is a secondary victim of the criminal machinations around her; she is also the unknowing catalyst for the murder. In this respect, she can be aligned with the character of Mary in Anna Katharine Green's later novel, *The Leavenworth Case*. Flora, however, does not fit into the "proper" feminine role accorded to women in the period. Herbert comments that "I

little thought that the quiet retiring girl I once met at Baden would ever exhibit such an independent spirit." Flora replies: "Baden is a very different sort of place to Australia [...]; besides people grow very independent in this colony" (p. 13).

Davitt's text not only makes Flora a strong central character but gives her a decided and independent voice in which to articulate her — and possibly Davitt's — ideas and emotions, in contrast to the women represented in earlier crime-centered fiction. The representation of Flora prefigures and makes possible the stronger women and heroines towards the end of the century as seen in, for example, Rosa Praed's *Outlaw and Lawmaker* (1893) and Ernest William Hornung's *Irralie's Bushranger* (1896). In *Force and Fraud*, "Chapter XIII: A Storm" (p. 46) consciously plays with the connotations of nature and the "natural" behavior of women when Flora reacts "unnaturally" to news of Herbert's arrest: "for Miss McAlpin, instead of falling senseless on the ground, stamped her foot, clenched her hand, and exclaimed in an angry tone, "Who dares to attribute such a crime to Mr. Lindsey?" (p. 46). She demands that Mr. Argueville discover the real killer, stating "I defy the law!" (p. 74). Flora is, however, partially recuperated into a non-threatening feminine role after Herbert is proved innocent: she is shown to "retire into the more natural position of domestic life. The likeness to her stern father now seems to have faded away, and her countenance again resumes the expression of her mother's gentle face" (p. 94). But this is because Flora has achieved her aims. She can, and does, disconcertingly feign "appropriate" gendered behavior until she is threatened or challenged. Earlier, Metta Victor's *The Backwoods' Bride* (1860) features the figure of Susan Carter in a detecting role. In undertaking this role, a change is enacted: "She, usually so gentle, so forgiving, had grown so hard and unrelenting as steel."[149] Her representation exposes the masquerade of femininity required in the period and suggests that women — or Australian women — were well aware of the constructedness of as well as the contradictions inherent in the role allocated to them.

Another strong-minded woman and potential proto-feminist presence in the narrative is Miss Bessie Garlick. Bessie is a daughter of Mrs. Garlick, and Pierce lodges in their home when he is in town. Bessie is a comical figure in the text, and she has unrequited affections for Pierce. She purloins his (stolen and hence crucial) snuff-box from his dressing table, for which he chases her. The text relays this incident and Pierce's attempts to reclaim the snuff-box, although Bessie is victorious: "She was a great strong girl, more than a match for Pierce Silverton" (p. 29). Silverton supports this when he comments: "What strength that girl has! I am quite done up!" (p. 29). Bessie's mischievousness, though, is ostensibly mediated or excused as the narrator communicates that "a little wildness was tolerated in consideration of her

youth" (p. 27). This assertion, however, does not detract from her cheeky challenges which are interspersed throughout the narrative.

There is also the resilient and proactive figure of Mrs. Roberts, who tests the limits to a greater extent than Bessie. In "Chapter XXII: The Court House" (p. 86) she is made to attend Herbert's trial as a witness. Regarding this, she clearly espouses feminist proclivities when says to her friend, Mrs. Busselman: "And if I don't give them the benefit of my tongue, may I bite it out" (p. 87). Earlier, Mrs. Roberts had found Herbert's handkerchief near the spot where McAlpin's body was discovered and, believing his innocence, secreted it. Consequently, Mrs. Roberts has an altercation with policemen due to her possession of this article. Subsequently, a couple of policemen arrive to arrest her as an accessory with Herbert Lindsey in the murder of McAlpin. She is bailed as a doctor's certificate pronounces her as an invalid, but — as she proves — she is not crippled in her convictions. She becomes feisty after her miscellaneous "Rubbish Drawer" is confiscated; the narrator describes her as "the amazon" (p. 65), and she indignantly tells the policeman who is ransacking the contents of her drawer (and who hurts his hand on a large carpet needle in the process): "Bad cess to ye for rummaging my things in that way. If I'd known I'd have put a good branch of prickly pear amongst them, and spoilt those fingers of yours, my boy" (p. 65). This chapter suggests that Davitt can challenge and mediate these feminist qualities and gendered challenges to both men and the disciplinary power of the law through comical guise.

A further quasi-victim is Herbert, who is falsely framed and arrested for the crime on the basis of circumstantial evidence and unfortunate timing. Herbert assisted a bushman (Evan Gillespie) with a large dog who had cut himself with his axe, binding the wound with his torn handkerchief. There is, consequently, blood on his artist's sponge and on the wristband of his clothes (which Harry Saunders perceives). He also loses his bowie-knife. The trial scene in *Force and Fraud* hinges upon the injured Gaelic bushman being found and entering the trial at the crucial time. Earlier, in Elizabeth Gaskell's *Mary Barton* the missing witness, critically appears at the trial to save Jem Wilson. Yet in Gaskell's text, Mary is then — in the tradition of women who attempt the role of the detective — overtaken with nervous convulsions which signify the end of her detecting foray. Herbert's artistic employment is perhaps deliberately chosen to set him apart from the other less sensitive male characters in the text and possibly also to locate him in the tradition of Wilkie Collins's protagonist in *The Woman in White*. Davitt potentially influenced Victor who, in her *Too True* (1868), includes the character of Miss Bayles, an artist and photo-tinter, who is drawn into the case in an amateur investigatory capacity. Victor included a chapter titled "Tableau Vivant — by the Young Artist." Bayles, though, is recuperated by marriage. Moreover, after Herbert's

arrest, Mr. Stewart, the gaol chaplain, locates Herbert in a specific literary and criminal tradition, with his reference to the gentleman scholar murderer, Eugene Aram: "the first book he [Mr. Stewart] selected was a volume of poems by Thomas Hood. It opened upon the subject of Eugene Aram, and then Mr. Stewart reflected that all murderers had not been branded ruffians" (p. 84). Unlike the guilty Aram, Herbert is, finally, absolved of the crime and allowed to fulfill his proper role as the romantic hero.

Unlike later crime/detective fiction, there is no holistic detecting sequence or specific detective figure in this mystery novel. As in Caroline Clive's *Paul Ferroll* (1855), there is no detective or sleuthing presence in this mystery. In a curious inversion, Silverton, in his superficially respectable social persona, feigns a semi-investigative capacity: "On arriving in Melbourne, Mr. Silverton found plenty to do. In the first place he had to call on certain detective officers respecting the necessary steps to be taken for the discovery of the murderer; in the second, to seek out Miss McAlpin's trustees" (p. 23). He is charged with these investigative duties by Flora: "I hope you will obtain all the information in your power, Mr. Silverton, that may lead to the detection of the real murderer" (p. 49). In featuring in the oppositional roles of detective and criminal, the representation of Silverton confuses and challenges preconceived social and generic categories. A year later in America, Victor's *The Dead Letter* included James, who acts in this manner, assisting Mr. Burton.

There are, however, many policemen who sporadically appear at intervals throughout Davitt's narrative, but they are not depicted positively and they are shown to be inefficient. This is the same as the policing representations in *The Broad Arrow*, *Mark Brown's Wife* and *The Forger's Wife*, and bears comparison with the initial reception of the police in British crime narratives.[150] At the court house for Herbert's trial there are many mounted police; a riot is suggested, and although this does not transpire it indicates the level of social tension generated by the murder case. The last appearance of the police is when they are involved in the apprehension and arrest of Thrashem: the law is, finally, shown to be effective when dealing with the proper criminal class.

Davitt's crime/mystery text has criminal and colonial connections. The existence of a conversation between countries is made clear in the narrative, as can be seen when the narrator states that McAlpin "bought [Flora] everything the colony could produce, or the mother country export" (p. 51). This economic conversation is replicated by the literary intercourse evident in the exchange between British and Australian criminal narratives and their publishers. Davitt, initially living in the United Kingdom was, in all probability, acquainted with and influenced by British crime fiction; additionally, British

fiction was frequently transported to Australia. This influence and possible reading of Collins' work can be seen in the inclusion of Herbert's handkerchief, which is found at the murder scene, and used as a red-herring. This trope is also seen in Wilkie Collin's "The Diary of Anne Rodway" (*Household Words*, July 1856) where the device of torn material from a cravat is used. Collins' novel, *No Name* (1862) used a scrap of cloth from the criminal's clothing. Poe's "The Mystery of Marie Rogêt" (1842–3) includes a pocket handkerchief as a clue, inscribed with Marie's name — and this clue, among others found, is indicative of a struggle. It also features a murderer who tore from a petticoat to tie about the neck and drag the dead body to the river. Crowe's *Susan Hopley* uses a fragment of clothing to identify the criminal. Herbert (the artist) has connections with Mr. Furbush in Spofford's "Mr. Furbush" story (*Harper's*, April 1865). While potentially drawing on the developing British crime fiction genre, Davitt reshaped them to fit her Australian setting, creating a new, more appropriate form. But while Australian male writers of crime fiction were recognized in Britain and their work published and reviewed there, there is little evidence that Davitt was accorded the same privilege.

Examples of these luminary Australia-based male writers are Francis Adams, who was on the staff of the *Sydney Bulletin*, yet wrote on Australia in the British journal, *Fortnightly Review*. Rolf Boldrewood (Thomas Alexander Browne) has his first and Australian-themed publication, "A Kangaroo Drive," appear first in *Cornhill* (1866). "Boldrewood"/Browne's renowned work, *Robbery Under Arms* (1883), was also published in England and well-received in 1888. While not mystery or crime, E. W. Hornung commented on Australian/British interactions in *A Bride from the Bush*, which was serialized in *Cornhill* from July–November 1890. Marcus Clarke's *His Natural Life* (*Journal*, 1870–72) appeared in shortened version in England in 1875. Fergus Hume's first and best-known work — *The Mystery of a Hansom Cab* (1886) was initially published in Australia, but it was not until it appeared in Britain in 1887 that it and its author achieved enormous popularity. These writers listed above were either/mostly born or educated in/had affiliations with England. Davitt was also in this position, yet as a female she was not as free or had limited opportunities to cross national and publishing bounds.

While *Force and Fraud* seems not to have "travelled" to England, a case can be made for the reverse transportation of Davitt's novel-length serial "Black Sheep: A Tale of Australian Life," which may have influenced the British novelist and journalist, Edmund Hodgson Yates (1831–1894). One year after Davitt's story was serialized in the *Journal* (25 November 1865–27 January 1866), Yates produced *Black Sheep!* (*All the Year Round*, 25 August 1866–30 March 1867).[151] The title of his story and the temporal proximity of its

publication suggest that this was unlikely to be coincidental. It also appeared in the Melbourne *Leader* (17 November–15 June). Unlike the title, the plot, while incorporating crime, does not have close relations with Davitt's novel. It is, however, indicative that the *Journal* was being read in London. This masculine appropriation of Australian women crime writers can also be seen in the case of Mary Helena Fortune, as will be discussed later. Davitt, as a *Journal* contributor, may be included in Knight's contention that "both Fortune and [James Skipp] Borlase were known in England. [...] through the British readership of the *Australian Journal*."[152] It is also possible that Davitt's *Force and Fraud* appeared in America, or that her narrative was read by the American writer, Metta Victoria Fuller Victor. Victor wrote the first American full-length crime serial/novel, *The Dead Letter*, and her plot may have been influenced by Davitt's text as it was serialized a few months after Davitt's. Victor's novel has many affinities with Davitt's text. This could be simply because of parallel genre developments, but there are many very specific similarities which suggest otherwise.

These include the device of multiple criminals and how these two criminals meet by coincidence and then concoct criminal plans (and where one performs the murder and one commissions it). In Davitt's text, Silverton has an honorable funeral and is not initially uncovered as a criminal; in Victor's novel the criminals are allowed to escape punishment so as to not embarrass the wealthy Argyll home and its occupants. After Pierce is initially rejected by Flora his reaction is one which Victor replicates with her character of Richard; Silverton has "[a] sudden attack [...] caught a sudden chill, but his nervous system has been out of order this long time" (p. 101). Silverton has to temporarily relocate to Queensland in Davitt's novel because "conscience that is undermining the health of Pierce Silverton — conscience, as much as his restless love" (p. 120). Equally, in *The Dead Letter*, Richard is made sick and has to remove himself from the Argyll house and to the care of his mother. Herbert's handkerchief, which is found at the murder scene, is used again in Victor's novel when the handkerchief of Leesey — another falsely accused and red-herring character — is found at the Argyll estate. Silverton's effeminate portrayal is a technique that Victor would use in her novel, and which Braddon used in her earlier novel, *Trail*. In *Force and Fraud*, Silverton faints when Herbert is found "not guilty"; this is almost exactly emulated in *The Dead Letter* when one of the criminals, James, swoons. And the criminal, James, in *The Dead Letter*, like Pierce in *Force and Fraud*, offers to help with the actual detecting of the crime.

Davitt's mystery is well constructed and is enjoyable to read, incorporating moments of humor within her interweaving of crime, characters and events. The comic and self-referential (Dickensian) quality of this work aligns

it with Braddon's *Trail*, which is very much in the same vein. It is equally a mystery why she has not been acknowledged or credited for her pioneering work in the emergent crime genre — both within Australia and internationally. This may have been because Davitt did not have a serial detective protagonist and/or because she wrote very little and only for a short time. She was an independent Australian woman whose originality in writing made a significant contribution to the Australian crime genre and to crime fiction generally. Perhaps impacting on and definitely writing concurrently with Davitt was the author, Mary Helena Fortune, whose crime fiction also appeared (at first anonymously) in the early volumes of the *Journal*.

Mary Helena Fortune c. 1833 –c. 1909/10[153]

An Australian woman writer who wrote considerably more than Davitt, who was consistently writing crime/detective fiction, and who is even more unfairly neglected is Mary Helena Fortune. She co-authored the original Australian Casebook, making her the first female contributor to a sub-genre of crime fiction which featured a policeman as narrator and central character. Fortune wrote more crime fiction than any other woman in the nineteenth century. Fortune wrote more than Anna Katharine Green (U.S.), but Green wrote more novels. Impressively, she was the first woman in Britain, America and Australia to write detective fiction specifically; her collection of short stories, *The Detective's Album* (1871), preceded Anna Katharine Green's detective novel, *The Leavenworth Case* (1878), by seven years. Stephen Knight has defined Mary Fortune as being "internationally the most significant woman writing about crime in the mid–nineteenth century."[154]

Born in Belfast, Ireland (c. 1833) the then Mary Helena Wilson emigrated while still a child to Quebec, Canada, with her father, George. She married Joseph Fortune in 1851. Fortune relocated to Australia in 1855, and married a mounted trooper, Percy Rollo Brett, in 1858. She had two sons, one of whom did not survive childhood (Joseph George died of meningitis in 1858, aged 5); the other (Eastbourne Vaudrey Fortune, also known as George) ironically followed a life of crime. Thus far the mystery surrounding Fortune and her relationships/marriages has remained unsolved; Lucy Sussex has suggested that Fortune may have absconded from Canada.[155] Despite Fortune's prolific output of writing, she published her work anonymously, which perhaps contributed to her continued lack of recognition after her death. Fortune's anonymity has been remedied by Sussex (1987 onwards), who suggests that possibly Fortune "had secrets that could threaten her reputation and her liveli-

hood as a female author," for example either one of her possibly bigamous marriages.¹⁵⁶ Sussex has stated that without the work of book collector John Kinmont Moir (1893–1958) Fortune's real name would still be unknown. There is a "Waif Wander" file in the Moir Collection in the State Library of Victoria. Fortune was determinedly autonomous and sustained herself by her writing; as she observed, tea "tastes unusually good when I remember that I have earned every penny of the money that bought it, myself! [...] God bless ye all, my dear friends, and grant me continued independence!"¹⁵⁷

Fortune's economic independence and irregular domestic and marital arrangements were held in common with fellow authors Mary E. Braddon, and George Eliot. Her refusal to capitulate to the contemporary social and gender values is made clear in "The Detective's Album" series when, in "A Woman's Revenge; Or, Almost Lost," her "W.W." persona writes "I have been told by some that I tell horrible stories, and by others that I am not sensational enough; and I have personally come to the conclusion that I shall tell just such stories as I please, and that those who do not like them need not read them."¹⁵⁸ Her independent stance with reference to her writing reflects that of Mrs. Gaskell as well as Braddon and Alcott.

Fortune was a versatile author; between 1865 and 1909 she wrote across many genres and in many formats: crime, Gothic, memoir, journalism, and poetry. Of these, her journalism is the most reprinted. But her work remained in Australia. As Henry W. Mitchell notes:

> had she lived in England or America, where literary talent is properly appreciated, she would have, years ago, been regarded as a literary novelist, and have occupied the proud position that merit demands.¹⁵⁹

Ron Campbell, later *Journal* editor, observed that: "she wrote more, and doubtless got less for it, than any other Australian writer of the time."¹⁶⁰ In his analysis of sensation fiction Andrew Mangham details Fortune's story, "The White Maniac: A Doctor's Tale" (1863, published 1912), yet there is no mention of the fact that she is Australian.¹⁶¹ There is, however, reason to believe that Fortune's writing perhaps had some literary influence on British authors, just as Davitt's work had possibly influenced American writers, a topic that shall be returned to later.

Fortune differed from her *Journal* contemporaries in that she did not live and work in the city where the *Journal* was produced, and had to communicate and submit her work by correspondence. Fortune mainly published in the *Journal*, but she also contributed pieces to the *Australian Town and Country Journal*, *The Mount Alexander Mail* (under "M. H. F."; that is, Mary Helena Fortune), and "sketches" to the now rare *Buninyong Advertiser*. Sussex notes that Fortune was offered a job as sub-editor and reporter for *The Mount Alexander Mail* on the basis of her contributions and their quality by the edi-

tor; this offer was retracted once they met her and realized her real gender.[162] Of the newspaper, the *Buninyong Advertiser* and these "sketches," Sussex comments that these are "now ghosts, as the relevant issues of this newspaper have not survived. What other writing she [Fortune] might have done in the late 1850s to early 1860s is unknown."[163] Fortune started writing poems and romantic short stories for the *Journal* under the pseudonym of "Waif Wander," and then anonymously wrote her first crime story, "The Stolen Specimens" (*Journal*, 14 October 1865), as part of the "Memoirs of an Australian Police Officer" series. Fortune wrote these first stories anonymously, with no pseudonym attached. She wrote "Adventures of an Australian Mounted Trooper." This series is interchangeable with Borlase's "Memoirs of an Australian Police Officer" and it is hard to differentiate between Borlase and Fortune. Initially it was thought that Borlase wrote the "Stolen Specimens" and he did claim this story as his own. Sussex and Burrows' computer-based textual analysis of anonymous fiction in the *Journal* have ascertained that it was as a response by Fortune to Borlase's initial story—"The Shepherd's Hut" (1865)—from his series, "Memoirs of an Australian Police Officer." They found that instead of "The Dead Witness" being her first short crime story, the two stories previously attributed to Borlase (printed anonymously) and his "Memoirs of an Australian Police Officer" series were, rather, written by Fortune. These titles are "Memoirs of an Australian Police Officer": "The Stolen Specimens" (*Journal*, 14 October 1865, 106–8) and "Memoirs of an Australian Police Officer" No. IV: "Traces of Crime" (*Journal*, 2 December 1865, 220–2). Burrows suggests that Borlase may have been editing Fortune's stories, which would explain the similarities. There were two separate titles because Fortune's detective was a goldfields trooper rather than a city-based detective like Borlase's.[164]

Fortune's series title may have derived from the pseudonymous "William Burrows"s' earlier *Adventures of a Mounted Trooper in the Australian Constabulary* (1859). The date of publication of Fortune's short story shows that she was writing detective fiction before her American sister in crime, Metta Victor, whose *The Dead Letter* began serialization in January, 1866. Fortune's "Dead Witness" story appeared in the same month and year as Victor's novel began to be serialized in *Beadle's Monthly*. "The Stolen Specimens" was Fortune's response to Borlase's anonymous "The Shepherd's Hut" (*Journal*, September 1865) in the first issue. For a woman to have such intricate crime knowledge was rare; Fortune's verisimilitude in these narratives may have derived from the fact that her second husband was a mounted police trooper as well as from her time spent in the Victorian goldfields. Fortune's protagonist in her short story is a goldfields trooper, in contrast to the numerous fictional city detectives who appeared contemporaneously in London, New

York and other cities. "The Stolen Specimens" was followed by "Traces of Crime" (*Journal*, 2 December 1865). The *Journal* used the contributions of Borlase and Fortune to create the first detective series in Australia; this collaboration ended when Borlase was sacked after being found guilty of plagiarism.[165] Although the series drew to a close in 1866, it continued to be regularly reprinted in the *Journal* until 1919. The stories written by Fortune and Borlase are so similar in style that, even today, it is not possible always to know which author wrote what.

Fortune subsequently wrote four serialized non-crime novels: "Bertha's Legacy" (*Journal*, 31 March–26 May 1866); "Dora Carleton: a Tale of Australia" (*Journal*, 14 July–25 August 1866); "The Secrets of Balbrooke" (*Journal*, 1 September–29 December 1866); and "Clyzia the Dwarf: a Romance" (*Journal*, 29 December 1866–30 March 1867). The *Journal* advertised "Bertha's Legacy" as being "by far the best and most cleverly written tale of Australian origin."[166] The later serials are more in the Gothic and sensational vein rather than Australian in content. A year after Borlase's dismissal the *Journal* wrote: "'THE POLICE STORIES,' which at one time formed so attractive a feature, will be resumed [...] as the leisure of the writer permits,"[167] and in 1867 Fortune returned to the crime genre and the short story format, changing her pseudonym from "Waif Wander" or "M.H.F." to "W.W." and producing solo detective fiction. By using these hidden names, Fortune is similar to Victor and Alcott, as they also wrote crime-related work pseudonymously. An untitled investigation in Michael J. Tolley's *The Body Dabbler* into "W.W.," or Mary Fortune, proposed that her choice of pseudonym resonates with William Wordsworth.[168] Henry W. Mitchell has commented that "her very name is shrouded in mystery [...] no one knows who she is or where she lives. [...] I am sorry that I am not in a position to place before my readers full details of the life and work of this popular author [...] I do not think that I ought to bring her forth from her obscurity."[169]

In 1868 Fortune inaugurated "The Detective's Album" casebook series, which comprised over 500 stories and ran from 1868 to 1908. The longevity of this specific crime series exceeds that of any of the women writers discussed elsewhere in this study. The short stories were written in the mode of her earlier work with Borlase and she averaged twelve stories per year. Her detective protagonist, Mark Sinclair, is original as the stories are told in the first person and from his perspective, prefiguring the private eye of the later "hard-boiled" detective genre, and he is one of the first serial detectives, if not the first. Spofford had her Mr. Furbush short stories, but Fortune's output was much more. Anna Katharine Green was pioneering with her inception of her series character, Mr. Gryce, in *The Leavenworth Case* in 1878, yet Mary Fortune achieved this ten years earlier. Fortune also maintained this series over forty

years. Sussex adds that "her earlier stories in the 'Detective's Album' series continued to be reprinted in the *Journal* until 1919. After this date the series was continued until 1933 by other writers."[170] Fortune has parallels with Green and Braddon in the fact that they all wrote over decades. Fortune's writing and ingenuity, though, should have worldwide significance as she was using the crime/detective genre in a new form of the police procedural. Sussex writes of these stories that:

> Sinclair's voice, though, is remarkably similar to that of Fortune in her journalism, being lively and colloquial, addressing the reader directly. Their personal histories also intersect to some degree. He might be regarded as Fortune in drag, a game of performative gender for her.[171]

Sinclair may, then, have been a medium through which Fortune could express opinions and ideas that were unconventional for a woman.

Fortune's ability to write in different genres is visible in the various literary tropes woven into her detective fiction: Sinclair is helped by ghosts in "The Illuminated Grave" ("W.W.," *Journal* October 1867), and "The Ghostly White Gate" ("W.W.," *Journal*, March 1885); Gothic dream states are employed in "To Be Left Till Called For" ("W.W.," *Journal*, January 1870). Interpolated among her detective stories are tales which are mystery narratives, without mediating police/detective figures; examples include "The Deserted Hut" ("Recollections of an Australian Mounted Trooper," *Journal*, 24 March 1866) and "Werrimut: A Tale" ("Waif Wander," *Journal*, 3 February 1866). Most significant in the context of this argument is that seven of these stories were reissued in book form, titled *The Detective's Album: Tales of the Australian Police* (1871).[172] This has been called the first detective fiction book in Australia. E. Morris Miller and Frederick T. Macartney write that it is the "first book of detective stories to appear in Australia, by the first woman writer of such stories."[173] Fortune's text is extremely rare and hard to track down today. Fortune also wrote one full-length crime novel, *The Bushranger's Autobiography* (1871-2), purportedly edited by Mark Sinclair, but the book proved much less popular than her short stories. In the *Journal* (June 1852, p. 584), Sinclair stated that he had grown tired of the serial.

While it would be impossible to discuss all (or even many) of Fortune's prolific works, this chapter will now briefly examine a selection of stories from her short fiction, taken variously from the "Adventures of An Australian Mounted Trooper" series, "The Detective's Album" series and, finally, a story from "The Navvies' Tales: Retold by the Boss" (1873–75). Fortune's title "In the Cellar" (*Journal*, 27 April 1867), published under the initials W.W,[174] seems to echo Spofford's short story, "In a Cellar" (1859), suggesting that Fortune had read the American writer. But Fortune's tale is very firmly set in Australia, in Maryborough/Amherst, and the only affinities between the two stories are

the title they hold in common and the fact that they both feature a detecting figure. However, as this chapter will demonstrate, the real similarities lie in Fortune's tale and Spofford's "In the Maguerriwock" (1868), which might indicate that Fortune influenced Spofford rather than the reverse. In contrast to Spofford, Fortune's "In the Cellar," as in Poe's "The Mystery of Marie Rogêt" (1842–3), used a real-life event and newspaper coverage as the basis for her story: in this Australian case it is the 1858 goldfields murder of Jewish hawkers Raphael Caro and Solomon Levy. The *Maryborough and Dunolly Advertiser* (Avoca district) reported on the original murder.

The now detective/unnamed narrator is telling about a case from before the time when he was made a police detective, recounting the dreariness of his night patrols at the Maryborough treasury. During this period he had encountered a digger, Ned Corcoran and his (unnamed) wife, who inhabited a flimsy calico tent nearby; the narrator meets the wife as she is dying. While her husband fetches her some water she tells the policeman, just before she dies: "'Don't forget. At Amherst, where we lived before — in the cellar'" (p. 549). These words prove to be the catalyst for the case. This cryptic and partial discourse and content, conveyed by a woman, resemble Spofford's later character/wife, Mrs. Craven, whose words form the crux of the case in "In the Maguerriwock."

Fortune's detective then visits the "Rush Store" at Amherst which the husband and wife had previously owned. The shop has since been demolished, and there is an excavation to uncover the cellar. Finally, the way is open and the body of a man is discovered, which proves to be that of Reuben Jacobs — a Jewish pedlar — who has incited jealousy in Ned by giving his wife a little brooch. Ned had lured Jacobs to the cellar allegedly in order to help him open a fresh case of porter, but Ned had then driven a pick into Jacobs' brain as he stooped over the case. This action is reminiscent of those in Poe's "The Cask of Amontillado" (1846). Ned's wife comes across the burial scene and it is this sight which initiates her subsequent ill-health and functions as "the death-blow of the poor creature" (p. 52). In Spofford's "In the Maguerriwock" there is also a death scene set in a cellar and incorporating alcohol — a barrel of cider, rather than porter. In both narratives the victim's occupation is that of traveling salesman, but the motives of the murderers are different: Ned kills out of jealousy while Spofford's criminal kills for financial gain. Ned is arrested and given the death sentence. While both Fortune's and Spofford's stories are focused on the masculine, it is a feminine voice in each case that initiates and enables the detectives' work, and this, this chapter suggests, has parallels with the female authors of these criminal texts.

Fortune's fifth story in the series of "Memoirs of an Australian Police Officer," "The Dead Witness; or, The Bush Waterhole" (20 January 1866) —

which was initially thought to have been her first crime story for the *Journal*—interconnects with Spofford's "Mr. Furbush" story, which appeared a year earlier and concentrated on photography.[175] Fortune's story features Borlase's police detective, James Brooke (who was named in Borlase's second "Memoir" story, "The Missing Fingers"). The investigation in "The Dead Witness" is into a missing young photographer named Edward Willis who had been based at a publichouse in the township of Kooama. This story has a distinct, and positive, Australian setting; Brooke begins his account by relaying that "I can scarcely fancy anything more enjoyable to a mind at ease with itself than a spring ride through the Australian bush, if one is disposed to think he can do without any disturbing influence whatever from the outer world" (p. 329). Although murder intrudes into this idyllic setting, this sympathetic representation of Australia differs from the harshness depicted by de Chabrillan and earlier Eurocentric writers.

The detective, Brooke, examines the missing artist's room and searches his photographic plates. To find a crucial clue he juxtaposes two plates of the same dioramic scene in Minarra Creek: one plate is "a truly beautiful bit of entirely Australian bush scenery; a steep, rocky bank for a back ground; at its foot, a still, deep waterhole reflecting every leaf of the twisted old white-stemmed gum trees that hung over it" (p. 330) and the one plate is imperfect. In the latter, Brooke notices a figure crouched in the bush: "I set to work reproducing this hiding figure, magnifying and photographing by aid of the good camera the young artist had left behind, and I succeeded at length in completing a likeness quite clear enough" (p. 330). He establishes that this figure is a shepherd, known locally as "Dick the Devil." The same name was used for the bushranger in "The Shepherd's Hut" ("Memoirs of an Australian Police Officer"). "Dick" was also used in Davitt's *Force and Fraud* and Lang's *The Forger's Wife*. The use of photography and magnification in detection directly echoes Spofford's recourse to the devices in "Mr. Furbush," which appeared in *Harper's New Monthly Magazine* (April 1865). It has been proved that Fortune had read Beecher Stowe's *Uncle Tom's Cabin* (1852), suggesting that she was familiar with American fiction, and it is possible that she had access to *Harper's* as it was widely available in Australia; the use of the photographic device in both Spofford and Fortune's stories certainly seems to point to this. In her article "How I Spent Christmas" Fortune references a character from *Uncle Tom's Cabin*, writing: "My strange lot has almost been like that of poor "Topsy," who believed she "growed," as I never knew either mother or sister or brother; but I never *did* feel so utterly lonely and thoroughly a "waif," as I did in this great city of yours on Christmas Day."[176] Brooke is again akin to Mr. Furbush in his claim that "I happen to be a bit of an amateur photographer myself, and I have found my knowledge in that

way of service to me on one or two occasions in connection with my professional duties already" (p. 329).

In Fortune's story, the detective Brooke obtains works as a hut keeper with the shepherd and suspect, Dick. This action is similar to "Traces of Crime" and Borlase's "The Night Fossickers" in that the detective works in disguise and feigns to work as a mate with or nearby to the suspected criminal. It is a common device, seen in the stories of "Tom Richmond," Eugène François Vidocq, William Russell, Catherine Crowe, John Lang, J. S. Borlase, the two 1864 female detectives (Mrs. G — and Mrs. Paschal) in Britain, and with Mr. Keen (in F. S. Wilson's "Broken Clouds! An Original Australian Tale," 1866–7). It transpires that the murdered man, a photographer named Willis, had chastised Dick after seeing him cut his own dog's throat; Dick had revenged himself a week later by cutting Willis' throat. He had then concealed Willis' body in a waterhole — held down by a rope attached to a rock — but the rope gives way and Willis' body reappears to confront his killer, hence the title "the dead witness." While the idea was not new, Fortune's positive descriptions of the Australian bush were innovative. This story is important: it conveys new and positive representations of Australian topography, it employs a new medium of detection (photography) in conjunction with the detective's acumen and, as has been demonstrated, points to the connections between the writerly criminal sisterhood between America and Australia. The earlier story, "Traces of Crime" (as part of "Memoirs of an Australian Police Officer." Reprinted in the *Journal* (March 1909), 245–6), has been proven to be written by Fortune, and so validates that her crime writing predates that of her American counterpart, Metta Victor (with *The Dead Letter* appearing in *Beadle's Monthly*, January 1866). The impetus of this story is an assault on a woman at Chinaman's Flat, which leads the detective to uncover many other assaults and crimes, including the murder of a man in Pipeclay Gully.

"The Hart Murder," from W.W.'s "The Detective's Album" (*Journal*, October 1870), is also significant as it incorporates an amateur female detective. More to the point, this detecting figure — Mary Crawford — possesses more knowledge than Mark Sinclair, Fortune's serial policeman who is residing at the station at Illancarra. Mary sees that Mrs. Bell, the housekeeper (and murderess of Mrs. Hart), is Emma Fairweather in disguise; she writes to Sinclair: "*You* a detective! Bah! That woman is young, and she wears a wig!"[177] This use of disguise is reminiscent of the first "Memoirs" story — "The Shepherd's Hut" — where "Dick the Devil" masquerades as an aged woman: "the deep wrinkles in the cheeks were skilfully put on with burnt cork and [...] the straggling locks of grey hair were the fascinations of a wig."[178] Sinclair says of the £500 reward he receives for Fairweather's capture that "the only part of it I could prevail upon Miss Mary to accept was a handsome pair of

gold bracelets, prettily formed in imitation of a pair of handcuffs, and bearing the motto, in fine diamonds, 'To the fair detective, in memory of August 15th, 1860'" (p. 111). The key word in Sinclair's comment is "imitation": Mary's detecting skills are implicitly depicted as mimicry, signified by the feminized and "pretty" handcuffs. The emblematic handcuff-shaped bracelets could further be read as a gendered recuperation: they symbolically lock her wrists into place, arresting her into proper feminine passivity and reasserting masculine (detecting) power. But despite being brought back into a recognizable and "fair" feminine positioning, Fortune's story still demonstrates Mary's superiority in knowledge over Sinclair. In so doing, Fortune to some extent promulgates the view of the idiotic or incompetent police that Leakey described earlier (and that de Boos would in the year following "The Hart Murder"), but in Fortune's tale Sinclair is not so much stupid as Mary is more intelligent and acute.

"The Hart Murder" contains other disconcerting elements that challenge male superiority. Sinclair becomes a temporary resident at the station after the Squire finds him in the middle of the road "lying insensible, with a broken arm, and a pretty well smashed skull" (p. 106) while traveling; in this sense, Sinclair's broken body can be paralleled with that of the murder victim, Mrs. Hart. Mrs. Hart is a rich old spinster who is violently murdered by having her throat compressed and receiving blows to her head from a heavy instrument. Sinclair too has his skull severely attacked. The killer, Emma Fairweather, drugs Sinclair in order to snoop through his belongings and read his *Police Gazette*, and it is almost as if Emma Fairweather has defeated him literally and figuratively. The female violence at the centre of the narrative also disputes the conventions of the genre; Emma Fairweather kills Mrs. Hart by savagely beating her about the head with an iron bar. Not only does she commit this act, but Emma Fairweather is an independent woman who, rather than being controlled by men, controls them, bribing Edward, a man in the employ of Mrs. Hart, in order to incriminate him. Emma Fairweather seems motivated purely by financial gain and the reader is given no details of her past life that might mitigate her acts.

A similar unconventional and evil female figure was earlier created by Fortune in "A Struggle for Life" (*Journal*, 3 February 1866), in which a woman murders her husband with the help of her lover, overpowers the detective, Sinclair, and then ties him up and places him in a cart with her husband's dead body; she then attempts to strangle her own daughter. This woman is "a huge unwomanly looking virago"[179]; she is described as "the amazon" (p. 363), "a devil" (p. 363), and "a demon." (p. 363) Sinclair details that:

> A more hideous looking specimen of the sex surely was never seen before. Her loose untidy dress, large limbs, and rough unkempt hair were but the fitting

set off to a coarse brutal face within which could not be traced a single expression soft or womanly; [...] I could not help thinking what a long career of vileness and vice it must have taken to have to obliterated every remnant of womanhood in the form and feeling of this horrible creature [p. 363].

Curiously, unlike her male accomplice, Pat, she is not named; Sinclair comments that "the woman [...] was called simply "missus" by her companion" (p. 362). This inability to track gendered identities connects with Emma Fairweather in "The Hart Murder" in that Fairweather's history is unknown and the narrative does not state if she is a Mrs., Miss, or Ms. And like Sinclair's physical abuse in "The Hart Murder," in this earlier narrative he is subjected to psychological scarring inflicted by a woman and her actions. He relays his journey in cart: "I never spent such a fearful time in my life, and the episode has left such an impression upon my mind that I still frequently dream I am being buried alive with a horrible corpse beside me" (p. 362). Sinclair and his mate, Herbert O'Connor (who tracks and rescues him), achieve narrative closure by capturing the two criminals; the woman, however, dies from her gunshot wound gained in the struggle before she is due for trial, and her accomplice turns informant and serves a term of imprisonment.

Printed alongside "The Detective's Album" (1868–1908) was a short-lived series entitled "Navvies' Tales: Retold by the Boss" (1873–75), which featured an important story, "The Dog Detective" (*Journal*, May 1873). Sutherland has Collins as the first creator of a dog detective, a claim supported by Julian Thompson: "Collins was devoted to dogs. A dog—based on one of Collins's own pets—does some sterling detective work in *My Lady's Money* (1879)."[180] This study suggests that Collins' idea might have been inspired by that of Fortune, which would support Knight's assertion that Fortune's work was circulating in England.[181] Fortune's story appeared four years before Wilkie Collins' "My Lady's Money" (1877), subtitled "An Episode in the Life of a Young Girl."

Crime fiction writers at times made reference to dogs, or used dogs in their narratives in some way, but Fortune was the first to have a dog with a detective function.[182] The phrase, to "dog someone" or to be "on the scent" is now a common saying, synonymous with crime literature and had been used in nineteenth-century fiction. In Alcott's "V.V.," Douglas tells Virginie that Victor Varens has "traced you with the instinct of a faithful dog, though his heart was nearly broken by your cruel desertion" ("V.V.," p. 398). In Lang's *The Forger's Wife*, Millighan the bushranger has a trusty dog, a small pug-nosed terrier named "Nettles." Nettles barks and growls at Flower, recognizing Flowers' threat to his master. When Flower kills Millighan, Nettles will not leave his master's side, dying of starvation. In Marcus Clarke's *His Natural*

Life (Middlesex: Penguin Classics, 1987), the front cover has a picture which depicts a skeleton of a man and the remains of a dog/small animal curled up next to it. The novel says "The cover shows a detail from "Grim Evidence" by Samuel Thomas Gill, in the National Gallery of Victoria, Melbourne." This is almost exactly the same scene as Lang conveyed earlier in *The Forger's Wife* (1855), with Millighan and his loyal dog, "Nettles."

Céleste de Chabrillan's novel, *The Gold Robbers*, features a dog that helps his master, Tom, to capture Max after he kidnaps Melida. This dog (Acteon) uses his senses to direct Tom to the sea shore; the dog then attaches himself to the criminal and keeps him in the sea until his pistols are soaked and unusable and so contributes to the story. Crowe's *Susan Hopley* (1841) has "old Tycho," who saves Harry from putting his boot on, which contained a little red snake. It is not detecting *per se*, but Tycho is gifted with knowledge unbeknown to Harry; Harry comments that the dog is endowed with Providence to save his life.[183] Two years prior to Fortune's story, in de Boos' *Mark Brown's Wife* (1871), Drewe nurses the injured dog belonging to Job Hicks back to health in the hope of "making it one day serviceable in tracing the murderer of its master" (p. 28). He re-names the dog "Tracker" (linking this animal to racial stereotypes of the black trackers/aborigines) and, although crippled, Tracker literally tracks footprints to the criminal Dick's den, yet almost gives Drewe away by howling. Dick is later apprehended, and the dog is killed when Dick kicks him. The text tells the reader that "[i]t was the interposition of the dog which had created a diversion in favour of Tom, and had to all intents and purposes saved that enterprising digger's life. The moment the animal caught sight of Ruggy Dick he sprang forward with a fierce growl, making a frantic effort to leap at the ruffian's throat" (p. 44).

While Fortune may have read or been aware of these Australian texts, she certainly had her own preoccupation with representations of dogs. This is evidenced earlier in her story "The Dead Witness," and in her short fiction, such as "The Dog Days" by "Waif Wander" (*Journal*, April 1869). She wrote "Dog Bruff's Discovery" (under "W.W." and as part of "The Detective's Album," *Journal*, July 1902) and "Bloodhound Parker" (*Journal*, December 1882). In a piece of journalism in 1876, Fortune conflated herself with a dog: "I am what my friends — ahem —! two-legged acquaintances call a 'very eccentric person,' and a '*rather* peculiar creature' [...] my friends and acquaintances are mostly of the canine species."[184] Sussex associates Fortune and her "Waif Wander" pseudonym with a waif dog, in her reading of Fortune's article, "Towzer & Co."[185] In this, Fortune writes of her three new canine friends— "Keeper," "Towzer," and an unnamed female dog called "Co"— and she terms herself "a chronicler of caninity." (p. 212) The article title refers to the latter two dogs. "Towzer" is a male terrier and "Co" (whose name suggests a mere

appendage), is a waif mongrel bitch, "little Nameless." It is hard not to read this article as both a commentary and critique of gender roles; as Fortune writes:

> If you admire, between the sexes, an exhibition of the old simile of the oak and the ivy, doubtless it would delight you to see little Nameless muzzling around Mr. Towzer's bristly neck [...] and if you are one of Mr. Towzer's fraternity [...] you will doubtless try and secure just such another 'Co.' of your own, and blink indolently at the fire while *she* fusses around you [p. 215].

Yet Fortune imparts rebellious advice to the "little Nameless":

> So fully do you now believe in Towzer, who condescends to [...] permit you to bask in the light of his august countenance (weak little 'Co.'), that you do not hesitate to follow in his wake [...] but you must act upon 'your own hook,' little Nameless, if you wish to become independent of Towzer and the dogman [p. 217].

Fortune is, ultimately, disparaging of "poor little silly" (p. 218) and her actions in blindly following Towzer and for not breaking this mould which is, she says, "life, all the world over" (p. 219). While "Towzer & Co" can be read in explicitly gendered terms, "The Dog Detective" shows Fortune's ability to work between and across genres, locating her as innovative and independent in her writing.

The primary characters of "The Dog Detective" are a drunken Irishman, Jimmy Roach, and his dog, Growl. Growl is mangy with red eyes; he is presented as

> a most uncompaniable dog, and would not condescend to take the slightest notice of any overtures from either dog or man; and in the second he was as ugly an animal of his kind as you can imagine. He might have been a mongrel mastiff, or a mongrel bull-dog; or an amalgamation of both breeds [p. 474].

Growl's name and description serve as the antithesis of Collins' later introduction of the clean-cut, British dog "Tommie" in *My Lady's Money*. The dogs' owners are equally dissimilar in gender and class as well as appearance: Tommie belongs to an upper-class female, and Growl belongs to a lower-class, Irish man. Fortune's narrative begins one night when Jimmy enters the bush, drunk, on his return from a shanty town and falls asleep by a fire. He awakes to find a Jewish pedlar, who proves to have been robbed, wrapped in blankets by Jimmy's fire with his brains dashed out. Jimmy is subsequently arrested for the murder and imprisoned; he is acquitted at trial and becomes a teetotaler with a monomania about discovering the true killer. When surveying the murder site Jimmy finds his brandy bottle with an improvised stopper made from tweed trousers, suggesting that his dog Growl had chased someone and torn their clothing.

Fortune cleverly incorporates a red herring — Joe Shelton, the shanty

owner—because Growl had previously bitten his leg when Jimmy had been ejected from the premises. The true murderer, however, proves to be Charles Marsh, an educated landowner and gambler; he had committed the robbery and murder to repay a gambling debt to George Hall. Marsh's employee, Mike, finds the ripped trousers sticking out of the water hole. As further evidence, Growl can later smell the blood on Marsh in Rigby's Hotel where he is playing cards and drinking: "His eyes, still fiery with the effects of his late chase, roamed around the little room, and his nose was elevated in a continued sniff, that ended in a prolonged and suggestive howl" (p. 478). In response to Growl's discovery, two troopers are called upon and the arrest of the right man finally made; as in "The Hart Murder," the police presence and their limited detective skills are belittled and the troopers are met with a deprecating response: "To think what a muddle you both made of the affair, and to be set right by a dog at last" (p. 479). Marsh confesses, and then commits suicide with poison. Growl literally sniffs out the perpetrator, succeeding where human agency fails: he is the detective of the story.

Fortune, then, was an innovative writer who challenged literary, generic and gender boundaries and conventions. Not only was her output abundant, exceeding that of her sisters in crime, in Australia, Britain and the United States, but she was genuinely ground-breaking, producing narratives which can with confidence be called crime and detective fiction. She has been, and in a sense still is, unfairly overlooked, although she is now beginning to receive the critical attention she deserves.

From 1880 crime writing in Australia began once more to be dominated by men. Eliza Winstanley's novel, *For Her Natural Life: A Tale of the 1830s*, appeared in 1876, and Mary Fortune was still writing, with a massive number of stories from 1880 onwards, but women writers in the crime genre in Australia were pitted against a masculine resurgence at the *fin de siècle* which caused a falling off in feminine literary productivity. Knight says of this gendered eclipse in Australia that "[i]n the two generations after the 1880s there were very few books either about or by women that deal with crime in any major way."[186] And this literary feminine pause was paralleled in Britain. Australia was no longer a nascent nation and was in the radical process of constructing its own national myths and ideologies. This differed markedly from Britain and America in that a specific masculine criminal heroization and anti-authoritarian, anti-policing stance were established, exemplified—indeed embodied, in the real-life, later legendary, figure of Ned Kelly and the Kelly Gang of bushrangers.

The bushranger-hero was a focal figure of dissent, a figure which had its origins in the goldfields, but which had died out in the 1840s and was revived.

Knight has defined this end-of-the-century literature and its sympathy for criminals as the "criminal saga." This later development in the Australian crime fiction genre bears comparison with the British Newgate novel of the 1840s, but the Australian criminal sagas were more self-consciously antiestablishment and part of the male "mate" culture of the Antipodes. In 1894 a visiting American official wrote of Australian crime writers in Sydney's *Cosmos Magazine* that:

> They clothe villainy with charming attributes and thrill the imagination with reckless love of adventure. Instead of warning the world against the fawning treachery of the villain's smile, they paint the suavity of wickedness with a heroic charm.... The Australian mind is of too fine a mould to rest long satisfied with 'crimson literature' and, when attuned to Australian nature, the mental force of the country will strongly incline to the study and the culmination of the true, the pure and the beautiful.[187]

The obscurity of Australian women crime writers in general has extended to recent times: the crime writing canon in Australia is still resolutely masculine. Writers such as Peter Temple are writing very masculine narratives, and there seem to be no readily available "big names" for women in Australia comparable to those of Val McDermid and Mo Hayder in Britain, and Sara Paretsky in America, although Ngaio Marsh was a prominent woman crime writer from New Zealand. In terms of nineteenth-century Australia, male writers who are both privileged, appear in nineteenth-century anthologies, and whose names have survived into the twenty and twenty-first century include "Rolf Boldrewood" (Thomas Alexander Browne),[188] Hume Nisbet,[189] Basil Farjeon, E [rnest]. W[illiam]. Hornung[190], Ernest Favenc,[191] Guy (Newell) Boothby,[192] Francis Adams,[193] Edmund Finn,[194] and Patrick Quinn.[195] Of these writers, some were Australian, but a number were English, writing and setting narratives in Australia; the latter group included Arthur Conan Doyle. Doyle located a story in Australia, on the Victorian goldfields: "The Gully of Bluemansdyke. A True Colonial Story" (1881). Doyle also wrote a Holmes story, "The Boscombe Valley Mystery" (*Strand Magazine*, October 1891), which although set in 1888 in the fictional Boscombe Valley in England, included Australian expatriates, and the Australian phrase/term "Cooee!" plays an integral part. The expatriate, Mr. Charles McCarthy, is found dead in the Boscombe pool. L. T. Meade and Robert Eustace wrote "The Secret of Emu Plain," which was set in Australia, and published in *Cassell's Magazine* (December 1898).

In terms of format, what became both paradigmatic of and propagated the bushman myth was the inception of the Australian nationalist magazine, the *Bulletin* (first issue, January 1880). Banjo Patterson, the creator of Australia's unofficial national anthem, "Waltzing Matilda," had his famous poem — "The Man from Snowy River" — first published in the *Bulletin* (April

1890). Knight details this song and its symbolic nature in terms of crime and detective fiction:

> It was a long step from the amiable protective James Brooke of Borlase to the anonymous troopers who cause the suicide of an archetypal bush Australian in that most austerely poetic of national songs, but it is a divide that separates early from modern Australian crime fiction, nineteenth from twentieth century representations of the emotive understanding of crime and its detection.[196]

A concurrent privileging of the masculine over and the disparagement of women writers is apparent in the *Bulletin's* commentary in 1889, that:

> feminine literature consists largely of that inane drivel of monthly journals, in which fifth-rate writers gush in pages of weltering stupidity about coroneted heroes, noblemen of impossible elegance, and demi-gods from the Upper House of the British Legislature.[197]

Celebrated Australian authors who wrote of the bush include Louis Stone, Henry Lawson, Steele Rudd, and Joseph Furphy. Comparatively, women and their experiences of the bush were less known; Barbara Baynton, Miles Franklin, Mary Gilmore, Katharine Susannah Pritchard, and Henrietta Drake-Brockman produced fiction that incorporated their experiences. For example, Barbara Baynton's "The Chosen Vessel" portrayed a female perspective on the bush and its dangers[198] when a woman is murdered by a swagman while her husband is away shearing:

> More than once she thought of taking her baby and going to her husband. But in the past, when she had dared to speak of the dangers to which her loneliness exposed her, he had taunted and sneered at her. She need not flatter herself, he had coarsely told her, that anybody would want to run away with her.[199]

Baynton's challenge to male supremacy and gender oppression, however, was curtailed in its retitled reincarnation as "The Tramp" by the *Bulletin* (1896). "The Tramp" version was cut greatly and the focus was more on masculine power.[200]

Another change was that the main mode of literary production shifted from periodical to the novel format, with the great publishing houses primarily based in urban Melbourne. The English journalist, George Augustus Sala, called the city "Marvellous Melbourne." The squatter and goldfields formats previously seen in with the writing of Davitt, Borlase, Fortune and their contemporaries gradually disappear as Australia recreated its national image and reconsidered its past. The short story form is replaced by the novel, as it had been in France following Gaboriau, and as would happen in Britain. Knight writes that:

> The Australian publishers seem to have been somewhat ahead of London in their use of the novel form, presumably imitating the French crime writer Emile Gaboriau. The London craze of the late 1880s and 1890s was for short

stories by Doyle and his followers. Crime novels became common in Britain in the later 1890s and 1900s, and indeed some short story collections were actually disguised as novels when they were collected.[201]

The best-known example of this Australian modification was the groundbreaking writer Fergus Wright Hume (1859–1932), with *The Mystery of a Hansom Cab* (1886). As with Green's *The Leavenworth Case*, this novel was not initially serialized; Hume's was the first international best-selling detective story. The 1887 London reprint edition sold around half a million copies.[202] This novel's success has been juxtaposed with and presented as more considerable in sales than Doyle's earliest British Sherlock Holmes story; Ron Goulart remarks that it "had early sales much more impressive than those of the first Holmes novel."[203] This would indicate that Hume's novel had better and wider sales than Green — at least initially. The figures for *The Leavenworth Case* vary from a quarter to three quarters of a million, to a million copies, but the implication is that these sales were over time, rather than the immediate success of the 1887 reprint of *The Mystery of a Hansom Cab*. In the preface to his 1896 edition, Hume stated that he sold the rights for fifty pounds. Julian Symons had noted that Australian publishers turned down the book in the belief that "no Colonial could write anything worth reading." [204]

The Mystery of a Hansom Cab was self-consciously based stylistically and in terms of plot on Gaboriau's detective stories and it was set in and described low life Melbourne. Less well-known works of his are *Madame Midas* (1888), which was reprinted once in 1986, and *Miss Mephistopheles* (1890). *Madame Midas* (London: Ward, Lock, 1888) is a novel concerning a woman on the Australian goldfields. It was based on the real life personage of Alice Cornwell ("Princess Midas") who owned a profitable mine in Ballarat and then successfully ventured into publishing in London, owning the *Sunday Times*. *Miss Mephistopheles* is most obviously influenced by *Faust* (Kitty plays/performs the character of Mephistopheles). However, this study suggests that Hume had read Louisa May Alcott. Hume's novel seems a mélange of "V.V." and the Gothic story *A Modern Mephistopheles*.[205] The latter, a prequel novel, featured a powerful woman who first appeared in *The Mystery of a Hansom Cab*: Kitty Marchurst. Kitty, the star of Melbourne theatre, parallels with "V.V." (who is a dancer who manipulates men) and Braddon's criminal women in *The Black Band*. Kitty manipulates men to commit crimes for her such as murder and embezzling. A year after *The Mystery of a Hansom Cab*, Francis Adams, a journalist and writer in Melbourne, published *Madeline Brown's Murder: A Realistic and Sensational Novel* (1887), which was also set in Melbourne.[206]

In the twentieth century it was again Australian men who were popular and even internationally known; such writers included Randolph Bedford, Arthur W. Upfield, J. M. Walsh, and A. E. Martin. Despite this masculine preva-

lence at the end of the century and into the twentieth, Australian women writers in the period before this not only were writing crime narratives, but were innovative and pushed the boundaries in order to form an Australian crime fiction, sometimes before their British and American male and female counterparts.

Against the male pantheon which predicates national identity upon the bush ethos, Schaffer posits a re-envisioning of the framework:

> Actual figures of women do not appear with regularity in the discourse on national identity, which critics often (and sometimes gleefully) concede as being "masculinist," even "misogynist," but this does not mean that the idea of woman is absent. In the relationship between the native son and the old-world father, she can stand in the place of parental authority. [...] The concept of a feminine landscape, even if repressed or censored, makes possible the specific constructions of the bushman-as-hero. Its content helps us locate another "place" for woman in the Australian tradition.[207]

A reason why this women's "place" was not earlier apparent may be because of the Australian construction of "mateship," which seemed to be reserved only for men; conversely, Debra Adelaide notes that "[f]ew women writers ever met, let alone formed valuable or helpful friendships."[208] Despite these limitations, however, women were writing post–1880 and, as Lynne Spender writes, "Australian life in the nineteenth century was not all about boys and the bush."[209] May 1888 saw the inaugural publication of Louisa Lawson's feminist periodical, *Dawn: A Journal for Australian Women* (1888–1905; published in Sydney).

Sussex has aligned Lawson's journal with Fortune's works: "It is not too great a claim that she likely influenced Louisa Lawson, an *Australian Journal* reader, who was later to voice similar sentiments in *The Dawn*, the first feminist paper in Australia."[210] Also appearing were the works of Rosa Praed, whose *Outlaw and Lawbreaker* (1893) was focused on issues of gender, as well as over forty other novels. Perhaps most iconic was Miles Franklin with her feminist autobiographical novel, *My Brilliant Career* (1901); while not detective fiction it had a significant impact upon the status of Australian literature, as the illustrious Miles Franklin Literary Award for the best Australian published novel demonstrates. Franklin also wrote a detective pastiche, *Bring the Monkey*, in 1933.[211] In the context of this study, there seems to be a hiatus between the 1890s and 1930s. Knight has acknowledged this, commenting that "[i]n Australia the gap between the last work by the nineteenth century women writers and the start of the twentieth century renaissance is a good deal wider than elsewhere."[212] And it is his research which has picked up on under-examined women writers who appeared much later in the mid-twentieth century:

there is in Australia a comparable group of writers of substantial achievement from the same period. Jean Spender, "Margot Neville," June Wright, Pat Flower and Pat Carlon were working through the period between the mid-thirties and the early seventies, that is, after the emergence of Christie and her colleagues and before the recent consciously feminist reworking of the crime novel.[213]

Other Australian women who were writing and who are not commonly talked about (although not writing crime/detective narratives) were "Henry Handel Richardson" (real name, Ethel Florence Lindesay Richardson), Ada Cambridge — who wrote thirty novels, and five collections of poetry, and Jessie Catherine Couvreur (pseudonym "Tasma"), with her short stories and six novels. It seems, then, that Australian crime writing develops beneath the radar.

Yet despite the innovations of Australian women from 1860 to 1880 and these later female figures, the period from 1860 to 1880 in Australia has long been overlooked in literary terms, with Britain and America being privileged in terms of critical work and contemporary print culture and its external circulation. While it has been indicated in this study that the work of Australian authors may have impacted upon British and American crime/detective authors and writing, this was, unfortunately not a common or recognized occurrence. Internally, however, the *Australian Journal* was a leading publisher of crime/detective authors and their fiction. The gold rushes at mid-century also provided much factual criminal content. In this period, if it is discussed at all, the masculine — in writing crime and in authorship is now generally privileged.

Notwithstanding these masculine figures, there was a very strong formation in Australia of women writers in the crime/mystery and detection form/s. Yet in comparison to the British and American exponents whose literature travelled the globe, these women were not heard of outside of Australia in their moment or indeed today. This national part title contends that Céleste de Chabrillan, "Oliné Keese" (Caroline Woolmer Leakey), Eliza Winstanley, Ellen Davitt, and Mary Helena Fortune all paved the way for what was to follow in the national criminography in Australia and in crime and detective fiction internationally. In looking for a female canon of crime writing in Australia, it seems subsumed and dominated by male voices. Equally, there are a small amount of people examining Australian nineteenth-century crime narratives — and when it is discussed, it is usually by writers who are Australian in origin or have Australian affinities, such as Lucy Sussex and Stephen Knight, who are both leading figures in this area. The question remains, however, as to why there are no major international Australian female crime writer/s, and why crime narratives cannot be sent back from Australia to Britain/Europe and America. Despite globalization (and unlike Britain and America), Australia's crime fiction has perhaps unfairly had relatively little international circulation.

Chapter Notes

Introduction

1. Clive Emsley, "The Changes in Policing and Penal Policy in Nineteenth-Century Europe," in *Crime and Empire 1840–1940: Criminal Justice in Local Government and Global Context*, ed. Barry S. Godfrey and Graeme Dunstall (Devon: Willan Publishing, 2005), 8–24 (p. 17).
2. Edgar Allan Poe, "The Purloined Letter," *Selected Tales* (London and New York: Penguin, 1994), p. 352.
3. R. F. Stewart, *... And Always a Detective: Chapters on the History of Detective Fiction* (Newton Abbot: David and Charles, 1980), p. 27.
4. Catherine Ross Nickerson, *The Web of Iniquity: Early Detective Fiction by American Women* (Durham and London: Duke University Press, 1998), p. xi.
5. Julian Symons, *Bloody Murder: From the Detective Story to the Crime Novel*, 3d ed. (London, Sydney and Auckland: Pan Books, 1994), p. 75.
6. H. D. Thomson, *Masters of Mystery* (London: Collins, 1931).
7. George N. Dove, *The Reader and the Detective Story* (Bowling Green, OH: Bowling Green State University Popular Press, 1997), p. 10.
8. Gollancz, 1972.
9. Dorothy L. Sayers, "The Omnibus of Crime," in *Detective Fiction: A Collection of Critical Essays*, ed. Robin W. Winks (Englewood Cliffs, NJ: Prentice-Hall, 1980), 53–83 (p. 53).
10. In *The Art of Murder: New Essays on Detective Fiction*, ed. H. Gustav Klaus and Stephen Knight (Tübingen: Stauffenburg, 1998), 77–89.
11. Jacques Barzun and Wendell Hertig Taylor, *A Catalogue of Crime* (New York: Harper and Row, 1971), pp. 417–18.
12. Tzvetan Todorov, *Genres in Discourse*, trans. Catherine Porter (Cambridge: Cambridge University Press, 1990), p. 33.
13. Originally published in the *American Magazine* (September 1928). http://gaslight.mtroyal.ca/vandine.htm.
14. From the "Introduction" to *The Best Detective Stories of 1928–29*. Reprinted in Howard Haycraft, *Murder for Pleasure: The Life and Times of the Detective Story* (Revised ed., New York: Biblio and Tannen, 1976).
15. Godwin's novel initially appeared as *Things as They Are* in 1794 (three volumes). From the 1831 edition onwards it was known by the initial subtitle: *Caleb Williams*. This book will use the more common title of *Caleb Williams* when subsequently referring to this novel.
16. Ian Ousby, *Bloodhounds of Heaven: The Detective in English Fiction from Godwin to Doyle* (Cambridge, MA, and London: Harvard University Press, 1976).
17. In *Detective Fiction: A Collection of Critical Essays*, ed. Robin W. Winks (Englewood Cliffs, NJ: Prentice-Hall, 1980), 179–87 (p. 179).
18. John Cooper and B. A. Pike, *Detective Fiction: The Collector's Guide* (Somerset: Barn Owl Books, 1988).
19. Alison Light, *Forever England: Femininity, Literature and Conservatism Between the Wars* (London: Routledge, 1991), p. 11.
20. John Sutherland, *The Stanford Companion to Victorian Fiction* (Stanford, CA: Stanford University Press, 1989), p. 2. This companion includes Australian and American writers as well as British, yet Ellen Davitt (Australia), Mary Helena Fortune (Australia), James Skipp Borlase (Australia), and Anna Katharine Green (America) are not mentioned or included in this survey.
21. George Eliot, *The Mill on the Floss* (Harmondsworth: Penguin, 1979 [1860]), p. 494.
22. Mrs. Grundy's inception was in Thomas Morton's 1798 play, *Speed the Plough*.
23. Luce Irigaray, *The Sex Which Is Not One*, trans. Catherine Porter (Ithaca: Cornell University Press, 1986), p. 76.

24. Michele Slung, "Women in Detective Fiction," in *The Mystery Story*, ed. John Ball (Del Mar, CA: University of California, San Diego/Publishers Inc., 1976), 125–40 (pp. 125–6).

Chapter One

INTRODUCTION

1. *Discipline and Punish: The Birth of the Prison*, 1977.
2. This work has been speculatively and inconclusively attributed to both Thomas Gaspey or Thomas Skinner Surr. The text materialized a year before the inception of the New Metropolitan Police Force and one year before Eugène François Vidocq's *Mémoires* (1827–1828; 1829 trans. to English). Like Vidocq, Richmond's earlier life is portrayed in a picaresque mode and he has criminal associations.
3. Keith Hollingsworth, *The Newgate Novel 1830–1847: Bulwer, Ainsworth, Dickens and Thackeray* (Detroit: Wayne State University Press, 1963)
4. Alfred Crowquill, "Outlines of Mysteries," *Bentley's Miscellany*, 17 May 1845, p. 529.
5. Leslie Stephen, "The Decay of Murder," *Cornhill Magazine*, December 1869.
6. Margaret Oliphant, "Sensation Novels," *Blackwood's Edinburgh Magazine* 91 (May 1862), 564–84.
7. Anon., "The Contested Marriage," in *The Experiences of a Barrister*, attributed to Samuel Warren (New York: Arno Press, 1976, p. 45. First published in *Chambers's Edinburgh Journal*, 31 March 1849, 193–97).
8. When these stories appeared in book form in 1856 the title changed to *Recollections of a Detective Police-Officer* and was endorsed as being written by "Waters." This was published in America in 1852 as *The Recollections of a Policeman* (New York: Cornish, Lamport & Co., 1852).
9. Dorothy L. Sayers, "The Omnibus of Crime," in *Detective Fiction: A Collection of Critical Essays*, ed. Robin W. Winks (Englewood Cliffs, NJ: Prentice-Hall, 1980), 53–83 (p. 67). Jorge Luis Borges adds to this when he comments that "[i]n England, where the detective story is written from the psychological point of view, we find the best detective novels ever written, those of Wilkie Collins: *The Woman in White* and *The Moonstone*." Jorge Luis Borges, "The Detective Story," trans. Alberto Manguel, *Descant* 51 (1985), 15–24 (p. 22). Robert P. Ashley sees Collins' work as less clear-cut: "in perhaps half a dozen stories and novels Collins crossed the border which separates the mystery from the detective story. Several of his narratives straddle this border and are difficult to classify." Robert P. Ashley, "Wilkie Collins and the Detective Story," *Nineteenth-Century Fiction* 6 (1951), 47–60 (p. 47). This list of liminal works include: *Hide and Seek* (1854); "A Stolen Letter" (1854); a collection of short work, *The Queen of Hearts* (1859, including "The Diary of Anne Rodway"); *No Name* (1862); *The Moonstone* (1868); *The Law and the Lady* (1875); *My Lady's Money* (1878); the short story "Who Killed Zebedee?" (1880; republished as "Mr. Policeman and the Cook" in 1887); and *I Say No* (1884).

10. Caroline Reitz, *Detecting the Nation: Fictions of Detection and the Imperial Venture* (Columbus: The Ohio State University Press, 2004), p. xvi.
11. Knight, "A Chronology of Crime Fiction," *Crime Fiction 1800–2000*, p. 210.
12. Symons, *Bloody Murder*, p. 62. Geoffrey Larken has argued that the pseudonymous "Charles Felix" could have been co-authored by Catherine Crowe due to its incorporation of mesmerism and science. (Geoffrey Larken, "Early Crime Fiction. A Case for Mrs. Catherine Crowe." Ts. Templeman Library, University of Kent, Canterbury. "The Ghost-Fancier — a Life of the Victorian Authoress, Mrs. Catherine Crowe." Ts. Templeman Library, University of Kent, Canterbury.)
13. Michael Cox, "Introduction," in *Victorian Detective Stories: An Oxford Anthology*, ed. Michael Cox (New York and Oxford: Oxford University Press, 1992), ix–xxvi (p. xvi).
14. Bradford K. Mudge, "The Man With Two Brains: Gothic Novels, Popular Culture, Literary History," *PMLA* 107, no. 1 (January 1992), 92–104 (p. 96).
15. *Athenaeum*, 30 December 1843, p. 1160.
16. Sandro Jung has recognized these elements in "Charlotte Brontë's *Jane Eyre*, the Female Detective and the 'Crime' of Female Selfhood" (*Brontë Studies* 32 [2007], 21–30) and "Curiosity, Surveillance and Detection in Charlotte Brontë's *Villette*" (*Brontë Studies* 35:2 [2010], 160–71).
17. Michael Sadleir, *Things Past* (London: Constable, 1944), p. 69. Fanny Trollope's impact and (retrospective) recognition can be exemplified in Pamela Neville-Sington's book, *Fanny Trollope: The Life and Adventures of a Clever Woman* (London: Penguin, 1998), and Helen Heineman's *Mrs. Trollope: The Triumphant Feminine in the Nineteenth Century* (Athens: Ohio University Press, 1979).
18. In *Frances Trollope and the Novel of Social Change*, ed. Brenda Ayres (Westport, CT: Greenwood Press, 2002), 137–52. Fanny Trollope wrote an anti-slavery novel — *The Life and*

Adventures of Jonathan Jefferson Whitlaw: or Scenes on the Mississippi (1836) — which predated Harriet Beecher Stowe's *Uncle Tom's Cabin* (1852) by sixteen years. After living and visiting America, she wrote both *Domestic Manners of the Americans* (1832) and *The Refugee in America* (1832). The *Quarterly Review* in a review of *The Refugee* wrote that it was "absurd nonsense from beginning to end" (Review, *Quarterly Review* 48 [1832], 507–13 [p. 509]). Lucy Poate and Richard Stebbins have termed *The Refugee* a "hodgepodge" (Lucy Poate Stebbins and Richard Stebbins, *The Trollopes: the Chronicle of a Writing Family* [New York: Columbia University Press, 1945], p. 50). Her novel, *Jessie Phillips: A Tale of the Present Day* (1843), attacks the Poor Law Amendment Act of 1834 and *Michael Armstrong: The Factory Boy* (1839: Colburn) examines child abuse. Of these novels, *The Refugee* and *Jessie Phillips* include crime content. It is clear that Fanny Trollope had read crime narratives: in *The Refugee* she references the Bow Street Runners and Vidocq. *The Refugee* has a part-time New York police officer/part-time newspaper co-editor called Mr. Hannibal Burns and two quasi-detecting women: Lady (Eleanor) Darcy and Emily Williams. *Jessie Phillips*, while predominantly concerned with infanticide, includes a sub-detecting plot in its search for the real cause of the infant's death. Joseph Kestner has noted these detecting moments in *Jessie Phillips* but he also recognizes the limitations of Trollope's inclusion of detection in her narrative; he writes: "detective function derives from the search by the characters for the child's murder [t]he difficulty with this dimension of the novel is that the reader knows [Frederic] Dalton will be the murderer because of his stereotypical portrayal as a rake" (Kestner, *Protest and Reform: The British Social Narrative by Women 1827–1867* [Madison: University of Wisconsin Press, 1985], p. 107).

19. Quoted in Brenda Ayres, "*Apis Trollopiana*: An Introduction to the Nearly Extinct Trollope," in *Frances Trollope and the Novel of Social Change*, ed. Brenda Ayres (Westport, CT: Greenwood Press, 2002), 1–10 (p. 9).

CATHERINE CROW

20. Three volumes, London: Nicholson, 1841.
21. John Forster, Review of *Susan Hopley; or, Circumstantial Evidence*, *Examiner*, 28 February 1841, p. 132.
22. Ayres, "*Apis Trollopiana*," p. 3.
23. Thomas Kibble Hervey, Review of Catherine Crowe's *Adventures of Susan Hopley; or Circumstantial Evidence*, *Athenæum* 30 January 1841, 93–4 (p. 94).

24. Crowe, *Adventures of Susan Hopley*, p. 167.
25. John Sutherland, *The Stanford Companion to Victorian Fiction* (Stanford, CA: Stanford University Press, 1989), p. 615.
26. *Examiner*, 16 December 1843, p. 788.

CAROLINE CLIVE

27. Elizabeth Gaskell. In *Further Letters of Mrs. Gaskell*, ed. John Chapple and Alan Shelston (Manchester: Manchester University Press, 2000), p. 147.
28. Sadleir, *Things Past*, p. 79.
29. Anon. "Detectives in Fiction and in Real Life," *Saturday Review*, 11 June 1864, 712–3 (p. 712).
30. Quoted in Richard Altick, *Evil Encounters: Two Victorian Sensations* (London: John Murray, 1987), p. 148. Henry Mansel also equated sensation fiction with a virus in the April 1863 *Quarterly Review*.
31. Henry Mansel, "Sensation Novels," *Quarterly Review* 113 (1863), 481–514 (pp. 495–6).
32. *The Improper Feminine: The Women's Sensation Novel and the New Woman Writing* (London and New York: Routledge, 1992.
33. Henry James, "Miss Braddon," *The Nation*, 9 November 1865, 593–5.
34. Sandra Gilbert and Susan Gubar, *The Madwoman in the Attic: The Woman Writer and the Nineteenth-Century Literary Imagination* (New Haven, CT: Yale University Press, 1979), p. 67.
35. Alison Young, *Imagining Crime: Textual Outlaws and Criminal Conversations* (London: SAGE, 1996), p. 13.
36. Email correspondence: 15 June 2008.
37. Ed. Clive Bloom, Brian Docherty, Jane Gibb and Keith Shand (New York: St. Martin's, 1988).
38. Joseph A. Kestner, *Sherlock's Sisters: The British Female Detective, 1864–1913* (Hampshire: Ashgate, 2003).
39. *Roots of Detection: The Art of Deduction Before Sherlock Holmes*, ed. Bruce Cassiday (New York: Frederick Ungar, 1983)
40. Marty Roth, *Foul and Fair Play: Reading Genre in Classic Detective Fiction* (Athens and London: The University of Georgia Press, 1995), p. xiii.
41. Email correspondence; 15 June 2008. The canine detective appeared in Collins's "My Lady's Money: An Episode in the Life of a Young Lady" (1877; Christmas number of the *Illustrated London News*). A case could be made for the originality and precedence of the Australian detective writer, Mary Helena Fortune. See Watson, "The Hounds of Fortune: Dog De-

tection in the Nineteenth Century," *Clues: A Journal of Detection* 29.1 (2011), 16–25.

42. Victoria Nichols and Susan Thompson, *Silk Stalkings: When Women Write of Murder. A Survey of Series Characters Created by Women Authors in Crime and Mystery Fiction* (Berkeley: Black Lizard Books, 1988), p. xiii.

43. *Clues: A Journal of Detection* 15 (1994), 63–74.

44. Foreword. E. T. A. Hoffmann, *Mademoiselle de Scudéri* (Hesperus Classics, 2002).

45. "Introduction," in E. T. A. Hoffmann's *The Life and Opinions of the Tomcat Murr* (London and New York: Penguin, 1999) vii–xxxii (p. ix).

46. "Introduction," in *Tales of Hoffmann*, by E. T. A. Hoffmann (New York: Penguin, 1982), 7–15 (p. 12).

47. Dagni Bredesen, "Investigating the Female Detective in Victorian and Edwardian Fiction," *Nineteenth-Century Gender Studies* 3 (2007). http://www.ncgsjournal.com/issue31/bredesen.htm.

48. Peter Haining, "Introduction," in *Hunted Down: The Detective Stories of Charles Dickens*, ed. Peter Haining (London and Chester Springs: Peter Owen, 2006), 7–21 (p. 8).

49. Michel Foucault, *The History of Sexuality. Volume One: The Will to Knowledge*, trans. Robert Hurley (Harmondsworth, Middlesex: Penguin, 1990), p. 3.

50. Ashley, "Wilkie Collins and the Detective Story," p. 50.

51. Bredesen, "Investigating the Female Detective in Victorian and Edwardian Fiction." http://www.ncgsjournal.com/issue31/bredesen.htm.

52. Wilkie Collins, *The Woman in White* (London: Penguin, 1994), pp. 24–5.

53. Gill Plain, *Twentieth-Century Crime Fiction: Gender, Sexuality and the Body* (Edinburgh: Edinburgh University Press, 2001), p. 148.

54. Dorothy L. Sayers, "The Omnibus of Crime," in *Detective Fiction: A Collection of Critical Essays*, ed. Robin W. Winks (Englewood Cliffs, NJ: Prentice-Hall, 1980), 53–83 (p. 59).

55. The feminine gender of the name "Anonyma" was probably intentionally used to make it a doubly feminine text; it alludes to the women of the London "demi-monde" novel. Rachel Sagner Buurma has written on "Anonyma's Authors," *SEL: Studies in English Literature 1500–1900* 48 (2008), 839–48. Additionally, *Revelations* is known as *The Experiences of a Lady Detective* (London: Charles Henry Clarke, 1864). Patricia Craig and Mary Cadogan have extensively detailed the argument over which text was first to appear. (Patricia Craig and Mary Cadogan, *The Lady Investigates: Women Detectives and Spies in Fiction* (Oxford: Oxford University Press, 1986)) The *Revelations of a Lady Detective* was written by "Anonyma" and has been retrospectively attributed to Hayward, although it is still inconclusive as to whom the real author was; other possible authors have been named such as Robert Owen and Bracebridge Hemyng. "Anonyma" wrote many novels in the 1860s (published by Vickers).

56. Judith Flanders, *The Invention of Murder: How the Victorians Revelled in Death and Detection and Created Modern Crime* (London: Harper Press, 2011), p. 298.

57. Michele Slung, "Women in Detective Fiction," in *The Mystery Story*, ed. John Ball (Del Mar, CA: University of California, San Diego/Publisher's Inc., 1976), 125–40 (p. 140).

58. Birgitta Berglund, "Desires and Devices: On Women Detectives in Fiction," in *The Art of Detective Fiction*, ed. Warren Chernaik (New York: St Martin's, 2000), 138–52 (p. 138).

59. Fay M. Blake, "Lady Sleuths and Women Detectives," *Turn-of-the-Century Women* 3 (1986), 29–42 (p. 29).

60. Sayers, "The Omnibus of Crime," pp. 58–9.

61. Jane C. Pennell, "The Female Detective: Pre- and Post-Women's Lib," *Clues: A Journal of Detection* 6:2 (1985), 85–98 (p. 85). Blake supports Pennell's notion: "The woman detectives of the period, however, are truly subversive females. [...] They are all freakish variations of the male detectives of the contemporary detective genre" (p. 39).

62. Knight, *Crime Fiction: 1800–2000*, p. 34.

63. Andrew Forrester, Jun., *The Female Detective* (London: Ward, Lock, and Tyler, 1864), p. 3. All further references are to this edition and are given parenthetically.

64. Klein, *The Woman Detective*, p. 18.

65. "Crime and its Detection," *Dublin University Magazine*, May 1861.

66. Anon., "Pages from the Diary of a Philadelphia Lawyer," "The Murderess," *Burton's Gentleman's Magazine* (1838), 107–12 (p. 107).

67. Inheritance/crime/property and rights were common and recurring concerns or preoccupations in the fiction of the Victorian period. The Newgate novels of the 1830s and 1840s dealt with this, as in Ainsworth's *Jack Sheppard* (1839). Bulwer Lytton's *Night and Morning* (1841) was a mystery revolving around inheritance. Samuel Warren's "The Experiences of a Barrister" series has as its first story "The Contested Marriage" (*Chambers's*, March 1849), which concerns Mr. Ferret finding evidence to the rightful owner of an estate. An-

other of the "Experiences"—"The Writ of Habeas Corpus" (*Chambers's*, June 1849)—revolves around inheritance as does "Bigamy or No Bigamy" in "The Confessions of an Attorney" (*Chambers's*, 16 November 1850), and Collins' *The Woman in White* (1860).

68. To some extent, this is suggestive of Thomas Waters' case, "The Twins" (*Chambers's*, 22 June 1850, 387–90), which involves a stolen inheritance and the abduction of the rightful newborn male twin and heir of income and estates.

69. Lisa M. Dresner, *The Female Investigator in Literature, Film, and Popular Culture* (Jefferson, NC: McFarland, 2007), p. 39.

70. Judith Flanders, "The Hanky-Panky Way: Creators of the First Female Detectives: A Mystery Solved." *Times Literary Supplement* 18 June 2010, 14–15 (p. 14).

71. Martin Kayman, *From Bow Street to Baker Street*, p. 214.

72. Knight, *Crime Fiction 1800–2000*, p. 36.

73. Knight, *Crime Fiction, 1800–2000*, p. 36.

74. Andrew Forrester Jr. "Arrested on Suspicion," in *A Treasury of Victorian Detective Stories*, ed. Everett F. Bleiler (New York: Charles Scribner's Sons, 1979), 15–34 (p. 19).

75. Sadleir 3417a. London: C. H. Clarke [1884].

76. Kathlyn Ann Fritz and Natalie Kaufman Hevener, "An Unsuitable Job for a Woman: Female Protagonists in the Detective Novel," *International Journal of Women's Studies* 2 (1979), 105–17 (p. 107).

77. Barbara Lawrence, "Female Detectives: The Feminist-Anti-Feminist Debate," *Clues: A Journal of Detection* 3:1 (1982), 38–48 (p. 38).

78. "Incognita," in *Revelations of a Lady Detective* (London: Vickers, 1864), 264–308 (p. 264). All further references are to this edition and are given parenthetically.

79. Kestner, *Sherlock's Sisters*, p. 10.

80. Michele B. Slung, "Introduction," in *The Experiences of Loveday Brooke, Lady Detective* [Pirkis] (New York: Dover, 1986), vii–xiii (p. xi).

ELIZABETH CLEGHORN
GASKELL

81. Some of her famous titles are *Mary Barton* (1848); *Ruth* (1853); *Cranford* (1853); *North and South* (1855); *Sylvia's Lovers* (1863); *Cousin Phillis* (1865); the unfinished *Wives and Daughters* (1866); and her biography on *The Life of Charlotte Brontë* (1857).

82. Richard Monckton Milnes, *The Athenaeum* (18 November 1865), quoted in "Elizabeth Gaskell: Biography," *The Victorian Web*. http://www.victorianweb.org/. Accessed 20 October 2008.

83. In *Elizabeth Gaskell: The Critical Heritage*, ed. Angus Easson (London: Routledge, 1991), p. 514.

84. Lord David Cecil, *Early Victorian Novelists: Essays in Revaluation* (London: Constable, 1934), p. 198.

85. Elizabeth Gaskell, quoted in *The Letters of Mrs. Gaskell*, ed. J.A.V. Chapple and Arthur Pollard (1966) (Manchester: Mandolin, 1997), p. 223.

86. Appearing as "The Ghost in the Garden Room."

87. Elise B. Michie, *Outside the Pale: Cultural Exclusion, Gender Difference, and the Victorian Woman Writer* (Ithaca and London: Cornell University Press, 1993), p. 98.

88. Patsy Stoneman, "Gaskell, Gender, and the Family," in *The Cambridge Companion to Elizabeth Gaskell*, ed. Jill L. Matus (Cambridge: Cambridge University Press, 2007), 131–47 (p. 133).

89. Elizabeth Gaskell, "Disappearances" in *Elizabeth Gaskell: Gothic Tales*, ed. Laura Kranzler (London: Penguin, 2004), 1–10 (p. 1) [*Household Words* 3 (7 June 1851), 246–50].

90. Dresner, *The Female Investigator*, p. 9. In her work Dresner draws on the Anglo-American female investigator from the Gothic up until the 1990s. In this instance she is referring to writers such as Anne Radcliffe, and works such as *Jane Eyre*, *Northanger Abbey*, and Collins' *The Woman in White*, and *The Law and the Lady*.

91. Elizabeth Gaskell, "The Grey Woman," in *Elizabeth Gaskell: Gothic Tales*, ed. Laura Kranzler (London: Penguin, 2004), 287–340 (p. 289). All further references are to this edition and are given parenthetically.

92. *The Life of Charlotte Brontë*, ed. Elisabeth Jay (Harmondsworth: Penguin Classics, 1997), p. 259.

93. This action has parallels with or may have been influenced by Catherine Crowe's *Susan Hopley* (1841). In *Susan Hopley*, the quasi-detecting figure of Julie Le Moine is assisted by her maid, Madeleine. Julie has her hair cut off and dresses as a page in order to infiltrate the villains' den. Although both Anna in *The Grey Woman* and Julie in *Susan Hopley* escape, like Anna — "The Grey Woman"— Julie is physically marked or altered by these transgressive and transvestite actions. Men also cross-dress, yet mainly these are criminals/liminal figures: Vidocq disguises as a nun and men in Australia follow this: J. S. Borlase's story "The Shepherd's Hut," and the employment of such gendered disguise is suggested in Charles de Boos' *Mark Brown's Wife*.

94. Judith Halberstam, *Skin Shows: Gothic Horror and the Technology of Monsters* (Durham

and London: Duke University Press, 1995), p. 21.
95. Eve Kosofsky Sedgwick, *Between Men: English Literature and Male Homosocial Desire* (New York: Columbia University Press, 1985), p. 92.
96. Halberstam, *Skin Shows*, p. 60.
97. Jacques Barzun and Wendell Hertig Taylor, *A Catalogue of Crime* (New York, San Francisco, and London: Harper and Row, 1971), p. 501.

MARY ELIZABETH BRADDON

98. All further references to *The Trail of the Serpent* will be shortened to *Trail*.
99. Martha Hailey DuBose, *Women of Mystery: The Lives and Works of Notable Women Crime Novelists* (New York: Thomas Dunne Books, 2000), p. 4.
100. *Punch*, 7 August 1841, p. 39.
101. Henry James, "Alphonse Daudet," in *Partial Portraits* (1881), quoted in M. Anesko, *Friction with the Market: Henry James and the Profession of Authorship* (Oxford: Oxford University Press, 1986), p. 34.
102. "Miss Braddon. The Illuminated Newgate Calendar," the *Eclectic Review*, January 1868.
103. For evidence of this relationship see Robert Lee Wolff, "Devoted Disciple: The Letters of Mary Elizabeth Braddon to Sir Edward Bulwer-Lytton, 1862–1873," *Harvard Library Bulletin* 12 (1974). They had met in 1854. Carnell has noted that Braddon performed in a stage version of *Jack Sheppard*. (Jennifer Carnell, *The Literary Lives of Mary Elizabeth Braddon: A Study of her Life and Work* (Hastings: The Sensation Press, 2000), p. 60) Before her writing career took off, Braddon was an actress, performing under the stage name of "Mary Seyton." As in *Trail*, *Paul Clifford* includes murder and an orphan with unknown parentage who becomes a criminal. *Trail* is unlike *Paul Clifford* as it is not a historical novel (in the Newgate vein) and both Jabez and his father are thoroughly criminal. Additionally, Ainsworth's popular *Jack Sheppard* (1839) has affinities with *Trail*.
104. Mary Elizabeth Braddon, *The Trail of the Serpent*, ed. Chris Willis (New York: Random House, 2003), p. 160. All further references are to this edition and are given parenthetically in the text.
105. The group who assist Mr. Peters and help to free Richard.
106. A self-referential scene is shown in Chapter VIII. In Augustus Darley's Friar Street surgery parlour, a hanging bookshelf is described as "a literary waterfall" (p. 239). This bookshelf inevitably tips and Mr. Percy Cordonner takes to "reading from the loose leaves the most fascinating *olla podrida* of literature, wherein the writings of Charles Dickens, George Sand, Harrison Ainsworth, and Alexandre Dumas are blended together in the most delicious and exciting confusion" (p. 303). Braddon also alludes to Aesop's fables, Shakespeare's *Othello* and *Macbeth*, the Bible, and mythology. As with Vidocq and Richmond, Mr. Peters dons a disguise at Liverpool docks in order to arrest Jabez.
107. Margaret Oliphant, "Novels," *Blackwood's Edinburgh Magazine* CII (1867), 257–80 (p. 275).
108. An example being the prominent 1840 case of Madame Laffarge: she was put on trial and imprisoned for murdering her husband with arsenic. The 1840 *Annual Register* states: "she was accused of having murdered her husband in his country house at Glandier, by administering arsenic, under circumstances of peculiar atrocity. [...] The most morbid sympathy was displayed throughout France in favour of the accused, who was ultimately found guilty, and sentenced to imprisonment for life." *The Annual Register or a View of the History, and Politics, of the Year 1840* ed. Edmund Burke (London: Rivington, 1841), 175–6. v.82 1840. Collins could have drawn on this for his short story "The Poisoned Meal" [From the Records of the French Courts] (*Household Words*, 18 September–2 October 1858). In 1859, for his short story "Hunted Down" (*The New York Ledger*, 20 August–2 September 1859), Dickens drew on the true 1830 case of Thomas Griffiths Wainewright who poisoned his sister-in-law in order to obtain her £18,000 insurance money. This masculine poisoner is repeated in *The Notting Hill Mystery* (1862–3; novel 1865). There was the factual case of Dr. William Palmer—"The Rugely Poisoner"—a scientist who murdered his family in order to obtain life-insurance money, as well as killing his associates over racing debts. He was executed in November 1855. Palmer's trial was the impetus for Dickens' article "The Demeanour of Murderers" (*Household Words*, 14 June 1856).
109. Mary Elizabeth Braddon, "'Devoted Disciple': The Letters of Mary Elizabeth Braddon to Sir Edward Bulwer Lytton, 1862–1873," ed. Robert Lee Wolff, *Harvard Library Bulletin*, 12 (1974), 129–61 (p. 158). Braddon was both a fan and acquaintance of Lytton, dedicating *Lady Audley's Secret* to him.
110. Kayman, *From Bow Street to Baker Street*, p. 75 Charles Dickens and W. H. Hills wrote on "Idiots" in *Household Words* (4 June 1853) and, later "Idiots Again" (*Household Words*, 15 April 1854).

111. This action is similar to *Jane Eyre*, and Braddon's *The Black Band*, where Joshua Slythe adopts the two children he saves from the Black Band's criminal den. The first person/purported autobiographical tale of life and criminality in the earlier *Newgate Calendar* are seen in *Trail* when the text gives Jabez a voice and intersperses this throughout the novel. This act, as well as drawing on the *Calendars*, is similar to Reynolds's *Mysteries*, where the criminals get to tell their own stories within, but do not control the main body of the text. Peters, though, suggests an alternative discourse; he communicates though sign language and this is perhaps again indicative of the changing of the known signifiers of both language/discourse and crime.

112. Carnell, *The Literary Lives*, p. 1.
113. Willis, "Afterword," p. 408.
114. All further references to this text will be given as *Three Times*. Originally, this title was printed in Beverley by C. R. Empson; Braddon refers to "the obscurity of its original production, and its re-issue as the ordinary two-shilling railway novel." Mary Elizabeth Braddon, "My First Novel," Appendix in *The Trail of the Serpent*, Mary Elizabeth Braddon, ed. Chris Willis (New York: Modern Library, 2003), 415–27 (p. 422). Originally found in "My First Novel: The Trail of the Serpent," *The Idler Magazine*, III (February–July 1893), 19–30. Chris Willis adds that "*Three Times Dead*, [was] published jointly by small firms in Hull and London, *Three Times Dead* sold badly" (Chris Willis, "Mary Elizabeth Braddon," www.litencyc.com). R. F. Stewart, in his Appendix 1 "Corrections/Comments on Dorothy Glover and Graham Greene's *Victorian Detective Fiction*" (1966), writes that "[t]his book was written in 1854 and published as *Three Times Dead: or, The Secret of the Heath*" (... *And Always a Detective*, p. 325). This "secret" refers to the body of Jim that is found on the heath and is mistaken as the body of his criminal twin brother, Jabez (or Ephraim in its original incarnation).
115. Mary Elizabeth Braddon, letter of March 13, 1904, to Malcolm C. Paton, quoted in Robert Lee Wolff, *Sensational Victorian: The Life and Fiction of Mary Elizabeth Braddon* (New York and London: Garland, 1979), p. 484. Braddon has commented about *Three Times Dead* and Beverley's stipulations for content, that they asked her to combine "the human interest and genial humour of Dickens with the plot-weaving of G. W. M. Reynolds" (Braddon, "My First Novel," p. 422).
116. Wolff, *Sensational Victorian*, p. 113. Jennifer Carnell, in her introduction to *The Black Band* (1998) dates *Three Times Dead* as 1860 and the re-titled *Trail* as 1866, instead of 1861 ("Introduction," p. xviii). The UCLA Michael Sadleir Collection (Sadleir 335) dates *Three Times Dead* as 1854. The catalogue states 1854, even though there is no date on the book itself. There is, however, a hand-written dated letter inside the book on the blank inside page before the text; this handwriting is difficult to discern and is ambiguously signed James [Janice?] Wills [Mills?]. This writing does confirm this earlier date: "These are the revised proof sheets of Miss [ME?] Braddon's first novel published in penny numbers by C. R. Empson Beverley in the year 1854 or thereabouts the proofs whereof revised for him — MEB. was then living near Beverley and the late [CW? CR?] and [F?G?]ilby were in some way interested in [?] The sheets were found and bound in August 1896" (*Three Times Dead; The Secret of the Heath*, by M. E. Braddon. London: — W. M. Clark, 16 & 17, Warwick Lane. Beverley: — C. R. Empson, Toll-Gavel, 1854). *Trail* is still relatively little known, with the original (*Three Times*) even harder to pinpoint. Though it may well be that Braddon worked on the novel before my period of 1860 to 1880, it is clear that *Trail* itself fits into the period and is important.
117. The initial figure, while ostensibly elusive, seems to have originated from Maxwell's letters to Braddon — circa February 1861 — which can be found in the Wolff collection in the University of Texas, Austin. Maxwell informs Braddon that *Trail* sold a thousand copies in one week without being reviewed.
118. George Eliot, letter to John Blackwood, 11 September 1860, in *The George Eliot Letters*, ed. G. Haight (New Haven: Yale University Press, 1954), IV. 309–10.
119. The British Library holds only one copy of the 1861 *Trail* text, and one of the original *Three Times Dead; or, The Secret of the Heath*. The UCLA special collections (Michael Sadleir) hold an 1866 copy of *Trail* (Sadleir 337. London: Ward, Lock, and Tyler, Warwick House, Paternoster Row). This copy is the same as the modern edition, but differs in that it has two illustrations and a Publisher's Announcement (iii–vi. Dated July 1866). This announcement comments that "In its serial form it was subjected to all the vicissitudes which can afflict the literary undertaking; but although always hastily, and sometimes recklessly, produced, the Novel was written *con amore*" (iii), "THE TRAIL OF THE SERPENT struggled into life" (iii) and "[t]he work now reprinted has been carefully revised, and in part re-written, but in no manner reconstructed. The sin of "sensationalism," pure and simple, can be fairly laid at its door; but as the word "sensa-

tion" was not perverted to its present use until after THE TRAIL OF THE SERPENT had run its unpretentious course, MISS BRADDON may reasonably demand forgiveness on the ground of having offended unconsciously against the canons of modern literary criticism. For what it is, and with this explanation of the difficulties under which it was written, the Publishers submit THE TRAIL OF THE SERPENT to the generous appreciation of both critical and non-critical readers" (vi).

120. From Jabez North to Raymond Marolles to Count de Marolles. Conan Doyle later included a character named Jabez Wilson in "The Red-Headed League" (*Strand Magazine*, August 1891).

121. William K. Everson, *The Bad Guys: A Pictorial History of the Movie Villain* (New York: Citadel, 1964), p. xi.

122. Mary Elizabeth Braddon, *Three Times Dead; or, The Secret of the Heath* (London: W. And M. Clark, Warwick Lane; Beverley: C. H. Empson, Toll-Gavel, n.d. [1860]), pp. 1–2, v.

123. This action, which is later replicated with Jabez's own son, draws on the sensational topics and tradition/preoccupation of the earlier broadsides. These include Anon., *The Liverpool Tragedy: Showing How a Father and Mother Barbarously Murdered Their Own Son*, and the Constance Kent case (of which a broadside — Anon., *Trial and Sentence of Constance Kent* — was made). The suicide of Jabez's partner is reminiscent of Anon., *Horrid Murder, Committed by a Young Man on a Young Woman*. (These titles can be found in Charles Hindley (ed.), *Curiosities of Street Literature* [1871] (London: Seven Dials Press, 1969)). There is also the already mentioned case of infanticide in Anon., "Pages from The Diary of a Philadelphia Lawyer: The Murderess" (1838).

124. Sarah Waters, "Introduction," in *The Trail of the Serpent*, Mary Elizabeth Braddon, ed. Chris Willis (New York: Modern Library, 2003), xv–xxiv (p. xviii).

125. Jabez is introduced in chapter one, titled "The Good Schoolmaster." This may play on the singular villain in Sue's *Mysteries of Paris* (1842–3): the central villain is named "the Schoolmaster" because though a criminal he is well-educated: he is Gothically punished by being made blind. After abandoning his family, Eugene Aram also worked as an usher in a school at King's Lynn, Norfolk.

126. Dennis Porter, *The Pursuit of Crime: Art and Ideology in Crime Fiction* (New Haven, CT: Yale University Press, 1981), p. 218.

127. Squire Griffiths in Gaskell's "The Doom of the Griffiths" (*Harper's New Monthly Magazine*, January 1858) is initially described as tender and feminine, yet he is dangerous under this cover of femininity. Falkland in *Caleb Williams* is also depicted as delicate; this representation contrasts with Barnabas Tyrell, who beats him. Falkland retaliates by later stabbing and killing Tyrell, thus propagating the feminized/criminal and appearance/reality binaries.

128. Hillary Waugh, however, strongly seems to believe that "until these recent times [written in 1991] [...] Male victims were the literary custom. Males are avaricious, vicious, vengeful, remorseless, arrogant, the embodiment of those qualities readers would like to see eliminated from the earth. Males had created the world in their own image and males were, consequently, responsible for the death and destruction it spawned. Women, on the other hand, were the nurturers, the innocents, the helpless. They had not shaped the world. Men deserved to die, but to have women slain was like having horses burn to death or children mutilated." Hillary Waugh, *Hillary Waugh's Guide to Mysteries and Mystery Writing* (Cincinnati, OH: Writer's Digest Books, 1991), p. 6. Waugh omits any female writers as he progresses smoothly from Poe to Vidocq and Gaboriau, to Collins and Dickens and then to Sherlock Holmes.

129. Lytton was drawing on an actual murder in his novel. Jacques Barzun and Wendell Hertig Taylor describe this as "the sordid murder of Mr. Weare by Thurtell and Hunt in 1821" (Jacques Barzun and Wendell Hertig Taylor, *A Catalogue of Crime* [New York: Harper Row Publishers, 1971], p. 347). Under "*Pelham: The Adventures of a Gentleman*, 2v. H. Colburn, 1828" they elaborate that "the character of Thornton owes something to the actual murderer Thurtell" (*A Catalogue of Crime*, p. 344). See also Heather Worthington, "Against the Law: Bulwer's Fictions of Crime" in *The Subverting Vision of Bulwer Lytton*, ed. Allan Christensen (Newark: University of Delaware Press, 2004), 54–67.

130. Murder by poison was well-known through the nineteenth century. An anonymous writer stated that "the public would no longer sit down to their daily meals with safety." Anon., "Central Criminal Court: Trial of Mrs. Wilson for Murder" (*Times*, 29 September 1862), p. 9. The trial in 1857 of Madeline Smith again echoes this concern — she was accused of putting arsenic in her lover's cocoa.

131. By this act of eavesdropping in a public house, Peters is identified with Mrs. Paschal in "The Stolen Letters" as she follows Brown to a public house and overhears his conversation with Wareham. Tom Richmond, Thomas Waters, Dickens' detectives in his journalistic work, and Mrs. G — also behave in this man-

ner. This is in contrast to Dupin's ratiocination and Holmes' later intellectual reasoning.

132. Andrew Mangham, *Violent Women and Sensation Fiction: Crime, Medicine and Victorian Popular Culture* (Hampshire: Palgrave Macmillan, 2007), p. 107.

133. Slosh, in the text, is interchangeable with "Sloshy." This naming harks to the derogatory naming of detective figures, for example Mr. Bucket in *Bleak House*, and the two Bow Street Runners in *Oliver Twist*: Blathers and Duff. Ellen Wood will later uphold this to some extent in her "Johnny Ludlow stories," where "Policeman Cripp" appears ("Finding Both of Them," *First Series*, p. 20). It seems that Braddon is purposefully challenging the negative connotations of the detective as criminal as her use of name and nicknames do not uphold these previous critical associations. Rather, the quasi-detecting characters of Slosh and "the Smasher" are allowed to continue and be successful in their detecting role/s.

134. Andrew Maunder, "Mapping the Victorian Sensation Novel: Some Recent and Future Trends," *Literature Compass* 2 (2005) 1–33 (p. 11).

135. Lyn Pykett, "The Newgate Novel and Sensation Fiction, 1830–1868," in *The Cambridge Companion to Crime Fiction*, ed. Martin Priestman (Cambridge: Cambridge University Press, 2003), 19–29 (p. 34).

136. Mangham, *Violent Women*, p. 41.

137. The notion of a criminal concealed in a casket or box is later seen in Forrester's Mrs. G—/ the *Female Detective* case: "The Unknown Weapon" (1864). Forrester could have read Braddon's *Trail*, which was published three years prior. In Mrs. G—'s case, a son secretes himself into a box in order to stealthily enter his father's house and steal his valuables. Earlier, in Russell's *Recollections of a Police Officer* (1849–53), the story "The Pursuit" (1850), details Waters' failed attempt to apprehend a swindler who escapes to America by a vessel.

138. Ian Ousby, *Bloodhounds of Heaven: The Detective in English Fiction from Godwin to Doyle* (Cambridge, MA, and London: Harvard University Press, 1976), p. viii.

139. Winifred Hughes, *The Maniac in the Cellar: Sensation Novels of the 1860s* (Princeton: Princeton University Press, 1980), p. 129.

140. Mary Elizabeth Braddon to her editor at *Temple Bar*. Quoted in Edmund Yates, *Fifty Years of London Life* (New York: Harper, 1885), 336–37.

141. Collins, who is well-known for his preoccupation with deformed, handicapped or grotesque characters, included a deaf and dumb figure in *Hide and Seek* (1854). Collins also included blind characters in *The Dead Secret* (1857) and *Poor Miss Finch* (1872). The jealous culprit of *The Law and the Lady* (1875), the crippled Miserrimus Dexter, is deemed mad and finally incarcerated. This is unlike the figure of Peters, where he earns power.

142. Braddon's Peters is reminiscent of Lytton's *Lucretia, Or the Children of the Night* (1846), where the illiterate crossing sweeper named Beck (who is actually her unknown son) unveils Lucretia's true, criminal nature. Dickens used an illiterate crossing sweeper (Jo) in *Bleak House* (1852–3). Braddon may also have been influenced by Catherine Crowe's *Susan Hopley* (1841). Braddon inverts or reworks this by conversely according and allowing her detective to increase in power. Indeed, in *Aurora Floyd* (1863), Braddon directly mentions the play of *Susan Hopley* (which was first dramatized on 31 May 1841). There was a well-known acrimony towards and perceived incompetence of detectives in mid–Victorian Britain. This negative image/conception was propagated in an unknown writer's article in the *Saturday Review* in 1856, titled "Undetected Crime," with a later article in the same publication on 15 February 1868 appearing by another writer titled "The Efficiency and Defects of the Police." This was later expounded in the contemporary events of 1877: the De Goncourt case exposed that many detectives of Scotland Yard were found to be taking bribes from a criminal gang. Yet Braddon uses her own discourse to present Peters differently. He subverts these images with his capability to solve crime/s under the veneer of his suggested stupidity.

143. Chris Willis, "Afterword," p. 411.

144. Jeanne F. Bedell's 1983 work specifically on "Amateur and Professional Detectives in the Fiction of Mary Elizabeth Braddon" fails to mention Peters or *Trail* (*Clues: A Journal of Detection* 4 (1983), 19–34), and the *Oxford Companion to Crime and Mystery Writing*'s entry on disabled sleuths states that "[r]elatively few writers have written crime fiction featuring a handicapped detective" (121–22, p. 121); and there is no mention of Braddon. Robert Lee Wolff promotes Braddon's character of John Faunce in *Rough Justice* (1898), calling him her "first notable detective" (Wolff, *Sensational Victorian: the Life and Fiction of Mary Elizabeth Braddon* [New York: Garland, 1979], p. 386).

145. Jennifer Carnell, "Introduction," in Mary Elizabeth Braddon *The Black Band; or, the Mysteries of Midnight*, ed. Jennifer Carnell (Hastings: The Sensation Press, 1998), vii–xxv (p. xix).

146. Gary Hoppenstand and Ray B. Browne, *The Defective Detective in the Pulps* (Bowling Green, OH: Bowling Green State University Popular Press, 1983), p. 1.

147. Hoppenstand and Browne, *The Defective Detective*, p. 5.
148. Martin Halliwell, *Images of Idiocy: The Idiot Figure in Modern Fiction and Film* (Aldershot: Ashgate, 2004), p. 45.
149. R. F. Stewart, though, sees Peters as a less impressive and supplementary figure; he writes that for "Miss Braddon, [...] detectives were favourite but far from essential characters, and certainly never heroes. Sometimes she cast them in strong supporting roles, as [...] in *The Trail of the Serpent*, Joseph Peters, who must have a claim to fame as the first dumb detective" (R. F. Stewart, *... And Always a Detective*, p. 181). Peters sees the scene of Mr. Harding's death too late, finding clues which he would have found earlier had he been allowed onto the crime scene. Peters' commentary on this exclusion aligns him with the ratiocinative powers possessed by Poe's Dupin in "The Murders in the Rue Morgue" (1841). Dupin tells the unnamed narrator about the eyes of the Parisian police: "not trusting to *their* eyes, I examined with my own" (Edgar Allan Poe, "The Murders in the Rue Morgue," *Selected Tales* [London: Penguin, 1994], p. 138). And, had Peters the class status to examine the scene, he crucially would have seen what the other policing eyes did not: that Richard Marwood's blood-stained coat sleeve was due to crevices in the flooring, which caused the blood to drop through and onto his clothes while he slept on the couch below.
150. "The Monomaniac," *Chambers's*, 24 April 1852, 259–63.
151. For further references, this study will use "Slosh." Braddon's Slosh/Sloshy may also have influenced Charles Dickens. Three years later in *Our Mutual Friend* (May 1864–November 1865), there is a character similarly named "Sloppy," who is a foundling who assists Betty Higden in taking care of children. Sloppy was raised in the workhouse, appears to have a learning disability but is nevertheless adept at reading the newspaper for Mrs. Higden, and is portrayed as inherently innocent because of his disability.
152. Chris Willis, "Afterword," p. 410. This was later picked up by Arthur Conan Doyle. His creation of the "Baker Street Irregulars" in *The Sign of Four* (1890) uses juveniles as paid assistants to Holmes. A US exponent is Edward L. Wheeler's *New York Nell, the Boy-Girl Detective* (New York: Beadle and Adams, 1886). The American Metta Victor later included an amateur schoolboy detective — Robbie Cameron — in *Too True: A Story of To-Day* (*Putnam's Monthly Magazine*, 1868).
153. Judith Flanders, *The Invention of Murder: How the Victorians Revelled in Death and Detection and Created Modern Crime* (London: Harper Press, 2011), p. 301.
154. Lyn Pykett, *The Sensation Novel: From The Woman in White to The Moonstone* (Plymouth: Northcote House, 1994), p. 50.
155. Pykett, *The Sensation Novel*, p. 44.
156. Mary Elizabeth Braddon, quoted in Chris Willis, "Mary Elizabeth Braddon (1835–1915)," *The Literary Encyclopedia* (28 March 2001) http://www.litencyc.com/php/speople.php?rec=true&UID=5053.
157. Mary Elizabeth Braddon, *The Black Band; Or, The Mysteries of Midnight*, ed. Jennifer Carnell (Hastings: The Sensation Press, 1998), p. 9. All further references are to this edition and are given parenthetically. Secret societies are seen in Mrs. Paschal's "The Secret Band," Gaskell's "The Grey Woman" and in Collins' *The Woman in White*, where the character of Count Fosco is murdered by a secret society.
158. In Chapter XXXII: The Two Detectives (p. 194). They are, even more unusually and challengingly, positively represented; one of the victims of the Black Band, Signor Marelli, says: "Nothing is hopeless to the detective police of London [...] Inspector Martin and his colleague, Sergeant Boulder [are] two of the cleverest detectives in London. They scent a crime as the thorough-bred hound scents a fox" (p. 197). When Joseph Raymond is walking the obscure streets of Manchester the text comments that "[w]e have need to respect the police, those soldiers of civilization, who encounter death and danger nightly while we are sleeping in our beds, secure in our confidence that it is their duty to protect us" (p. 347). This contrasts strongly to the treatment given to police detectives in the fiction Braddon wrote for her middle-class audience. In *The Black Band*, the detectives actually play a relatively minor role. After their first, elevated appearance they do not reappear in the text until much later in the narrative.
159. This is very much in the pattern of the earlier memoirs of barristers, lawyers and attorneys. Slythe, with his degrading name, can be perceived as a negative version of Mr. Samuel Ferret in "Experiences of a Barrister" anecdotes. He can be directly compared to Dickens's sly Uriah Heep in *David Copperfield* (1850), who is depicted as the thieving and manipulative law partner of the alcoholic Mr. Wickfield, and the earlier sinister and mysterious investigator/secret enquiry agent, Mr. Nadgett, who dogs Jonas Chuzzlewit in *Martin Chuzzlewit* (1844).
160. Chris Willis, "Mary Elizabeth Braddon (1835–1915)," www.litencyc.com/php/speople.php?rec=true&UID=5053.

MRS. HENRY (ELLEN) WOOD

161. "The Secret of Mrs. Henry Wood," *The Times*, 13 April 1914, p. 11.
162. *East Lynne* includes murder, theft and deception, and social/sexual deviance is also duly punished. In 1862 she published her popular novel, *The Channings* (serialized in the *Quiver*). This featured a detective named Butterby, who comes to the wrong conclusions as to who committed the crime of stealing a £20 note from a solicitor's office. Butterby reappears in *Roland Yorke* (1869), in a more advanced role, and solves the crime (the shooting of a lawyer, Ollivera). Wood's writing for the *New Monthly Magazine* included crime content/murder, such as "Maria Ernach's Last Pilgrimage" (May, 1851) and "The Self-Convicted" (August 1853). Later, the interconnected narratives of "The Diamond Bracelet," "Going Into Exile" and "Coming Out of Exile" (appearing in *Bentley's Miscellany*, June–August 1858; reprinted in the *Argosy* (1874)) dealt with the theft/discovery of the thief of the bracelet of the title (it is a window cleaner), and incorporated a gentleman police detective. *Trevlyn Hold* (1864) also features detecting and mystery elements. Sussex identifies two female detectives in Wood's *The Master of Greylands* (1873) and *Within the Maze* (1872) in *Cherchez Les Femmes* (p. 191). The former involves a wife who goes undercover as a French governess to investigate her husband's murder.
163. Knight, *Crime Fiction 1800–2000*, p. 43.
164. Knight, *Crime Fiction 1800–2000*, p. 42.
165. E. Murch, *The Development of the Detective Novel* (London: Peter Owen, 1968), p. 153.
166. Margaret Oliphant, "Men and Women," *Blackwood's Magazine* 157 (April 1895), 620–50 (p. 645).
167. DuBose, *Women of Mystery*, p. 3. John Sutherland further specifies that *East Lynne* "went through 36 editions in its first 20 years, selling 400,000 copies by 1895." John Sutherland, *Victorian Novelists and Publishers* (London: Athlone, 1976), p. 85. The combined total sales have been said to amount to one million ("The Modern Novel," *Chambers' Journal* (April 1895), p. 283).
168. Emma Liggins, "Introduction: Ellen Wood, Writer," *Women's Writing* 15 (2008), 149–56 (p. 149).
169. Sayers, "The Omnibus of Crime," p. 64.
170. Wood may have been influenced by Catherine Crowe's *Susan Hopley*, where the impetus for Susan's detecting role is to find her missing brother, Andrew, and to clear him from suspicion as the murderer of Mr. Wentworth. In *East Lynne* Barbara Hare later becomes Carlyle's second wife after the apparent death of Isabel.
171. Mrs. Henry Wood, *East Lynne* (London: William Clowes and Sons Ltd., 1890), p. 212. All further references will be to this edition and will be given parenthetically.
172. Ten years earlier Elizabeth Gaskell had written a novella titled *My Lady Ludlow* (*Household Words*, 19 June–25 September 1858). This was set during the French Revolution. In addition to the obvious parallel in title/names, Wood's Johnny Ludlow tales have affinities with Gaskell's novella in the sense that *My Lady Ludlow* was narrated by a young person: Margaret Dawson (who is sixteen years old at the start of the narrative). As with Johnny, Margaret's father is dead and this leads her into the wealthy household of Lady Ludlow (much like Johnny with the rich Squire Todhetley). However, Margaret's mother (unlike Johnny's) is still alive.
173. Mrs. Henry Wood, "Losing Lena," *Johnny Ludlow First Series* (London: Macmillan and Co., 1912), 1–15 (p. 14).
174. This generic cross over is evidenced by the fact that Michael Cox and R. A. Gilbert included this story in their edited *The Oxford Book of Victorian Ghost Stories* (Oxford: Oxford University Press, 1991), 115–29. The supernatural reappears in "Sandstone Torr" in the *Fourth Series* (1890).
175. Everett F. Bleiler's edited collection, *A Treasury of Victorian Detective Stories* (1979), includes a Johnny Ludlow story, "Going Through the Tunnel" (*Johnny Ludlow First Series* (London: Bentley, 1895)). This inclusion implicitly suggests that Bleiler defines this story as "detective fiction." Bleiler writes that the Johnny Ludlow stories were: "A continued series based on the life and surroundings of a country family, they were often concerned with crime and detection" (p. 173). The story details how Squire Todhetley has been robbed of his pocket book (holding fifty pounds) while he is on a train with Johnny. It transpires that the crime is undertaken by three members of a clever swell-mob, and includes a London detective. Michael Cox includes "The Mystery at Number Seven" (1877) (which was collected in the *Johnny Ludlow Sixth Series*: Macmillan, 1889) in his edited collection, *Victorian Detective Stories: An Oxford Anthology*.
176. Michael Flowers, "The *Johnny Ludlow* Stories." http://www.mrshenrywood.co.uk/ludlow.html.
177. Jennifer Phegley, "Domesticating the Sensation Novelist: Ellen Price Wood as the Author and Editor of the *Argosy Magazine*," *Victorian Periodicals Review* 38 (2005), 180–98 (p. 185).

178. These collections were republished in six volumes from 1874 to 1899, although the stories were not in the same chronological order as the serial.
179. Ellen Wood, London, September 1880. Preface to *Johnny Ludlow: First Series*, Fifth Edition (London: Bentley, 1883).
180. Alison Jaquet, "Domesticating the Art of Detection: Ellen Wood's Johnny Ludlow Series," in *Formal Investigations: Aesthetic Style in Late-Victorian and Edwardian Detective Fiction*, ed. Paul Fox and Koray Melikoglu (Stuttgart: Ibidem, 2007), 179–95 (p. 179).
181. Lucy Sussex, "Mrs. Henry Wood and her Memorials," *Women's Writing* 15 (2008), 157–68 (p. 158).
182. "Domesticating the Art of Detection," p. 182. Michael Cox, "Introduction," in *Victorian Detective Stories*, p. xv.
183. Jaquet, "Domesticating the Art of Detection," p. 186.
184. Some titles demarcate themselves as mystery, such as "A Great Mystery" (April 1873), "The Mystery at Number Seven" (January 1877), and "The Mystery of Jessy Page" (1871).
185. *The Academy*, 2 May 1874, p. 483.
186. *The Saturday Review*, 13 November 1880 (50), pp. 618–9.
187. *The Saturday Review*, 18 July 1885 (60), pp. 91–2.
188. Bruce F. Murphy, *The Encyclopaedia of Murder and Mystery* (New York: Palgrave, 1999), p. 535.
189. Hugh Carleton Greene, "Introduction," in *The Crooked Counties: Further Rivals of Sherlock Holmes*, ed. Hugh Carleton Greene (London: Bodley Head, 1973). Unpaginated.

COLONIAL CONNECTIONS

190. In Lytton's *Paul Clifford* (1830), Paul is transported to Australia and finally moves to America after he leaves the penal colony. Collins, in his first crime-focused novel, *Hide and Seek: or the Mystery of Mary Grice* (1854) shows the influence of James Fenimore Cooper and is reminiscent of frontier pathfinders. It features Matthew Marksman in a detective-role; he has returned from America where he was scalped. Walter in *The Woman in White* returns from South America, and this signifies a change, making him stronger and able to detect. Knight writes that "Collins's consistent use, in his early mysteries, of transatlantic detectives suggests that for him, at least, the genre has a non-English, even American dynamic" (Knight, *Crime Fiction, 1800–2000*, p. 40). Collins had visited Northern America, conducting a lecture tour there in 1873–4, and had stayed in New York in November 1873. Collins' short stories appeared first in American periodicals, such as *Harper's Monthly Magazine*, the *Atlantic Monthly*, and *The New York Fireside Companion*. In *David Copperfield* (1849–50), Dickens relocates Mr. Micawber and his family to Australia. In "Three Detective Anecdotes" (*Household Words*, September 1850), Sergeant Dornton, on the tail of the criminal, follows clues to Doctor Dundey, who robbed a bank in Ireland and then absconded to America where he was eventually arrested. Dickens' *Great Expectations* (1860–1) features a transported convict, Magwitch. Dickens' *The Life and Adventures of Martin Chuzzlewit* (1844) incorporates American scenes and satire as well; Dickens' impetus and content had stemmed from his American reading tour of 1842. Also in *Barnaby Rudge* (1841), Joe Willet loses his arm in the American War of Independence. In Russell's "Recollections," in "Legal Metamorphoses" (*Chambers's*, September 1850), the figure of Mme. Levasseur Edmonton is sent to Australia, declaring revenge. In Charles Reade's successful *It Is Never Too Late To Mend* (1856), George Fielding emigrates to Australia after a man named Meadows initiates his downfall. The narrative also examines the treatment of a thief (Tom Robinson), and prison and transportation experiences. The two characters and narratives converge and they restart their lives working on the Australian gold diggings. Articles in Dickens' *Household Words* discussed Australia, with titles such as "First Stage to Australia" (10 September 1853), and "Friends in Australia" (21 May 1859).

191. Gaskell's narrative which was set in seventeenth-century New England was "Lois the Witch" (*All the Year Round*, October 1859).
192. Shirley Foster, "Elizabeth Gaskell's Shorter Pieces," in *The Cambridge Companion to Elizabeth Gaskell*, ed. Jill L. Matus (Cambridge: Cambridge University Press, 2007), 108–30 (pp. 109–10). Gaskell's works published in *Sartain's* were "The Last Generation in England" (July 1849) and "Martha Preston" (February 1850).
193. "To Charles Eliot Norton, 9 March [1859]," Letter 418, in *The Letters of Mrs. Gaskell*, ed. J. A. V. Chapple and Arthur Pollard (Cambridge: Harvard University Press, 1967), p. 536.
194. Michie, *Outside the Pale*, p. 91.
195. Michie, *Outside the Pale*, p. 92. In Gaskell's *Mary Barton* (1848), Mary Barton and Jem Wilson marry and emigrate to Canada to start a new life at the close of the novel.
196. Nancy Henry, "Elizabeth Gaskell and Social Transformation," in *The Cambridge Companion to Elizabeth Gaskell*, ed. Jill L.

Matus (Cambridge: Cambridge University Press, 2007), 148–63 (p. 149).
 197. Foster, "Elizabeth Gaskell's Shorter Pieces," p. 116.
 198. Elizabeth Gaskell, *The Moorland Cottage and Other Stories*, ed. Suzanne Lewis (Oxford: World's Classics, 1998), p. 61. All further references are to this edition and are given parenthetically.
 199. Henry, "Elizabeth Gaskell and Social Transformation," p. 152.
 200. Michie, *Outside the Pale*, p. 81.
 201. This edition is what UCLA special collections stock. UCLA Charles E. Young Research Library Special Collections. Record ID: 756146. "Illustrated by Gustave Doré, Janet Lange, Bertal, and other artists." George Vickers was a London publisher, and so this book is an example of it being taken and shipped to the U.S.
 202. Jennifer Carnell, http://www.sensationpress.com/maryelizabethbraddonontheblackbandimages.htm.
 203. Braddon's published texts between 1872 and 1880 were *To the Bitter End, Strangers and Pilgrims, Publicans and Sinners, Taken at the Flood, An Open Verdict, Vixen, The Cloven Foot, The Story of Barbara: Her Splendid Misery and Her Gilded Cage*, and *Just as I Am*. These were published in *Age, Sydney Mail, Town & Country, Leader, Brisbane Courier*, and *Queenslander*. Braddon's brother, Edward Braddon, became the premier of Tasmania. In Braddon's crime novelette, "Ralph the Baliff" (*St. James Magazine*, April–June 1861), the scheming siblings, Ralph Purvis and Martha, become rich through Dudley Carleon and emigrate to Australia where they obtain a prosperous sheep farm. In 1907 Braddon published a novel titled *Her Convict* (UCLA Sadleir: 292).
 204. An anonymous nineteenth-century reviewer unusually identifies a national element in Braddon's texts: she is said to be "part of England; she has woven herself into it; without her it would be different.... She is in the encyclopaedias; she ought to be in the dictionaries." Anon., "Miss Braddon: An Enquiry," in *Academy* LVIII (October 1899).
 205. Toni Johnson-Woods, "Mary Elizabeth Braddon in Australia: Queen of the Colonies," in *Beyond Sensation: Mary Elizabeth Braddon in Context*, ed. Marlene Tromp, Pamela K. Gilbert, and Aeron Haynie (New York: State University of New York Press, 2000), 111–25 (p. 112). This title is in addition to her well-known one as the "Queen of the Circulating Libraries."
 206. Lyn Pykett, "Afterword," in *Beyond Sensation*, 277–80 (p. 279).
 207. Johnson-Woods, "Mary Elizabeth Braddon in Australia," p. 114.

 208. Mangham, in his discussion of violent women, makes connections in relation to madness and hysteria between Lady Audley and Menamenee, and also the character of Spanish Valerie de Cevennes in *Trail* (*Violent Women*, p. 96).
 209. In *Lady Audley's Secret* (1862), Braddon replicates the trip which Jabez attempts to make: after Lady Audley (then Lucy Graham) attempts the murder of her first husband — George Talboys — he climbs out of the well, flees to Liverpool and sails to America.
 210. "Edging Women Out? Reviews of Women Novelists in the *Athenaeum*, 1860–1900," *Victorian Studies: An Interdisciplinary Journal of Social, Political, and Cultural Studies* 39:2 (1996), 151–71.
 211. Sutherland, *The Stanford Companion*, p. 182.

Chapter Two

Introduction

 1. Edith Birkhead, *The Tale of Terror: A Study of the Gothic Romance* (New York, 1920), p. 197.
 2. Karl Miller, *Doubles: Studies in Literary History* (Oxford: Oxford University Press, 1985), p. 349.
 3. Stephen Knight, "Sherlock Holmes's Grandmother: An Untraditional Look at the Anglophone Crime Fiction Tradition," *Anglo Files: Journal of English Teaching* 149 (2008), 29–37 (p. 31).
 4. Charles Brockden Brown, "To the Editor of the Weekly Magazine," *Weekly Magazine*, I, 17 March 1798, p. 202.
 5. Charles Brockden Brown, *Three Gothic Novels* (New York: The Library of America, 1998), p. 641.
 6. Sydney J. Krause and S. W. Reid see the figure of Clara as significant; they write that "[i]n short, while not quite a Lady Macbeth, Clara Wieland, to her time, was probably one of the strongest — if not *the* strongest — female character in the history of romantic fiction" (Sydney J. Krause and S. W. Reid, "Introduction," in Charles Brockden Brown, *Wieland or The Transformation An American Tale* (Kent, OH: Kent State University Press, 1993), ed. Sydney J. Krause and S. W. Reid, vii–xxv (p. xxiii).
 7. Charles Brockden Brown, *Wieland, or the Transformation*, ed. Fred Lewis Pattee (New York: Harcourt Brace Jovanovich, 1958), p. 227. Brown's novel may have been inspired by the 1796 case in Tomhannock (New York) where James Yates murdered his four children and his

wife and also attacked his sister while under a religious delusion. The impact of Brown's work can be seen in Stephen King's *The Shining* (1977), where Jack Torrance, like Wieland, hears voices and then tries to kill his wife and his son.

8. Charles J. Rzepka has the spelling as *Arthur Merwyn. Detective Fiction* (Cambridge and Malden, MA: Polity Press, 2005), p. 56.

9. In Larry Landrum, *American Mystery and Detective Novels: A Reference Guide* (Westport, CT: Greenwood, 1991), p. 1.

10. The impact of this work is exemplified by the appearance in 1856–7 of Alexandre Dumas' *Les Mohicans de Paris* (16 parts. Paris: Cadot, 1856–7). This was translated in 1875 by John Lately as *The Mohicans of Paris* (London: Routledge, 1875).

11. These include: "Ned Buntline" (E.Z.C. Judson's) *The Mysteries of New York* (1848); the anonymously written *The Mysteries of Philadelphia* (1844); Henry Spofford's *The Mysteries of Worcester* (1846); and Ned Buntline's *The Mysteries and Miseries of New Orleans* (1851). Other titles include: Philip Pendant's, *The Mysteries of Fitchburg* [n.d.]; Frank Hazelton's *The Mysteries of Troy* (1847); the anonymous *Mysteries of Nashua* (1849); and George Lippard's *The Quaker City* (1845). For a comprehensive discussion see David S. Reynolds, *Beneath the American Renaissance: The Subversive Imagination in the Age of Emerson and Melville* (New York: Alfred A. Knopf, 1988, p. 82).

12. Samuel Walker, *Popular Justice: A History of American Criminal Justice* (New York and Oxford: Oxford University Press, 1980), p. 59.

13. LeRoy Lad Panek, *The Origins of the American Detective Story* (Jefferson, NC, and London: McFarland, 2006), p. 5. Tony Magistrale and Sidney Poger's work on Poe's impact and literary descendants mentions Agatha Christie and Dorothy L. Sayers but does not include or mention earlier women writers (*Poe's Children: Connections Between Tales of Terror and Detection* [New York: Peter Lang, 1999]).

14. Charles E. May, "From Small Beginnings: Why Did Detective Fiction Make Its Debut in the Short Story Format?," *The Armchair Detective* 20 (1987), 77–81 (p. 77). Stephen Knight adds that "[c]uriously, even English crime fiction shows this American influence: Wilkie Collins's first three detective figures all come from across the Atlantic, in *Hide and Seek*, in "The Diary of Anne Rodway" and, in the transatlantically invigorated Walter Hartright in *The Woman in White*" (Knight, "Sherlock Holmes's Grandmother," pp. 30–1). Ordean A. Hagen, though, contests both this and the predominant role of Poe within the crime fiction genre, writing under "origins" that "[i]t is interesting today to realize that it was the French and English who further developed the detective story after Poe had set the example. While Poe's stories created a great deal of interest at home and were widely read, they had very little effect on other American writers who made no attempt to imitate them or develop the form" (Ordean A. Hagen, *Who Done It? A Guide to Detective, Mystery and Suspense Fiction* [New York and London: R. R. Bowker Company, 1969], p. 621). Hagen furthers this: "It seems incredible now that Poe's tales made such a slight impression on American readers, and hardly any on American writers, who failed to follow his example which would have been a sure sign of success" (p. 631). William Kittredge and Steven M. Krauzer say that it was not until the late nineteenth century that American and British male detectives and writers start to diverge. They do not include any women in their study. They comment on the "differences between the two great detectives [Nick Carter in the United States in 1866, and Sherlock Holmes in England in 1887] we see the American sleuth already begin to deviate from the classical archetype" (William Kittredge and Steven M. Krauzer, "Introduction," in *The Great American Detective: 15 Stories Starring America's Most Celebrated Private Eyes*, ed. William Kittredge and Steven M. Krauzer [New York and Ontario: Mentor, 1978], x-xxxiv [pp. xxi-xiii]).

15. A detecting/sidekick/assistant configuration was earlier seen in Cooper's *The Last of the Mohicans* (1826) with Natty Bumppo and his friend, the Native Indian Chingachgook. This is later seen with Doyle's Holmes and Watson.

16. "The Murders in the Rue Morgue," p. 121.

17. Symbiosis was more fully attempted with a whole reprint in 1845 which included fifteen changes (John Evangelist Walsh, *Poe the Detective: The Curious Circumstances behind "The Mystery of Marie Roget"* [New Brunswick, NJ: Rutgers University Press, 1968, p. 69]).This story is subtitled "A Sequel to 'The Murders in the Rue Morgue.'" Poe's story has similarities with Brockden Brown's earlier novel, *Wieland* (1798).

18. "The Purloined Letter," p. 346. Dupin's status is indeterminate; while he initially "investigates" out of interest piqued by the newspaper/s in "The Murders in the Rue Morgue," in "The Purloined Letter" he says to the Prefect of the Parisian police, Monsieur G—, that he will only hand him the letter once he has received a cheque for fifty thousand francs. This

oscillation is reminiscent of the positioning of the Bow Street Runners in British fiction and in reality.

19. Part of this title—"Curiosities of Crime"—is identical to that of Scottish writer, James McLevy's *Curiosities of Crime in Edinburgh* (1861). This indicates an American borrowing two years later.

20. In 1865 this reappeared as *The New York Detective Police Officer*, and is edited by "John B. Williams, M.D." It comprised of twenty-two short stories plus an introduction. This version of the stories was published by John Maxwell in London, which also proves a link with Mary Elizabeth Braddon, as he was her husband as well as one of her main publishers.

21. Sarah Weinman, "Rediscovering Early Fictional America Detective James Brampton," *Los Angeles Times* 26 October 2008.

22. *The New York Detective Police Officer. Edited by John B. Williams, M.D. Never Before Printed* (London: John Maxwell and Company, 122 Fleet Street, James Brampton, 1865). (UCLA: Sadleir 3527) p. 4. All further references are to this edition and are given parenthetically. This text has been collected and reprinted in 2008 by Westholme Publishing as *Leaves From the Note-Book of a New York Detective: The Private Record of J.B.*

23. Clues to the cases are continually in newspapers which J.B. sees. This use of discourse links to Poe; Dupin's first story, "The Murders in the Rue Morgue," is triggered by the evening edition of the Gazette des Tribunaux newspaper, declaring that there have been "EXTRAORDINARY MURDERS.—." In J.B.'s "The Silver Pin" a newspaper almost exactly tells of a "MYSTERIOUS DEATH" (p. 17). And this newspaper function is again interpolated in "The Mystery of Marie Rogêt." J.B.'s "Introduction" story again emulates Poe in its initial description of the murder scene: "All the doors and windows were fastened *on the inside*, for Hannah had given the alarm from the window" (pp. 7–8). "The Mysterious Advertisement" echoes Poe's "The Purloined Letter" in that Mr. Norval's will is stolen and replaced with blank paper. The reasons for the crimes in J.B.'s stories are predominantly motivated by money, property, revenge, or being rebuffed. Of these, the crimes spurred by money and property possession recur the most. The author of these stories may have been influenced, to some extent, by British writers. Brampton's first story, detailed in the "Introduction," shows how finding a vest button made of blue porcelain at the murder scene leads J.B. to the murderer of Miss Millwood: the ostler at the Eagle Tavern, Bill Holsley. Bill is wearing a vest which is missing its middle button. British "Charles Martel" (pseudonym for Thomas Delf (?)) in *The Detective's Notebook* (1860) has a story called "The Button," where a button acts as a clue and is matched, by chance by Sergeant Bolter, to a waistcoat. Braddon's *Aurora Floyd* (1863) used a button as wadding of a pistol—a clue which leads back to the waistcoat of the murderer. In J.B.'s "The Silver Pin" the criminal is named Markham—a literary allusion to Reynolds' earlier criminal in *Mysteries of London*. Brown's elm tree in *Edgar Huntly* (1799) may have impacted J.B.'s story "The Accusing Leaves": in this J.B.'s friend, Mr. Palmer, is found with his throat cut in his garden under an almond tree. In J.B.'s "The Struggle for Life" the criminal, Bristol Jem, has "cataleptic attacks, in which condition he appeared exactly as if he were dead" (p. 66); this may have been drawn from Henry Thomson's "Le Revenant" (1827), where the criminal feigns death; it is also a forerunner for half-dead in Bram Stoker's *Dracula* at the end-of-the-century (1897).

24. Heather Worthington, "From *The Newgate Calendar* to Sherlock Holmes," in *A Companion to Crime Fiction*, ed. Charles J. Rzepka and Lee Horsley (Chichester: Wiley-Blackwell, 2010), 113–27 (p. 25).

25. An example is in the "Introduction." J.B. finds the wrongly accused Miss Millwood "a very pretty girl, but very delicate and frail" (p. 8). Yet Hannah, the servant who has criminal initiative, has an open countenance "but there was an expression of deceit about her lips that I did not like" (p. 9). He later says that Hannah was "a thoroughly bad woman" (p. 12): Hannah is imprisoned by the close of the story.

26. "From *The Newgate Calendar*," p. 25.

27. Mary Roberts Rinehart, *Miss Pinkerton* (New York: Dell Publishing, 1964), p. 8.

28. Catharine Maria Sedgwick, *Hope Leslie: or, Early Times in Massachusetts* (New Brunswick, NJ: Rutgers University Press, 1987 [1827]), p. 98.

29. British women writers (such as Crowe), though, were making steps towards the crime genre from the 1840s. An early example of a crime/mystery-related narrative was Caroline Hargrave's *The Mysteries of Salem!* (1845); this was influenced by Sue's *Les Mystères de Paris* with its concentration on the city and mystery.

30. Dr. Benjamin Rush, "Thoughts Upon Female Education...," in *Essays, Literary, Moral and Philosophical*, 2d ed. (Philadelphia: Thomas and William Bradford, 1806; first edition 1798).

31. Anne E. Boyd, *Writing for Immortality: Women Writers and the Emergence of High Literary Culture in America* (Baltimore: Johns Hopkins University Press, 2004), p. 28.

32. The first novel to advocate women's suf-

frage in this period was Hannah Gardner Creamer's *Delia's Doctors: or, A Glance Behind the Scenes* (New York: Fowlers and Wells, 1852). This dealt with the right to train in any profession. This novel and its contents contrasts with Wilkie Collins's disparaging short story and with the masculine medico-legal writings from the 1830s onwards in Britain.

33. Elaine Showalter, *A Jury of Her Peers: American Women Writers from Anne Bradstreet to Annie Proulx* (New York: Alfred A. Knopf, 2009), p. 108.

34. Nathaniel Hawthorne, in *Hidden Hands: an Anthology of American Women Writers, 1790–1870*, ed. Lucy M. Freibert and Barbara A. White (New Brunswick, NJ: Rutgers University Press, 1985), p. 356.

35. Nathaniel Hawthorne, to his publisher, William Ticknor (January 1854), about women editors, such as Grace Greenwood of *The Little Pilgrim* magazine. In *Nathaniel Hawthorne, The Centenary Edition of the Works of Nathaniel Hawthorne*, ed. William Charvat, et al. (Columbus: Ohio State University Press, 1987), 17:161.

36. Mudge, "The Man With Two Brains."

37. New York: Beadle, 1863. Among other forms of writing (such as for the Boston story papers and an antislavery novel) she also wrote the Gothic-reminiscent dime novel, *The Prisoner of La Vintresse; or, the Fortunes of a Cuban Heiress* (1860), and, in the 1850s, a seduction novel: *Gracie Amber*. Other dime novels written for Beadles included *Chip: The Cave Child* (1860) and *Ruth Margerie: A Romance of the Revolt of 1689* (1862).

38. LeRoy Lad Panek, *Probable Cause: Crime Fiction in America* (Bowling Green, OH: Bowling Green State University Popular Press, 1990), p. 20.

39. Lisa Maria Hogeland and Mary Klages, "Preface," in *The Aunt Lute Anthology of U.S. Women Writers*, ed. Lisa Maria Hogeland and Mary Klages (San Francisco, CA: Aunt Lute Books, 2004), xxiii–xxxi I. (xxv).

40. Susan Coultrap-McQuin, *Doing Literary Business: American Women Writers in the Nineteenth Century* (Chapel Hill and London: University of North Carolina Press, 1990), p. 3.

41. Marilyn Olsen, *State Trooper: America's State Troopers and Highway Patrolmen* (Paducah, KY: Turner Publishing, 2001), p. 40.

42. Gloria E. Myers, *A Municipal Mother: Portland's Lola Greene Baldwin, America's First Policewoman* (Corvallis: Oregon State University Press, 1995). Yet Baldwin was still limited in terms of the gendered stereotype of the "mother"; her primary function was to "protect women and girls from the moral dangers and temptations of urban life" (Myers, *A Municipal Mother*, p. 23). The LAPD hired the first African-American police officer, Georgia Ann Robinson, in 1916.

43. Barbara R. Price, "Female Police Officers in the United States," in *Policing in Central and Eastern Europe: Comparing Firsthand Knowledge with Experience from the West*, ed. Milan Pagon (Ljubljana, Slovenia: College of Police and Security Studies, 1996). Html conversion of chapter: http://www.ncjrs.gov/policing/fem 635.htm.

44. Blake, "Lady Sleuths and Women Detectives," pp. 31–2.

45. Gary L. Bunker, "The Art of Condescension: Postbellum Caricature and Woman Suffrage," *Common-place: The Interactive Journal of Early American Life* 7:3 (April 2007), unpaginated, http://www.common-place.org/vol-07/no-03/bunker/.

46. *New York Daily Graphic* (5 June 1873).

47. Blake, "Lady Sleuths and Women Detectives," p. 31.

48. Dresner, *The Female Investigator*, p. 2.

HARRIET PRESCOTT SPOFFORD

49. Spofford shares similarities with her contemporary, Louisa May Alcott, as both women wrote fiction for children. Halbeisen writes that "[i]t was quite the thing in the sixties to contribute to the literature of childhood" (Elizabeth K. Halbeisen, *Harriet Prescott Spofford: A Romantic Survival* [Philadelphia: University of Philadelphia Press, 1935], p. 172). Halbeisen expands upon this: "Harriet Prescott Spofford's contributions to the literature of childhood consist of short stories, some of which were collected in *Hester Stanley's Friends*; three book-length stories, *Hester Stanley at St. Marks*, *A Lost Jewel*, and *The Children of the Valley*; juvenile articles; verse found principally in *Ballads about Authors* and *The Great Procession and other Verses for and about Children*; and one play, *The Fairy Changeling*. In comparison with her literary work in general, it must be said that this writing is marked by little of that individuality which brought her prominence" (pp. 172–3). Spofford had British counterparts who also wrote stories for children: Ellen Wood and Catherine Crowe. Metta Victor also wrote for a juvenile audience.

50. Marvin Lachman, *A Reader's Guide to The American Novel of Detection* (New York: G. K. Hall and Co., 1993).

51. *The Critic*, N.S. XVI, 56, 1 August 1891.

52. Emily Dickinson, quoted in T. W. Higginson, "Emily Dickinson's Letters," *Atlantic Monthly*, LXVIII (October 1891), p. 446.

53. Emily Dickinson, quoted in Martha Dickinson Bianchi, *Emily Dickinson Face to Face* (Boston: Houghton, Mifflin, 1932), p. 28.

54. Letter to Annie Fields quoted in James H. Matlack, "The Literary Career of Elizabeth Barstow Stoddard" (PhD, Yale University, 1968), p. 560. Found in Showalter, *A Jury of Her Peers*, p. 82.

55. Other popular stories written by Spofford around this time, but which were less concerned with detecting and more with suspense and the supernatural are "The Amber Gods" (*Atlantic*, January–February 1860) and "Circumstance" (*Atlantic*, May 1860). In Spofford's novel, *Sir Rohan's Ghost: A Romance* (Boston: J. E. Tilton and Company, 1860), a man attempts to murder his mistress.

56. Thomas Wentworth Higginson. *Letters and Journals of Thomas Wentworth Higginson, 1846–1906*, ed. Mary Thacher Higginson (Boston: Houghton Mifflin, 1921), p. 104.

57. "Legal Metamorphoses," *Chambers's*, 28 September 1850, 195–9.

58. Harriet Prescott Spofford, "In a Cellar," in *"The Amber Gods" and Other Stories*, ed. Alfred Bendixen (New Brunswick and London: Rutgers University Press, 1989), p. 7. All further references are to this edition and are given parenthetically.

59. This could relate to the overlooking of clues in Poe's stories. The criminal valet, Mr. Hay, then relocates to the Antipodes at the end of the story. Spofford's story may have been influenced by the criminal jeweller and murderer in Hoffmann's "Mademoiselle de Scudéry." A detective who cannot draw the case together is seen earlier in Britain (yet set in America) by Fanny Trollope in *The Refugee in America* (1832). In this novel the part-time New York policeman, Mr. Hannibal Burns, fails to solve the case. Ellen Wood's interconnecting serials ("The Diamond Bracelet," "Going Into Exile," and "Coming Out of Exile"; *Bentley's Miscellany*, June–August 1858) dealt with jewel crime. Later, Metta Victor, in *Too True: A Story of To-Day* (*Putnam's Monthly Magazine*, 1868), includes inherited jewels, which are the goal for the villain, Louis Dassel. Jewellery theft, however, is common.

60. Bendixen spells his name as "Mr. Furbish" (Alfred Bendixen, "Introduction," in Harriet Prescott Spofford, *"The Amber Gods" and Other Stories* ed. Alfred Bendixen, ix-xxxvii (p. xxix)); Halbeisen spells it as "Furbush" (p. 92) as does Sussex.

61. Bendixen, "Introduction," in Harriet Prescott Spofford, *"The Amber Gods" and Other Stories*, p. xxix.

62. Harriet Prescott Spofford, "Mr. Furbush" (*Harper's Monthly*, April 1865), 623–6 (p. 624). All further references are to this edition and are given parenthetically.

63. Rita Bode, "A Case for the Re-covered Writer: Harriet Prescott Spofford's Early Contributions to Detective Fiction," *Clues: A Journal of Detection* 26 (2008), 23–36. Birgit Spengler's "Gendered Vision(s) in the Short Fiction of Harriet Prescott Spofford" (*Legacy* 21:1 [2004], 68–73) examines Spofford by using Jonathan Crary's work, *Techniques of the Observer: On Vision and Modernity in the Nineteenth Century* (Cambridge, MA: MIT Press, 1990) and his notions of a "break with the [...] dominant perspectivalist scopic regime" (p. 68). Spengler focuses on "Mr. Furbush" and then the gendered roles and representations of fine art and perception in "The Amber Gods" and "Desert Sands." Spengler also draws upon Ronald R. Thomas's "Making Darkness Visible: Capturing the Criminal and Observing the Law in Victorian Photography and Detective Fiction" (in *Victorian Literature and the Victorian Visual Imagination*, ed. Carol T. Christ and John O. Jordan [Berkeley: University of California Press, 1995], 134–68). Roland Barthes' last work, *Camera Lucida: Reflections on Photography*, trans. Richard Howard (London: Vintage, 2000 [1980]), examines the true identity of the subject/as a sign. In this story's case, however, the photograph becomes a literal sign of crime.

64. Ronald R. Thomas, *Detective Fiction and the Rise of Forensic Science* (Cambridge: Cambridge University Press, 1999). R. F. Stewart, commenting on the detectives in the nineteenth century, writes that "other factors of a more technical nature also operated to keep their effectiveness at a minimum." These include photography: "scientific aids were limited to the telegraph, occasional photography and plaster of Paris [for taking footprints]" (Stewart, ... *And Always a Detective*, p. 138). Photography, then, is seen as an impediment in Britain, yet in the American context they are useful, and in Spofford's story, perhaps solving the case when it might otherwise have not have been. "Drawings of shadows" were in vogue in the mid-1830s and attempting to capture ghosts in photographs from the 1860s (ectoplasm). Dickens has compared his work to that of "a fanciful photographer," where his mind would take "a fanciful photograph" of a scene. Gaboriau's Monsieur Godeuil also possesses a photographic memory. In his 1876 story, "The Little Old Man of Batignolles," the narrator, Monsieur Godeuil, states of his impressions of the murdered man — M. Pigoreau's — room: "I noticed all these details at a glance [...] My eye had become a photographic objective; the stage of the murder had portrayed itself in my mind, as on a prepared plate, with such precision that [...] I can sketch the apartment [...] without omitting anything" (Émile Gaboriau, "The Lit-

tle Old Man of Batignolles," in *A Treasury of Victorian Detective Stories*, ed. Everett F. Bleiler [New York: Charles Scribner's Sons, 1979], p. 138).

65. This act is original, with films deploying and emulating this tactic; Lucy Sussex comments that this device is used in Michelangelo Antonioni's *Blow Up* (1966) (Lucy Sussex, "The First American Woman to Write Detective Fiction? Harriet Prescott Spofford," *Mystery Scene* 68 [2000], p. 44). This is used in a similar way again in the film, *8mm* (1999), which uses an examination and magnification of a film reel. Sussex also interconnects this story and its clever plot with Dion Boucicault's play, *The Octoroon* (1859), where evidence of murder is later found on photographic plates (Sussex, *Cherchez*, p. 118). Later, Wilkie Collins incorporated the use of new photographic technology in his short story *Mr. Policeman and the Cook* (originally appearing in *The Seaside Library*, 26 January 1881 as "Who Killed Zebedee?"). In this story, a photograph of the murder weapon — a knife with a partially known inscription — is circulated to every police station. Three years prior to Spofford's story, William Russell, in "Murder under the Microscope" (*Experiences of a Real Detective* [London: Ward and Lock, 1862]), examines a hand-axe belonging to James Somers: "I examined it minutely. First with the naked eye, then with a strong magnifier, which I was seldom or never without. The axe had been washed [...] and though nothing was visible to the naked eye, my magnifier discovered upon the blade, not only spots of red rust [...] but a number of what looked like minute fibres of fur sticking to the stains" ("Murder Under the Microscope," in *A Treasury of Victorian Detective Stories*, ed. Everett F. Bleiler [New York: Charles Scribner's Sons, 1979], p. 49). These findings are affirmed at the trial: the spots and fibers are human blood and squirrel fur from the victim's cloak collar. Yet Spofford takes this further.

66. Roland Barthes, *Camera Lucida*, p.10, p. 106.

67. Anon. "Photography," in *Household Words* (19 March 1853), 54–63 (p. 55).

68. This conflation of madness and loss of children was earlier seen in "Thomas Waters"/William Russell's "The Revenge" (*Chambers's*, 9 November 1850, 294–98) in "Recollections of a Police Officer." In this story a Frenchwoman–Madame Jaubert — is made mad due to the loss of her child. She is incarcerated in bedlam and, after she is released, joins criminals. Waters plays on this knowledge: initially she is Waters' informant, turned double-crosser (an act which almost has Waters murdered). Waters then tells Madame that he knows where her child is. On finding out this is untrue, she once again lapses into insanity. She is reinstated into society, but only the help of a man can facilitate this — Mrs. Craven is not offered the same rehabilitation, perhaps because Spofford is a woman writer. In Braddon's *Trail*, madness and desperation incite both Jabez's mother and Jabez's partner to throw children (Jabez and Slosh, respectively) into the river.

69. Harriet Prescott Spofford, "In the Maguerriwock," in *"The Amber Gods" and Other Stories*, ed. Alfred Bendixen (New Brunswick, NJ, and London: Rutgers University Press, 1989), p. 105. All further references are to this edition. The dead man is in fact secreted in a ten-year-old barrel of cider: Mr. Craven offers Mr. Furbush a glass, calling it "real pippin cider of any new apple-orchard" (p. 105). Spofford may well be referring to Poe's short story "The Cask of Amontillado" (*Godey's Lady's Book*, November 1846). Her story is reminiscent of Poe's both in title (cask) and content: of crime and intentionally killing and immuring a body. Poe sets his story in Italy in the carnival season and uses wine. The victim, Fortunato, had insulted Montresor, who seeks revenge; he achieves this through luring Fortunato to his vaults with the promise of a pipe of Amontillado. Once the victim is intoxicated, Montresor fetters Fortunato to an interior recess in his catacombs and seals the space up by building a wall. The notion of voice which Spofford uses is earlier seen in Poe's story as Montresor tells the reader that "I replied to the yells of him who clamoured. I re-echoed — I aided — I surpassed them in volume and in strength" ("The Cask," *Selected Tales*, p. 379). Yet Poe's victim is never found and the criminal is not punished.

70. Harriet Prescott Spofford, letter to Fred Lewis Pattee. Quoted in Halbeisen, *Harriet Prescott Spofford*, p. 122.

71. Henry James, Review of Spofford's *Azarian* (*North American Review*, January 1865), 268–77 (p. 272).

72. New England was one of the earliest English settlements in Northern America. The first pieces of American literature were produced in New England. Hawthorne's writing is based around or preoccupied with New England. Spofford's New England sketches were travel-focussed, compiled together in book form in *New-England Legends* (Boston: James R. Osgood and Company, 1871). The contents of this book were: "The True Account of Captain Kidd"; "Charlestown"; "Newburyport"; "Dover"; "Portsmouth"; in addition to a list of illustrations.

LOUISA MAY ALCOTT

73. Katharine Rodier, "'Astra Castra': Emily Dickinson, Thomas Wentworth Higginson, and Harriet Prescott Spofford," in *Separate Spheres No More: Gender Convergence in American Literature, 1830–1930*, ed. Monika M. Elbert (Tuscaloosa and London: University of Alabama Press, 2000), 50–72 (p. 54).

74. *A Modern Mephistopheles* and *A Whisper in the Dark* (Boston: Roberts Brothers, 1889). Alcott had given permission for her name to be used prior to her death.

75. Her other juvenile fiction includes *An Old-Fashioned Girl* (1869 onwards, serial in *Merry's Museum*; book form April 1870 (Roberts Brothers)), *Little Men* (May 1871), *My Boys* (January 1872, in *Aunt Jo's Scrap-Bag* series). She contributed to the periodicals of *Harper's Young People* and *The Youth's Companion*. *Little Women* Part 1 appeared on 1 October 1868, and Part Two was completed on 1 January 1869.

76. Ann Douglas, "Mysteries of Louisa May Alcott," *New York Review of Books*, XXV (28 September 1978), 61–3 (p. 61).

77. Madeleine B. Stern, "Introduction," in *Freaks of Genius: Unknown Thrillers of Louisa May Alcott*, ed. Daniel Shealy, Madeleine B. Stern and Joel Myerson (New York and London: Greenwood Press, 1991), 1–25 (pp. 21–2).

78. Louisa May Alcott, Letter, April 1861, in *The Journals of Louisa May Alcott*, ed. Joel Myerson, Daniel Shealy, and Madeleine B. Stern (Boston: Little, Brown and Company, 1989), p. 105.

79. Ruth K. MacDonald, "Alcott, Louisa May (1832–1888)," in *The Oxford Companion to Women's Writing in the United States*, ed. Cathy N. Davidson and Linda Wagner-Martin (New York and Oxford: Oxford University Press, 1995), 44–5 (p. 45).

80. Louisa May Alcott to Maria S. Porter, 1874, in *The Selected Letters of Louisa May Alcott*, ed. Joel Myerson, Daniel Shealy, and Madeleine B. Stern (Boston: Little, Brown and Company, 1987), p. 190.

81. Louisa May Alcott, letter to Alf Whitman, June 22, 1862, in Madeleine Stern "Introduction," *Behind a Mask: the Unknown Thrillers of Louisa May Alcott* (London: W.H. Allen, 1976), vii–xxviii (p. vii). The imagined title of "The Maniac Bride," curiously enough, is reminiscent of the Australian, Mary Fortune's 1863 story, published in 1912: "The White Maniac: A Doctor's Tale" in which a bride is, indeed, represented by a "maniac."

82. Leona Rostenberg and Madeleine B. Stern, "Five Letters That Changed an Image," in *Louisa May Alcott: From Blood and Thunder to Hearth and Home*, ed. Madeleine B. Stern (Boston: Northeastern University Press, 1998), 83–92 (p. 132).

83. Catherine Ross Nickerson, *The Web of Iniquity: Early Detective Fiction by American Women* (Durham and London: Duke University Press, 1998), p. 23.

84. Louisa May Alcott, "Memoir of My Childhood," *The Woman's Journal* 19 (26 May 1888), p. 180.

85. Louisa May Alcott, quoted in *Louisa May Alcott*, ed. Ednah D. Cheney, p. 89.

86. *The Hidden Louisa May Alcott*, II, 595.

87. Elaine Showalter observes that Alcott "followed the American model of hyperfeminine pen names, calling herself first 'Flora Fairfield,' then self-mocking names that expressed her discomfort with the role of woman intellectual or activist, such as 'Minerva Moody,' 'Oranthy Bluggage,' or 'Tribulation Periwinkle'" (Elaine Showalter, *Sister's Choice: Tradition and Change in American Women's Writing* [New York: Oxford University Press, 1991], p. 49). Yet, although feminine, "Flora Fairfield" wrote in 1854, "The Rival Prima Donnas" (*Saturday Evening Gazette*), where a singer morbidly kills another in jealousy with an iron ring. Leona Rostenberg conjectures that the name A. M. Barnard, which was used for "Behind a Mask," "may have been suggested either by fancy or a chain of associations. The A may have been derived from any one of the family names, Amos, Abba or Anna. The M more than likely represented her mother's maiden name, May, likewise Miss Alcott's middle name. Her father claimed Henry Barnard, the Connecticut schoolmaster, as a close friend and the suitability of this surname may have attracted his inspired daughter" (Leona Rostenberg, "Some Anonymous and Pseudonymous Thrillers of Louisa M. Alcott," in *Critical Essays on Louisa May Alcott*, ed. Madeleine B. Stern [Boston, MA: G. K. Hall, 1984], 43–50 [p. 44]). In a series of letters in 1865, publisher James Elliott did repeatedly ask her to use her own name for her "thriller" tales. Critics have posited many interpretations for Alcott's sensational pseudonym. A. Susan Williams generally states that "most women authors of the fantastic were anxious to conceal their accomplishments" (A. Susan Williams, "Introduction," in *The Lifted Veil: The Book of Fantastic Literature by Women 1800-World War II*, ed. A. Susan Williams [New York: Carroll and Graf, 1992], vii–xv [p. ix]). Margaret Strickland comments about Alcott's mask that "[she] felt chained by her upbringing, education, and Concord society. She had to wear the mask of the sentimental author in order to maintain decorum and her reputation among her family and friends" (Margaret

Strickland, "'Like a Wild Creature in its Cage, Paced That Handsome Woman': The Struggle between Sentiment and Sensation in the Writings of Louisa May Alcott," http://www.women writers.net/domesticgoddess/strickland.htm). This could be why "Alcott herself experiences the schizophrenic split between "little women" and public, outspoken women in her role as a writer" (Monika M. Elbert, "Introduction," in *Separate Spheres No More: Gender Convergence in American Literature, 1830–1930*, ed. Monika M. Elbert [Tuscaloosa and London: University of Alabama Press, 2000], 1–25 [p. 4]). As a woman, Alcott is still limited in her subversion of the conventions, literary and cultural. Alcott did, however, not conceal her name for *The Mysterious Key and What It Opened* (1867; appearing as No. 50 in the *Ten Cent Novelette series of Standard American Authors* (Boston: Elliott, Thomes and Talbot)), which had a male hero. The others concentrated, for the most part, on heroines.

88. *Papers of the Bibliographical Society of America*, XXXVII: 2

89. LaSalle Corbell Pickett, from a conversation with Louisa May Alcott, "[Louisa May Alcott's "Natural Ambition" for the "Lurid Style" Disclosed in Conversation]," *Across My Path: Memories of People I Have Known* (New York: Brentano's, 1916) pp. 107–8.

90. Corbell Pickett, pp. 107–8.

91. Madeleine B. Stern, *Imprints in History: Book Publishers and American Frontiers* (Bloomington: Indiana University Press, 1956), pp. 211–14.

92. This was originally published in two separate volumes: *Behind a Mask: The Unknown Thrillers of Louisa May Alcott* and *Plots and Counterplots: More Unknown Thrillers of Louisa May Alcott*.

93. This appeared as being written "By a Well Known Author." It was reprinted under "A. M. Barnard" for the *Ten Cent Novelettes of Standard American Authors* series (No. 80). The subtitle is reminiscent of the chapters in Reynolds's *The Mysteries of London*: "LXIII: The Plot" (I) and "LXIV: The Counterplot" (I) and "CCXXXV: Plots and Counterplots" (II). Virginie's profession was potentially influenced by Reynolds's *Mysteries*, where there is a figure, Ellen Monroe, who does doubtful jobs before becoming a dancer/actress. Charles Martel's "Hanged by the Neck: A Confession," in *The Detective's Note-Book* (1860), uncovers the crime of a murdered nineteen-year-old *danseuse*, Maria G—. She is said to have been charming and had two lovers: Lieutenant King and a machinist, Julius Kenneth. The latter, her eventual fiancé, kills her due to jealousy over her continuing bond with King. Parallels between this story and "V.V." can be made, although Alcott significantly does something new. Australian author John Lang's first novel was *Violet the Dansuese: A Portraiture of Human Passions and Character* (London: Colburn, 1836). The figure of the *danseuse* was similar to that of the actress and was common in literature of the time; they were both presented as "criminalized" and unwomanly. Henry Mayhew states that "Balletgirls have a bad reputation, which is in most cases well deserved [as their] natural levity" leads to prostitution (Henry Mayhew, *London Labour and the London Poor* (4 Vols. New York: Dover, 1968 [1861]), 4: 257). Much later in *Nights at the Circus* (1984), Angela Carter constructed a feminist literary play on this figure with her inclusion of the character of Fevvers, an *aerialiste* (acrobat).

94. Louisa May Alcott, "V. V. or Plots and Counterplots," in *The Hidden Louisa May Alcott: A Collection of Her Unknown Thrillers*, ed. Madeleine Stern (New York: Avenel Books, 1984), p. 391. All further references are to this edition and are given parenthetically.

95. Stern, *The Hidden Louisa May Alcott*, II. 283.

96. Sutherland, *The Stanford Companion*, p. 182.

97. For an extended discussion of this, see Kate Watson, "The Imprint in Print: Tattoos, Women, and Nineteenth-Century Criminography."

98. Later, Mrs. Oliphant would include a French mayor, Martin Dupin, in her supernatural story, *A Beleaguered City: A Story of the Seen and the Unseen* (London: Macmillan, 1880).

99. Stern, *The Hidden Louisa May Alcott*, II. 286.

100. XXI: 41, 42, 43, 44 (October 13, 20, 27– November 3, 1866).

101. Rostenberg, "Some Anonymous and Pseudonymous Thrillers," p. 45.

102. Letters from Louisa May Alcott. Letter V, II August 1866. MSS, Box II, Houghton Library. Found in Leona Rostenberg, "Some Anonymous and Pseudonymous Thrillers of Louisa May Alcott," in *Louisa May Alcott: From Blood and Thunder to Hearth and Home*, ed. Madeleine B. Stern (Boston: Northeastern University Press, 1998), 73–82 (p. 77).

103. Showalter, *Sister's Choice*, p. 3.

104. Andrew Forrester, Jun., "Georgy," *The Female Detective*, 1864, 97–113 (p. 97).

105. "Incognita," p. 308.

106. *From Bow Street to Baker Street*, p. 125.

107. In July 1865 Alcott travelled to Europe with Anna Weld and in 1866 to Nice and Paris; on 17 May 1866 Alcott went to London. Following this trip and upon her return to the United States, she then wrote "Behind a Mask."

In 1870 Alcott again visited Europe (Italy, Switzerland, and France), but this time with her sister, May, and Alice Bartlett. Later, Alcott's story "The Abbot's Ghost" would include an English abbey.

108. Elizabeth Lennox Keyser, *Whispers in the Dark: The Fiction of Louisa May Alcott* (Knoxville: The University of Tennessee Press, 1993), p. 4.

109. Mrs. Lillie Devereux Umsted, *Southwold: A Novel* (New York: Rudd and Carleton, 1859), p. 13.

110. Natalie Schroeder and Ronald A. Schroeder, *From Sensation to Society: Representations of Marriage in the Fiction of Mary Elizabeth Braddon, 1862–1866* (Newark: University of Delaware Press, 2006), p. 18.

111. Braddon, *The Black Band*, p. 4.

112. Perhaps Alcott/Jean was a forerunner for the later fictional female criminal in Britain, Madame Sara. Sara can be located as a powerful figure in London, a criminal, and an uncatchable one at that. Sara featured in *The Sorceress of the Strand* (1903). By L. T. Meade and Robert Eustace, these comprised six short stories which appeared in the *Strand Magazine* from October 1902 to March 1903.

113. Louisa May Alcott, *Behind a Mask* (London: Hesperus Press, 2004), p. 4. All further references are to this edition and are given parenthetically.

114. Douglas, "Mysteries of Louisa May Alcott," p. 236.

115. Karen Halttunen, "The Domestic Drama of Louisa May Alcott," *Feminist Studies* 10 (1984), 233–54 (p. 241).

116. There are similar figures to Jean in Collins' *The Dead Secret* (1857), which features Mrs. Treverton, a former actress, who had hoodwinked her husband. Collins' short story, "Mr. Lismore and the Widow" (originally appearing as "She Loves and Lies" in *The Spirit of the Times*, 22 December 1883), uses a young woman who dresses as an old woman in order to secure a marriage — later seducing her husband as her real, younger self. This latter story may have been influenced by Alcott's.

117. *The Wellesley Index to Victorian Periodicals 1824–1900*, ed. Walter E. Houghton, et al. 4 volumes (University of Toronto Press/ Routledge and Kegan Paul, 1966–87 (I. 317).

118. "The Woman with the Yellow Hair: A Tale," in *A Treasury of Victorian Detective Stories*, ed. E. F. Bleiler (New York: Scribner's, 1979), 52– 70 (p. 70) [*Dublin University Magazine*, November 1861; reprinted in 1862 as *The Woman with the Yellow Hair and Other Modern Mysteries*].

119. Stern, "Introduction," in *Behind a Mask: the Unknown Thrillers*, p. xviii. This multilingualism is reminiscent of Jabez in *Trail*.

120. Lennox Keyser, *Whispers in the Dark*, p. 52.

121. In *Louisa May Alcott*, ed. Cheney, p. 65.

122. Karen L. Kilcup, "The Conversation of 'The Whole Family': Gender, Politics, and Aesthetics in Literary Tradition," in *Soft Canons: American Women Writers and Masculine Tradition*, ed. Karen L. Kilcup (Iowa City: University of Iowa Press, 1999), 1–24 (p. 9).

123. *The New York Detective Police Officer*, p. 36.

METTA VICTORIA FULLER VICTOR

124. *A Woman of the Century: Fourteen Hundred-Seventy Biographical Sketches Accompanied by Portraits of Leading American Women in all Walks of Life*, ed. Frances Willard and Mary Livermore (New York: Gordon Press, 1975), pp. 734–5.

125. *A Woman of the Century*, p. 735.

126. New York: Beadle and Co., 1861.

127. Albert Johannsen, *The House of Beadle and Adams and its Dime and Nickel Novels: The Story of a Vanished Literature* 3 vols. (Norman: University of Oklahoma Press, 1950–62), I. 40.

128. Akiyo Okuda is the only critic who mentions "The Skeleton at the Banquet" as written under the pseudonym of "Seeley Regester" (as well as *The Dead Letter* and *The Figure Eight*). In her article she does not give this story a specific date, yet writes in her bibliography: "'The Skeleton at the Banquet.' *Stories and Sketches by our Best Authors.* Boston: Lee, 1867, 9–33." She précis's the story: "This Poesque story where a physician narrator encounters a man who believes his younger sister to be deranged, and who turns out to be the one who is going insane, is quite suspenseful. Victor seems to be distinguishing these mystery-orientated writings from other writings" (Akiyo Okuda, "Metta Victoria Fuller Victor's *The Dead Letter* [1864] and the Rise of Detecting Culture/Detective Fiction," *Clues: A Journal of Detection* 19.2 [1998], 35–57 [p. 36]). "Dora Elmyr's Worst Enemy; or, Guilty or Not Guilty" (1878) is also represented as a crime-related text, which was published the same year as *The Leavenworth Case*. In the same year, however, Alcott wrote the similarly titled story, *The Skeleton in the Closet* (Boston: Elliott, Thomes & Talbot [1867] as No. 49 in the Ten Cent Novelettes of Standard American Authors series).

129. Kathleen L. Maio, "Metta Victoria Fuller Victor," in *American Women Writers: A Critical Guide from Colonial Times to the Present*, ed. Lina Mainiero (New York: Ungar, 1982), Volume 4, 302–4 (p. 303).

130. Sussex, "The Art of Murder and Fine

Furniture: The Aesthetic Projects of Anna Katharine Green and Charles Rohlfs," in *Formal Investigations: Aesthetic Style in Late-Victorian and Edwardian Detective Fiction*, ed. Paul Fox and Koray Melikoglu (Stuttgart: Ibidem, 2007), 159–78 (p. 176).

131. In critical work there has been an oscillation between the spellings of "Meta" or "Metta," and "Regester" or "Register." Kathleen Gregory Klein uses "Meta" and "Regester" (see Klein, "Introduction," in *Great Women Mystery Writers Classic to Contemporary*, ed. Kathleen Gregory Klein (Westport and London: Greenwood Press, 1994), 1–9), yet Sussex, *The Aunt Lute Anthology*, and Panek all use "Register" (see Lucy Sussex and John Burrows "Whodunit? Literary Forensics and the Crime Writing of James Skipp Borlase and Mary Fortune," *BSANZ Bulletin* 21.2 (1997), 73–106). Okuda has "Regester" and Panek "Metta" (see "Metta Victoria Fuller Victor"s *The Dead Letter*," in *Clues*). The 2003 Duke University Press reprint of *The Dead Letter* and Catherine Ross Nickerson in her "Introduction" to the novel have "Metta" and "Regester." Hagen spells "Meta" with a single "t" (*Who Done It?*, p. 387). Hagen also only lists *The Dead Letter* and does not include any of Victor's other works. The Library of Congress spells her name "Metta Fuller Victor." Just as her novel eludes fixed definition, so does the author—in name and pseudonym. The original serial in *Beadle's Monthly* has "Regester."

132. Catherine Ross Nickerson, "Introduction," in Metta Fuller Victor *The Dead Letter and The Figure Eight* (Durham and London: Duke University Press, 2003), 1–10 (p. 1).

133. Suzanne Young, "The Simple Art of Detection: The Female Detective in Victorian and Contemporary Mystery Novels," *MFS: Modern Fiction Studies* 47 (2001), 448–57 (p. 449).

134. Young, "The Simple Art of Detection," p. 450.

135. *... And Always a Detective*, p. 35.

136. See Leonard Cassuto, *Hard-Boiled Sentimentality: The Secret History of American Crime Stories* (New York: Columbia University Press, 2009).

137. Knight, *Crime Fiction 1800–2000*, p. 44.

138. DuBose, *Women of Mystery*, p. 4.

139. Edmund Pearson, *Dime Novels; or, Following an Old Trail in Popular Literature* (Boston: Little Brown, 1929), pp. 13–14.

140. Ross Nickerson, *The Web of Iniquity*, p. 30.

141. Johannsen, *The House of Beadle and Adams*, I. 15.

142. Panek, *The Origins of the American Detective Story*, p. 10.

143. Elizabeth Foxwell, Back-cover comment, *The Dead Letter* and *The Figure Eight*, in Metta Fuller Victor *The Dead Letter and The Figure Eight* (Durham and London: Duke University Press, 2003), unpaginated.

144. Ross Nickerson, "Introduction," in *The Dead Letter*, p. 1.

145. Ross, "Seeley Regester," p. 294.

146. *The Saturday Journal*, 2 July 1881, p. 2.

147. Okuda, "Metta Victoria Fuller Victor's *The Dead Letter*," p. 37.

148. Michael Denning, *Mechanic Accents: Dime Novels and Working-Class Culture in America* (London and New York: Verso, 1987), p. 15.

149. Denning, *Mechanic Accents*, p. 11.

150. Reynolds, *Beneath the American Renaissance*, p. 47.

151. Sussex, *Cherchez Les Femmes*, p. 289.

152. Sussex, *Cherchez Les Femmes*, p. 291.

153. Johannsen, *The House of Beadle*, II. 278.

154. Sussex, *Cherchez Les Femmes*, pp. 292–3.

155. Metta Fuller Victor, *The Dead Letter and The Figure Eight* (Durham and London: Duke University Press, 2003), p. 13. All further references are to this edition and are given parenthetically.

156. "The Purloined Letter," *Selected Tales*, p. 354.

157. Andrew Forrester, Jr., "Arrested on Suspicion," in *A Treasury of Victorian Detective Stories*, ed. Everett F. Bleiler (New York: Scribner's, 1979), 15–34 (p. 15).

158. Catherine Clinton, *The Other Civil War: American Women in the Nineteenth Century* (New York: Hill and Wang, 1986), p. 151.

159. Clinton, *The Other Civil War*, p. 151.

160. Worthington, *The Rise of the Detective*, p. 30.

161. Frederick Newberry has written on "Male Doctors and Female Illness in American Women's Fiction, 1850–1900" (in *Separate Spheres No More: Gender Convergence in American Literature, 1830–1930*, ed. Monika M. Elbert (Tuscaloosa and London: University of Alabama Press, 2000), 143–57).

162. Karen Halttunen, *Confidence Men and Painted Women: A Study of Middle-Class Culture in America, 1830–1870* (New Haven: Yale University Press, 1982), p. 7, p. 10, p. 42.

163. Gambling recurs in crime narratives; earlier "Waters"/William Russell's *Recollections of a Detective Police-Officer* (London: W. Clover and Sons, 1856) has "One Night in a Gaming-House" as its first story. (First published in "Recollections of a Police-Officer" in *Chambers's*, 28 July 1849, 55–9) Finance and sexual jealousy are interconnected in "nineteenth-

century America [which] was convulsed by the ups and downs and pell-mell growth of boom-bust capitalism" (Michael Sappol, *A Traffic of Dead Bodies: Anatomy and Embodied Social Identity in Nineteenth-Century America* [Princeton: Princeton University Press, 2002], p. 15).

164. Mabel Collins Donnelly, *The American Victorian Woman: The Myth and the Reality* (New York, Westport, and London: Greenwood Press, 1986), p. 14. This is in congruence with Braddon's *Trail*: it is a female-authored text with male victims.

165. Anon., "The Woman with the Yellow Hair.—A Tale," p. 63.

166. Thomas Waters/William Russell, "One Night in a Gaming-House," in *Recollections of a Detective Police-Officer* (London: W. Clover, 1856), p. 9.

167. Charles Dickens, *Bleak House* (Harmondsworth: Penguin, 1971), p. 368.

168. Émile Gaboriau, *The Widow Lerouge: A Novel*, trans. Fred Williams and George A. O. Ernst (Boston: James R. Osgood and Company, 1873), p. 13.

169. Ross Nickerson, "Introduction," in *The Dead Letter*, p. 5.

170. B. J. Rahn, "Seeley Regester: America's First Detective Novelist," in *The Sleuth and the Scholar: Origins, Evolution, and Current Trends in Detective Fiction*, ed. Barbara A. Rader and Howard G. Zettler (Westport: Greenwood Press, 1988), 47–61 (p. 60).

171. Earlier, in *Lady Audley's Secret*, it is handwriting which leads Robert Audley to ascertain that Lady Audley is Helen Maldon. Later, Sherlock Holmes can also deduce characters and characteristics through handwriting. As Holmes comments in "The Reigate Puzzle": "You may not be aware that the deduction of a man's age from his writing is one which has been brought to considerable accuracy by experts" (Arthur Conan Doyle, "The Reigate Puzzle," *The Complete Sherlock Holmes* [Harmondsworth: Penguin, 1981], 398–411 [p. 408] [*Strand Magazine*, June 1893]).

172. Rahn, "Seeley Regester: America's First Detective Novelist," p. 60.

173. "The Poor Clare," in *Gothic Tales: Elizabeth Gaskell*, ed. Laura Kranzler (London and New York: Penguin, 2000), p. 68.

174. Rahn, "Seeley Regester: America's First Detective Novelist," p. 53.

175. DuBose, *Women of Mystery*, p. 4.

176. "Introduction," *The Dead Letter*, p. 5.

177. Panek, *The Origins of the American Detective Story*, p. 13.

178. Maio, "Murder in Grandma's Attic," p. 47.

179. Donnelly, *The American Victorian Woman*, p. 21.

180. Mrs. Henry Wood, *Dene Hollow* (London: Macmillan, 1911), p. 126. [1871]

181. Ross Nickerson has Mrs. Scott as an Irish woman; she calls Mrs. Scott and her husband "[t]he Irish caretakers" (Ross Nickerson, *The Web of Iniquity*, p. 34).

182. William Busnach, *Lecoq The Detective's Daughter* (London: W. Busnach and H. Chabrillat, 1888), p.6. All further references are to this edition and are given parenthetically.

183. Anon. "Our American Letter," *Bookman* 37 (1910), p. 169.

184. Ellery Queen (pseud. of Frederic Dannay and Manfred B. Lee), *Queen's Quorum* (Boston: Little, Brown, 1951), p. 64.

185. Maida, *Mother of Detective Fiction*, p. 6.

186. Johannsen, *The House of Beadle and Adams*, I. 59.

187. Patricia D. Maida, *Mother of Detective Fiction: The Life and Works of Anna Katharine Green* (Bowling Green, OH: Bowling Green State University Popular Press, 1989), p. 18. Maida explains this change from the original name and spelling to the popular version: "As a first step in assuming a professional image, Anna changed her middle name to 'Katharine'" (p. 22).

188. Joyce Warren, *The American Narcissus* (New Brunswick, NJ: Rutgers University Press, 1984), p. 9.

189. E. F. Harkins and C. H. L. Johnson, *Little Pilgrimages Among the Women Who Have Written Famous Books* (Boston: L. C. Page, 1901), p. 91.

190. Wentworth Higginson, *Letters and Journals of Thomas Wentworth Higginson*, p. 104.

191. Cathy Giffuni has compiled "A Bibliography of Anna Katharine Green," *Clues: A Journal of Detection* 8:2 (1987), 113–33.

192. Cheri L. Ross, "The First Feminist Detective: Anna Katharine Green's Amelia Butterworth," *Journal of Popular Culture* 25 (1991), 77–86.

193. Nancy Y. Hoffman, "Mistress of Malfeasance," in *Dimensions of Detective Fiction*, ed. Larry N. Landrum, Pat Browne, Ray B. Browne (Bowling Green, OH: Bowling Green State University Popular Press, 1976), 97–101 (p. 97).

194. Barbara Lawrence, "Female Detectives: The Feminist-Anti-Feminist Debate," *Clues: A Journal of Detection* 3:1 (1982), 38–48 (pp. 38–9).

195. Lawrence, "Female Detectives," p. 39.

196. Knight, *Crime Fiction 1800–2000*, pp. 53–4.

197. Wilkie Collins, *The Critic* (28 January 1893), p. 152.

198. Carolyn Wells, *The Technique of the Mystery Story* (Springfield, MA: Home Correspondence School, 1913), p. 17.
199. Murch, *The Development of the Detective Novel*, p. 159.
200. Ross Nickerson, *The Web of Iniquity*, p. 62.
201. Knight, *Crime Fiction 1800–2000* (2004), p. 53.
202. Barrie Hayne, "Anna Katharine Green," in *10 Women of Mystery*, ed. Earl F. Bargainnier (Bowling Green, OH: Bowling Green State University Popular Press, 1981), 153–78 (p. 160).
203. Symons, *Bloody Murder*, p. 73.
204. "Anna Katharine Green" [Obit.], *Publisher's Weekly* 127 (20 April 1935), 1599.
205. Michael Mallory, "'The Mother of American Mystery' Anna Katharine Green," http://www.mysteryscenemag.com/articles/96annakatharinegreen.pdf.
206. Mallory, "'The Mother of American Mystery.'"
207. Luther Mott, *Golden Multitudes: The Stories of Best Sellers in the United States* (New York: Macmillan, 1947), p. 63.
208. Barrie Hayne "Anna Katharine Green," p. 153.
209. Crowe's play was performed first in London in May 31, 1841, and later in America and Sydney, Australia. The play, though, was modified: the detecting and crime elements were minimized, and the important figure of Julie omitted.
210. Anna Katharine Green, interview in Buffalo *Courier*, May 25, 1902.
211. Letter from Anna Katharine Green to Hatch, "Author of *The Leavenworth Case*," 161. The letter is undated. (Quoted in Ross Nickerson, *The Web of Iniquity*, p. 67.)
212. "Anna K. Green Dies; Noted Author, 88," *New York Times*, 12 April 1935: 23.
213. T. S. Eliot, "Wilkie Collins and Charles Dickens," in *Selected Essays, 1917–32* (London: Faber, 1932), p. 412.
214. Anna Katharine Green, *The Leavenworth Case: A Lawyer's Story* (New York: Dover Publications, 1981). All further references are to this edition and are given parenthetically.
215. Knight, *Crime Fiction 1800–2000*, p. 211.
216. Gillian Gill, *Agatha Christie: The Woman and Her Mysteries* (London: Robson Books, 1991), p. 32.
217. Anna Katharine Green, "Why Human Beings Are Interested in Crime," *American Magazine* 87 (February 1919), 38–39, 82–86.
218. William Godwin, "Appendix II: Godwin's Account of the Composition of *Caleb Williams*," in William Godwin *Caleb Williams*, ed. David McCracken (Oxford and New York: Oxford University Press, 1970), 335–41 (p. 340).
219. Ross Nickerson, *The Web of Iniquity*, p. 95.
220. Katharine Green, "Why Human Beings Are Interested in Crime," p. 87.
221. S. S. Van Dine [Willard Huntington Wright], "Introduction," in Anna Katharine Green *The Leavenworth Case: A Lawyer's Story* (New York: Modern Age Books, 1937), p. 2.
222. Maida, *Mother of Detective Fiction*, p. 14.
223. DuBose, *Women of Mystery*, p. 8.
224. Carnell, "Introduction," p. xxi.
225. Alexis de Tocqueville, *Democracy in America*, 4th ed. (Cambridge: Sever and Francis, 1864), trans. Henry Reeve, Esq., II. 241–2 (Chapter IX: Education of Young Women in the United States).
226. This was published in 1879 by Donnelley, Gassette & Loyd of Chicago. The British Library stocks three copies, dated "[n.d]," 1884, and 1887. For the "no date" entry, in the detailed view under the "general note" is "Originally published: Chicago, Donnelley, Gassette & Loyd [c1879]." http://catalogue.bl.uk/F/RSG53GKVFV3XEKDJUS6X6C42Y16186GA7R5KH8P5RQE2SBVHAR-67588?func=full-set-set&set_number=106112&set_entry=000003&format=999.
227. Hagen (in *Who Done It? A Guide to Detective, Mystery and Suspense Fiction* (New York and London: R. R. Bowker, 1969), p. 384) briefly mentions Van Deventer but fails to include Spofford, Davitt, Fortune, and Braddon's work outside of *Lady Audley's Secret*. Kathleen L. Maio discusses Van Deventer and *Shadowed by Three* and includes a plate from the 1883 Donnelley, Gassette and Loyd edition of the novel, which depicts Lenore Armyn hitting a woman-basher with a mallet and has the words "Lie there, you brute" underneath (Maio, "'A Strange and Fierce Delight' The Early Days of Women's Mystery Fiction," *Chrysalis: A Magazine of Women's Culture* 10 [1980], 93–105).
228. Panek, *The Origins of the American Detective Story*, p. 17.
229. Anon. "'Current Fiction': *Shadowed by Three*. By Lawrence L. Lynch. Chicago: Donnelley, Gassette & Loyd. $1. 50," *The Literary World: A Fortnightly Review of Current Literature* Volume XI March 27 1880, 111–12 (p. 111).
230. Emma Van Deventer ("Lawrence L. Lynch, of the Secret Service"), *Madeline Payne, the Detective's Daughter* (Chicago: Alex T. Loyd and Co, 1884).
231. Emma Van Deventer ("Lawrence L. Lynch"), *Against Odds* (Chicago: Rand McNally, 1894), p. 196.

232. Bessie Turner, *Circumstantial Evidence* (New York: Norman L. Munro, 1884), p. 109.

Chapter Three

Introduction

1. The term *terra nullius* means "empty land" or "land belonging to no one." In Australia, it was assumed by European settlers that the land did not belong to anyone and could consequently be claimed.
 2. "A Suburban Study," *Australasian*, 10 April 1869, p. 456.
 3. Richard White has scrutinized Australian national assumptions in *Inventing Australia: Images and Identity, 1688–1980* (Sydney: Allen and Unwin, 1981).
 4. Anne Summers, *Damned Whores and God's Police: The Colonization of Women in Australia* (Ringwood, Australia: Allen Lane, 1975), p. 35.
 5. This is used as the title of a chapter in his work on the convict experience in early Australia. (A. W. Baker, *Death Is A Good Solution: The Convict Experience in Early Australia* [Brisbane, Australia: Queensland University Press, 1984], p. 78. The cessation of transportation to NSW was in 1840 and to Western Australia in 1868.
 6. Stephen Knight, "A Blood Spot on the Map: Place and Displacement in Australian Crime Fiction," *Australian Cultural History* 12 (1993), 145–59 (p. 145).
 7. Murch, *The Development of the Detective Novel*, p. 8.
 8. Hagen, *Who Done It?*, p. 631. DuBose, *Women of Mystery: The Lives and Works of Notable Women Crime Novelists* (New York: Thomas Dunne Books, 2000), p. 2.
 9. Aaron Marc Stein, "The Mystery Story in Cultural Perspective," in *The Mystery Story*, ed. John Ball (Del Mar, CA: University of California, San Diego/Publisher's, 1976), 29–59 (p. 30).
 10. *Investigating Identities: Questions of Identity in Contemporary International Crime Fiction*, ed. Marieke Krajenbrink and Kate M. Quinn (Amsterdam: Rodopi, 2009).
 11. *Poe Abroad: Influence, Reputation, Affinities*, ed. Lois Davis Vines (Iowa: University of Iowa Press, 1999).
 12. For a comprehensive discussion of these sub-genres see Knight, *Continent of Mystery: A Thematic History of Australian Crime Fiction* (Carlton South, Australia: Melbourne University Press, 1997).
 13. Elizabeth Webby, "Colonial Writers and Readers," in *The Cambridge Companion to Australian Literature*, ed. Elizabeth Webby (Cambridge: Cambridge University Press, 2000), 50–73 (p. 53).
 14. Tim Dolin, "First Steps Toward a History of the Mid-Victorian Novel in Colonial Australia," *Australian Literary Studies* 22 (2006), 273–93 (p. 277).
 15. Stephen Knight, "Peter Temple: Australian Crime Fiction on the World Stage," *Clues: A Journal of Detection* 29.1 (2011), 71–81 (p. 72).
 16. For example, Collins' *The Law and the Lady* was serialized in 1875 in the *Town and Country Journal*. Under the literature section in the *Illustrated Sydney News*, Henry Thomson's "Le Revenant" (*Blackwood's*, April 1827) was anonymously reprinted as "I Have Been Hanged and Am Alive" (*Illustrated Sydney News*, 16 August 1867, p. 218). This miscellany also included an Émile Gaboriau (Lecoq) story: "Who Robbed the Banker's Strong-Box. A Detective's Story" (*Illustrated Sydney News*, 18 February 1869).
 17. Johnson-Woods, *Index to Serials*, p. 7. Braddon's work first appeared in the *Age* with "To the Bitter End" (1872).
 18. Wood's work printed in Australia was: "The Surgeon's Daughters" (*Melbourne Journal*, April 1885); *A Life's Secret* (*Sydney Mail*, 16 August–27 December 1863); *Oswald Grey* (*Sydney Mail*, 19 November–23 September 1867); *Anne Hereford* (*Queenslander*, 5 December–27 March, 1868); *Roland Yorke* (*Queenslander*, 16 April–18 June 1870); *Within the Maze* (*Town and Country Journal*, 29 June–15 March 1872); *Edina* (*Sydney Mail*, 5 February–26 August 1876).
 19. "Charmian" (*Once a Week*, 6 June–22 August 1885); "The Wrong Husband!" (*Once a Week*, 17 October–2 January 1885); "A Dead Man's Double" (*Once a Week*, 24 December–17 March 1887); "Fighting Her Own Battles" (*Australian Town and Country Journal*, 22 July–9 December 1882). Stowe's Australian-published work was *The Minister's Wooing* (*Melbourne Leader*, 21 May–3 March 1859).
 20. Toni Johnson-Woods, *Index to Serials in Australian Periodicals and Newspapers: Nineteenth Century* (Canberra: Mulini Press, 2001), p. 6.
 21. "The Library Table," *Australian Journal*, part 70, No. VI, 1871, p. 398.
 22. H. M. Green, *A History of Australian Literature Pure and Applied: Volume I: 1789–1923* (Sydney: Angus and Robertson, 1961), p. 292.
 23. Johnson-Woods, *Index to Serials*, p. 8.
 24. Johnson-Woods, *Index to Serials*, p. 7.
 25. 1 October 1864: 8.
 26. "Answers to Correspondents," *Australian Journal*, August 1873.

27. *Temple Bar*, November 1870, pp. 233–4.
28. "Restrictions upon Colonial Literature," *Colonial Monthly*, September 1869, pp. 23–4.
29. Knight, *Continent of Mystery*, pp. 58–9.
30. *Walch's Literary Intelligencer*, September 1865:1.
31. G. B. Barton, *Literature in New South Wales* (Sydney: Thomas Richards, Govt. Printer, 1866), pp. 8–9.
32. Ronald G. Campbell, *The First Ninety Years: the Printing House of Massina, Melbourne, 1859 to 1949* (Melbourne: Massina, 1949), p. 51.
33. Andrew McCann, *Marcus Clarke's Bohemia: Literature and Modernity in Colonial Melbourne*, (Carlton, Australia: Melbourne University Press, 2004), p. 143.
34. Alexander Harris, *Settlers and Convicts or, Recollections of Sixteen Years' Labour in the Australian Backwoods, by an Emigrant Mechanic*; Foreword by Manning Clark (Melbourne: Melbourne University Press, 1969).
35. See Knight, *Continent of Mystery*.
36. Robert Haldane, *The People's Force: A History of the Victoria Police* (Melbourne: Melbourne University Press, 1986), p. 17.
37. "From Sleuths to Technicians? Changing Images of the Detective in Victoria," in *Police Detectives in History, 1750–1950*, ed. Clive Emsley and Haia Shpayer-Makov (Aldershot: Ashgate, 2006), 135–56 (p. 137).
38. *Report from the Select Committee on the Police Force, 1863, Votes and Proceedings of the Legislative Assembly of Victoria*, II. 1862–63, Appendix G, Minutes of Evidence, p. 104.
39. John Lahey has written *Damn You, John Christie! The Public Life of Australia's Sherlock Holmes* (Melbourne: State Library of Victoria, 1993), labelling Christie as such in his title. Christie is reminiscent of Eugène François Vidocq in his actions and employment of disguise. These memoirs were collected in 1913 as *The Reminiscences of Detective-Inspector Christie* (related by J. B. Castieau. Melbourne: Robertson and Co., 1913).
40. Summers, *Damned Whores and God's Police*, p. 267.
41. Summers, *Damned Whores and God's Police*, p. 268.
42. Summers, *Damned Whores and God's Police*, p. 292.
43. The Australian Women's Register, http://www.womenaustralia.info/biogs/PR00393b.htm.
44. *Register*, 28 April 1915.
45. H. A. Lindsay, "The World's First Policewoman," *Quadrant* (March 1959), 75–7 (p. 76).
46. For more information on these ballads see Jack Meredith, *The Wild Colonial Boy* (Melbourne: Red Rooster Press, 1982) and Stephen Knight (who details the different versions) in "The Case of the Stolen Jumbuck," in *Reconnoitres: Essays Presented to G. A. Wilkes*, ed. M. Harris and E. Webby (Sydney: Oxford University Press, 1992).
47. *Continent of Mystery*, p. 17.
48. Knight, *Continent*, p. 24. James Tucker, *Ralph Rashleigh* (Sydney: Angus and Robertson, 1952)
49. See M. H. Ellis, "Did Greenway Write "Ralph Rashleigh"?," *Bulletin* (3 December 1952), 2–3, 35; and Ellis, "Further Argument on Who Wrote "Ralph Rashleigh"?," *Bulletin* (7 January 1953), 25–6. Colin Roderick has also written "Introduction" to *Ralph Rashleigh* (Sydney: Angus and Robertson, 1952); "The Authorship of 'Ralph Rashleigh,'" *Bulletin* (24 December 1952), 22–3, 34; and "'Ralph Rashleigh,'" *Bulletin* (28 January 1953), 2. Lord Birkenhead wrote an "Introduction" to *Ralph Rashleigh* (London: Cape, 1929).
50. Knight, *Continent*, p. 20. *The Secret Police* was reprinted by Mulini Press in 2009 (No 26).
51. Victor Crittenden, "Introduction," John Lang, *Frederick Charles Howard* (Canberra: Mulini, 1990), p. v.
52. John Lang, *Frederick Charles Howard* (Canberra: Mulini, 1990), p. 124.
53. Victor Crittenden, "Introduction," *Lucy Cooper* (Canberra: Mulini, 1992), pp. ii–iv. *Lucy Cooper* was printed twice in Australia: in the *Corio Chronicle* (1848) and the *Illustrated Sydney News* (1853).
54. A ticket of leave was a document of parole issued to convicts who had been transported from Britain to Australia. Issued for good behaviour and renewable yearly, it allowed them freedoms such as the ability to marry, to purchase property, and employment. However, they were not allowed to leave the district without permission from the government. If these conditions were adhered to (and after serving half of their sentence), then they could be granted a conditional pardon, which gave them complete freedom, except the right to leave the colony. Conversely, if convicts did not comply with the ticket of leave stipulations, then they could be arrested.
55. H. M. Green, *A History of Australian Literature, Pure and Applied*, 2 vols. (Sydney: Angus and Robertson, 1961), pp. 258 & 264.
56. Nancy Keesing, "Introduction," *The Forger's Wife* (Sydney: John Ferguson, 1979), p. 86.
57. John Lang, *The Forger's Wife* (Sydney: John Ferguson, 1979), p. 46. All further references are to this edition and are given parenthetically.

58. A. G. Mitchell, "Australian English," The Australian Quarterly XXIII (March 1951), 9–17 (p. 10).
59. London: Routledge, Warne and Routledge.
60. Illustrated Sydney News, 16 May 1866, p. 2. All further quotations are from this edition and are given parenthetically.
61. In The Australian: A Monthly Magazine. No author is attached to the story/ies in the Magazine. This is set in N.S.W. A story from this was titled "A Night in a Sly Grog-Shop" (April 1880–September 1880, IV. 555).
62. Robert Whitworth, Mary Summers: A Romance of the Australian Bush (Canberra: Mulini, 1994), p. 47. Whitworth was an editor of the Journal from 1874–75.
63. This was published in the Journal and reprinted in the twentieth century in shorter form under the title Settlers and Savages. This novel dealt with settlement and pioneer and aboriginal conflict.
64. Victor Crittenden, "The Stockman's Daughter: Charles de Boos' Bushranger Novel of 1856," Margin 77 (April 2009), unpaginated.
65. Crittenden, "The Stockman's Daughter," unpaginated. "Bail up" is a slang term commonly associated with Australian bushrangers. It means to call to a halt, with the intention of robbery.
66. Nan Bowman Albinski has identified "M. C." as Marcus Clarke (Nan Bowman Albinski, "Marcus Clarke's First Australian Publication," Margin 21 [1989]: 1). "Wonderful!" was reprinted in Margin in 1989 (Number 21). Lucy Sussex too states that this story's writer was "almost certainly the young Marcus Clarke" (Lucy Sussex, "Introduction," in Lucy Sussex and Elizabeth Gibson Mary Helena Fortune ["Waif Wander"/ "W.W."] c. 1833–1910. A Bibliography. Victorian Research Guide 27 [The University of Queensland], 1–11 [p. 4]).
67. Lucy Sussex, "The Earliest Australian Detective Story?," Margin 22 (1990), 30–1 (p. 31).
68. M. C. "Wonderful! When You Come to Think of It," Margin 21 (1989), 2–10 (p. 3).
69. Also known as For the Term of His Natural Life. The first book edition in 1874 was published in Australia. The book had significant alterations. The English publisher, Richard Bentley, changed it to the longer title in the 1884 and 1885 versions. Knight says it first bore this longer title in an 1882 reprint. A shortened version/edition of His Natural Life followed in England in 1875 (which was a failure) and an American edition in 1876. This shortened version is still widely published and published for/used in schools.
70. McCann, Marcus Clarke's Bohemia, p. 142.
71. Stephen Murray-Smith, "Introduction," in Marcus Clarke His Natural Life (Harmondsworth: Penguin Classics, 1987), 7–23 (p. 7).
72. Marcus Clarke His Natural Life (Harmondsworth: Penguin Classics, 1987) ed. Stephen Murray-Smith, pp. 827–8.
73. Borlase as well as using his own name, wrote under the pseudonyms of "J.G. Bradley," "Skip Borlase" (also Skipp), J. J. G. Bradley, and "Captain Leslie."
74. "Some Interesting Notes about Mr. James Skipp Borlase," Derby and Chesterfield Reporter, 11 November 1887: 2.
75. Knight, Continent of Mystery, p. 116.
76. Lucy Sussex and John Burrows, "Whodunit?: Literary Forensics and the Crime Writing of James Skipp Borlase and Mary Fortune," BSANZ Bulletin 21.2 (1997), 73–106.
77. John Cordy Jeaffreson, Review of The Night Fossickers by James Skipp Borlase, Athenaeum (27 July 1867), p. 114.
78. "Our Whatnot," Australian Journal, December 1870, p. 219.
79. London: Warne, 1867; republished in Melbourne, 1893.
80. Michael Ackland, "Introduction," in The Penguin Book of Nineteenth-Century Australian Literature (Melbourne: Penguin, 1993), xiii–xxvii (p. xxi).
81. Sussex, "Whodunit?," p. 79.
82. Found in Folder 1: Papers Relating to Australian Children's Literature, 1883–1988 (Terry O'Neill Manuscript: National Library of Australia, Canberra. MS 7661).
83. "Melbourne in 1869," Temple Bar 30 (September 1870), 225–35 (p. 233).
84. Sussex, "'Bobbing Around,'" p. 8.
85. For more information on this Gordon/Borlase relationship see Sussex, "'Bobbing Around.'"
86. Elizabeth Lawson, "Louisa Atkinson, Naturalist and Novelist," in A Bright and Fiery Troop: Australian Women Writers of the Nineteenth Century, ed. Debra Adelaide (Ringwood: Penguin, 1988), pp. 69, 73.

CÉLESTE DE CHABRILLAN

87. A. R. Chisholm, "Céleste de Chabrillan and the Gold Rush," Meanjin Quarterly XXVIII (1969), 197–201 (p. 200).
88. Patricia Clancy and Jeanne Allen, "Introduction," in Céleste de Chabrillan, The French Consul's Wife: Memoirs of Céleste de Chabrillan in Gold-Rush Australia, trans. Patricia Clancy and Jeanne Allen (Melbourne: Miegunyah, 1998), 1–13 (p. 4).
89. Published in 1857, Michel Lévy Freres, Paris; translated and published as The Gold Robbers in Australia by Sun Books in 1970).

90. Céleste de Chabrillan, *The Gold Robbers*, trans. Lucy and Caroline Moorehead (Melbourne: Sun Books, 1970), p. ix. All further references are to this edition and are given parenthetically.
91. Punctuation as in the quotation.
92. Eugène Sue, *Les Mystères de Paris* (*Journal des Débats*, May 1842–October 1843; in English in 1845).
93. Joanne is his name and this is how it is spelt in the text. In Sue's *Mystères*, "le Surineur" ("slasher"), is an ex-convict.
94. Michael Sturma, *Vice in A Vicious Society: Crime and Convicts in Mid-Nineteenth Century New South Wales* (St Lucia: University of Queensland Press, 1983), p. 3.
95. Chabrillan, *The Gold Robbers*, p. 160.

Caroline Woolmer Leakey

96. *Continent of Mystery*, p. 24.
97. Richard Bentley and Son, *The Archives of Richard Bentley and Son 1829–1898* (Cambridge: Chadwyck-Healey, 1976); British Library, Book 58, Folio 195.
98. Alison Jane Rukavina, *Cultural Darwinism and the Literary Canon: A Comparative Study of Susanna Moodie's Roughing It in the Bush and Caroline Leakey's The Broad Arrow* (Simon Fraser University: 2000), p. 34.
99. *Bentley's Quarterly Review* 2 July 1859, 466–72 (p. 466).
100. *The Archives of Richard Bentley*, Book 41, Folio 186.
101. Jenna Mead, "Caroline Woolmer Leakey," *Dictionary of Literary Biography*, p. 7.
102. *Bentley Archives*, British Library 59629, 40–5.
103. *Walch's Literary Intelligencer*, March 1860, pp. 169–70.
104. Miles Franklin, *Laughter, Not For a Cage* (Sydney: Angus and Robertson, 1956), 46–7 (p. 45).
105. Knight, *Continent of Mystery*, p. 24.
106. Debra Adelaide, "Introduction: A Tradition of Women," in *A Bright and Fiery Troop: Australian Women Writers of the Nineteenth Century*, ed. Debra Adelaide (Ringwood: Penguin, 1988), 1–14 (pp. 3–4).
107. Murray-Smith, "Introduction," p. 10.
108. *Literature in the Marketplace: Nineteenth-Century British Publishing and Reading Practices*, ed. John Jordan and Robert Patten (London: Cambridge University Press, 1995), p. 403. Literary critics who have both recognized and written on Leakey and *The Broad Arrow* include: Anna Rutherford; Jenna Mead; Joan Poole; Dorice Williams Elliott; John Scheckter; Patricia Clarke; Gillian Winter; Shirley Walker; and Alison Jane Rukavina.

109. Lurline Stuart, "Early Convict Novels," *Proceedings*, Sixteenth Annual Conference, Association for the Study of Australian Literature, Canberra, Australian Defence Force Academy (1994), p. 102.
110. *The Literary Examiner*, 28 May 1859, p. 340.
111. *The Spectator*, 14 May 1859, p. 518.
112. Laurie Hergenhan, *Unnatural Lives: Studies in Australian Convict Fiction* (St. Lucia: University of Queensland Press, 1993), p. 31.
113. There is a query about the authorship of *Lucy Cooper*.
114. Caroline Leakey, *The Broad Arrow* (London: Bentley, 1859), p. v. All further references are to this edition and are given parenthetically.
115. "Convict Servants," p. 179.

Eliza Winstanley

116. Winstanley's text was reprinted in 1992 as part of the *Australian Books on Demand* series (No. 5: Canberra, Mulini Press).
117. Knight, *Continent of Mystery*, p. 29.
118. Williams Elliott, "Convict Servants," p. 183.
119. Eliza Winstanley, *For Her Natural Life: A Tale of the 1830s* (Canberra: Mulini Press, 1992), p. 193.
120. Lucy Sussex, "Introduction," in Ellen Davitt, *Force and Fraud: A Tale of the Bush* (Canberra: Mulini Press, 1993), i–ix.

Ellen Davitt

121. Sisters in Crime Australia was inspired by the American organization of the same name, which was initiated by Sara Paretsky and other women crime writers in 1986. The Australian organization was launched at the Feminist Book Festival in Melbourne in September 1991. "The Davitt" is awarded for the best crime novel by an Australian woman published in book form in Australia in the previous year; the award comprises three categories: the best adult novel; the best young fiction book; and the reader's choice award (voted by members of Sisters in Crime). http://home.vicnet.net.au/~sincoz/welcome.htm.
122. Victorian Public Record Series 892, Unit 32, Special Case 525, 74/9448.
123. *Kyneton Observer*, 9 January, 1864, p. 2.
124. Victorian Public Record Series 892, Unit 32, Special Case 525, 75/20722.
125. See Sutherland, *The Stanford Companion to Victorian Fiction*, p. 183.
126. *Hamilton Spectator*, 2 October 1863, p. 2.
127. "Weekly Miscellany," *Examiner* (20 April 1861), p. 7.

128. "Christopher Sly" (James Neild), "A Peep at the Pictures," *Examiner and Melbourne Weekly News* (12 December 1857), p. 8.
129. J. Alex Allan, *The Old Model School: Its History and Romance 1852–1904* (Melbourne: Melbourne University Press, 1934), p. 21.
130. Allan, *The Old Model School*, p. 64.
131. Victor Crittenden, *Australian Nineteenth Century Literature in Print*, Broadsheet 2 (1991): 2.
132. On 2 September 1865. It ran from 2 September-18 November 1865. This positioning is in contrast to Johnson-Woods' discussion of the *Journal* in the following decade: "in the 1870s, the *lead* serial was more often than not an imported one." Johnson-Woods, *Index to Serials*, p. 20.
133. Sussex, "Introduction," *Force and Fraud*, p.vii.
134. The *Dictionary of Australian Arts Online* spells it as "Atlanta" yet in its original incarnation the *Journal* spelt it as "Atalanta."
135. *Journal*, 23 March 1867, p. 479.
136. Sussex, "'Bobbing Around,'" p. 7.
137. For example, her short story "The Highlander's Revenge" (*Journal*, 31 August 1867) was attributed to "the author of Edith Travers, etc."
138. Victor Crittenden, "Introduction," in Robert Whitworth *Mary Summers: A Romance of the Australian Bush* (Canberra: Mulini, 1994), unpaginated. Whitworth includes crime and a detective (David Turner), rather than the host of quasi-detectives of *Force and Fraud*.
139. Marcus Clarke, *His Natural Life*, ed. Stephen Murray-Smith (Harmondsworth: Penguin Classics, 1987), p. 69.
140. Ellen Davitt, *Force and Fraud: A Tale of the Bush* (Canberra: Mulini Press, 1993), p. 17. All further references are to this edition and are given parenthetically.
141. *Continent of Mystery*, p. 42.
142. George William MacArthur Reynolds, *The Mysteries of London* (London: George Vickers, 1846) II. 424.
143. "Social Reform," in *The Critic: A Weekly Journal Specially Devoted to the Encouragement of Australian Literature, Science, and Art*, Sydney, Saturday, 22 November 1873, I.157.
144. Andrew Forrester Jun. "The Unraveled Mystery," in *The Female Detective* (London, Fleet Street: Ward & Lock, 1864), 114–36 (pp. 119–20).
145. "Murder," in *The Critic: A Weekly Journal Specially Devoted to the Encouragement of Australian Literature, Science, and Art*, Sydney, Saturday, 27 September 1873, I. 14.
146. David Indermaur, "No. 61: Violent Crime in Australia: Interpreting the Trends," from *University of Western Australia Crime Research Centre, Australian Institute of Criminology Canberra. Trends and Issues in Crime and Criminal Justice* (October 1996), p. 1.
147. Kay Schaffer, *Women and the Bush: Forces of Desire in the Australian Cultural Tradition* (Melbourne, Cambridge, and New York: Cambridge University Press, 1988), p. 22.
148. Schaffer, *Women and the Bush*, p. 22.
149. Metta Victor, *The Backwoods' Bride: A Romance of Squatter Life* (New York: Beadle, 1860), p. 89.
150. For a comprehensive discussion of this treatment of the police and literary police see Worthington, *The Rise of the Detective*.
151. And as a novel: London: Tinsley, 1867 (3 vols).
152. Stephen Knight, "Introduction," in *Dead Witness: Best Australian Mystery Stories*, ed. Stephen Knight (Ringwood: Penguin, 1989), ix–xxv (p. xiii).
Mary Helena Fortune
153. The exact date is unknown. Lucy Sussex and Elizabeth Gibson's bibliography on Mary Fortune states her dates as "c. 1833–1910" (*Victorian Research Guide*).
154. Knight, *Continent of Mystery*, p. 4.
155. For a full discussion, please see Sussex, "Introduction," the *Victorian Research Guide* (27), p. 6.
156. Lucy Sussex, "A Woman of Mystery: Mary Fortune," http://lsussex.customer.netspace.net.au/womanofmystery.htm.
157. Waif Wander, "How I Spent Christmas," in *The Fortunes of Mary Fortune*, ed. Lucy Sussex (Melbourne: Penguin, 1989), 167–88 (p. 187). (Originally in *Journal*, 30 January 1869, 362–5).
158. W. W. "A Woman's Revenge; Or, Almost Lost" (*Journal*, February 1871), 333–8 (p. 333).
159. Henry W. Mitchell, "A Well Known Contributor: Waif Wander" (*Journal*, Vol. 15, March 1880), 487–8 (p. 487).
160. Ron Campbell, quoted in Lucy Sussex, "Mary Fortune's Three Murder Mysteries," *Margin* 78 (July–August 2009), p. 33.
161. Mangham links Mary Fortune with British texts and authors, suggesting that they influence her: "The image of a woman buried in whiteness, for example, is clearly indebted to *The Woman in White* (1860) and *Great Expectations* (1860–1), while the notion of one sibling attacking and drinking the blood of another replicated Bertha Rochester's assault on her brother in *Jane Eyre* (1847)" Mangham, *Violent Women*, p. 12. Lucy Sussex has written extensively on Fortune. Andrew McCann mentions Fortune in his book *Marcus Clarke's Bohemia*. Johnson-Woods includes Fortune and her stories in her *Index to Serials*. Knight

takes account of Fortune in *Continent of Mystery* and Worthington also acknowledges her in "From *The Newgate Calendar*."
162. "Introduction," *Victorian Research Guide*, p. 5.
163. "Introduction," *Victorian Research Guide*, pp. 5–6.
164. See Sussex and Burrows, "Whodunit?"
165. The collaboration between Borlase and Fortune comprises eleven stories and they were all written anonymously.
166. *Journal*, 24 March 1866, p. 479.
167. *Journal*, 23 March 1867, p. 479.
168. Untitled, "'The Dead Witness,' by W.W. and W. W.," *The Body Dabbler: An Occasional Newsletter Concerned Especially with Australasian Crime Fiction* 11 (1989), 1–2.
169. Henry W. Mitchell, "A Well Known Contributor: Waif Wander" (*Journal*, March 1880), 487–88 (p. 487).
170. Lucy Sussex, "A Woman of Mystery: Mary Fortune."
171. Lucy Sussex, "A Woman of Mystery: Mary Fortune."
172. Published by Clarson, Massina & Co. Ken Gelder and Rachael Weaver have this title as *The Detective's Album: Recollections of an Australian Police Officer*. (*The Anthology of Colonial Australian Crime Fiction*, ed. Ken Gelder and Rachael Weaver (Melbourne: Melbourne University Press, 2008), p. 2). These seven stories were: "The Evidence of the Grave" (originally in the *Journal*, September 1870), "The Hart Murder" (October 1870), "The Last Scene" (November 1870), "The Twenty-Ninth of November" (December 1870), "To Be Left Till Called For" (January 1870), "A Woman's Revenge; or, Almost Lost" (February 1871), and "The Diamond Robbery" (March 1870). These were the stories which appeared in the *Journal* from September 1870 to March 1871, rather than a collection based on her most popular or best stories.
173. E. Morris Miller and Frederick T. Macartney, *Australian Literature: A Bibliography to 1938* (Sydney: Angus and Robertson, 1956), p. 477.
174. pp. 549–52. Later, Fortune would write "The Cellarton Mystery" ("W. W.," *Journal*, August 1891, 684–91) and "The Cellar at No. 9," both as part of "The Detective's Album" ("W. W.," *Journal*, May 1900, 296–303).
175. "Memoirs of an Australian Police Officer" No. V: "The Dead Witness; or, The Bush Waterhole," *Journal*, 20 January 1866, 329–31. Reprinted in the *Journal* February 1909, 113–15.
176. Waif Wander, "How I Spent Christmas," in *The Fortunes of Mary Fortune*, ed. Lucy Sussex (Melbourne: Penguin, 1989), p.

167. Originally in the *Journal*, 30 January 1869, 330–3.
177. "W.W.," "The Hart Murder," *Journal*, October 1870, 106–11 (p. 111). This story was reprinted in *The Detective's Album* (1871) and again later in the *Journal* (July 1910, 433–9).
178. *Journal*, September 2, 1865, 4–7 (p. 5).
179. Mary Helena Fortune, "A Struggle for Life," *Journal* (3 February 1866), 361–64 (p. 361). All further references are to this edition and are given parenthetically.
180. Julian Thompson, in *Wilkie Collins: The Complete Shorter Fiction*, ed. Julian Thompson (London: Robinson, 1995), p. 911.
181. Knight, "Introduction," in *Dead Witness*, p. xiii.
182. For a full discussion on dogs in detective fiction see Kate Watson, "The Hounds of Fortune: Dog Detection in the Nineteenth Century," *Clues: A Journal of Detection* 29.1 (2011), 16–25.
183. Catherine Crowe, *Susan Hopley: or, The Adventures of a Maid Servant* (London: G. Routledge & Co, 1852), p. 197.
184. Waif Wander, "My Friends and Acquaintances," *Journal*, December 1876, 197–9 (p. 197). Fortune also wrote a short fiction piece entitled "The Dog Days," *Journal*, April 1869, 482–84.
185. Waif Wander, "Towzer & Co.," in *The Fortunes of Mary Fortune*, ed. Lucy Sussex (Melbourne: Penguin, 1989), 211–19. Originally published in the *Journal* (August 1870, 712–13). All further references are to this edition and are given parenthetically. Fortune also later wrote a crime story with a dog named Towzer in "Towzer's Teeth" (*Journal*, February 1891). Sussex has noted that "Towzer" is "[a] favourite name for dogs in Mary Fortune's writing" (*The Fortunes of Mary Fortune*, p. 219).
186. Knight, *Continent of Mystery*, pp. 74–5.
187. In *The Anthology of Colonial Australian Crime Fiction*, ed. Ken Gelder and Rachael Weaver (Melbourne: Melbourne University Press, 2008), pp. 5–6.
188. 1826–1915. "Rolf Boldrewood"/Thomas Alexander Browne was London-born, arriving in Australia in 1831 and becoming a police magistrate and squatter. His first published piece was printed in *Cornhill* in 1866 ("A Kangaroo Drive"). He is most well-known for *Robbery Under Arms* (serialized in the *Sydney Mail* in 1883; published in London in 1888): this was a bushranger's (Captain Starlight) account of his experiences before he is due to hang, yet, in a similar way to Henry Thomson's "Le Revenant" (1827), he is saved from this fate at the crucial moment. Browne also wrote "The Mailman's Yarn" (July 1882–August 1883 in the

Notes — Chapter Three

Sydney Mail; abbreviated version London, 1888) and an earlier series of articles, "Old Melbourne Memories," for the *Town and Country* and the *Australasian* (1881–1883).
189. 1849–1921? His best-known novel or crime-related work was *Bail Up* (1890), which detailed bush-ranging in Queensland. Other titles of his are *A Bush Girl's Romance* (1894); *The Great Secret, A Tale of Tomorrow* (1895); *In Sheep's Clothing* (1900), a ghost thriller, "The Haunted Station" (1894), and *The Swampers* (1897).
190. 1866–1921. Hornung was British, visiting Australia from 1880–1886. He wrote Australian-set crime: *The Amateur Cracksman* (1898) was a collection of stories featuring an educated gentleman named Raffles who is also a criminal/burglar. This was followed by *Raffles, The Further Adventures of the Amateur Cracksman* (1901). He wrote *Stingaree the Gentleman Bushranger* (1905); his squatter thrillers comprised *The Boss of Taroomba* (1894) and *Irralie's Bushranger* (1896).
191. "My Only Murder" (from same-titled 1899 collection).
192. Boothby (1867–1905) wrote adventures and romances but also detective novels. The latter genre includes *The Mystery of the Clasped Hands* (1901). Perhaps his most popular crime work, which was a series, featured "Dr. Nikola" (*A Bid for Fortune, or Dr. Nikola's Vendetta* (1895); *Dr. Nikola* (1896); *Dr. Nikola's Experiment* (1899); and *Farewell Nikola* (1901)). Johnson-Woods spells this as "Nickola" (*Index to Serials*, p. 88). He wrote a story series—*A Prince of Swindlers* (*Pearson's Magazine*, 1897)—which featured the thief, Simon Carne.
193. *Madeline Brown's Murder* (1887); *Dr. Fletcher's Love Story* (1892).
194. *The Hordern Mystery* (1889).
195. *The Jewelled Belt* (1896).
196. *Continent of Mystery*, p. 120.
197. *Bulletin*, 9 March 1889.
198. This also appeared in the *Bulletin Story Book* in 1901.
199. Barbara Baynton, *Bush Studies* (Sydney: Angus and Robertson, 1965), p. 134.
200. Schaffer details this editing in *Women and the Bush* (pp. 153–70).
201. *Continent of Mystery*, pp. 68–9.
202. Published in Melbourne by Kemp and Boyce in 1886, then in London by the "Hansom Cab Publishing Company."
203. Ron Goulart, "Introduction," in *The Great British Detective: 15 Stories Starring England's Unsurpassable Super-Sleuths*, ed. Ron Goulart (New York and Ontario: Mentor, 1982), ix–xiv (p. xi).
204. Symons, *Bloody Murder*, p. 60.
205. "No Name Series": 1877; posthumously reprinted under her own name as a book with "A Whisper in the Dark" in 1889.
206. Originally published as *Madeline Brown's Murderer* (Melbourne: Kemp & Boyce, 1887), later as *The Murder of Madeline Brown*.
207. Schaffer, *Women and the Bush*, p. 22.
208. Adelaide, "Introduction: A Tradition of Women," p. 9.
209. Lynne Spender, *Her Selection: Writings by Nineteenth-Century Australian Women* (Victoria, Australia: Penguin, 1988), p. 1.
210. Lucy Sussex, "What the Mischief Does a Bonnet Want Here? An Introduction to Mary Fortune (Waif Wander)," in *The Fortunes of Mary Fortune*, ed. Lucy Sussex, preface by Judith Brett (Ringwood: Penguin, 1989), xii–xxiii (p. xx).
211. See Bronwen Levy, "Introduction," Miles Franklin *Bring the Monkey* (London: Pandora, 1987), vii–xvii.
212. Knight, *Continent of Mystery*, p. 76.
213. Knight, *Continent of Mystery*, p. 81.

Bibliography

Primary Sources

Adams, Francis. *Madeline Brown's Murder.* Melbourne: Kemp and Boyce, 1887.

Ainsworth, William Harrison. *Jack Sheppard.* 1839.

———. *Rookwood.* 1834.

Alcott, Louisa May. "Enigmas." *Frank Leslie's Illustrated Newspaper*, XVIII, 14, 21 May 1864.

———. *Flower Fables.* 1855.

———. "How I Went Out to Service." *The Independent*, XXVI: 1331, 4 June 1874.

———. In *Louisa May Alcott: Her Life, Letters, and Journals*, ed. Ednah D. Cheney. Boston: Roberts Brothers, 1889.

———. *Little Women.* 1868.

———. Letter, April 1861.In *The Journals of Louisa May Alcott*, ed. Joel Myerson, Daniel Shealy, and Madeleine B. Stern. Boston: Little, Brown, 1989.

———. Letter to Alf Whitman [22 June 1862]. In Madeleine Stern "Introduction," *Behind a Mask: the Unknown Thrillers of Louisa May Alcott*. London: W. H. Allen, 1976, vii–xxviii.

———. Letter to Maria S. Porter, 1874. In *The Selected Letters of Louisa May Alcott*, ed. Joel Myerson, Daniel Shealy, and Madeleine B. Stern. Boston: Little, Brown, 1987.

———. Letter V, II August 1866. MSS, Box II, Houghton Library. Found in Leona Rostenberg "Some Anonymous and Pseudonymous Thrillers of Louisa May Alcott," in *Louisa May Alcott: From Blood and Thunder to Hearth and Home*. Boston: Northeastern University Press, 1998, 73–82.

———. "Love and Self-Love." *Atlantic Monthly*, March 1860.

———. "Memoir of My Childhood." *The Woman's Journal* 19, 26 May 1888.

———. *The Mysterious Key and What It Opened.* 1867; no. 50 in the *Ten Cent Novelettes of Standard American Authors* series. Boston: Elliott, Thomes and Talbot.

———. "Pauline's Passion and Punishment." *Frank Leslie's Illustrated Newspaper*, 3 and 10 January 1863.

———. *The Skeleton in the Closet.* Boston: Elliott, Thomes and Talbot, 1867; reprinted for *Ten Cent Novelettes of Standard American Authors* series, no. 49.

———. "V.V.: or, Plots and Counterplots." In *The Hidden Louisa May Alcott: A Collection of Her Unknown Thrillers*, ed. Madeleine Stern. New York: Avenel Books, 1984. [*The Flag of Our Union*, 4, 11, 18, 25 February 1865.]

———. [A. M. Barnard]. "The Abbot's Ghost or Maurice Treherne's Temptation." *The Flag of Our Union*, XXII; 5, 12, 19, 26 January 1867.

———. [A. M. Barnard]. "Behind a Mask: or, A Woman's Power." London: Hesperus Press, 2004. [*The Flag of Our Union* XXI: 41, 42, 43, 44; 13, 20, 27 October, 3 November 1866.

———. [A. M. Barnard]. "A Marble Woman: or, The Mysterious Model. A Novel of Absorbing Interest." *The Flag of Our Union*, 20, 27 May, 3, 10 June 1865.

———. [Anon]. *A Modern Mephistopheles.* Roberts Brothers of Boston's "No Name Series," 1877.

———. [Anon]. "A Pair of Eyes; or Modern Magic." *Frank Leslie's Illustrated Paper*, 24–31 October 1863.

———. [Anon]. "A Whisper in the Dark." *Frank Leslie's Illustrated Newspaper*, XVI, 6, 13 June 1863; reprinted as *A Modern Mephistopheles and A Whisper in the Dark*. Boston, 1889.

———. [Flora Fairfield]. "The Rival Prima Donnas." *Saturday Evening Gazette*, 1854.

———. [L. M. A.]. "Perilous Play." *Frank Leslie's Chimney Corner*, VIII. 3 February 1869.

Anon. [Percy Fitzgerald?]. "The Woman with the Yellow Hair.—A Tale," in *A Treasury of Victorian Detective Stories*, ed. E. F. Bleiler. New York: Charles Scribner's Sons, 1979, 52–70 [*Dublin University Magazine*, November

1861; reprinted in 1862 as *The Woman with the Yellow Hair and Other Modern Mysteries*].

Anon. *The Boy Detective, or, The Crimes of London*. London, Newsagent's Publishing Co., [1865–6].

———. *Horrid Murder, Committed by a Young Man on a Young Woman*, Charles Hindley, ed., *Curiosities of Street Literature*. London: Seven Dials, 1969 [1871].

———. *The Liverpool Tragedy. Showing How a Father and Mother Barbarously Murdered Their Own Son*, Charles Hindley, ed., *Curiosities of Street Literature*. London: Seven Dials, 1969 [1871].

———. "Pages from The Diary of a Philadelphia Lawyer," "The Murderess." *Burton's Gentleman's Magazine*, 1838, 107–12.

———. *Strange Stories of a Detective; or, Curiosities of Crime, by a Retired Member of the Detective Police*, 1863.

Anonyma [William Stephens Hayward?]. *Revelations of a Lady Detective*. London: Vickers, 1864.

Atkinson, Louisa. *Gertrude the Emigrant: A Tale of Colonial Life by an Australian Lady*, 1857.

Austen, Jane. *Northanger Abbey*. (1818).

B. and R. *Helen Elwood, The Female Detective; or, A Celebrated Forger's Fate*. Chicago: G.W. Ogilvie, 1885.

Banim, John. *Revelations of the Dead-Alive*. London: W. Simpkin and R. Marshall, 1824.

Baynton, Barbara. "The Chosen Vessel." Sydney: Cunningham, undated; as "The Tramp," *Bulletin*, 12 December 1896. *Bush Studies* (Sydney): Angus and Robertson, 1965.

Beale, Anne. *Gladys the Reaper*. London: Bentley, 1860.

Beckford, William. *Vathek*, ed. Robert Lonsdale. Oxford: Oxford University Press, 1970.

Bennett John [Tom Fox]. *Tom Fox; or, The Revelations of a Detective*. London: George Vickers, 1860.

Borlase, J.S. *Temple Bar*, November 1870, 233–4.

———. Letter to a publishing firm in May 1895, regarding a position as "Publisher's Reader or Editor." Found in Folder 1: Papers Relating to Australian Children's Literature, 1883–1988. Terry O' Neill (Manuscript; National Library of Australia, Canberra. MS 7661).

Borlase, James Skipp. *Australian Tales of Peril and Adventure*, told by an Officer of the Victorian Police (London: Warne, 1870).

———. *Bluecap the Bushranger; or, the Australian Dick Turpin*. London: Hogarth House, Fleet Street, [1855?]; *The Boys' Leisure Hour*, 1885.

———. *Daring Deeds: Tales of Peril and Adventure*. London: Warne, 1868.

———. "The Duel in the Bush." *Australian Journal*, 11 November 1865.

———. "Melbourne in 1869." *Temple Bar* 30, September 1870, 225–35.

———. *Memoirs of an Australian Police Officer*, September 1865–February 1866.

———. "The Missing Fingers." *Australian Journal*, 18 November 1865.

———. *Ned Kelly: The Ironclad Australian Bushranger*. London: Alfred J. Isaacs, 1881.

———. *The Night Fossickers of Moonlight Flat and Other Australian Tales of Peril and Adventure*. London: Warne, 1867; republished in Melbourne, 1893.

———. "Pursuing and Pursued." *Australian Journal* 15, 9 December 1865.

———. *Stirring Tales of Colonial Adventure: A Book for Boys*. London: Warne, 1894.

———. [Anon.]. "The Shepherd's Hut; Or, 'Tis Thirteen Years Since," "Memoirs of an 'Australian Police Officer.'" *Australian Journal*, 2 September 1865, 4–7.

Braddon, Mary Elizabeth. *Aurora Floyd*. 1863.

———. *The Black Band; Or, The Mysteries of Midnight*, ed. Jennifer Carnell. Hastings: Sensation, 1998 [*The Halfpenny Journal*, 1 July 1861–23 June 1862].

———. "Devoted Disciple": The Letters of Mary Elizabeth Braddon to Sir Edward Bulwer Lytton, 1862–1873, ed. Robert Lee Wolff. *Harvard Library Bulletin*, 12 (1974), 129–61

———. *Eleanor's Victory*. London: Maxwell, 1863.

———. *Her Convict*. 1907.

———. *La Trace du Serpent*. 1864.

———. *Lady Audley's Secret*. 1862.

———. Letter of March 13, 1904, to Malcolm C. Paton, from *The Robert Lee Wolff Collection of Victorian Fiction*. Quoted in Robert Lee Wolff, *Sensational Victorian: The Life and Fiction of Mary Elizabeth Braddon*. New York and London: Garland, 1979.

———. Letter to her editor at *The Temple Bar*. Quoted in Edmund Yates, *Fifty Years of London Life*. New York: Harper, 1885, 336–7

———. "My First Novel," Appendix in *The Trail of the Serpent*, Mary Elizabeth Braddon, ed. Chris Willis. New York: Modern Library, 2003, 415–27 [Originally "My First Novel: The Trail of the Serpent," *The Idler Magazine* (February–July 1893), III. 19–30].

———. "Ralph the Baliff." *St. James Magazine*, April–June 1861.

———. *Run To Earth*. 1868.

———. *Sir Jasper's Tenant*. London: Maxwell, 1865.

———. *Three Times Dead; or, The Secret of the Heath*. London: W. and M. Clark, Warwick Lane; Beverley: C. H. Empson, Toll-Gavel, n.d. [1860]) [UCLA Sadleir 335: 1854 (?)].

———. "The Trail of the Serpent." *My First*

Book. London: Chatto and Windus, 1894, 109–22.

———. *The Trail of the Serpent*, ed. Chris Willis. New York: Random House, 2003.

———. [Discussing hack work] quoted in Chris Willis, "Mary Elizabeth Braddon," The Literary Encyclopedia, 28 March 2001, http://www.litencyc.com/php/speople.php?rec=true&UID=5053.

Brampton, James. *The New York Detective Police Officer*. Edited by John B. Williams, M.D. Never Before Printed. London: John Maxwell and Company, 122 Fleet Street, 1865.

Brontë, Charlotte. *Jane Eyre*. 1847.

Brown, Charles Brockden. *Arthur Mervyn; or, Memoirs of the Year 1793*. In *Three Gothic Novels: Wieland, Arthur Mervyn, Edgar Huntly*. New York: Library of America, 1998 [1799].

———. *Edgar Huntly, or the Memoirs of a Sleep-Walker*. 1799.

———. Preface to *Edgar Huntly*. In *Three Gothic Novels: Wieland, Arthur Mervyn, Edgar Huntly*. New York: Library of America, 1998.

———. "To the Editor of the Weekly Magazine." *Weekly Magazine*, I, 17 March 1798.

———. *Wieland, or the Transformation*, ed. Fred Lewis Pattee. New York: Harcourt Brace Jovanovich, 1958 [1798].

Browne, Thomas A. [Rolf Boldrewood]. "The Mailman's Yarn," in *In Bad Company*. London: Macmillan, 1901.

———. [Rolf Boldrewood]. *Robbery Under Arms* (London: Remington, 1888)

Burrows, William. *The Adventures of a Mounted Trooper in Australia*. London: Routledge, 1859.

———. *Tales of Adventure by a Log-Fire*. 1859.

Burton, William E. "Leaves from a Life in London." *American Gentleman's Magazine*, 1837.

———. "The Secret Cell." *Burton's Gentleman's Magazine*, 1837, 206–10, 255–61.

Busnach, William, and Henri Chabrillat. *Lecoq: The Detective's Daughter*. London: W. Busnach and H. Chabrillat, 1888. Series: Vizetelly's Sensational Novels, 5. UCLA Sadleir 3709: 2. [*La Fille de M. Lecoq*, 1886].

Clacy, Ellen. *A Lady's Visit to the Gold-Diggings of Australia in 1852–3*, 1853.

Clarke, Marcus. "Democracy in Australia 2," in *A Colonial City: High and Low Life; Selected Journalism of Marcus Clarke*, ed. L. T. Hergenhan. Brisbane: University of Queensland Press, 1972, 388–91 [*Daily Telegraph*, 6 September 1877].

Clarke, Marcus [Andrew Hislop]. "The Doppelganger." *The Australian Monthly Magazine*, July 1866.

———. *His Natural Life*, ed. Stephen Murray-Smith. Middlesex: Penguin Classics, 1987

[*Australian Journal*, March 1870–June 1872; Melbourne: Robertson, 1874].

———. "Lower Bohemia" series. *Australasian*, 1869.

———. *The Mystery of Major Molineux*. 1881.

———. "Night Scenes in Melbourne" series. *Argus*, February–March 1868.

———. "Wonderful! When You Come to Think of It," *Margin* 21 (1989), 2–10 [*Hamilton Spectator*, 26 January 1865].

Clarke, Marcus [Andrew Hislop?]. "Experiences of a Detective by E.C.M." *Australasian*, 11, 18 March 1865.

Clive, Caroline [V]. *Paul Ferroll*. 1855.

———. *Why Paul Ferroll Killed His Wife*. 1860.

Collins, Wilkie. *The Dead Secret*. *Household Words*, January–June 1857.

———. "The Diary of Anne Rodway." *Household Words* XIV, 26 July 1856.

———. "Fie! Fie! Or, the Fair Physician." *The Pictorial World Christmas Supplement* and *The Spirit of the Times*, 23 December 1882, appearing simultaneously.

———. *The Law and the Lady*. 1875.

———. "Mr. Lismore and the Widow." Originally appearing as "She Loves and Lies" in *The Spirit of the Times*, 22 December 1883.

———. *Mr. Policeman and the Cook*. Originally appearing in *The Seaside Library*, 26 January 1881, as "Who Killed Zebedee?"

———. *The Moonstone*. 1868.

———. "My Lady's Money: An Episode in the Life of a Young Lady." Christmas number of the *Illustrated London News*, 1877.

———. *No Name*. 1862.

———. "The Poisoned Meal (From the Records of the French Courts)." *Household Words*, 18 September–2 October 1858. Reprinted as a "Case Worth Looking At" in *My Miscellanies*, 1863.

———. Preface. *Basil*. 1852.

———. "A Stolen Letter." Originally published as "The Fourth Poor Traveller" in the 1854 Christmas Extra number of *Household Words*. Republished as "A Lawyer's Story," *Harper's New Monthly Magazine*, February 1855, X, no. 57, 385–91. Republished in Collins' collection of six short stories, *After Dark*, 1856, as "The Lawyer's Story of a Stolen Letter."

———. *The Twin Sisters*. *Bentley's Miscellany*, March 1851.

———. "Who is the Thief? (Extracted from the Correspondence of the London Police.)" Anon., *Atlantic Monthly*, April 1858; reprinted as "The Biter Bit" in *The Queen of Hearts*, 1859.

———. *The Woman in White*. London: Penguin, 1994.

Cooper, James Fenimore. *The Deerslayer; or The First Warpath*. 1841.
———. *The Last of the Mohicans*. 1826.
———. *The Pathfinder; or, The Inland Sea*. 1840.
———. *The Pioneers; or, The Sources of the Susquehanna*. 1823.
———. *The Prairie: A Tale*. 1827.
Creamer, Hannah Gardner. *Delia's Doctors: or, A Glance Behind the Scenes*. New York: Fowlers and Wells, 1852.
Crowe, Catherine. *Adventures of Susan Hopley; or Circumstantial Evidence*. 3 vols. London: Nicholson, 1841.
———. *Men and Women: or, Manorial Rights*. 3 vols. London: Saunder and Otley, 1843.
———. *The Night Side of Nature*. 1848.
———. *Spiritualism and the Age We Live In*. 1859.
———. *Susan Hopley: or, The Adventures of a Maid Servant*. London: G. Routledge and Co., 1852.
Curtis, Robert. *The Irish Police Officer*. 1861.
Davitt, Ellen. "Black Sheep: A Tale of Australian Life." *Australian Journal*, 25 November 1865–27 January 1866.
———. *Force and Fraud: A Tale of the Bush*. Canberra: Mulini, 1993 [*Australian Journal*, 2 September-18 November, 1865].
———. "Past and Futures: A Tale of the Early Explorers." *Australian Journal*, 18–24 March 1866.
———. "Uncle Vincent; or, Love and Hatred. A Romance of Modern Times." *Australian Journal*, 5 May-23 June 1866.
———. Victorian Public Record Series 892, Unit 32, Special Case 525, 74/9448.
———. Victorian Public Record Series 892, Unit 32, Special Case 525, 75/20722.
———. "The Wreck of Atalanta," *Australian Journal*, 6 April-20 July 1867.
De Boos, Charles. *Fifty Years Ago. An Australian Tale*. 1867.
———. *Mark Brown's Wife*. Canberra: Mulini, 1992 [*Sydney Mail*, 1871].
———. *The Stockman's Daughter*. *The People's Advocate*, 1856.
De Chabrillan, Céleste. *The French Consul's Wife: Memoirs of Céleste de Chabrillan in Gold-Rush Australia*, trans. Patricia Clancy and Jeanne Allen. Melbourne: Miegunyah, 1998.
———. *Les Voleurs d'Or*. Paris: Levy, 1857; trans. Lucy and Caroline Moorehead as *The Gold Robbers*. Melbourne: Sun, 1970.
Defoe, Daniel. *Moll Flanders*. 1722.
Denison, Mary Andrews. *The Mad Hunter; or, the Downfall of the Le-Forests*. New York: Beadle, 1863.
De Quincey, Thomas. *The Collected Writings of Thomas De Quincey*, ed. David Masson. New York: AMS, 1968.
———. *Confessions of an Opium-Eater*. *London Magazine*, 1821.
———. "On Murder Considered as One of the Fine Arts." *Blackwood's Edinburgh Magazine*, 1827.
"Detective Warren." *The Whitechapel Murders: Or, On the Track of the Fiend*. New York: Munro's Publishing House, 1888.
Dickens, Charles. *Barnaby Rudge*. *Master Humphrey's Clock*, 1841.
———. *Bleak House*. Harmondsworth: Penguin, 1971.
———. "The Demeanour of Murderers." *Household Words*, 14 June 1856.
———. "A 'Detective' Police Party." *Household Words* 1:18, 27 July 1850, 409–14; Part II: *Household Words* 1:20, 10 August 1850, 457–60.
———. "Down with the Tide." *Household Words* 6:150, 5 February 1853, 481–85.
———. "Hunted Down." *New York Ledger*, 20 August-2 September 1859.
———. *Martin Chuzzlewit*. 1844.
———. "The Metropolitan Protectives," collaboratively written with W. H. Wills *Household Words* 3:57, 26 April 1851, 97–105.
———. "The Murdered Person." *Household Words*, 11 October 1856.
———. *Oliver Twist*. 1838.
———. "On Duty with Inspector Field." *Household Words* 3:64, 14 June 1851, 265–70.
———. *Our Mutual Friend*. New York: Oxford University Press, 1987.
———. "Three 'Detective' Anecdotes." *Household Words* 1:25, 14 September 1850, 557–80.
Dickens, Charles, and W. H. Hills. "Idiots." *Household Words*, 4 June 1853, 313–17.
———. "Idiots Again." *Household Words*, 15 April 1854, 197–200.
Doyle, Arthur Conan. "The Boscombe Valley Mystery." *Strand Magazine*, October 1891.
———. "The Gully of Bluemansdyke: A True Colonial Story." *London Society*, 1881.
———. Letter to Mary Braddon, 25 July 1909. Robert Lee Wolff Collection of Victorian Fiction. Harry Ransom Humanities Research Center, University of Texas at Austin.
———. *The Memoirs of Sherlock Holmes*. 1894.
———. "The Red-Headed League." *Strand Magazine*, August 1891.
———. "The Reigate Puzzle." In *The Complete Sherlock Holmes*. Harmondsworth: Penguin, 1981, 398–411 [*Strand Magazine*, June 1893].
———. *A Study in Scarlet*. London: Penguin, 1981 [London: Ward Lock, 1887].
Dumas, Alexandre. *Les Mohicans de Paris*. Paris: Cadot, 1856–7, trans. John Lately, *The Mohicans of Paris*. London: Routledge, 1875.
Eliot, George. *Adam Bede*. *Blackwood's*, January 1859.

_____. *The Mill on the Floss.* Harmondsworth: Penguin, 1979 [1860].
Ellis, Edward. *Ruth the Betrayer; or, The Female Spy.* London: John Dicks, 1863.
Felix, Charles. *The Notting Hill Mystery. Once a Week,* 1862–63; novel 1865.
Fielding, Henry. *The History of Tom Jones, a Foundling.* 1749.
Fielding, Henry. *The Life of Mr. Jonathan Wild, the Great.* 1743.
Forrester, Andrew, Jun. "Arrested on Suspicion." In *A Treasury of Victorian Detective Stories,* ed. Everett F. Bleiler. New York: Charles Scribner's Sons, 1979, 15–34.
_____. *The Female Detective.* London: Ward, Lock, and Tyler, 1864.
_____. *Revelations of a Private Detective.* London: Ward and Lock, 1863.
_____. *Secret Service; or, Recollections of a City Detective.* London: Ward Lock, 1864.
Forrester, Mrs. *Fair Women.* London: Hurst and Blackett, 1868.
_____. *From Olympus to Hades.* London: Hurst and Blackett, 1868.
_____. *My Hero.* London: Hurst and Blackett, 1868.
Fortune, Mary Helena. "Adventures of an Australian Mounted Trooper: A Struggle for Life." *Australian Journal,* 3 February 1866), 361–4.
_____. "Clyzia the Dwarf: A Romance." *Australian Journal,* 29 December 1866–30 March 1867.
_____. "The Detective's Album: The Bushranger's Autobiography." *Australian Journal,* September 1871–June 1872: 34–40, 94–99, 154–60, 214–20, 274–81, 334–41, 394–7, 581–4.
_____. "Dora Carleton: A Tale of Australia." *Australian Journal,* 14 July-25 August 1866: 721–4, 739–43, 756–9, 772–5, 788–92, 803–7, 826–7.
_____. "The Secrets of Balbrooke." *Australian Journal,* 1 September-29 December 1866.
_____. [Attributed to Fortune, based on Sussex and Burrows's research]. "The Stolen Specimens." *Australian Journal,* 14 October 1865), 106–8.
Fortune, Mary Helena [W.W.]. "Bloodhound Parker." *Australian Journal,* December 1882, 218–25.
_____. "The Cellarton Mystery." *Australian Journal,* August 1891, 684–91.
_____. *The Detective's Album: Tales of the Australian Police.* Melbourne: Clarson, 1871.
_____. "Dog Bruff's Discovery." *Australian Journal,* July 1902, 420–6.
_____. "The Dog Detective," "Navvies' Tales: Retold by the Boss." *Australian Journal,* May 1873, 473–9.
_____. "The Ghostly White Gate." *Australian Journal,* March 1885, 383–90.
_____. "The Hart Murder." *Australian Journal,* October 1870, 106–11.
_____. "The Illuminated Grave." *Australian Journal,* 12 October 1867, 106–10.
_____. "In the Cellar." *Australian Journal,* 27 April 1867, 549–52.
_____. "Memoirs of an Australian Police Officer" no. V: "The Dead Witness; or, The Bush Waterhole." *Australian Journal,* 20 January 1866, 329–31 [reprinted in *Australian Journal,* February 1909, 113–5].
_____. "To Be Left Till Called For." *Australian Journal,* January 1870, 247–52.
_____. "Towzer's Teeth." *Australian Journal,* February 1891, 331–8.
_____. "Traces of Crime: Memoirs of an Australian Police Officer" no. IV. *Australian Journal,* 2 December 1865), 220–2.
_____. "The Waters of Oblivion." *Australian Journal,* February 1883, 320–7.
_____. "A Woman's Revenge; Or, Almost Lost." *Australian Journal,* February 1871, 333–8.
Fortune, Mary Helena [Waif Wander]. "Bertha's Legacy." *Australian Journal,* 31 March-26 May 1866.
_____. "The Dog Days." *Australian Journal,* April 1869, 482–4.
_____. "How I Spent Christmas," in *The Fortunes of Mary Fortune,* ed. Lucy Sussex. Melbourne: Penguin, 1989, 167–88 [*Australian Journal,* 30 January 1869, 362–5].
_____. "My Friends and Acquaintances." *Australian Journal,* December 1876, 197–9.
_____. "Towzer & Co.," in *The Fortunes of Mary Fortune,* ed. Lucy Sussex. Melbourne: Penguin, 1989, 211–9 [*Australian Journal,* August 1870, 712–3].
_____. "The White Maniac: A Doctor's Tale." *Australian Journal,* 13 July 1867, 725–8.
Gaboriau, Émile. *Le Crime d'Orcival.* 1866–67.
_____. *Le Dossier no. 113.* 1867.
_____. "The Little Old Man of Batignolles," in *A Treasury of Victorian Detective Stories,* ed. Everett F. Bleiler. New York: Charles Scribner's Sons, 1979.
_____. *Monsieur Lecoq.* 1868.
_____. "Who Robbed the Banker's Strong-Box? A Detective's Story." *Illustrated Sydney News,* 18 February 1869.
_____. *The Widow Lerouge: A Novel,* trans. Fred Williams and George A.O. Ernst. Boston: James R. Osgood and Company, 1873 [*L'Affaire Lerouge,* 1866].
Gaskell, Elizabeth. In *Further Letters of Mrs. Gaskell,* ed. John Chapple and Alan Shelston. Manchester: Manchester University Press, 2000.
_____. *The Letters of Mrs. Gaskell,* ed. J.A.V.

Chapple and A. Pollard. Manchester: Mandolin, 1997.

———. "To Charles Eliot Norton, 9 March [1859]." Letter 418, in *The Letters of Mrs. Gaskell*, ed. J.A.V. Chapple and Arthur Pollard. Cambridge: Harvard University Press, 1967.

Gaskell, Elizabeth Cleghorn. "The Crooked Branch." Extra Christmas Number: *All the Year Round*, 13 December 1859, 31–48.

———. "Curious, If True." *Cornhill Magazine*, February 1860, 208–19.

———. "A Dark Night's Work." *All the Year Round*, January–March 1863.

———. "Disappearances." In *Elizabeth Gaskell: Gothic Tales*, ed. Laura Kranzler. London: Penguin, 2004, 1–10 [*Household Words*, 7 June 1851, 246–50].

———. "The Doom of the Griffiths." *Harper's New Monthly Magazine*, January 1858, 220–34.

———. "The Grey Woman," in *Elizabeth Gaskell: Gothic Tales*, ed. Laura Kranzler. London: Penguin, 2004, 287–340 [*All the Year Round*, 5, 12, 19 January 1861, 300–06; 321–8; 347–55.

———. *The Life of Charlotte Brontë*. ed. Elisabeth Jay. Harmondsworth: Penguin Classics, 1997.

———. "Lois the Witch." *All the Year Round*, 8, 15, 22 October 1859, 564–71; 587–97; 609–24.

———. *Mary Barton*. 1848.

———. *The Moorland Cottage and Other Stories*, ed. Suzanne Lewis. Oxford: World's Classics, 1998.

———. *My Lady Ludlow*. Household Words, 19 June-25 September 1858.

———. "The Old Nurse's Story." *A Round of Stories by the Christmas Fire*, in *Household Words*, December 1852, 11–20.

———. "The Poor Clare." In *Elizabeth Gaskell: Gothic Tales*, ed. Laura Kranzler. London: Penguin, 2004, 49–102 [*Household Words* 13, 20, 27 December 1856, 510–15; 532–44; 559–65].

———. "The Squire's Story." *Another Round of Stories by the Christmas Fire*, in *Household Words*, December 1853, 19–25.

Gaspey, Thomas. *The Adventures of George Godfrey*. London: Colburn, 1828.

Godwin, William. "Appendix II: Godwin's Account of the Composition of *Caleb Williams*." In William Godwin *Caleb Williams*, ed. David McCracken. Oxford and New York: Oxford University Press, 1970, 335–41.

———. *Caleb Williams*, ed. David McCracken. Oxford and New York: Oxford University Press, 1998 [1794: *Things As They Are*/1831: *Caleb Williams*].

Goodfellow, Robin [Thomas Harrison]. "Was it Murder? Or, Passages in the Life of a Tasmanian Settler." *The Australian Monthly Magazine*, December 1866–February 1867.

Green, Anna Katharine. *The Gray Madam*. 1899.

———. Interview in Buffalo *Courier*, 25 May 1902.

———. *The Leavenworth Case: A Lawyer's Story*. New York: Dover, 1981.

———. Letter to Hatch, undated. "Author of *The Leavenworth Case*," 161. Found in Ross Nickerson, *The Web of Iniquity*.

———. "Why Human Beings Are Interested in Crime." *American Magazine* 87 (February 1919), 38–39, 82–86.

———. *The Woman in the Alcove*. 1906.

———. *X. Y. Z*. New York: G. P. Putnam's Sons, 1883.

Haggard, H. Rider. *Mr. Meeson's Will*. London: Spencer Blackett, 1888.

Hargrave, Caroline. *The Mysteries of Salem!* 1845.

Hawthorne, Nathaniel. *The Scarlet Letter*. 1850.

Hoffmann, E. T. A. "Mademoiselle de Scudéry" (originally "Das Fraülein von Scuderi," 1820. In *Tales*, ed. Victor Lange. The German Library 26. New York: Continuum, 1982, 101–62.

———. "Der Magnetiseur" [written in 1813 and published in 1814 in vol. 2 of *Fantasiestücke in Callots Manier*].

Hogg, James. *The Private Memoirs and Confessions of a Justified Sinner*. 1824.

Hornung, E.W. *Irralie's Bushranger*. London: New Vagabond Library, 1896.

———. *Stingaree*. London: Chatto and Windus, 1905.

Howitt, William. *Tallangetta: The Squatter's Home*. London: Longman, 1857.

Hume, Fergus. *Madame Midas*. London: Hansom Cab Publishing Co., 1888.

———. *Miss Mephistopheles*. London: White, 1980.

———. *The Mystery of a Hansom Cab*. Melbourne: Kemp and Boyce, 1886; London: Hogarth, 1985.

"I Have Been Hanged and Am Alive." *Illustrated Sydney News*, 16 August 1867.

An Inquiry into Destitution, Prostitution and Crime in Edinburgh. James G. Betram and Co., 1851. Reprinted as *Low Life in Victorian Edinburgh by a Medical Gentleman*. Edinburgh: Paul Harris, 1980.

Irving, Washington. "The Legend of Sleepy Hollow." 1820.

James, P.D. *An Unsuitable Job for a Woman*. London: Faber and Faber, 1972.

Judson, Edward Zane Carroll [Ned Buntline]. *The Mysteries and Miseries of New York*. 1848.

Ka. "The Adventure of the Tomato on the Wall." *The Student*, Edinburgh University Magazine, 1894.
———. "The Identity of Miss Angela Vespers." *The Student*, Edinburgh University Magazine, 1894.
Kingsley, Henry. *The Recollections of Geoffry Hamlyn.* London: Macmillan, 1859.
Lang, John. *Barrington.* 1859.
———. *The Forger's Wife.* Sydney: John Ferguson, 1979 [London: Ward Lock, 1855].
———. *Frederick Charles Howard.* Canberra: Mulini, 1990 ["Legends of Australia." Sydney: Tegg, 1842].
———. "The Ghost on the Rail." *Household Words*, 5 March 1853.
———. [attributed to John Lang]. *Lucy Cooper.* London: *Sharpe's Magazine*, 1846.
———. *The Secret Police.* 1859.
———. *Violet the Dansuese: A Portraiture of Human Passions and Character.* London: Colburn, 1836 [Canberra: Mulini, 2006].
Lawson, Henry. *The Drover's Wife.* Bulletin, 23 July 1892.
"Leaves from a Surveyor's Field Book." "A Night in a Sly Grog-Shop" no IV. *The Australian: A Monthly Magazine*, April 1880–September 1880, 555.
Le Fanu, J. Sheridan. *Checkmate.* 1871.
———. [Anon.]. "The Murdered Cousin." In *Ghost Stories and Tales of Mystery.* Dublin: 1851.
Leakey, Caroline [Oliné Keese]. *The Broad Arrow: Being Passages from the History of Maida Gwynnham, A Lifer.* London: Bentley, 1859.
Lewis, Leon. "Found Guilty; or, the Hidden Crime." *New York Ledger*, 1878.
Lewis, Matthew. *The Monk.* 1796.
Lytton, Bulwer. *Eugene Aram.* 1832.
———. *Lucretia, Or the Children of the Night.* 1846.
———. *Paul Clifford.* 1830.
———. *Pelham; or the Adventures of a Gentleman.* 1828.
———. *A Strange Story. All the Year Round*, August 1861–March 1862.
Martel, Charles. *The Detective's Note-Book.* London: Ward and Lock, 1860.
———. *The Diary of an Ex-Detective.* 1860.
McGovan, James. *Brought to Bay; or, Experiences of a City Detective.* 1878.
———. *Hunted Down or Recollections of a City Detective.* 1878.
McLevy, James. *Curiosities of Crime in Edinburgh.* Edinburgh: William P. Nimmo, 1861.
———. *The Sliding Scale of Life: or, Thirty Years' Observations of Falling Men and Women in Edinburgh.* Edinburgh: William P. Nimmo, 1861.

Meade, L.T., and Robert Eustace. "The Secret of Emu Plain." *Cassell's Magazine*, December 1898.
———. *The Sorceress of the Strand.* Strand Magazine, October 1902–March 1903.
Müllner, Adolph. "Der Kaliber" (1828). "The Caliber," *Early German and Austrian Detective Fiction: An Anthology*, trans. and ed. Mary W. Tannert and Henry Kratz. Jefferson, NC, and London: McFarland, 1999, 10–53
The Newgate Calendar or Malefactors' Bloody Register. New ed. chosen and arranged B. Laurie. London: T. Werner Laurie, 1932.
Oliphant, Margaret. *Beleaguered City: A Story of the Seen and the Unseen.* London: Macmillan, 1880.
O'Reilly, J.B. *Moondyne: A Tale of the Underworld.* Boston: Robertson, 1879.
Pastor, Tony. "Old Sleuth, the Detective; or, the Bay Ridge Mystery." The Fireside Companion, 10 June–14 October 1872.
Pinkerton, A.F. *The Whitechapel Murders; Or, An American Detective in London.* Chicago: Laird and Lee, 1888.
Pinkerton, Allan. *The Expressman and the Detective.* 1875.
———. *The Gypsies and the Detective.* 1879.
Pirkis, Catherine Louisa. *The Experiences of Loveday Brooke, Lady Detective.* 1894.
Poe, Edgar Allan. "The Cask of Amontillado." In Edgar Allan Poe, *Selected Tales.* London and New York: Penguin, 1994 [*Godey's Lady's Book*, November 1846].
———. "How to Write a Blackwood Article." *American Museum*, November 1838.
———. "The Murders in the Rue Morgue." In *Selected Tales.* London and New York: Penguin, 1994 [*Graham's Lady's and Gentleman's Magazine*, April 1841].
———. "The Mystery of Marie Rogêt." In *Selected Tales.* London and New York: Penguin, 1994 [*Snowden's Ladies Companion*, 1842–3].
———. "The Purloined Letter." In *Selected Tales.* London and New York: Penguin, 1994 [*The Gift*, 1845].
———. "The Raven." *The New York Evening Mirror*, 29 January 1845.
———. "Tales of the Arabesque and Grotesque." 1840
———. "The Tell Tale Heart." In *Selected Tales.* London and New York: Penguin, 1994 [*The Pioneer*, 1843].
———. "Thou Art the Man." *Godey's Lady's Book.* 1844.
Praed, Rosa. *Outlaw and Lawmaker.* 1893.
Radcliffe, Ann. *The Italian.* 1797.
———. *The Mysteries of Udolpho.* 1794.
———. *A Sicilian Romance.* 1792.

Reach, Angus Bethune. *Clement Lorimer: Or, The Book with the Iron Clasps. Morning Chronicle*, 1848–9.
Reade, Charles. *Griffith Gaunt, or Jealousy. Argosy*, December 1865–November 1866.
The Reminiscences of Detective-Inspector Christie (related by J. B. Castieau). Melbourne: Robertson and Co., 1913.
Reynolds, G.W.M. *Robert Macaire in England.* 1840.
____. *The Mysteries of London.* 2 vols. London: George Vickers, 1846 [serial George Vickers, 1844–45].
Richmond, Tom. *Richmond: Scenes in the Life of a Bow Street Runner. Drawn Up from his Private Memoranda.* New York: Dover, 1976 [March 1827].
Roberts Rinehart, Mary. *Miss Pinkerton.* New York: Dell, 1964.
Rowcroft, Charles. *The Bushranger of Van Diemen's Land.* London: Smith and Elder, 1846.
____. *Tales of the Colonies.* London: Smith and Elder, 1843.
Russell, William. *Autobiography of an English Detective.* 1863.
____. *The Experiences of a Real Detective.* 1862.
____. *Leaves from the Diary of a Law Clerk.* London: J. and C. Brown, 1857.
Russell, William [Waters]. "Flint Jackson." *Chambers's Edinburgh Journal*, 15 November 1851, 306–11.
____. "Mary Kingsford." *Chambers's Edinburgh Journal*, 3 May 1851, 274–9.
____. "Murder under the Microscope." In *A Treasury of Victorian Detective Stories,* ed. Everett F. Bleiler. New York: Charles Scribner's Sons, 1979, 35–51 [*Experiences of a Real Detective,* London: Ward and Lock, 1862].
____. "One Night in a Gaming-House." In *Recollections of a Detective Police-Officer.* London: W. Clover, 1856, 9–28.
____. "The Revenge." *Chambers's Edinburgh Journal*, 9 November 1850, 294–8.
____. "The Twins." *Chambers's Edinburgh Journal*, 22 June 1850, 387–90.
____. *The Recollections of a Policeman.* New York: Cornish, Lamport and Co., 1852, http://books.google.co.uk/books?id=joEvAAAAMAAJ&dq=Recollections+of+a+Policeman&printsec=frontcover&source=bl&ots=8ud7KmFx_V&sig=3nOaFX2U5PJzJpMLIdlh4M3Jk64&hl=en&ei=NXFQS5uJDNW14QaG-MCOCQ&sa=X&oi=book_result&ct=result&resnum=1&ved=0CAcQ6AEwAA#v=onepage&q=&f=false.
Savery, Henry. *Quintus Servinton.* Hobart: Melville, 1831.
Sedgwick, Catharine Maria. *Hope Leslie: or,* *Early Times in Massachusetts.* New Brunswick, NJ: Rutgers University Press, 1987 [1827].
Shelley, Mary. *Frankenstein.* 1818.
____. "Rodger Dodsworth: The Reanimated Englishman." 1826.
Sims, George R. *Dorcas Dene, Detective: Her Adventures.* London: F.V. White, 1897.
Smith, Charlotte. *Emmeline, or the Orphan of the Castle.* 1788.
Spofford, Harriet Prescott. "The Amber Gods." *Atlantic Monthly,* January–February 1860.
____. "Circumstance." *Atlantic Monthly,* May 1860.
____. "In a Cellar." In *"The Amber Gods" and Other Stories,* ed. Alfred Bendixen. New Brunswick, NJ, and London: Rutgers University Press, 1989 [*Atlantic Monthly,* February 1859].
____. "In the Maguerriwock." In *"The Amber Gods" and Other Stories,* ed. Alfred Bendixen. New Brunswick, NJ, and London: Rutgers University Press, 1989 [*Harper's New Monthly Magazine,* August 1868].
____. "Mr. Furbush." *Harper's New Monthly Magazine,* April 1865, 623–6.
____. *New-England Legends.* Boston: James R. Osgood and Company, 1871.
____. *Sir Rohan's Ghost: A Romance.* Boston: J.E. Tilton and Company, 1860.
Stowe, Harriet Beecher. *Uncle Tom's Cabin.* 1852.
Sue, Eugène. *Les Mystères de Paris. Journal des Débats,* June 1842–October 1843; in English in 1845.
Thackeray, William Makepeace. *Catherine: A Story. Fraser's Magazine,* May 1839–February 1840.
Thomson, Henry. "Le Revenant." *Blackwood's Edinburgh Magazine,* 23: 124, April 1827, 409–16.
Trollope, Frances. *Domestic Manners of the Americans.* 1832.
____. *Hargrave; or, The Adventures of a Man of Fashion.* 1843.
____. *Jessie Phillips: A Tale of the Present Day.* London, 1843.
____. *The Life and Adventures of Jonathan Jefferson Whitlaw: Or Scenes on the Mississippi.* 1836.
____. *Michael Armstrong: The Factory Boy.* Colburn: 1839.
____. *The Refugee in America: A Novel.* 2 vols. London: Whittaker, Treacher, and Co., 1832.
A True Relation of a Horrid Murder Committed Upon the Person of Thomas Kidderminster. London, 1688.
Tucker, James [?]. *Ralph Rashleigh.* Sydney: Angus and Robertson, 1952.
Turner, Bessie. *Circumstantial Evidence.* New York: Norman L. Munro, 1884.

Turner, Bessie A. *A Woman in the Case: A Story*. Toronto: Bedford, 1875.

Umsted, Mrs. Lillie Devereux. *Southwold: A Novel*. New York: Rudd and Carleton, 1859.]

Van Deventer, Emma [Lawrence L. Lynch]. *Against Odds*. Chicago: Rand McNally, 1894.

Van Deventer, Emma Murdoch [Lawrence L. Lynch, "Ex-Detective."]. *Shadowed by Three*. Chicago: Donnelley, Gassette and Loyd, 1879].

Van Deventer, Emma Murdoch [Lawrence L. Lynch, of the Secret Service]. *Madeline Payne, the Detective's Daughter*. Chicago: Alex T. Loyd and Co, 1884 [1883].

Victor, Metta. *The Backwoods' Bride: A Romance of Squatter Life*. New York: Beadle, 1860.

———. *The Dead Letter: An American Romance*. Durham, NC, and London: Duke University Press, 2003 [*Beadle's Monthly: A Magazine of To-Day*, January–September 1866].

———. *The Dime Recipe Book, Embodying the Latest and Best Information for the American Household*. New York and Buffalo: Beadle, 1859.

———. "Dora Elmyr's Worst Enemy; or, Guilty or Not Guilty." 1878.

———. *The Figure Eight; or, The Mystery of Meredith Place*. New York: Beadle, 1869.

———. *The Housewife's Manual*. New York: Beadle, 1865.

———. *Maum Guinea and Her Plantation "Children," or, Holiday-Week on a Louisiana Estate: A Slave Romance*. New York: Beadle and Co., 1861.

———. *Mormon Wives; a Narrative of Facts Stranger Than Fiction*. New York: Derby and Jackson, 1856.

———. *Passing the Portal: Or, A Girl's Struggle. An Autobiography*. New York: G.W. Carleton, 1876.

———. "The Skeleton at the Banquet." In *Stories and Sketches by our Best Authors*. Boston: Lee, 1867, 9–33.

———. *Too True: a Story of To-Day*. New York: Putnam's Monthly Magazine, 1868.

Vidocq, Eugène François. *Mémoires*. 1827–1828; 1829 trans. to English.

Vogan, A.J. *The Black Police*. London: Hutchinson, 1890.

Walpole, Horace. *The Castle of Otranto*. 1764.

Walstab, George. "Confessed at Last." *Australian Journal*, 25 April–8 August 1868.

———. *Looking Back*. Calcutta: The Englishman Press, 1864.

Warren, Samuel. "Bigamy or No Bigamy." *Chambers's Edinburgh Journal*, 16 November 1850, 307–11.

———. "The Confessions of an Attorney" series. *Chambers's Edinburgh Journal*, October 1850–June 1852.

———. "The Experiences of a Barrister" series. *Chambers's Edinburgh Journal*, 1849–50; collected in book form in 1856.

———. "The Life Assurance" [later "The Life Policy" in the American edition in 1859].

———. "Passages from the Diary of a Late Physician" series. *Blackwood's Edinburgh Magazine*, 1830–37.

———. [Anon., attributed to Warren]. "The Contested Marriage." In *The Experiences of a Barrister*. New York: Arno, 1976 [*Chambers's Edinburgh Journal*, 31 March 1849, 193–97].

Wells, Thomas. *Michael Howe, the Last and Worst of the Tasmanian Bushrangers*. Hobart: Bent, 1818.

Wheeler, Edward L. *New York Nell, the Boy-Girl Detective*. New York: Beadle and Adams, 1886.

Whitworth, Robert. *Mary Summers: A Romance of the Australian Bush*. Canberra: Mulini, 1994 [*Australian Journal*, 1865].

Wilson, F. S. "Broken Clouds! An Original Australian Tale." *Illustrated Sydney News*, 16 May 1866–August 1867.

Winstanley, Eliza. *For Her Natural Life: A Tale of the 1830s*. Canberra: Mulini, 1992) [London, *Bow Bells*, July–December 1876].

———. *Shifting Scenes in Theatrical Life*. 1859.

Wood, Ellen (Mrs. Henry). *Dene Hollow*. London: Macmillan, 1911 [*Argosy*, January–December, 1871].

———. *East Lynne*. London: William Clowes and Sons Ltd., 1890 [*New Monthly Magazine*, January 1860–September 1861].

———. "Losing Lena." *Johnny Ludlow First Series*. London: Macmillan, 1912, 1–15.

———. *Mrs. Halliburton's Troubles*. 1862.

———. "Reality or Delusion?" *Johnny Ludlow First Series* collection. 1874 [*Argosy*, December 1868].

———. *Roland Yorke*. 1869.

———. "Sandstone Torr." *Johnny Ludlow Fourth Series*. 1890.

———. Preface to *Johnny Ludlow: First Series*, 5th ed. London: Bentley, 1883.

Yates, Edmund Hodgson. *Black Sheep! All the Year Round*, 25 August 1866–30 March 1867; Tinsley, 1867, 3 vols.

Secondary Sources, Scholarship and Criticism

"Aboriginals Roasting Emu" (illustration). *Illustrated Sydney News* 37, 16 September 1867, 229.

The Academy. 2 May, 1874 [on the "Johnny Ludlow" stories].

Ackland, Michael. "Introduction." In *The Pen-*

guin Book of Nineteenth-Century Australian Literature. Melbourne: Penguin, 1993, xiii–xxvii.
Adair, Gilbert. Foreword. In E.T.A. Hoffmann, Mademoiselle de Scudéri. London: Hesperus Classics, 2002.
Adelaide, Debra. "Introduction: A Tradition of Women." In A Bright and Fiery Troop: Australian Women Writers of the Nineteenth Century, ed. Debra Adelaide. Ringwood: Penguin, 1988, 1–14.
Adler, Jeremy. "Introduction." In E.T.A. Hoffmann, The Life and Opinions of the Tomcat Murr. London and New York: Penguin, 1999, vii–xxxii.
Advertisement for Ellen Davitt's "Bertha's Legacy." Australian Journal, 24 March 1866, 479.
Advertisement for F. S. Wilson's "Broken Clouds! An Original Australian Tale." Illustrated Sydney News, 16 May 1866, 2.
Albinski, Nan Bowman. "Marcus Clarke's First Australian Publication." Margin 21 (1989): 1.
Alburger, Mary Anne. "Afterword: The Mysterious Maister McGovan." In James McGovan, The McGovan Casebook: Experiences of a Detective in Victorian Edinburgh. Edinburgh: Mercat, 2003, 195–98.
Alcott, A. Bronson. Letter to Mrs. A. Bronson Alcott. [St. Louis, November 30, 1866]. In The Letters of A. Bronson Alcott, ed. Richard L. Herrnstadt. Ames: Iowa State University Press, 1969.
Allan, J. Alex. The Old Model School: Its History and Romance 1852–1904. Melbourne: Melbourne University Press, 1934.
Allen, Michael. Poe and the British Magazine Tradition. New York: Oxford University Press, 1969.
Altick, Richard. Evil Encounters: Two Victorian Sensations. London: John Murray, 1987.
The American Women's Dime Novel Project. http://chnm.gmu.edu/dimenovels/authors/victor.html.
"Anna K. Green Dies; Noted Author, 88." New York Times, 12 April 1935, 23
"Anna Katharine Green" [Obit.]. Publisher's Weekly 127, 20 April 1935.
Anon. Advertisement for The Dead Letter. The Saturday Journal, 2 July 1881.
_____. Bulletin. 9 March 1889.
_____. "Central Criminal Court: Trial of Mrs. Wilson for Murder." The Times, 29 September 1862.
_____. "Current Fiction: Shadowed by Three. By Lawrence L. Lynch. Chicago: Donnelley, Gassette & Loyd. $1.50." The Literary World: A Fortnightly Review of Current Literature, Vol. XI, March 27, 1880, 111–2.

_____. "Detectives in Fiction and in Real Life." Saturday Review, 11 June 1864, 712–3.
_____. "The Efficiency and Defects of the Police." Saturday Review, 15 February 1868.
_____. "Harriet Prescott Spofford: A Flaming Fire Lily Among the Pale Blossoms of New England." The Critic, N.S. XVI, 56, August 1, 1891.
_____. "Miss Braddon. The Illuminated Newgate Calendar." The Eclectic Review, January 1868.
_____. "The Modern Novel." Chambers's Journal, April 1895.
_____. On Frances Trollope. [The New Monthly Magazine, 1839] Quoted in F.E. Trollope, Frances Trollope: Her Life and Literary Work from George III to Victoria. London, 1895, 4.
_____. [On the Newgate novel]. Punch, 7 August 1841.
_____. "Our American Letter." Bookman 37 (1910).
_____. "Photography." Household Words, March 19, 1853, 54–63.
_____. "Recent Novels and Tales" [about Richmond]. Monthly Review, n.s., 5 June 1827.
_____. Review of Catherine Crowe's Men and Women: Or, Manorial Rights. The Examiner, 16 December 1843.
_____. Review of Frances Trollope's The Refugee. Quarterly Review 48 (1832), 507–13.
_____. Review of Wilkie Collins' Armadale. Westminster Review, October 1866.
_____. Sydney's Cosmos Magazine (1894) in The Anthology of Colonial Australian Crime Fiction, ed. Ken Gelder and Rachael Weaver. Melbourne: Melbourne University Press, 2008.
_____. "The Secret of Mrs. Henry Wood." The Times, 13 April 1914.
_____. "Undetected Crime." Saturday Review, 1856.
"Answers to Correspondents." Australian Journal, August 1873.
Ascari, Maurizio. A Counter-History of Crime Fiction: Supernatural, Gothic, Sensational. Basingstoke and New York: Palgrave Macmillan, 2007.
Ashley, Michael. "Introduction: Equals in Horror." In Mrs. Gaskell's Tales of Mystery and Horror, ed. Michael Ashley. London: Victor Gollancz, 1978, 11–5.
Ashley, Robert P. "Wilkie Collins and the Detective Story." Nineteenth-Century Fiction 6 (1951), 47–60.
Askew, M., and B. Hubber. "The Colonial Reader Observed: Reading in its Cultural Context." In The Book in Australia: Essays Towards a Cultural and Social History, ed. D. Borchardt and W. Kirsop, Centre for Bibli-

ographical and Textual Studies. Melbourne: Monash University, 1988.

The Australian Women's Register. http://www.womenaustralia.info/biogs/PR00393b.htm.

Ayres, Brenda. "*Apis Trollopiana*: An Introduction to the Nearly Extinct Trollope." In *Frances Trollope and the Novel of Social Change*, ed. Brenda Ayres. Westport, CT: Greenwood, 2002, 1–10.

Baker, A.W. *Death Is a Good Solution: The Convict Experience in Early Australia*. Brisbane, Australia: Queensland University Press, 1984.

Barthes, Roland. *Camera Lucida: Reflections on Photography*, trans. Richard Howard. London: Vintage, 2000 [1980].

Barton, G.B. *Literature in New South Wales*. Sydney: Thomas Richards, Govt. Printer, 1866.

Barzun, Jacques, and Wendell Hertig Taylor. *A Catalogue of Crime*. New York, San Francisco, and London: Harper and Row, 1971.

Baym, Nina. *Feminism and American Literary History*. New Brunswick, NJ: Rutgers University Press, 1992.

_____. *Women's Fiction: A Guide to Novels by and about Women in America, 1820–1870*, 2d ed. Urbana: University of Illinois Press, 1993.

Baynton, Barbara. *Bush Studies*. Sydney: Angus and Robertson, 1965.

Bedell, Jeanne F. "Amateur and Professional Detectives in the Fiction of Mary Elizabeth Braddon." *Clues: A Journal of Detection* 4 (1983), 19–3.

Bendixen, Alfred. "Introduction." In Harriet Prescott Spofford, "*The Amber Gods*" *and Other Stories*, ed. Alfred Bendixen, New Brunswick, NJ, and London: Rutgers University Press, 1989, ix–xxxvii.

Bentham, Jeremy. *Panopticon; or, the Inspection House*. London: T. Payne, 1791.

Bentley, Richard, and Son. *The Archives of Richard Bentley and Son, 1829–1898*. Cambridge: Chadwyck-Healey, 1976 [British Library Archives of British and American Publishers: Bentley Archives].

Berglund, Birgitta. "Desires and Devices: On Women Detectives in Fiction." In *The Art of Detective Fiction*, ed. Warren Chernaik. New York: St. Martin's, 2000, 138–52.

Bergmann, G.F.J. "John Harris, the First Australian Policeman." *Australian Jewish Historical Society Journal* (December 1959) V.

Bird, Delys, and Brenda Walker. "Introduction." In *Killing Women: Rewriting Detective Fiction*, ed. Delys Bird (Sydney: Angus and Robertson, 1993), 1–60.

Birkhead, Edith. *The Tale of Terror: A Study of the Gothic Romance*. New York, 1920.

Birkenhead, Lord. "Introduction." *Ralph Rashleigh*. London: Cape, 1929.

Blake, Fay M. "Lady Sleuths and Women Detectives." *Turn-of-the-Century Women* 3 (1986), 29–42.

Bleiler, Everett F. On Ellen Wood's *Johnny Ludlow* story "Going Through the Tunnel." In *A Treasury of Victorian Detective Stories*, ed. Everett F. Bleiler. New York: Charles Scribner's Sons, 1979, 173.

Bloom, Clive, Brian Docherty, Jane Gibb and Keith Shand, ed. *Nineteenth-Century Suspense: From Poe to Conan Doyle*. Basingstoke: Macmillan, 1988.

Bode, Rita. "A Case for the Re-covered Writer: Harriet Prescott Spofford's Early Contributions to Detective Fiction." *Clues: A Journal of Detection* 26 (2008), 23–36.

Borges, Jorge Luis. "The Detective Story," trans. Alberto Manguel. *Descant* 51 (1985), 15–24.

Boyd, Anne E. *Writing for Immortality: Women Writers and the Emergence of High Literary Culture in America*. Baltimore: Johns Hopkins University Press, 2004.

Bredesen, Dagni. "Conformist Subversion: Ambivalent Agency in *Revelations of a Lady Detective*." *Clues: A Journal of Detection*, 25:1 (2006), 30–32.

_____. Introduction. *The First Female Detectives: The Female Detective (1864) and Revelations of a Lady Detective (1864)*. Ann Arbor, MI: Scholars Facsimiles and Reprints, 2010.

_____. "Investigating the Female Detective in Victorian and Edwardian Fiction." *Nineteenth-Century Gender Studies* 3 (2007), http://www.ncgsjournal.com/issue31/bredesen.htm.

Browne, Stephenson. *The New York Times* Saturday Review of Books, 22 January 1910.

Bunker, Gary L. "The Art of Condescension: Postbellum Caricature and Woman Suffrage." *Common-Place: The Interactive Journal of Early American Life* 7:3 (April 2007), n.pag. http://www.common-place.org/vol-07/no-03/bunker/.

Burke, Edmund, ed. *The Annual Register or a View of the History, and Politics, of the Year 1840*. London: Rivington, 1841.

Buurma, Rachel Sagner. "Anonyma's Authors." *SEL: Studies in English Literature 1500–1900* 48 (2008), 839–48.

Campbell, Ronald G. *The First Ninety Years: The Printing House of Massina, Melbourne, 1859 to 1949*. Melbourne: Massina, 1949.

Carnell, Jennifer. http://www.sensationpress.com/maryelizabethbraddontheblackbandimages.htm.

_____. "Introduction." In Mary Elizabeth Braddon, *The Black Band; or, the Mysteries of Midnight*, ed. Jennifer Carnell. Hastings: Sensation, 1998, vii–xxv.

_____. *The Literary Lives of Mary Elizabeth*

Braddon: A Study of her Life and Work. Hastings: Sensation, 2000.

Casey, Ellen Miller. "Edging Women Out? Reviews of Women Novelists in the *Athenaeum*, 1860–1900." *Victorian Studies: An Interdisciplinary Journal of Social, Political, and Cultural Studies* 39:2 (1996), 151–71.

Cassiday, Bruce, ed. *Roots of Detection: The Art of Deduction Before Sherlock Holmes.* New York: Frederick Ungar, 1983.

Cassuto, Leonard. *Hard-Boiled Sentimentality: The Secret History of American Crime Stories.* New York: Columbia University Press, 2009.

Cecil, Lord David. *Early Victorian Novelists: Essays in Revaluation.* London: Constable, 1934.

Chapple, J.A.V., and Arthur Pollard, ed. *The Letters of Mrs. Gaskell.* Manchester: Mandolin, 1997.

Chisholm, A.R. "Céleste de Chabrillan and the Gold Rush." *Meanjin Quarterly* XXVIII (1969), 197–201.

Clancy, Patricia, and Jeanne Allen. "Introduction." Céleste de Chabrillan, *The French Consul's Wife: Memoirs of Céleste de Chabrillan in Gold-Rush Australia*, trans. Patricia Clancy and Jeanne Allen. Melbourne: Miegunyah, 1998, 1–13.

Clarke, Patricia. *Pen Portraits: Women Writers and Journalists in Nineteenth Century Australia.* London: Pandora, 1988.

Clinton, Catherine. *The Other Civil War: American Women in the Nineteenth Century.* New York: Hill and Wang, 1986.

Cobbe, Frances Power. "Criminals, Idiots, Women and Minors." *Fraser's Magazine* 78 (December 1868), 777–94.

Cooper, John, and B.A. Pike, ed. *Detective Fiction: The Collector's Guide.* Somerset, UK: Barn Owl, 1988.

Coultrap-McQuin, Susan. *Doing Literary Business: American Women Writers in the Nineteenth Century.* Chapel Hill and London: University of North Carolina Press, 1990.

Cox, Michael. "Introduction." In *Victorian Detective Stories: An Oxford Anthology*, ed. Michael Cox. Oxford and New York: Oxford University Press, 1992, iv–xxvi.

Cox, Michael, and R.A. Gilbert, ed. *The Oxford Book of Victorian Ghost Stories.* Oxford: Oxford University Press, 1991.

Craig, Patricia, and Mary Cadogan. *The Lady Investigates: Women Detectives and Spies in Fiction.* Oxford: Oxford University Press, 1986.

Crary, Jonathan. *Techniques of the Observer: On Vision and Modernity in the Nineteenth Century.* Cambridge, MA: MIT Press, 1990.

Crittenden, Victor. *Australian Nineteenth Century Literature in Print*, Broadsheet 2 (1991): 2.

_____. "Introduction." John Lang, *Frederick Charles Howard*. Canberra: Mulini, 1990.

_____. "Introduction." *Lucy Cooper*. Canberra: Mulini, 1992, ii–iv.

_____. "Introduction." Robert Whitworth, *Mary Summers: A Romance of the Australian Bush*. Canberra: Mulini, 1994, unpaginated.

_____. "The Stockman's Daughter: Charles De Boos' Bushranger Novel of 1856." *Margin* 77 (April 2009), unpaginated.

Crowquill, Alfred. "Outlines of Mysteries." *Bentley's Miscellany*, 17 May 1845.

David, Deirdre, ed. *The Cambridge Companion to the Victorian Novel.* Cambridge: Cambridge University Press, 2001.

"'The Dead Witness,' by W.W. and W. W." *The Body Dabbler: An Occasional Newsletter Concerned Especially with Australasian Crime Fiction* 11 (1989), 1–2.

Denning, Michael. *Mechanic Accents: Dime Novels and Working-Class Culture in America.* London and New York: Verso, 1987.

De Tocqueville, Alexis. *Democracy in America*, trans. Henry Reeve, Esq, 4th ed. Cambridge: Sever and Francis, 1864, II.

Dickens, Charles. *The Letters of Charles Dickens*, ed. Graham Storey and Kathleen Tillotson, 10 vols. Oxford: Clarendon Press, 1995, VIII.

Dickinson, Emily. In Martha Dickinson Bianchi, *Emily Dickinson Face to Face*. Boston: Houghton, Mifflin, 1932.

_____. Letter to Sue Gilbert Dickinson. In T.W. Higginson, "Emily Dickinson's Letters." *Atlantic Monthly*, LXVIII, October 1891.

"Disabled Sleuths." *The Oxford Companion to Crime and Mystery Writing*, ed. Rosemary Herbert. New York and Oxford: Oxford University Press, 1999, 121–2.

Dixson, Miriam. *The Real Matilda: Woman and Identity in Australia 1788 to 1975.* Harmondsworth: Penguin, 1976.

Docherty, Brian, ed. *American Crime Fiction: Studies in the Genre.* New York: St. Martin's, 1988.

Dolin, Tim. "First Steps Toward a History of the Mid-Victorian Novel in Colonial Australia." *Australian Literary Studies* 22 (2006), 273–93.

Donnelly, Mabel Collins. *The American Victorian Woman: The Myth and the Reality.* New York, Westport, CT, and London: Greenwood, 1986.

Donnelly, Thomas. "Crime and its Detection." *Dublin University Magazine*, May 1861.

Douglas, Ann. "Introduction." Louisa May Alcott, *Little Women*. New York: NAL, 1983, vii–xxvii.

_____. "Mysteries of Louisa May Alcott." *New York Review of Books* XXV (28 September 1978), 61–3.

Dove, George N. *The Reader and the Detective Story.* Bowling Green, OH: Bowling Green State University Popular Press, 1997.

Dresner, Lisa M. *The Female Investigator in Literature, Film, and Popular Culture.* Jefferson, NC: McFarland, 2007.

Drexler, Peter. "Mapping the Gaps: Detectives and Detective Themes in British Novels of the 1870s and 1880s." In *The Art of Murder: New Essays on Detective Fiction,* ed. H. Gustav Klaus and Stephen Knight. Tübingen: Stauffenburg, 1998, 77–89.

DuBose, Martha Hailey. *Women of Mystery: The Lives and Works of Notable Women Crime Novelists.* New York: Thomas Dunne, 2000.

Editor. "The Woman Who Dared." *New York Daily Graphic,* June 5, 1873.

_____. "The Wreck of Atalanta." *Australian Journal,* 23 March 1867.

Edwards, Lee R., and Arlyn Diamond, ed. *American Voices, American Women.* New York: Avon, 1973.

Elbert, Monika M. "Introduction." In *Separate Spheres No More: Gender Convergence in American Literature, 1830–1930,* ed. Monika M. Elbert. Tuscaloosa and London: University of Alabama Press, 2000, 1–25.

Eliot, George. Letter to John Blackwood, 11 September 1860, in *The George Eliot Letters,* ed. G. Haight. New Haven: Yale University Press, 1954, IV, 309–10.

Eliot, T.S. "Wilkie Collins and Charles Dickens." In *Selected Essays, 1917–32.* London: Faber, 1932.

Ellen, Mary. "Writing Anglo-Australian History: Writing the Female Convict." *Women's Writing* 5:2 (1998), 253–64.

Elliott, Dorice Williams. "Convict Servants and Middle-Class Mistresses." *Lit: Literature Interpretation Theory* 16:2 (2005), 163–87.

Ellis, M.H. "Did Greenway Write 'Ralph Rashleigh'?" *Bulletin* (3 December 1952), 2–3, 35.

_____. "Further Argument on Who Wrote 'Ralph Rashleigh.'" *Bulletin* (7 January 1953), 25–6.

Emsley, Clive. "The Changes in Policing and Penal Policy in Nineteenth-Century Europe." In *Crime and Empire 1840–1940: Criminal Justice in Local Government and Global Context,* ed. Barry S. Godfrey and Graeme Dunstall. Devon: Willan, 2005), 8–24.

Everson, William K. *The Bad Guys: A Pictorial History of the Movie Villain.* New York: Citadel, 1964.

Fetterley, Judith. "Impersonating 'Little Women': The Radicalism of Alcott's *Behind a Mask.*" *Women's Studies* 10 (1983), 1–14.

Flanders, Judith. "The Hanky-Panky Way: Creators of the First Female Detectives: A Mystery Solved." *Times Literary Supplement* (18 June 2010), 14–15 http://www.timesonline.co.uk.

_____. *The Invention of Murder: How the Victorians Revelled in Death and Detection and Created Modern Crime.* London: Harper, 2011.

Flowers, Michael. "The *Johnny Ludlow* Stories." http://www.mrshenrywood.co.uk/ludlow.html.

Forster, John. Review of *Susan Hopley; or, Circumstantial Evidence. Examiner,* 28 February 1841.

Foster, Shirley. "Elizabeth Gaskell's Shorter Pieces." In *The Cambridge Companion to Elizabeth Gaskell,* ed. Jill L. Matus. Cambridge: Cambridge University Press, 2007, 108–30.

Fothergill, Henry Chorley. Review of Catherine Crowe's *Men and Women: Or, Manorial Rights. Athenaeum,* 30 December 1843.

Foucault, Michel. *Discipline and Punish: The Birth of the Prison,* trans. Alan Sheridan. London: Allen Lane, 1977.

_____. *The History of Sexuality. Volume One: The Will to Knowledge,* trans. Robert Hurley. Harmondsworth, Middlesex: Penguin, 1990.

Foxwell, Elizabeth. Back cover comment. In Metta Fuller Victor, *The Dead Letter and The Figure Eight.* Durham, NC, and London: Duke University Press, 2003, unpaginated.

Franklin, Miles. *Laughter, Not For a Cage.* Sydney: Angus and Robertson, 1956.

Friedman, Lawrence M. *Crime and Punishment in American History.* New York: Basic, 1993.

Fritz, Kathlyn Ann, and Natalie Kaufman Hevener. "An Unsuitable Job for a Woman: Female Protagonists in the Detective Novel." *International Journal of Women's Studies* 2 (1979), 105–17.

Gelder, Ken, and Rachael Weaver, ed. *The Anthology of Colonial Australian Crime Fiction.* Melbourne: Melbourne University Press, 2008.

Giffuni, Cathy. "A Bibliography of Anna Katharine Green." *Clues: A Journal of Detection* 8:2 (1987), 113–33.

Gilbert, Sandra, and Susan Gubar. *The Madwoman in the Attic: The Woman Writer and the Nineteenth-Century Literary Imagination.* New Haven, CT: Yale University Press, 1979.

Gill, Gillian. *Agatha Christie: The Woman and Her Mysteries.* London: Robson, 1991.

Gosselin, Adrienne Johnson, ed. *Multicultural Detective Fiction: Murder from the "Other" Side.* New York: Garland, 1999.

Goulart, Ron. "Introduction." In *The Great British Detective: 15 Stories Starring England's*

Unsurpassable Super-Sleuths, ed. Ron Goulart. New York and Ontario: Mentor, 1982, ix–xiv.

Grass, Sean. *The Self in the Cell: Narrating the Victorian Prisoner*. New York and London: Routledge, 2003.

Gray, Frances. *Women, Crime and Language*. Basingstoke and New York: Palgrave Macmillan, 2003.

Green, H.M. *A History of Australian Literature, Pure and Applied*, 2 vols. Sydney: Angus and Robertson, 1961.

Greene, Hugh Carleton. "Introduction." In *The Crooked Counties: Further Rivals of Sherlock Holmes*, ed. Hugh Carleton Greene. London: Bodley Head, 1973.

Gunning, Tom. "Lynx-Eyed Detectives and Shadow Bandits: Visuality and Eclipse in French Detective Stories and Films before WWI." *Yale French Studies* 108 (2005).

Hagen, Ordean A. *Who Done It? A Guide to Detective, Mystery and Suspense Fiction*. New York and London: R. R. Bowker, 1969.

Haining, Peter. "Introduction." In *Hunted Down: The Detective Stories of Charles Dickens*, ed. Peter Haining. London and Chester Springs: Peter Owen, 2006, 7–21.

Halbeisen, Elizabeth K. *Harriet Prescott Spofford: A Romantic Survival*. Philadelphia: University of Philadelphia Press, 1935.

Halberstam, Judith. *Skin Shows: Gothic Horror and the Technology of Monsters*. Durham, NC, and London: Duke University Press, 1995.

Haldane, Robert. *The People's Force: A History of the Victoria Police*. Melbourne: Melbourne University Press, 1986.

Halliwell, Martin. *Images of Idiocy: The Idiot Figure in Modern Fiction and Film*. Aldershot: Ashgate, 2004.

Halttunen, Karen. *Confidence Men and Painted Women: A Study of Middle-Class Culture in America, 1830–1870*. New Haven: Yale University Press, 1982.

____. "The Domestic Drama of Louisa May Alcott." *Feminist Studies* 10 (1984), 233–54.

Hamilton Spectator, 2 October 1863 [on Ellen Davitt's lecture/s].

Harkins, E.F., and C.H.L. Johnson. *Little Pilgrimages Among the Women Who Have Written Famous Books*. Boston: L.C. Page, 1901.

Harris, Alexander. *Settlers and Convicts or, Recollections of Sixteen Years' Labour in the Australian Backwoods, by an Emigrant Mechanic*. Foreword by Manning Clark. Melbourne: Melbourne University Press, 1969.

Hawthorne, Nathaniel. In *Hidden Hands: An Anthology of American Women Writers, 1790–1870*, ed. Lucy M. Freibert and Barbara A. White. New Brunswick, NJ: Rutgers University Press, 1985.

____. To His Publisher, William Ticknor (January 1854). In *Nathaniel Hawthorne, The Centenary Edition of the Works of Nathaniel Hawthorne*, ed. William Charvat, et al. Columbus: Ohio State University Press, 1987, 17:161.

Hawthorne, Sophia Peabody. Letter to Annie Fields regarding Harriet Prescott Spofford's "Circumstance." In James H. Matlack, "The Literary Career of Elizabeth Barstow Stoddard." Ph.D. dissertation, Yale University, 1968.

Hayne, Barrie. "Anna Katharine Green." In *10 Women of Mystery*, ed. Earl F. Bargainnier. Bowling Green, OH: Bowling Green State University Popular Press, 1981, 153–78.

Heineman, Helen. *Mrs. Trollope: The Triumphant Feminine in the Nineteenth Century*. Athens: Ohio University Press, 1979.

Henry, Nancy. "Elizabeth Gaskell and Social Transformation." In *The Cambridge Companion to Elizabeth Gaskell*, ed. Jill L. Matus. Cambridge: Cambridge University Press, 2007, 148–63.

Herbert, Rosemary, ed. *The Oxford Companion to Crime and Mystery Writing*. Oxford: Oxford University Press, 1999.

Herdman, John. *The Double in Nineteenth-Century Fiction*. Hampshire and London: Macmillan, 1990.

Hergenhan, Laurie. *Unnatural Lives: Studies in Australian Convict Fiction*. St. Lucia: University of Queensland Press, 1993.

Hervey, Thomas Kibble. Review of Catherine Crowe's *Adventures of Susan Hopley; or Circumstantial Evidence*. *Athenæum* 30 January 1841, 93–4.

Herzberg, Max J., and the Staff of the Thomas Y. Crowell Company. "Victor, Metta Victoria [Fuller]." *The Reader's Encyclopedia of American Literature*. New York: Crowell, 1962.

Higginson, Thomas Wentworth. *Letters and Journals of Thomas Wentworth Higginson, 1846–1906*, ed. Mary Thacher Higginson. Boston: Houghton Mifflin, 1921.

____. Quoted in Richard Benson Sewall, *The Life of Emily Dickinson*. Harvard: Harvard University Press, 1994, I.

Hoffman, Nancy Y. "Mistress of Malfeasance." In *Dimensions of Detective Fiction*, ed. Larry N. Landrum, Pat Browne and Ray B. Browne. Bowling Green, OH: Popular Press, 1976, 97–101.

Hogeland, Lisa Maria, and Mary Klages. "Preface." In *The Aunt Lute Anthology of U.S. Women Writers*, ed. Lisa Maria Hogeland and Mary Klages. San Francisco, CA: Aunt Lute, 2004, I. xxiii–xxxi.

Hollingdale, R.J. "Introduction." In *Tales of*

Hoffmann, by E.T.A. Hoffmann. New York: Penguin, 1982, 7–15.

Hollingsworth, Keith. *The Newgate Novel 1830–1847: Bulwer, Ainsworth, Dickens and Thackeray*. Detroit: Wayne State University Press, 1963.

Holroyd, J.P. "Mullen, Samuel (1828–1890)." *Australian Dictionary of Biography*, Vol. 5. Melbourne: Melbourne University Press, 1974, 309–10.

Holroyd, John. *George Robertson of Melbourne 1825–1898, Pioneer Bookseller and Publisher*. Melbourne: Robertson and Mullens, 1968.

Hoppenstand, Gary, and Ray B. Browne. *The Defective Detective in the Pulps*. Bowling Green, OH: Bowling Green State University Popular Press, 1983.

Houghton, Walter E., et al., ed. *The Wellesley Index to Victorian Periodicals, 1824–1900*. 4 vols. University of Toronto Press/Routledge and Kegan Paul, 1966–87.

Hubin, Allen J. "Patterns in Mystery Fiction: The Durable Series Character." In *The Mystery Story*, ed. John Ball. Del Mar, CA: University of California, San Diego/Publishers Inc., 1976, 291–318.

Hughes, Winifred. *The Maniac in the Cellar: Sensation Novels of the 1860s*. Princeton: Princeton University Press, 1980.

Indermaur, David. "No. 61: Violent Crime in Australia: Interpreting the Trends." From *University of Western Australia Crime Research Centre, Australian Institute of Criminology Canberra. Trends and Issues in Crime and Criminal Justice*, October 1996.

Irigaray, Luce. *The Sex Which Is Not One*, trans. Catherine Porter. Ithaca: Cornell University Press, 1986.

Irons, Glenwood, ed. *Feminism in Women's Detective Fiction*. Toronto, Buffalo and London: University of Toronto Press, 1995.

Jalland, Pat. *Australian Ways of Death: A Social and Cultural History 1840–1918*. Melbourne: Oxford University Press, 2002.

James, Henry. "Alphonse Daudet." In *Partial Portraits* (1881), quoted in M. Anesko, *Friction with the Market: Henry James and the Profession of Authorship*. Oxford: Oxford University Press, 1986.

_____. "Miss Braddon." *The Nation*, 9 November 1865, 593–5.

_____. Review of Spofford's *Azarian*, *North American Review*, January 1865, 268–77.

James, P.D. "*Emma* Considered as a Detective Story." Presentation to the Jane Austen Society, 1998.

Jaquet, Alison. "The Disturbed Domestic: Supernatural Spaces in Ellen Wood's Fiction." *Women's Writing* 15:2 (2008), 244–58.

_____. "Domesticating the Art of Detection: Ellen Wood's Johnny Ludlow Series." In *Formal Investigations: Aesthetic Style in Late-Victorian and Edwardian Detective Fiction*, ed. Paul Fox and Koray Melikog˘lu. Stuttgart: Ibidem, 2007, 179–95.

Jeaffreson, John Cordy. Review of *The Night Fossickers* by James Skipp Borlase. *Athenaeum*, 27 July 1867.

Johannsen, Albert. *The House of Beadle and Adams and its Dime and Nickel Novels: The Story of a Vanished Literature*, 3 vols. Norman: University of Oklahoma Press, 1950–62.

Johnson-Woods, Toni. *Index to Serials in Australian Periodicals and Newspapers: Nineteenth Century*. Canberra: Mulini Press, 2001.

_____. "Mary Elizabeth Braddon in Australia: Queen of the Colonies." In *Beyond Sensation: Mary Elizabeth Braddon in Context*, ed. Marlene Tromp, Pamela K. Gilbert, and Aeron Haynie. New York: State University of New York Press, 2000, 111–25.

Jordan, John, and Robert Patten, ed. *Literature in the Marketplace: Nineteenth-Century British Publishing and Reading Practices*. London: Cambridge University Press, 1995.

Jordan Smith, Wilbur. "Mystery Fiction in the Nineteenth Century." *The Mystery and Detection Annual*, ed. Donald K. Adams, 1973.

Joyce, Simon. *Capital Offenses: Geographies of Class and Crime in Victorian London*. Charlottesville and London: University of Virginia Press, 2003.

Jung, Sandro. "Charlotte Brontë's *Jane Eyre*, the Female Detective and the 'Crime' of Female Selfhood." *Brontë Studies* 32 (2007), 21–30.

_____. "Curiosity, Surveillance and Detection in Charlotte Brontë's *Villette*." *Brontë Studies* 35:2 (2010), 160–71.

Katrizky, Linde. "The Intriguing Case of Hargrave: A Tragi-Comedy of Manners." In *Frances Trollope and the Novel of Social Change*, ed. Brenda Ayres. Westport, CT: Greenwood, 2002, 137–52.

Kayman, Martin A. *From Bow Street to Baker Street: Mystery, Detection and Narrative*. Hampshire and London: Macmillan, 1992.

Keesing, Nancy. "Introduction." *The Forger's Wife*. Sydney: John Ferguson, 1979.

Kendall, Henry. "Introductory." *Colonial Monthly*, January 1870, 327.

Kestner, Joseph. *Protest and Reform: The British Social Narrative by Women 1827–1867*. Madison: University of Wisconsin Press, 1985.

Kestner, Joseph A. *Sherlock's Sisters: The British Female Detective, 1864–1913*. Hampshire: Ashgate, 2003.

Kilcup, Karen L. "The Conversation of 'The Whole Family': Gender, Politics, and Aes-

thetics in Literary Tradition." In *Soft Canons: American Women Writers and Masculine Tradition*, ed. Karen L. Kilcup. Iowa City: University of Iowa Press, 1999, 1–24.

Kittredge, William, and Steven M. Krauzer. "Introduction." In *The Great American Detective: 15 Stories Starring America's Most Celebrated Private Eyes*, ed. William Kittredge and Steven M. Krauzer. New York and Ontario: Mentor, 1978, x–xxxiv.

Klein, Kathleen Gregory. "Introduction." In *Great Women Mystery Writers Classic to Contemporary*, ed. Kathleen Gregory Klein. Westport, CT, and London: Greenwood Press, 1994, 1–9.

_____. *The Woman Detective: Gender and Genre*, 2d ed. Urbana: University of Illinois Press, 1995.

Knight, Stephen. "A Blood Spot on the Map: Place and Displacement in Australian Crime Fiction." *Australian Cultural History* 12 (1993), 145–59.

_____. "The Case of the Missing Genre: In Search of Australian Crime Fiction." *Southerly* 48 (1988), 235–49.

_____. "The Case of the Stolen Jumbuck." In *Reconnoitres: Essays Presented to G.A. Wilkes*, ed. M. Harris and E. Webby. Sydney: Oxford University Press, 1992.

_____. *Continent of Mystery: A Thematic History of Australian Crime Fiction*. Carlton South, Australia: Melbourne University Press, 1997.

_____. *Crime Fiction, 1800–2000: Detection, Death, Diversity*. Hampshire and New York: Palgrave Macmillan, 2004.

_____. "Crimes Domestic and Crimes Colonial: The Role of Crime Fiction in Developing Postcolonial Consciousness." In *Postcolonial Postmortems: Crime Fiction from a Transcultural Perspective*, ed. Christine Matzke and Susanne Mühleisen. Amsterdam and New York: Rodopi, 2006, 17–33.

_____. *Form and Ideology in Crime Fiction*. London: Macmillan, 1980.

_____. "Introduction." In *Dead Witness: Best Australian Mystery Stories*, ed. Stephen Knight. Ringwood: Penguin, 1989, ix–xxv.

_____. "Mounted Trooper a Ring-In: Borlase Borrows from Burrows." Unpublished essay, 1992.

_____. "Peter Temple: Australian Crime Fiction on the World Stage." *Clues: A Journal of Detection* 29.1 (2011), 71–81.

_____. "Sherlock Holmes's Grandmother: An Untraditional Look at the Anglophone Crime Fiction Tradition." *Anglo Files: Journal of English Teaching* 149 (2008), 29–37.

_____. ed., *Dead Witness: Best Australian Mystery Stories*. Ringwood: Penguin, 1989.

Knox, Ronald. *Ten Commandments* or *Decalogue* (1929). [Introduction to *The Best Detective Stories of 1928–29*]. Reprinted in Howard Haycraft, *Murder for Pleasure: The Life and Times of the Detective Story*, rev. ed. New York: Biblio and Tannen, 1976.

Krajenbrink, Marieke, and Kate M. Quinn, ed. *Investigating Identities: Questions of Identity in Contemporary International Crime Fiction*. Amsterdam: Rodopi, 2009.

Krause, Sydney J., and S.W. Reid, "Introduction." In Charles Brockden Brown, *Wieland or The Transformation An American Tale*, ed. Sydney J. Krause and S.W. Reid. Kent, OH: Kent State University Press, 1993, vii–xxv.

Kungl, Carla Therese. *Creating the Fictional Female Detective: The Sleuth Heroines of British Women Writers, 1890–1940*. Jefferson, N.C and London: McFarland, 2006.

Kyneton Observer, 9 January, 1864.

Lachman, Marvin. *A Reader's Guide to The American Novel of Detection*. New York: G.K. Hall, 1993.

Lahey, John. *Damn You, John Christie! The Public Life of Australia's Sherlock Holmes*. Melbourne: State Library of Victoria, 1993.

Larken, Geoffrey. "Early Crime Fiction: A Case for Mrs. Catherine Crowe." Ts., Templeman Library, University of Kent, Canterbury.

_____. "The Ghost-Fancier — A Life of the Victorian Authoress, Mrs. Catherine Crowe." Ts., Templeman Library, University of Kent, Canterbury.

Lawrence, Barbara. "Female Detectives: The Feminist-Anti-Feminist Debate." *Clues: A Journal of Detection* 3:1 (1982), 38–48.

Lawson, Elizabeth. "Louisa Atkinson, Naturalist and Novelist." In *A Bright and Fiery Troop: Australian Women Writers of the Nineteenth Century*, ed. Debra Adelaide. Ringwood: Penguin, 1988.

Lee, Christopher A. "E.T.A. Hoffmann's 'Mademoiselle de Scudéry' as a Forerunner of the Detective Story." *Clues: A Journal of Detection* 15 (1994), 63–74.

Lennox Keyser, Elizabeth. *Whispers in the Dark: The Fiction of Louisa May Alcott*. Knoxville: University of Tennessee Press, 1993.

Levy, Bronwen. "Introduction." Miles Franklin, *Bring the Monkey*. London: Pandora, 1987, vii–xvii.

"The Library Table." *Australian Journal*, Part 70, VI, 1871.

Liggins, Emma. "Introduction: Ellen Wood, Writer," *Women's Writing* 15 (2008), 149–56

Light, Alison. *Forever England: Femininity, Literature and Conservatism Between the Wars* (London: Routledge, 1991)

Lindsay, H. A. "The World's First Policewoman," *Quadrant* (March 1959), 75–7.

Lowes, John Livingston. *The Road to Xanadu: A Study in the Ways of the Imagination* (London: Picador, 1978).

MacDonald, Ruth K. "Alcott, Louisa May (1832–1888)." In *The Oxford Companion to Women's Writing in the United States,* ed. Cathy N. Davidson and Linda Wagner-Martin. New York and Oxford: Oxford University Press, 1995, 44–5.

Macdonald, Ross. "The Writer as Detective Hero." In *Detective Fiction: A Collection of Critical Essays,* ed. Robin W. Winks. Englewood Cliffs, NJ: Prentice-Hall, 1980, 179–87.

Magistrale, Tony, and Sidney Poger. *Poe's Children: Connections Between Tales of Terror and Detection.* New York: Peter Lang, 1999.

Maida, Patricia D. *Mother of Detective Fiction: The Life and Works of Anna Katharine Green.* Bowling Green, OH: Bowling Green State University Popular Press, 1989.

Maio, Kathleen L. "Metta Victoria Fuller Victor." In *American Women Writers: A Critical Guide from Colonial Times to the Present,* ed. Lina Mainiero. New York: Ungar, 1982, IV, 302–4.

_____. "Murder in Grandma's Attic." In *Murderess Ink: The Better Half of the Mystery,* ed. Dilys Winn. New York: Workman, 1979, 47–9.

_____. "'A Strange and Fierce Delight': The Early Days of Women's Mystery Fiction." *Chrysalis: A Magazine of Women's Culture* 10 (1980), 93–105.

Mallory, Michael. "'The Mother of American Mystery'" Anna Katharine Green." http://www.mysteryscenemag.com/articles/96annakatharinegreen.pdf.

Mangham, Andrew. *Violent Women and Sensation Fiction: Crime, Medicine and Victorian Popular Culture.* Basingstoke: Palgrave Macmillan, 2007.

Mann, Jessica. *Deadlier Than the Male: An Investigation into Feminine Crime Writing.* Newton Abbot: David and Charles, 1981.

Mansel, Henry. "Sensation Novels." *Quarterly Review* 113 (1863), 481–514.

Masson, David. On Elizabeth Gaskell in *Macmillan's Magazine,* quoted in *Elizabeth Gaskell: The Critical Heritage,* ed. Angus Easson. London: Routledge, 1991.

Maunder, Andrew. "Ellen Wood Was A Writer: Rediscovering Collins's Rival." *Wilkie Collins Society Journal,* no. 3 (2000), 17–31.

_____. "Mapping the Victorian Sensation Novel: Some Recent and Future Trends." *Literature Compass* 2 (2005), 1–33.

May, Charles E. "From Small Beginnings: Why Did Detective Fiction Make Its Debut in the Short Story Format?" *The Armchair Detective* 20 (1987), 77–81.

Mayhew, Henry. *London Labour and the London Poor,* 4. vols. New York: Dover, 1968 [1861].

McCann, Andrew. *Marcus Clarke's Bohemia: Literature and Modernity in Colonial Melbourne.* Carlton, Australia: Melbourne University Press, 2004).

McLaren, Ian F. "For the Term of His Natural Life: 1927 Film Epic. *Margin* 7 (1981), 4–6.

Mead, Jenna. Caroline Leakey. *Dictionary of Literary Biography,* vol. 230 *Australian Literature 17–88–1914,* first series, ed. Selina Samuels. Detroit and London: Gale, 2001, 245–53.

_____. "Caroline Leakey: Body and Authorship." *a/b auto/biography studies* 8: 2 (1993), 198–216.

_____. "Caroline Leakey, Oliné Keese and Bio/discourse." *Australian Feminist Studies* 20 (1994), 53–76.

_____. "(Re)producing a Text: Caroline Leakey's *The Broad Arrow.*" *Meridian: The La Trobe University English Review* 10 (May 1991), 81–8.

Meredith, Jack. *The Wild Colonial Boy.* Melbourne: Red Rooster, 1982.

Michie, Elsie B. *Outside the Pale: Cultural Exclusion, Gender Difference, and the Victorian Woman Writer.* Ithaca and London: Cornell University Press, 1993.

Miller, D.A. *The Novel and the Police.* Berkeley and Los Angeles: University of California Press, 1988.

Miller, E. Morris, and Frederick T. Macartney. *Australian Literature. A Bibliography to 1938.* Sydney: Angus and Robertson, 1956.

Miller, Karl. *Doubles: Studies in Literary History.* Oxford: Oxford University Press, 1985.

Miller, Wilbur R. *Cops and Bobbies: Police Authority in New York and London, 1830–1870.* Chicago and London: University of Chicago Press, 1977.

Milnes, Richard Monckton. On Elizabeth Gaskell in the *Athenaeum,* 18 November, 1865.

"Mr. Skipp Borlase's 'Stirring Tales of Colonial Adventure.'" *The Spectator,* November 1894. Found in "Press Notices of Skipp Borlase's Published Books" in Folder 1: Papers Relating to Australian Children's Literature, 1883–1988, Terry O' Neill. Manuscript; National Library of Australia, Canberra. MS 7661.

Mitchell, A.G. "Australian English." *The Australian Quarterly* XXIII (March 1951), 9–17.

Mitchell, Henry W. "A Well Known Contributor: Waif Wander." *Australian Journal,* March 1880, XV, 487–8.

Mitchell, Sally. *The Fallen Angel: Chastity, Class and Women's Reading 1835–1880.* Bowling

Green, OH: Bowling Green University Popular Press, 1981.
Miyoshi, Masao. *The Divided Self: A Perspective on the Literature of the Victorians*. New York and London: New York University Press, 1969.
Mott, Luther. *Golden Multitudes: The Stories of Best Sellers in the United States*. New York: Macmillan, 1947.
Mudge, Bradford K. "The Man with Two Brains: Gothic Novels, Popular Culture, Literary History." *PMLA* 107 (January 1992), 92–104.
The Mulini Press: John Lang Project. http://home.mysoul.com.au/heritagefutures/lang/LangWorks.html.
Murch, A.E. *The Development of the Detective Novel*. London: Peter Owen, 1958, rev. ed. 1968.
"Murder." *The Critic: A Weekly Journal Specially Devoted to the Encouragement of Australian Literature, Science, and Art*. Vol. I — No. 2. Sydney, September 27, 1873.
Murphy, Bruce F. *The Encyclopaedia of Murder and Mystery*. New York: Palgrave, 1999.
Murray-Smith, Stephen. "Introduction." In Marcus Clarke, *His Natural Life*. Harmondsworth: Penguin Classics, 1987, 7–23.
Myers, Gloria E. *A Municipal Mother: Portland's Lola Greene Baldwin, America's First Policewoman*. Corvallis: Oregon State University Press, 1995.
Nash, Roderick Frazier. *Wilderness and the American Mind*. New Haven and London: Yale University Press, 2001.
Neville-Sington, Pamela. *Fanny Trollope: The Life and Adventures of a Clever Woman*. London: Penguin, 1998.
"A New Gang of Bushrangers." *Illustrated Sydney News*, 16 September 1867, 229.
The New York Daily Graphic, June 5, 1873 [regarding Susan B. Anthony].
Newberry, Frederick. "Male Doctors and Female Illness in American Women's Fiction, 1850–1900." In *Separate Spheres No More: Gender Convergence in American Literature, 1830–1930*, ed. Monika M. Elbert. Tuscaloosa and London: University of Alabama Press, 2000, 143–57.
Newman, Robert D. "Indians and Indian-Hating in *Edgar Huntly* and *The Confidence Man*." *MELUS: The Society for the Study of the Multi-Ethnic Literature of the United States* 15 (1988), 65–74.
Nichols, Victoria, and Susan Thompson. *Silk Stalkings: When Women Write of Murder: A Survey of Series Characters Created by Women Authors in Crime and Mystery Fiction*. Berkeley: Black Lizard Books, 1988.
Nickerson, Catherine Ross. "Introduction." In Metta Fuller Victor, *The Dead Letter and The Figure Eight*. Durham and London: Duke University Press, 2003, 1–10.
_____. *The Web of Iniquity: Early Detective Fiction by American Women*. Durham and London: Duke University Press, 1998.
Nicolson, Charles Hope. Inspector of Detectives. *Report from the Select Committee on the Police Force, 1863, Votes and Proceedings of the Legislative Assembly of Victoria*, II, 1862–63. Appendix G, Minutes of Evidence.
"The Night Fossickers." *Athenaeum*, 27 July, 1867. In "Warne's 'Doing and Daring' Library" in Folder 1: Papers Relating to Australian Children's Literature, 1883–1988. Terry O'Neill. Manuscript; National Library of Australia, Canberra. MS 7661.
O'Carroll, John. "Upside-Down and Inside Out: Notes on the Australian Cultural Unconscious." In *Imagining Australian Space: Cultural Studies and Spatial Inquiry*, ed. Ruth Barcan and Ian Buchanan. Nedlands, W.A.: University of Western Australia Press, 1999, 13–36.
Okuda, Akiyo. "Metta Victoria Fuller Victor's *The Dead Letter* (1864) and the Rise of Detecting Culture/Detective Fiction." *Clues: A Journal of Detection* 19.2 (1998), 35–57.
Oliphant, Margaret. "Men and Women." *Blackwood's Edinburgh Magazine* 157 (April 1895), 620–50.
_____. "Novels." *Blackwood's Edinburgh Magazine* CII (1867), 257–80.
_____. "Sensation Novels." *Blackwood's Edinburgh Magazine* 91 (May 1862), 565–84.
Olsen, Marilyn. *State Trooper: America's State Troopers and Highway Patrolmen*. Paducah, KY: Turner, 2001.
"Opening Address." *The Australasian*, 1 October 1864, 8.
"Opening Address." *Illustrated Sydney News*, 3 October 1853, 2.
Oulton, Carolyn W. De La L. *Romantic Friendship in Victorian Literature*. Hampshire: Ashgate, 2007.
"Our Whatnot." *Australian Journal*, December 1870.
"Ourselves." *The Critic: A Weekly Journal Specially Devoted to the Encouragement of Australian Literature, Science, and Art*, Vol: I-0.I. Sydney, September 20, 1873.
Ousby, Ian. *Bloodhounds of Heaven: The Detective in English Fiction from Godwin to Doyle*. Cambridge, MA, and London: Harvard University Press, 1976.
Palmer, Beth. "'Dangerous and Foolish Work': Evangelicalism and Sensation in Ellen Wood's *Argosy* Magazine." *Women's Writing* 15:2 (2008), 187–98.
Panek, LeRoy Lad. *The Origins of the American*

Detective Story. Jefferson, NC, and London: McFarland, 2006.

_____. *Probable Cause: Crime Fiction in America*. Bowling Green, OH: Bowling Green State University Popular Press, 1990.

_____, and Mary M. Bendel-Simso, ed. *Early American Detective Stories: An Anthology*. Jefferson, NC: McFarland, 2008.

Pattee, Fred Lewis. *The Feminine Fifties*. New York: Wilson, 1936.

Pearson, Edmund. *Dime Novels; or, Following an Old Trail in Popular Literature*. Boston: Little Brown, 1929.

Pennell, Jane C. "The Female Detective: Pre- and Post-Women's Lib." *Clues: A Journal of Detection* 6:2 (1985), 85–98.

Peterson, Audrey. *Victorian Masters of Mystery: From Wilkie Collins to Conan Doyle*. New York: Frederick Ungar, 1984.

Phegley, Jennifer. "Domesticating the Sensation Novelist: Ellen Price Wood as the Author and Editor of the *Argosy Magazine*." *Victorian Periodicals Review* 38 (2005), 180–98.

Pickett, LaSalle Corbell. From a conversation with Louisa May Alcott, "[Louisa May Alcott's "Natural Ambition" for the 'Lurid Style' Disclosed in Conversation]." *Across My Path: Memories of People I Have Known*. New York: Brentano's, 1916, 107–8.

Plain, Gill. *Twentieth-Century Crime Fiction: Gender, Sexuality and the Body*. Edinburgh: Edinburgh University Press, 2001.

Poole, Joan. "The Broad Arrow: A Reappraisal." *Southerly* XXVI (1966), 117–24.

Porter, Dennis. *The Pursuit of Crime: Art and Ideology in Crime Fiction*. New Haven, CT: Yale University Press, 1981.

Price, Barbara R. "Female Police Officers in the United States." In *Policing in Central and Eastern Europe: Comparing Firsthand Knowledge with Experience from the West*, ed. Milan Pagon. Ljubljana, Slovenia: College of Police and Security Studies, 1996. http://www.ncjrs.gov/policing/fem635.htm.

Priestman, Martin. *Detective Fiction and Literature: The Figure on the Carpet*. Basingstoke: Macmillan, 1990.

Publisher's Announcement. In Mary Elizabeth Braddon, *The Trail of the Serpent*. UCLA: Sadleir 337 [London: Ward, Lock, and Tyler, Warwick House, Paternoster Row, 1866, iii–vi]. [Dated July 1866].

Pykett, Lyn. "Afterword." In *Beyond Sensation: Mary Elizabeth Braddon in Context*, ed. Marlene Tromp, Pamela K. Gilbert, and Aeron Haynie. New York: State University of New York Press, 2000, 277–80.

_____. *The "Improper" Feminine: The Women's Sensation Novel and the New Woman Writing*. London and New York: Routledge, 1992.

_____. "The Newgate Novel and Sensation Fiction, 1830–1868." In *The Cambridge Companion to Crime Fiction*, ed. Martin Priestman. Cambridge: Cambridge University Press, 2003, 19–39.

_____. "Sensation and the Fantastic in the Victorian Novel." In *The Cambridge Companion to the Victorian Novel*, ed. Deirdre David. Cambridge: Cambridge University Press, 2001, 192–211.

_____. *The Sensation Novel: From The Woman in White to The Moonstone*. Plymouth: Northcote House, 1994.

The Queanbeyan Age, 8 August 1868.

Queen, Ellery. *Queen's Quorum*. Boston: Little, Brown, 1951.

Rahn, B.J. "Regester, Seeley." In *The Oxford Companion to Crime and Mystery Writing*, ed. Rosemary Herbert. New York and Oxford: Oxford University Press, 1999, 380–1.

_____. "Seeley Regester: America's First Detective Novelist." In *The Sleuth and the Scholar: Origins, Evolution, and Current Trends in Detective Fiction*, ed. Barbara A. Rader and Howard G. Zettler. Westport, CT: Greenwood, 1988), 47–61.

"Regarding the Continuation of the 'Police Stories.'" *Australian Journal*, 23 March 1867, 479.

Reitz, Caroline. *Detecting the Nation: Fictions of Detection and the Imperial Venture*. Columbus: The Ohio State University Press, 2004.

"Restrictions upon Colonial Literature." *Colonial Monthly*, September 1869, 23–4.

Review of Caroline Leakey's *The Broad Arrow*. *The Athenaeum*, 30 April 1859, 580.

Review of Caroline Leakey's *The Broad Arrow*. *The John Bull*, 23 April 1859, 268.

Review of Caroline Leakey's *The Broad Arrow*. *The Literary Examiner*, 28 May 1859, 340.

Review of Caroline Leakey's *The Broad Arrow*. *The Spectator*, 14 May 1859, 518.

Review of Caroline Leakey's *The Broad Arrow*. *Walch's Literary Intelligencer*, March 1860, 169–70.

Review of Recent Publications [discussing *Adam Bede* and *The Broad Arrow*]. *Bentley's Quarterly Review* 2 July 1859, 466–72.

Reynolds, David S. *Beneath the American Renaissance: The Subversive Imagination in the Age of Emerson and Melville*. New York: Alfred A. Knopf, 1988.

Roderick, Colin. "The Authorship of 'Ralph Rashleigh.'" *Bulletin*, 24 December 1952, 22–3, 34.

_____. "Introduction" to *Ralph Rashleigh*. Sydney: Angus and Robertson, 1952.

_____. "'Ralph Rashleigh.'" *Bulletin*, 28 January 1953, 2.

Rodier, Katharine. "'Astra Castra': Emily Dickinson, Thomas Wentworth Higginson, and Harriet Prescott Spofford." In *Separate Spheres No More: Gender Convergence in American Literature, 1830–1930*, ed. Monika M. Elbert. Tuscaloosa and London: University of Alabama Press, 2000, 50–72.

Rosenman, Ellen Bayuk. "'Just Man Enough to Play the Boy': Theatrical Cross-Dressing in Mid-Victorian England." In *Gender Blending*, ed. Bonnie Bullough, Vern L. Bullough, and James Elias. Amherst, NY: Prometheus, 1997, 303–10.

_____. "Spectacular Women: The Mysteries of London and the Female Body." *Victorian Studies* 40 (1996), 31–4.

Ross, Cheri L. "The First Feminist Detective: Anna Katharine Green's Amelia Butterworth." *Journal of Popular Culture* 25 (1991) 77–86.

Ross, Cheri Louise. "Seeley Regester (1831–1885)." In *Great Women Mystery Writers: Classic to Contemporary*, ed. Kathleen Gregory Klein. Westport, CT: Greenwood, 1994, 293–5.

Rostenberg, Leona. "Some Anonymous and Pseudonymous Thrillers of Louisa M. Alcott." In *Critical Essays on Louisa May Alcott*, ed. Madeleine B. Stern. Boston, MA: G.K. Hall, 1984, 43–50 [originally *Papers of the Bibliographical Society of America*, XXXVII: 2; 1943].

_____, and Madeleine B. Stern, "Five Letters That Changed an Image." in *Louisa May Alcott: From Blood and Thunder to Hearth and Home*, ed. Madeleine B. Stern. Boston: Northeastern University Press, 1998, 83–92.

Roth, Marty. *Foul and Fair Play: Reading Genre in Classic Detective Fiction*. Athens and London: University of Georgia Press, 1995.

Routley, Erik. *The Puritan Pleasures of the Detective Story*. London: Gollancz, 1972.

Rukavina, Alison Jane. *Cultural Darwinism and the Literary Canon: A Comparative Study of Susanna Moodie's Roughing It in the Bush and Caroline Leakey's The Broad Arrow*. Master of Arts diss., Simon Fraser University, June 2000.

Rush, Dr. Benjamin. "Thoughts Upon Female Education...." In *Essays, Literary, Moral and Philosophical*, 2d ed. Philadelphia: Thomas and William Bradford, 1806; first ed. 1798.

Rutherford, Anna. "The Wages of Sin: Caroline Leakey's *The Broad Arrow*." In *The Commonwealth Writer Overseas: Themes of Exile and Expatriation*, ed. Alastair Niven. Brussels: Didier, 1976, 245–54.

Rzepka, Charles J. *Detective Fiction*. Cambridge and Malden, MA: Polity, 2005.

Sadleir, Michael. *Things Past*. London: Constable, 1944.

Sapora, Carol Baker. "Female Doubling: The Other Lily Bart in Edith Wharton's 'The House of Mirth.'" *Papers on Language and Literature* 29 (27 September 1993).

Sappol, Michael. *A Traffic of Dead Bodies: Anatomy and Embodied Social Identity in Nineteenth-Century America*. Princeton: Princeton University Press, 2002.

The Saturday Review. [On the "Johnny Ludlow" stories]. 13 November 1880 (50), 618–9.

The Saturday Review. [On the "Johnny Ludlow" stories]. 18 July, 1885 (60), 91–2.

Saxton, Martha. "The Secret Imaginings of Louisa Alcott." In *Critical Essays on Louisa May Alcott*, ed. Madeleine B. Stern. Boston: G.K. Hall, 1984, 256–60.

Sayers, Dorothy L. "The Omnibus of Crime." In *Detective Fiction: A Collection of Critical Essays*, ed. Robin W. Winks. Englewood Cliffs, NJ: Prentice-Hall, 1980, 53–83.

Schaffer, Kay. *Women and the Bush: Forces of Desire in the Australian Cultural Tradition*. Melbourne, Cambridge, and New York: Cambridge University Press, 1988.

Scheckter, John. "*The Broad Arrow*: Conventions, Convictions, and Convicts." *Antipodes: A North American Journal of Australian Literature* 1 (1987), 89–91.

Schroeder, Natalie, and Ronald A. Schroeder. *From Sensation to Society: Representations of Marriage in the Fiction of Mary Elizabeth Braddon, 1862–1866*. Newark: University of Delaware Press, 2006.

"Scrub." Definition. The Oxford English Dictionary Online. http://dictionary.oed.com/cgi/entry/50217027?query_type=word&queryword=scrub&first=1&max_to_show=10&sort_type=alpha&result_place=1&search_id=j5Vj-K0r81O-2230&hilite=50217027.

Sedgwick, Eve Kosofsky. *Between Men: English Literature and Male Homosocial Desire*. New York: Columbia University Press, 1985.

Sheridan, Susan. *Along the Faultlines: Sex, Race and Nation in Australian Women's Writing 1880s-1930s*. St. Leonards, N.S.W.: Allen and Unwin, 1995.

Showalter, Elaine. *A Jury of Her Peers: American Women Writers from Anne Bradstreet to Annie Proulx*. New York: Alfred A. Knopf, 2009.

_____. *Sister's Choice: Tradition and Change in American Women's Writing*. New York: Oxford University Press, 1991.

Sikes, Wirt. "Talked About People: Metta Victoria Victor," *Saturday Journal*, 25 June 1881.

Sims, Michael, ed. *The Penguin Book of Victorian Women in Crime: All the Great Detectives and a Few Great Crooks*. London: Penguin, 2010.

Sisters in Crime (Australia). http://home.vicnet.net.au/~sincoz/welcome.htm.
Skilton, David. "Introduction." Wilkie Collins, *The Law and the Lady*. London and New York: Penguin Classics, 1998, vii–xxii.
Slung, Michele. "Introduction." Seeley Regester, *The Dead Letter*. Boston: Gregg, 1979, v–ix.
Slung, Michele. "Women in Detective Fiction." In *The Mystery Story*, ed. John Ball. Del Mar: University of California, San Diego/Publishers Inc., 1976, 125–40.
Slung, Michele B. "Introduction." In *The Experiences of Loveday Brooke, Lady Detective* [Pirkis]. New York: Dover, 1986, vii–xiii.
Sly, Christopher [James Neild]. "A Peep at the Pictures." *Examiner and Melbourne Weekly News*, 12 December 1857.
"Social Reform." *The Critic: A Weekly Journal Specially Devoted to the Encouragement of Australian Literature, Science, and Art*, vol. 1, no. 10. Sydney, 22 November 1873.
"Some Interesting Notes about Mr. James Skipp Borlase." *Derby and Chesterfield Reporter*, 11 November 1887, 2.
The South Australian *Register*, 28 April 1915 [on women police].
Spender, Lynne. *Her Selection: Writings by Nineteenth-Century Australian Women*. Victoria, Australia: Penguin, 1988.
Spengler, Birgit. "Gendered Vision(s) in the Short Fiction of Harriet Prescott Spofford." *Legacy* 21 (2004), 68–73.
Spiller, Robert E. In Larry Landrum, *American Mystery and Detective Novels: A Reference Guide*. Westport, CT: Greenwood, 1991.
Spofford, Harriet Prescott. Letter to Fred Lewis Pattee. Found in Elizabeth K. Halbeisen, *Harriet Prescott Spofford: A Romantic Survival*. Philadelphia: University of Pennsylvania Press, 1935.
Stebbins, Lucy Poate, and Richard Stebbins. *The Trollopes: The Chronicle of a Writing Family*. New York: Columbia University Press, 1945.
Stein, Aaron Marc. "The Mystery Story in Cultural Perspective." In *The Mystery Story*, ed. John Ball. Del Mar: University of California, San Diego/Publishers Inc., 1976, 29–59.
Stephen, Leslie. "The Decay of Murder." *Cornhill Magazine* 20, December 1869.
Stern, Madeleine B. *Imprints in History: Book Publishers and American Frontiers*. Bloomington: Indiana University Press, 1956.
_____. "Introduction." In *Freaks of Genius: Unknown Thrillers of Louisa May Alcott*, ed. Daniel Shealy, Madeleine B. Stern and Joel Myerson. New York and London: Greenwood, 1991, 1–25.
_____. "Introduction," in *The Hidden Louisa May Alcott: A Collection of Her Unknown Thrillers*, ed. Madeleine Stern. New York: Avenel, 1984, I. ix–xxxv.
Stewart, R. F. ... *And Always a Detective: Chapters on the History of Detective Fiction*. Newton Abbot: David and Charles, 1980.
"Stirring Tales of Colonial Adventure: A Book for Boys." *Illustrated London News*, 8 December 1894. In Folder 1: Papers Relating to Australian Children's Literature, 1883–1988. Terry O' Neill. Manuscript; National Library of Australia, Canberra. MS 7661.
Stoneman, Patsy. "Gaskell, Gender, and the Family." In *The Cambridge Companion to Elizabeth Gaskell*, ed. Jill L. Matus. Cambridge: Cambridge University Press, 2007, 131–47.
Story, W.W. "In a Studio." *Blackwood's Magazine*, 1875.
Strickland, Charles. *Victorian Domesticity: Families in the Life and Art of Louisa May Alcott*. University: University of Alabama Press, 1985.
Strickland, Margaret. "'Like a Wild Creature in its Cage, Paced That Handsome Woman': The Struggle between Sentiment and Sensation in the Writings of Louisa May Alcott." http://www.womenwriters.net/domesticgoddess/strickland.htm.
Stuart, Lurline. "Early Convict Novels." *Proceedings*, Sixteenth Annual Conference, Association for the Study of Australian Literature. Canberra: Australian Defence Force Academy, 1994.
Sturma, Michael. *Vice in a Vicious Society: Crime and Convicts in Mid-Nineteenth Century New South Wales*. St. Lucia: University of Queensland Press, 1983.
"A Suburban Study." *Australasian*, 10 April 1869.
Summers, Anne. *Damned Whores and God's Police: The Colonization of Women in Australia*. Ringwood, Australia: Allen Lane, 1975.
Sussex, Lucy. "The Art of Murder and Fine Furniture: The Aesthetic Projects of Anna Katharine Green and Charles Rohlfs." In *Formal Investigations: Aesthetic Style in Late-Victorian and Edwardian Detective Fiction*, ed. Paul Fox and Koray Melikog˘lu. Stuttgart: Ibidem, 2007, 159–78.
_____. "'Bobbing Around': James Skipp Borlase, Adam Lindsay Gordon, and Surviving in the Literary Market of Australia, 1860s." *Victorian Periodicals Review* 37:4 (2004), 1–18.
_____. "*Cherchez Les Femmes*: The Lives and Literary Contribution of the First Women to Write Crime Fiction." Ph.D. dissertation, Cardiff University, February 2005.
_____. "The Detective Maidservant: Catherine

Crowe's Susan Hopley." In *Silent Voices: Forgotten Novels by Victorian Women Writers*, ed. Brenda Ayres. Westport, CT, and London: Praeger, 2003, 57–66.

———. "The Earliest Australian Detective Story?" *Margin* 22 (1990), 30–1.

———. "An Early Australian Murder Mystery Novel: Ellen Davitt and *Force and Fraud*." *Margin* 25 (1991), 7–11.

———. "The First American Woman to Write Detective Fiction? Harriet Prescott Spofford." *Mystery Scene* 68 (2000).

———. "The Fortunes of Mary: Authenticity, Notoriety and the Crime-Writing Life." *Women's Writing* 14 (2007), 449–59.

———. "Introduction." In Ellen Davitt, *Force and Fraud: A Tale of the Bush*. Canberra: Mulini, 1993, i–ix.

———. "Introduction." In Lucy Sussex and Elizabeth Gibson, *Mary Helena Fortune ("Waif Wander"/ "W.W.") c. 1833–1910: A Bibliography*. Victorian Research Guide 27 (The University of Queensland), 1–11.

———. "Mary Fortune's Three Murder Mysteries." *Margin* 78 (July–August 2009), 33.

———. "Mrs. Henry Wood and her Memorials." *Women's Writing* 15 (2008), 157–68.

———. "Strangers on a Train: Céleste de Chabrillan and William Makepeace Thackeray." *Notes and Furphies* 42 (October 1999), 8–10.

———. "What the Mischief Does a Bonnet Want Here? An Introduction to Mary Fortune (Waif Wander)." In *The Fortunes of Mary Fortune*, ed. Lucy Sussex, preface by Judith Brett. Ringwood: Penguin, 1989, xii–xxiii.

———. "A Woman of Mystery: Mary Fortune." http://lsussex.customer.netspace.net.au/womanofmystery.htm.

———. *Women Writers and Detectives in Nineteenth Century Crime Fiction: The Mothers of the Mystery Genre*. Basingstoke: Palgrave-Macmillan, 2010.

———, and Elizabeth Gibson. *Mary Helena Fortune ("Waif Wander"/ "W.W.") c. 1833–1910. A Bibliography*. Victorian Research Guide 27 (University of Queensland)

———, and John Burrows. "Whodunit? Literary Forensics and the Crime Writing of James Skipp Borlase and Mary Fortune." *BSANZ Bulletin* 21.2 (1997), 73–106.

Sutherland, John. Email correspondence: 15 June 2008.

———. *The Stanford Companion to Victorian Fiction*. Stanford, CA: Stanford University Press, 1989.

———. *Victorian Novelists and Publishers*. London: Athlone, 1976.

Symons, Julian. *Bloody Murder: From the Detective Story to the Crime Novel*, 3d ed. London, Sydney and Auckland: Pan, 1994.

Thomas, Ronald R. *Detective Fiction and the Rise of Forensic Science*. Cambridge: Cambridge University Press, 1999.

———. "Making Darkness Visible: Capturing the Criminal and Observing the Law in Victorian Photography and Detective Fiction." In *Victorian Literature and the Victorian Visual Imagination*, ed. Carol T. Christ and John O. Jordan. Berkeley: University of California Press, 1995, 134–68.

Thompson, Julian, ed. *Wilkie Collins: The Complete Shorter Fiction*. London: Robinson, 1995.

Thomson, H.D. *Masters of Mystery*. London: Collins, 1931.

Todorov, Tzvetan. *Genres in Discourse*, trans. Catherine Porter. Cambridge: Cambridge University Press, 1990.

———. *The Poetics of Prose*, trans. Richard Howard. Ithaca: Cornell University Press, 1977.

"Trackers Finding the Pistols: The Murder of Mr. T. Ulicke Burke, at Piggoreet, near Ballarat, Victoria." Illustration. *Illustrated Sydney News*, no. 37, 15 June 1867, 185.

Trollope, Anthony. *An Autobiography*, ed. David Skilton. Harmondsworth: Penguin, 1996.

Twelve Women Detective Stories, ed. Laura Marcus. Oxford: Oxford University Press, 1997.

Tymms, Ralph. *Doubles in Literary Psychology*. Cambridge: Bowes and Bowes, 1949.

Uglow, Jenny. *Elizabeth Gaskell: A Habit of Stories*. London: Faber and Faber, 1993.

Van Dine, S.S. [Willard Huntington Wright]. "Introduction." In Anna Katharine Green, *The Leavenworth Case: A Lawyer's Story*. New York: Modern Age, 1937).

Vines, Lois Davis, ed. *Poe Abroad: Influence, Reputation, Affinities*. Ames: University of Iowa Press, 1999.

Walch's Literary Intelligencer, September 1865,1.

Walker, Samuel. *Popular Justice: A History of American Criminal Justice*. New York and Oxford: Oxford University Press, 1980.

Walker, Shirley. "'Wild and Wilful' Women: Caroline Leakey and *The Broad Arrow*." In *A Bright and Fiery Troop: Australian Women Writers of the Nineteenth Century*, ed. Debra Adelaide. Ringwood: Penguin, 1988, 85–99.

Walsh, John Evangelist. *Poe the Detective: The Curious Circumstances behind "The Mystery of Marie Roget."* New Brunswick, NJ: Rutgers University Press, 1968.

Warren, Joyce. *The American Narcissus*. New Brunswick, NJ: Rutgers University Press, 1984.

Waters, Sarah. "Introduction." In Mary Elizabeth Braddon, *The Trail of the Serpent*, ed. Chris Willis. New York: Modern Library, 2003, xv–xxiv.

Watson, Kate. "The Hounds of Fortune: Dog Detection in the Nineteenth Century." *Clues: A Journal of Detection* 29.1 (2011), 16–25.

Waugh, Hillary. *Hillary Waugh's Guide to Mysteries and Mystery Writing.* Cincinnati, OH: Writer's Digest, 1991.

Webby, Elizabeth. "Colonial Writers and Readers." In *The Cambridge Companion to Australian Literature*, ed. Elizabeth Webby. Cambridge: Cambridge University Press, 2000, 50–73.

"Weekly Miscellany." *Examiner*, 20 April 1861.

Weinman, Sarah. "Rediscovering Early Fictional America Detective James Brampton." *Los Angeles Times*, 26 October 2008.

Wells, Carolyn. *The Technique of the Mystery Story.* Springfield, MA: Home Correspondence School, 1913.

West, Kathryn. "Mystery and Detective Fiction." In *The Oxford Companion to Women's Writing in the United States*, ed. Cathy N. Davidson and Linda Wagner-Martin. New York and Oxford: Oxford University Press, 1995, 597–9.

White, Richard. *Inventing Australia: Images and Identity, 1688–1980.* Sydney: Allen and Unwin, 1981.

Willard, Frances, and Mary Livermore, ed. *A Woman of the Century: Fourteen Hundred Seventy Biographical Sketches Accompanied by Portraits of Leading American Women in all Walks of Life.* New York: Gordon, 1975.

Williams, A. Susan. "Introduction." In *The Lifted Veil: The Book of Fantastic Literature by Women 1800-World War II*, ed. A. Susan Williams. New York: Carroll and Graf, 1992, vii–xv.

Willis, Chris. "Afterword." In Mary Elizabeth Braddon, *The Trail of the Serpent*, ed. Chris Willis. New York: Modern Library, 2003, 408–14.

_____. "Mary Elizabeth Braddon (1835–1915)." www.litencyc.com/php/speople.php?rec=trtyue&UID=5053.

Wilson, Dean, and Mark Finnane. "From Sleuths to Technicians? Changing Images of the Detective in Victoria." In *Police Detectives in History, 1750–1950*, ed. Clive Emsley and Haia Shpayer-Makov. Aldershot: Ashgate, 2006, 135–56.

Winter, Gillian. "'We Speak that We Do Know, and Testify that We Have Seen': Caroline Leakey's Tasmanian Experiences and Her Novel *The Broad Arrow*." *THRA Papers and Proceedings* 40:4 (1993), 133–53.

Wolff, Robert Lee. "'Devoted Disciple': The Letters of Mary Elizabeth Braddon to Sir Edward Bulwer-Lytton, 1862–1873." *Harvard Library Bulletin* 12 (1974), 5–35, 129–61.

Wolff, Robert Lee. *Sensational Victorian: The Life and Fiction of Mary Elizabeth Braddon.* New York: Garland, 1979.

Wood, Charles. "Mrs. Henry Wood: In Memoriam." *Argosy* 43 (1887) 251–70, 334–53, 422–42.

Worthington, Heather. "Against the Law: Bulwer's Fictions of Crime." In *The Subverting Vision of Bulwer Lytton*, ed. Allan Christensen. Newark: University of Delaware Press, 2004, 54–67.

_____. "From *The Newgate Calendar* to Sherlock Holmes." In *A Companion to Crime Fiction*, ed. Charles J. Rzepka and Lee Horsley. Chichester: Wiley-Blackwell, 2010, 113–27.

_____. *The Rise of the Detective in Early Nineteenth-Century Popular Fiction.* Hampshire and New York: Palgrave Macmillan, 2005.

Wright, Willard Huntington [S. S. Van Dine]. "Twenty Rules for Writing Detective Stories." *American Magazine*, September 1928; http://gaslight.mtroyal.ca/vandine.htm.

Young, Alison. *Imagining Crime: Textual Outlaws and Criminal Conversations.* London: SAGE, 1996.

Young, Arelene. "'Petticoated Police': Propriety and the Lady Detective in Victorian Fiction." *Clues: A Journal of Detection* 26 (2008), 15–28.

Young, Suzanne. "The Simple Art of Detection: The Female Detective in Victorian and Contemporary Mystery Novels." *MFS: Modern Fiction Studies* 47 (2001), 448–57.

Index

Adam Bede 153
Adams, Francis 133, 170, 185, 187; *Madeline Brown's Murder* 187, 221
"The Adventure of the Tomato on the Wall" 29
Adventures of a Mounted Trooper 143, 150, 174
The Adventures of George Godfrey 140
Adventures of Susan Hopley 21, 27, 83, 97, 121, 145, 170, 182, 195, 199, 201
The Affair Next Door 119
Against Odds 130
Ainsworth, William Harrison 16, 44–45, 59, 194, 196; *Jack Sheppard* 16, 45, 194, 196; *Rookwood* 16, 45
Alcott, Louisa May 2, 11, 12, 75–76, 81, 84–99, 101, 105, 108–109, 112, 115, 123, 125, 147, 173, 175, 181, 187, 206, 209–211; "Behind a Mask" 90–93, 96–97, 99, 105, 123, 128, 147, 209–210; *Little Women* 84, 86–87, 99; "A Marble Woman" 115; *A Modern Mephistopheles* 84, 87, 115, 187; "Pauline's Passion and Punishment" 87; "V.V." 81, 86–90, 94, 108–109, 112, 181, 187, 210
All the Year Round 39–40, 107, 113, 135, 170, 202
Allingham, Margery 5
"The Amber Gods" 84, 207
"Anne Rodway" 21, 26, 28, 90, 144–145, 170, 204
Anonyma 29, 194
Aram, Eugene 169, 198
Argosy 62, 100, 115, 201
Armadale 24, 91, 94
"Arrested on Suspicion" 35, 105
Arthur Mervyn 70, 115
The Athenaeum 38, 149, 155, 192–193, 195, 203, 217
Atkinson, Louisa 151; *Gertrude the Emigrant* 151
The Atlantic Monthly 11, 56, 79–80, 202, 206
Aurora Floyd 21, 46, 199, 205
Australasian 132, 135, 146–147, 215, 221
Australasian Monthly Review 137
Australian Journal 11, 135–137, 144, 147–150, 161, 170–182, 188–189, 215, 217, 219–220

Australian Tales of Peril and Adventure 149–150
B. and R. 79; *Helen Elwood, the Female Detective* 79
The Backwoods' Bride 167
Barchester Towers 93
Baynton, Barbara 186; "The Chosen Vessel" 186
Beadle and Adams 100, 102–103, 118
Beadle's Dime Cook Book 100
Beadle's Monthly 100, 102–103, 174, 179, 212
"Behind a Mask" 90–93, 96–97, 99, 105, 123, 128, 147, 209–210
Bentham, Jeremy 16, 97
Bentley's Miscellany 16
"Bertha's Legacy" 175
The Black Band 47, 57–59, 66, 93, 187, 197, 200
"Black Sheep" 161, 170
Black Sheep! 170
Blackwood's Edinburgh Magazine 11, 16, 192, 196
Blake, Lillie Devereux 92; *Southwold* 92
Bleak House 7, 18, 26, 96, 111, 132, 199
Bloodhounds of Heaven 8
Bluecap the Bushranger 150
"Boldrewood, Rolf" 133, 170, 185, 220; "A Kangaroo Drive" 170, 220; *Robbery Under Arms* 170, 220
Boothby, Guy 133, 185, 221
Borlase, James Skipp 136, 138, 146, 148–150, 161, 171, 174–175, 178–179, 186, 191, 195, 212, 217; *Australian Tales of Peril and Adventure* 149–150; *Bluecap the Bushranger* 150; *Daring Deeds: Tales of Peril and Adventure* 150; "The Duel in the Bush" 150; "The Missing Fingers" 149, 178; *Ned Kelly: The Ironclad Australian Bushranger* 150; *The Night Fossickers* 149–150; "The Night Fossickers" 146, 150, 179; "Pursuing and Pursued" 150; "The Shepherd's Hut" 149, 174, 178–179, 195; *Stirring Tales of Colonial Adventure* 149–150
"The Boscombe Valley Mystery" 185
Botany Bay 141
Bow Bells 157

245

Bow Street Runners 193, 199, 205
Braddon, Mary Elizabeth 2, 9–10, 12, 18, 20, 21, 23–25, 28, 37, 43–59, 60–61 66–67, 86–87, 90–93, 95, 100, 103, 105–106, 109, 111, 113, 117, 125, 127–128, 130, 132, 135, 145, 157, 164, 171–173, 176, 187, 196–200, 203, 205, 208, 213–215; *Aurora Floyd* 21, 46, 199, 205; *The Black Band* 47, 57–59, 66, 93, 187, 197, 200; *Eleanor's Victory* 28, 59; *Lady Audley's Secret* 23, 37, 46–47, 51, 57, 59, 88, 91–93, 96, 113, 117, 196, 203, 213–214; *Run to Earth* 28; *The Trail of the Serpent* 12, 43–52, 54–55, 57–59, 66–67, 90, 93, 103, 105–106, 109, 111, 127, 132, 155, 171–172, 196–200, 203, 208, 211, 213
Bring the Monkey 188
The Broad Arrow 153–155, 157, 169, 218
"Broken Clouds! An Original Australian Tale" 144, 149, 179
Brontë, Charlotte 20, 41, 45, 96, 192, 195; *Jane Eyre* 20, 45, 76, 91, 93, 96, 115, 192, 195, 197, 219
Brown, Charles Brockden 69, 70, 80, 83, 109, 112, 115, 132, 203–205; *Arthur Mervyn* 70, 115; *Edgar Huntly* 69–70, 80, 109, 205; *Wieland* 69, 112, 203–204
Bucket, Inspector (fictional detective) 18, 26, 81, 110–111, 199
The Bulletin 133, 185–186
Bulwer-Lytton, Edward 16, 44–45, 49, 57, 79, 93, 107–108, 135, 194, 196, 198–199, 202; *Eugene Aram* 16, 45; *Lucretia, or the Children of Night* 44, 93, 199; *Paul Clifford* 16, 44, 196, 202; *Pelham* 49, 108; *A Strange Story* 107
"Burrows, William" 138, 143, 148, 150, 174; *Adventures of a Mounted Trooper* 143, 150, 174; *Tales of Adventure by a Log-Fire* 143
Burton, William E. 26, 71; "Leaves from a Life in London" series 71; "The Secret Cell" 26
"The Bushranger's Autobiography" 176
Busnach, William 117, 130; *Lecoq the Detective's Daughter* 117, 130
Butterworth, A. (fictional detective) 119

"C., M." 146, 217; "Wonderful! When You Come to Think of It!" 146, 163, 217
Caleb Williams 8, 15, 18, 21, 40, 45, 70, 97, 123, 164, 191, 198
casebook genre 8, 11, 29, 73, 144, 146, 148, 172, 175
"The Cask of Amontillado" 177, 208
Cassell's Illustrated Family Paper 103, 136, 185
Chabrillat, Henri 117, 130; *Lecoq the Detective's Daughter* 117, 130
Chambers's Edinburgh Journal 11, 17–18, 21, 27, 32, 56, 110, 113, 120
The Channings 201
Checkmate 18
"A Child Found Dead" 34
"The Chosen Vessel" 186

Christie, Agatha 5, 112, 122–123, 189, 204
"Circumstance" 79–80, 83, 109, 207
Clacy, Ellen 150–151; *A Lady's Visit* 150–151
Clarke, Marcus 135, 137, 146–147, 150, 154–155, 157–158, 162, 170, 181, 216, 217; "The Doppelganger" 147; *His Natural Life* 137, 147–148, 154, 158, 162, 170, 217; *The Mystery of Major Molineux* 147; "Night Scenes in Melbourne" series 146
Clarson, Massina & Co. 135
Clive, Caroline 2, 12, 22–39, 41, 169; *Paul Ferroll* 22, 39, 41, 169; *Why Paul Ferroll Killed His Wife* 23
"Clyzia the Dwarf" 175
Collins, Wilkie 1, 7–8, 18–19, 21, 24–28, 30, 37, 41, 57–58, 60, 66, 91, 94, 98, 107, 117, 120, 122, 129, 135, 145, 159, 168, 170, 181, 183, 192–200, 202, 204, 206, 208, 211, 215; "Anne Rodway" 21, 26, 28, 90, 144–145, 170, 204; *Armadale* 24, 91, 94; *The Dead Secret* 41, 199, 211; "Fie! Fie! or, the Fair Physician" 30, 107; *The Law and the Lady* 28, 192, 195, 199, 215; *The Moonstone* 7, 18–19, 57, 66, 98, 115, 122, 159; "My Lady's Money: An Episode in the Life of a Young Lady" 181, 183, 192–193; *No Name* 21, 28, 170, 192; "A Stolen Letter" 18, 192; *The Woman in White* 7, 28, 37, 58, 90, 117, 129, 168, 195, 200, 202, 204, 219
Conan Doyle, Arthur 1, 5–8, 15, 25, 33, 63, 67, 73, 107, 112, 119–120, 126–127, 135, 185, 187, 191, 198–200, 204; "The Boscombe Valley Mystery" 185; "The Gully of Bluemansdyke" 185; "The Red-Headed League" 198; "The Reigate Puzzle" 213; "A Study in Scarlet" 5, 7
"Confessions of an Attorney" series 17, 27, 32; "The Life Assurance" 32
"The Contested Marriage" 17, 192, 194
Cooper, James Fenimore 70–71, 83, 110, 132, 137, 145, 202, 204; *The Last of the Mohicans* 70, 204
Cornhill Magazine 39, 94, 135, 170, 220
Covent-Garden Journal 15
Cranford 43, 195
The Critic 164–165
Crittenden, Victor 137, 141, 144–145, 160–161
Crowe, Catherine 2, 11, 12, 20–22, 27, 34, 83, 97–98, 120–121, 124, 145, 170, 179, 182, 192, 193, 195, 199, 201, 205–206, 214; *Adventures of Susan Hopley* 21, 27, 83, 97, 121, 145, 170, 182, 195, 199, 201; *Men and Women* 20, 22, 34, 98, 120, 124; *The Story of Lilly Dawson* 21

Daring Deeds: Tales of Peril and Adventure 150
"A Dark Night's Work" 37, 39
David Copperfield 105, 200, 202
Davitt, Ellen 2, 11, 13, 136, 151, 158–173, 178, 186, 189, 191, 214, 218–219; "Black Sheep" 161, 170; *Force and Fraud* 12–13, 158–161, 163, 167–168, 170–171, 178, 219

Index

Davitt Award 159
The Dead Letter 12, 100–104, 106–109, 111, 114, 116–117, 119, 123–129, 164, 169, 171, 174, 179, 211–212
The Dead Secret 41, 199, 211
"The Dead Witness" 82, 104, 148–149, 174, 177–178, 182
Deadlier Than the Male 10
de Boos, Charles 144, 146, 155, 166, 180, 182, 195; *Fifty Years Ago: An Australian Tale* 144; *Mark Brown's Wife* 145–146, 155, 164, 166, 169, 182, 195; *The Stockman's Daughter* 144–145
de Chabrillan, Céleste 2, 13, 151–153, 158, 178, 182, 189; *The Gold Robbers* 152, 158, 182
Defoe, Daniel 6, 15, 91; *Moll Flanders* 15, 91
Dene Hollow 115
Denison, Mary 77; *The Mad Hunter* 77
de Quincey, Thomas 16, 120; "On Murder" 16, 120
"A 'Detective' Police Party" 32
The Detective's Album 172, 176, 220
"The Detective's Album," published serially in the *Australian Journal* 11, 173, 175–176, 179, 181–182, 220
Dickens, Charles 7, 16–19, 26, 32, 39–41, 44, 65–66, 81, 96, 107, 110–111, 135, 141, 147, 160, 171, 196–200, 202, 207; *Bleak House* 7, 18, 26, 96, 111, 132, 199; *David Copperfield* 105, 200, 202; "A 'Detective' Police Party" 32; *Martin Chuzzlewit* 16, 200, 202; *The Mystery of Edwin Drood* 19; *Oliver Twist* 16, 199; *Sketches by Boz* 17, 147
dime magazine 73
dime novel 1, 17, 75, 79, 87, 100, 102–103, 122, 206
"Disappearances" 39–40, 43
"The Dog Detective" 181, 183
Domestic Manners of the Americans 193
"The Doom of the Griffiths" 39–40, 65, 164, 198
"The Doppelganger" 147
"Dora Carleton" 175
Dublin University Magazine 31
"The Duel in the Bush" 150
Dumas, Alexandre 81, 152, 196, 204; *The Mohicans of Paris* 204

East Lynne 12, 25, 41, 59–61, 63–64, 89, 90, 92, 94, 96, 201
"E.C.M." 146; "Experiences of a Detective" 146
Edgar Huntly 69–70, 80, 109, 205
Edgeworth, Maria 19, 155
Eleanor's Victory 28, 59
Eliot, George 9, 34, 47, 153, 155, 173; *Adam Bede* 153
Emerson, Ralph Waldo 77, 85
Emsley, Clive 3
Eugene Aram 16, 45
"Experiences of a Barrister" (series) 17, 21, 27, 32, 113, 192, 194, 200; "The Contested Marriage" 17, 192, 194; "The Writ of Habeas Corpus" 21, 32, 195
"Experiences of a Detective" 146
Experiences of a Real Detective 107, 208
The Experiences of Loveday Brooke 38

Fair Women 29, 33–35
Family Herald 136
Felix, Charles 18, 120, 192; *The Notting Hill Mystery* 18, 115, 123, 196
The Female Detective 29–30, 33–35, 91, 164, 199
female detectives 10, 21, 25–26, 28–30, 32–36, 38, 58, 67, 79, 91, 110, 113, 116–117, 119, 139, 164, 179, 201
Féval, Paul 20; *Les Mystères de Londres* 20
"Fie! Fie! or, the Fair Physician" 30, 107
Fielding, Henry 6, 15, 20, 45; *Covent-Garden Journal* 15; *Tom Jones* 45
Fifty Years Ago: An Australian Tale 144
The Figure Eight 100–102, 106, 211
Fitzgerald, Percy 45; "The Woman with the Yellow Hair" 94, 109, 211
The Flag of Our Union 87, 90
For Her Natural Life 157, 184
Force and Fraud 12–13, 158–161, 163, 167–168, 170–171, 178, 219
The Forger's Wife 141–142, 145, 147, 150, 152, 155, 158, 169, 178, 181–182
"Forrester, Andrew" 8, 29, 30–31, 33–35, 38, 82, 91, 105–106, 120, 164, 199; "Arrested on Suspicion" 35, 105; "A Child Found Dead" 34; *The Female Detective* 29–30, 33–35, 91, 164, 199; "Georgy" 91; *Revelations of a Private Detective* 30; *Secret Service; or, Recollections of a City Detective* 30; "Tenant for Life" 32, 82; "The Unknown Weapon" 33–34, 199; "The Unraveled Mystery" 31, 34
Forrester, Daniel 30
Forrester, John 30
"Forrester, Mrs." 29, 33–35; *Fair Women* 29, 33–35
Fortune, Mary 1–2, 11, 13, 82, 104, 136, 138, 148–156, 158, 161, 171–191, 193, 209, 214, 219–221; "Bertha's Legacy" 175; "The Bushranger's Autobiography" 176; "Clyzia the Dwarf" 175; "The Dead Witness" 82, 104, 148–149, 174, 177–178, 182; *The Detective's Album* 172, 176, 220; "The Detective's Album," published serially in the *Australian Journal* 11, 173, 175–176, 179, 181–182, 220; "The Dog Detective" 181, 183; "Dora Carleton" 175; "The Ghostly White Gate" 176; "The Hart Murder" 179–181, 184, 220; "How I Spent Christmas" 178; "The Illuminated Grave" 176; "In the Cellar" 176–177; "My Friends and Acquaintances" 182; "Mystery and Murder" 149; "Navvies' Tales: Retold by the Boss" series 176, 181; "The Stolen Speci-

mens" 149, 174–175; "A Struggle for Life" 180; "To Be Left Till Called For" 176, 220; "Towzer & Co." 182–183, 220; "Traces of Crime" 174–175, 179; "The White Maniac" 173, 209; "A Woman's Revenge" 173, 220
Fothergill, Henry 20
Fouché, Joseph 37
Frank Leslie's Illustrated Newspaper 87, 90
Franklin, Miles 154, 186, 188; *Bring the Monkey* 188; *My Brilliant Career* 188
Frederick Charles Howard 141
Fuller, Metta *see* Victor, Metta

Gaboriau, Émile 1, 5, 7–8, 71, 110, 117, 120, 137, 186–187, 198, 207, 215; "The Little Old Man of Batignolles" 207
Gaskell, Elizabeth 2, 12, 22–23, 25, 37–43, 49, 58, 64–66, 87, 98, 112–113, 164, 168, 173, 198, 200–202; *Cranford* 43, 195; "A Dark Night's Work" 37, 39; "Disappearances" 39–40, 43; "The Doom of the Griffiths" 39–40, 65, 164, 198; "The Grey Woman" 39–41, 43, 49, 58, 65, 98, 113, 164, 195, 200; "The Heart of John Middleton" 65; *The Life of Charlotte Brontë* 41, 195; *Mary Barton* 39, 168, 195, 202; "The Moorland Cottage" 65; "The Poor Clare" 39–40, 112; "The Squire's Story" 39–40, 43
Gaspey, Thomas 140, 192; *The Adventures of George Godfrey* 140
Geoffry Hamlyn 143–144
"Georgy" 91
Gertrude the Emigrant 151
"The Ghost on the Rail" 141
"The Ghostly White Gate" 176
Godwin, William 1, 8, 15, 19, 21, 40, 45, 70, 97, 123, 191; *Caleb Williams* 8, 15, 18, 21, 40, 45, 70, 97, 123, 164, 191, 198
"The Gold Bug" 105, 128
The Gold Robbers 152, 158, 182
Golden Age (of detective fiction) 5, 7, 98, 116, 122, 124
The Golden Slipper and Other Problems for Violet Strange 119
Gothic 1, 5, 18–19, 26, 36–43, 45, 58, 63, 68–72, 76–80, 83, 85–86, 92, 98, 101–102, 112–114, 128, 142, 147, 164, 173, 175–176, 187, 195, 198, 206
"The Gray Madam" 41
Great Women Mystery Writers 10, 212
Green, Anna Katharine 1–2, 9–10, 12, 25, 41, 71, 75, 79, 97–98, 101–102, 117–131, 142, 159, 166, 172, 175–176, 187, 191; *The Affair Next Door* 119; *The Golden Slipper and Other Problems for Violet Strange* 119; "The Gray Madam" 41; *The Leavenworth Case* 1, 12, 97–98, 101–102, 117–124, 126, 129–131, 166, 172, 175, 187, 211; *The Woman in the Alcove* 119; *X.Y.Z.* 120
"The Grey Woman" 39–41, 43, 49, 58, 65, 98, 113, 164, 195, 200

Griffith Gaunt 62
"The Gully of Bluemansdyke" 185

Haggard, H. Rider 88; *Mr. Meeson's Will* 88
Halfpenny Journal 47, 57
Hamilton Spectator 146, 154–155, 160, 163
Hardy, Thomas 135
Hargrave 20, 81
Harper's New Monthly Magazine 11, 24, 102, 202
Harrison Ainsworth, William 16, 44–45, 59, 194, 196; *Jack Sheppard* 16, 45, 194, 196; *Rookwood* 16, 45
"The Hart Murder" 179–181, 184, 220
Hatch, Mary 131
Hawthorne, Nathaniel 51, 71, 76–77, 80; *The Scarlet Letter* 51
Hayward, William Stephens ("Anonyma") 29–30, 35, 37–38, 91–92, 94, 97, 194; "Incognita" 33, 35–37, 91–92, 94, 97; "The Mysterious Countess" 36–37, 92; *Revelations of a Lady Detective* 29, 35, 194; "The Stolen Letters" 37, 198
"The Heart of John Middleton" 65
Helen Elwood, the Female Detective 79
His Natural Life 137, 147–148, 154, 158, 162, 170, 217
Hoffmann, E.T.A. 26, 32, 72, 115, 135, 207; "Mademoiselle de Scudéry" 26, 32, 72, 207
Hogg, James 19; *The Private Memoirs and Confessions of a Justified Sinner* 19
Holmes, Sherlock (fictional character) 5–9, 15, 18, 25, 33, 67, 73, 112, 119, 127, 138, 185, 187, 198–200, 204, 213
Home Journal 104
Hornung, E.W. 133, 167, 170, 185, 221; *Irralie's Bushranger* 167, 221; *Stingaree* 221
Household Words 17, 26, 32, 39–41, 65, 82, 107, 112, 141, 147, 170, 202
"How I Spent Christmas" 178
"How to Write a Blackwood Article" 72
Howitt, William 137, 143; *Tallangetta: The Squatter's Home* 137, 143
Hume, Fergus 1, 8, 12, 133, 170, 187; *Madame Midas* 187; *Miss Mephistopheles* 187; *The Mystery of a Hansom Cab* 8, 122, 133, 170, 187

"The Identity of Miss Angela Vespers" 29
"The Illuminated Grave" 176
Illuminated Western World 100
Illustrated Sydney News 137, 144, 149, 216
"In a Cellar" 56, 80–81, 89, 119, 176
"In the Cellar" 176–177
"In the Maguerriwock" 80–83, 163, 177, 208
"Incognita" 33, 35–37, 91–92, 94, 97
Irralie's Bushranger 167, 221
The Italian 19

Jack Sheppard 16, 45, 194, 196
James, Henry 24, 44, 84

James, P.D. 5, 20, 29
Jane Eyre 20, 45, 76, 91, 93, 96, 115, 192, 195, 197, 219
Jessie Phillips 193
"Johnny Ludlow" series 9, 61–64, 67, 199, 201

"Ka" 29; "The Adventure of the Tomato on the Wall" 29; "The Identity of Miss Angela Vespers" 29
"Der Kaliber" 22
"A Kangaroo Drive" 170, 220
Kestner, Joseph 37, 193; *Sherlock's Sisters* 25
Kidderminster, Anne 26
Kidderminster, Thomas 27
Killing Women 10
Kingsley, Henry 143–144; *Geoffry Hamlyn* 143–144
Klein, Kathleen Gregory 10, 31, 212; *Great Women Mystery Writers* 10, 212; *The Woman Detective* 10
Knight, Stephen 9, 18, 20, 29–30, 33–34, 60, 69, 101, 120, 122–123, 133–134, 136, 138, 140–141, 148, 150, 153–154, 157, 163, 165, 171–172, 181, 184–186, 188–189, 202, 204, 216–217, 219

Lady Audley's Secret 23, 37, 46–47, 51, 57, 59, 88, 91–93, 96, 113, 117, 196, 203, 213–214
A Lady's Visit 150–151
Lang, John George 137, 141–143, 145–147, 150, 152, 155, 178–179, 181–182, 210; *Botany Bay* 141; *The Forger's Wife* 141–142, 145, 147, 150, 152, 155, 158, 169, 178, 181–182; *Frederick Charles Howard* 141; "The Ghost on the Rail" 141; *Lucy Cooper* 141, 155, 216, 218; *The Secret Police* 141
Larken, Geoffrey 192
The Last of the Mohicans 70, 204
The Law and the Lady 28, 192, 195, 199, 215
Lawson, Henry 186
Lawson, Louisa 188
Leakey, Caroline 2, 13, 151, 153–157, 180, 189, 218; *The Broad Arrow* 153–155, 157, 169, 218
The Leavenworth Case 1, 12, 97–98, 101–102, 117–124, 126, 129–131, 166, 172, 175, 187, 211
"Leaves from a Life in London" series 71
Leaves from the Notebook of a New York Detective 73, 205
Lecoq, M. (fictional detective) 8, 71, 117, 215
Lecoq the Detective's Daughter 117, 130
Le Fanu, Joseph 18, 123; *Checkmate* 18; "The Murdered Cousin" 123; *Wylder's Hand* 18
"Legal Metamorphoses" 56, 81, 202
Lewis, Matthew 19, 69; *The Monk* 19
"The Life Assurance" 32
The Life of Charlotte Brontë 41, 195
"The Little Old Man of Batignolles" 207
Little Women 84, 86–87, 99
Livermore, Mary 99–100
London Journal 135–136

London Labour and the London Poor 210
Looking Back 137
"Losing Lena" 61
Lucretia, or the Children of Night 44, 93, 199
Lucy Cooper 141, 155, 216, 218
Ludgate Monthly 38

The Mad Hunter 77
Madame Midas 187
Madeline Brown's Murder 187, 221
Madeline Payne 130
"Mademoiselle de Scudéry" 26, 32, 72, 207
Maida, Patricia 118, 126, 213
Maio, Kathleen 10, 101, 114, 214
Mann, Jessica 10; *Deadlier Than the Male* 10
"A Marble Woman" 115
Mark Brown's Wife 145–146, 155, 164, 166, 169, 182, 195
Martin Chuzzlewit 16, 200, 202
Mary Barton 39, 168, 195, 202
"Mary Kingsford" 26
Mary Summers 144, 161
Marple, Miss Jane (fictional detective) 26
Marsh, Ngaio 5, 185
Martel, Charles 30, 205, 210
Masson, David 38
Maxwell, John 46–47, 57, 103, 197, 205
Mayhew, Henry 210; *London Labour and the London Poor* 210
McGovan, James 228, 231
McLevy, James 205
Meade, L.T. 64, 185, 211
melodrama 16–18, 60, 92, 120, 128, 140, 142, 147, 149, 151–152, 154, 157, 161
Mémoires 122, 149, 192
Men and Women 20, 22, 34, 98, 120, 124
Miss Mephistopheles 187
"The Missing Fingers" 149, 178
"Mr. Furbush" 80–83, 113, 170, 175, 178, 207
Mr. Meeson's Will 88
Mitchell, Henry 173, 175
A Modern Mephistopheles 84, 87, 115, 187
Mofussilite 141
The Mohicans of Paris 204
Moll Flanders 15, 91
The Monk 19
The Moonstone 7, 18–19, 57, 66, 98, 115, 122, 159
"The Moorland Cottage" 65
Mount Alexander Mail 173
Mrs. Halliburton's Troubles 60
Mudie's Circulating Library 24, 136
Müllner, Adolph 22; "Der Kaliber" 22
"Murder Under the Microscope" 208
"The Murdered Cousin" 123
"The Murders in the Rue Morgue" 72, 200, 204–205
My Brilliant Career 188
"My Friends and Acquaintances" 182
"My Lady's Money: An Episode in the Life of a Young Lady" 181, 183, 192–193

Index

Les Mystères de Londres 20
Les Mystères de Paris 16, 21, 71, 152, 205
mysteries 7, 16, 64, 146, 163, 202, 204
The Mysteries of London 16, 163, 197, 205, 210, 219
The Mysteries of Udolpho 19
"A Mysterious Affair" *see* Victor, Metta *Too True*
"The Mysterious Countess" 36–37, 92
"Mystery and Murder" 149
The Mystery of a Hansom Cab 8, 122, 133, 170, 187
The Mystery of Edwin Drood 19
The Mystery of Major Molineux 147
"The Mystery of Marie Rogêt" 72, 122, 170, 177, 205

National Police Gazette 71
"Navvies' Tales: Retold by the Boss" series 176, 181
Ned Kelly: The Ironclad Australian Bushranger 150
Never Too Late to Mend 155, 202
New Monthly Magazine 20, 39, 59, 80, 201
The New York Detective Police Officer 106, 205
New York Ledger 135, 147, 196
New York Nell 200
New York Times 122
New York Weekly 118
Newgate Calendar 1, 5, 15, 40, 45, 197
Newgate novel 1, 16, 22–23, 40, 44–47, 54, 58, 185, 194
"The Night Fossickers" 146, 150, 179
The Night Fossickers 149–150
"Night Scenes in Melbourne" series 146
No Name 21, 28, 170, 192
The Notting Hill Mystery 18, 115, 123, 196

Oliphant, Margaret 16–17, 20, 45, 60, 103, 135, 210
Oliver Twist 16, 199
"On Murder" 16, 120
Once a Week 18
Once a Week (Melbourne) 135
Ousby, Ian 8, 54; *Bloodhounds of Heaven* 8
Outlaw and Lawmaker 167

Panek, Leroy 71, 77, 102, 114, 130, 212
Paretsky, Sara 5, 28, 185, 218
"Passages from the Diary of a Late Physician" series 27, 106, 113
Paterson, Banjo 138, 185; "Waltzing Matilda" 138, 185
Paul Clifford 16, 44, 196, 202
Paul Ferroll 22, 39, 41, 169
"Pauline's Passion and Punishment" 87
Pelham 49, 108
Pinkerton, Allan 56, 74, 79
Pirkis, Catherine 38, 64; *The Experiences of Loveday Brooke* 38

Poe, Edgar Allan 1, 4–8, 26, 63, 71–74, 81, 89, 105, 108, 111, 113–115, 118, 120, 122, 128–129, 134–136, 146, 170, 177, 198, 200, 204–205, 207–208, 211; "The Cask of Amontillado" 177, 208; "The Gold Bug" 105, 128; "How to Write a Blackwood Article" 72; "The Murders in the Rue Morgue" 72, 200, 204–205; "The Mystery of Marie Rogêt" 72, 122, 170, 177, 205; "The Purloined Letter" 4, 73, 105, 123, 146, 204–205; "Thou Art the Man" 108
Poirot, Hercule (fictional detective) 123
police procedural *see* casebook genre
"The Poor Clare" 39–40, 112
Praed, Rosa 167, 188; *Outlaw and Lawmaker* 167
The Private Memoirs and Confessions of a Justified Sinner 19
"The Purloined Letter" 4, 73, 105, 123, 146, 204–205
"Pursuing and Pursued" 150
Putnam, George 101, 120
Putnam's Monthly Magazine 71, 101
Pykett, Lyn 15, 24, 51, 57, 66

Quarterly Review 153, 193
Queanbeyan Age 104
"Queen, Ellery" 118
Quintus Servinton 140, 148, 154

Radcliffe, Ann 19, 40, 58, 69, 86, 195; *The Italian* 19; *The Mysteries of Udolpho* 19; *A Sicilian Romance* 19
Reade, Charles 62, 135, 155, 202; *Griffith Gaunt* 62; *Never Too Late to Mend* 155, 202
"Reality or Delusion?" 62
"Recollections of a Police-Officer" series 18, 212
"The Red-Headed League" 198
Reeve, Clara 19
The Refugee in America 193, 207
"Regester, Seeley" *see* Victor, Metta
"The Reigate Puzzle" 213
Revelations of a Lady Detective 29, 35, 194
Revelations of a Private Detective 30
"The Revenge" 208
Reynolds, G.W.M 16–17, 71, 163, 197, 205, 210; *The Mysteries of London* 16, 163, 197, 205, 210, 219; *Robert Macaire in England* 16
Reynolds's Miscellany 16, 149, 157
Richmond 16, 32, 110, 142, 179, 192, 196, 198
Robbery Under Arms 170, 220
Robert Macaire in England 16
Robin Goodfellow 143
Roland Yorke 201, 215
roman policier 7
Rookwood 16, 45
Rowcroft, Charles 140, 154
Run to Earth 28
Russell, William *see* "Waters"

Sadleir, Michael 20, 23, 35, 66–67, 197
Sala, George 186

Saturday Journal 103
Saturday Review 63, 199
Savery, Henry 140, 148, 154; *Quintus Servinton* 140, 148, 154
Sayers, Dorothy 5–6, 18, 28, 30, 60–61, 204
The Scarlet Letter 51
Schaffer, Kay 166, 188, 221
"The Secret Cell" 26
The Secret Police 141
Secret Service; or, Recollections of a City Detective 30
sensation genre 1, 5, 9, 16, 18, 20, 23–24, 29, 34, 38–41, 43–47, 49–51, 53, 57–61, 63–64, 67, 72, 75, 77, 84–86, 91–93, 96, 99, 101–104, 120, 124, 128, 141, 147, 152, 163, 173, 175, 193, 197–198, 209
Shadowed by Three 130, 214
Shakespeare, William 6, 85, 109, 123, 160, 196
Shelley, Mary 19–20, 115
"The Shepherd's Hut" 149, 174, 178–179, 195
Sherlock's Sisters 25
Showalter, Elaine 68, 75–76, 85, 91, 209
A Sicilian Romance 19
Sisters in Crime (Australia) 159, 218
"The Skeleton at the Banquet" 100–101, 211
Sketches by Boz 17, 147
Slung, Michele 9, 29, 37
Southwold 92
Spofford, Harriet Prescott 2, 9–12, 56, 75, 79–84, 89, 109, 113, 118–120, 159, 163, 170, 175–178, 206–208, 214; "The Amber Gods" 84, 207; "Circumstance" 79–80, 83, 109, 207; "In a Cellar" 56, 80–81, 89, 119, 176; "In the Maguerriwock" 80–83, 163, 177, 208; "Mr. Furbush" 80–83, 113, 170, 175, 178, 207
"The Squire's Story" 39–40, 43
Stingaree 221
Stirring Tales of Colonial Adventure 149–150
The Stockman's Daughter 144–145
"A Stolen Letter" 18, 192
"The Stolen Letters" 37, 198
"The Stolen Specimens" 149, 174–175
The Story of Lilly Dawson 21
Stowe, Harriet Beecher 21, 76, 135, 178, 193, 215; *Uncle Tom's Cabin* 21, 76, 103, 178, 193
Strand Magazine 7, 11, 64, 67, 185, 211
A Strange Story 107
"A Struggle for Life" 180
"A Study in Scarlet" 5, 7
Sue, Eugène 16–17, 20–21, 71, 152, 198, 205, 218; *Les Mystères de Paris* 16, 21, 71, 152, 205
Sussex, Lucy 4, 9, 63, 101, 103–104, 146, 148, 150, 158–161, 172–174, 176, 182, 188–189, 201, 208, 212, 217, 219–220
Sydney Mail 145, 151, 157, 203, 220–221

Tales of Adventure by a Log-Fire 143
Tallangetta: The Squatter's Home 137, 143
Temple Bar 100, 136
"Tenant for Life" 32, 82

Thackeray, William Makepeace 93; *Vanity Fair* 93
thief-taker 36, 137–138, 142
Thomson, Henry 91, 205, 215, 220
"Thou Art the Man" 108
Three Times Dead see *The Trail of the Serpent*
The Times 60
"To Be Left Till Called For" 176, 220
Tom Jones 45
Too True 101, 104, 168, 200, 207
"Towzer & Co." 182–183, 220
"Traces of Crime" 174–175, 179
"The Tragedy in Judd Street" 107
The Trail of the Serpent 12, 43–52, 54–55, 57–59, 66–67, 90, 93, 103, 105–106, 109, 111, 127, 132, 155, 171–172, 196–200, 203, 208, 211, 213
Trollope, Anthony 20, 93, 106, 135, 159–160; *Barchester Towers* 93
Trollope, Frances (Fanny) 11, 20, 81, 160, 192–193, 207; *Domestic Manners of the Americans* 193; *Hargrave* 20, 81; *Jessie Phillips* 193; *The Refugee in America* 193, 207; *A True Relation of a Horrid Murder* 27

Uncle Tom's Cabin 21, 76, 103, 178, 193
"The Unknown Weapon" 33–34, 199
"The Unraveled Mystery" 31, 34
Upfield, Arthur 138, 187

Van Deventer, Emma Murdoch 130, 214; *Against Odds* 130; *Madeline Payne* 130; *Shadowed by Three* 130, 214
Vanity Fair 93
Victor, Metta 2, 9–10, 12, 75, 79, 87, 99–118, 125, 129, 135, 167–169, 171, 174–175, 179, 200, 206–207, 211–212; *The Backwoods' Bride* 167; *Beadle's Dime Cook Book* 100; *The Dead Letter* 12, 100–104, 106–109, 111, 114, 116–117, 119, 123–129, 164, 169, 171, 174, 179, 211–212; *The Figure Eight* 100–102, 106, 211; "The Skeleton at the Banquet" 100–101, 211; *Too True* 101, 104, 168, 200, 207
Victor, Orville 103
Vidocq, Eugène 37, 44, 122, 149, 179, 192–193, 195–196, 198, 216; *Mémoires* 122, 149, 192
A Vindication of the Rights of Women 19
"V.V." 81, 86–90, 94, 108–109, 112, 181, 187, 210

"Waif Wander" see Fortune, Mary
Walstab, George 137, 147, 150; *Looking Back* 137
"Waltzing Matilda" 138, 185
Warren, Samuel 17, 21, 27, 106, 113, 194; "Passages from the Diary of a Late Physician" series 27, 106, 113
"Waters" 8, 18, 26, 29, 31–32, 56, 73–74, 81, 110, 120, 146, 148, 192, 195, 198–199, 208, 212; *Experiences of a Real Detective* 107, 208;

"Legal Metamorphoses" 56, 81, 202; "Mary Kingsford" 26; "Murder Under the Microscope" 208; "Recollections of a Police-Officer" series 18, 212; "The Revenge" 208; "The Tragedy in Judd Street" 107
Wellesley Index 94
Wheeler, Edward 79, 200; *New York Nell* 200
"The White Maniac" 173, 209
Whitworth, Rober t 136, 144, 147, 161, 217, 219; *Mary Summers* 144, 161
Why Paul Ferroll Killed His Wife 23
Wieland 69, 112, 203–204
Williams, John B. ("J.B") 73–74, 97, 106, 205; *Leaves from the Notebook of a New York Detective* 73, 205; *The New York Detective Police Officer* 106, 205
Wilson, F.S. 144, 149, 179; "Broken Clouds! An Original Australian Tale" 144, 149, 179
Winn, Dilys 10
Winstanley, Eliza 2, 13, 151, 157–158, 184, 189; *For Her Natural Life* 157, 184
Wolff, Robert Lee 46, 196–197, 199
Wollstonecraft, Mary 19; *A Vindication of the Rights of Women* 19; *The Wrongs of Woman* 19
The Woman Detective 10
The Woman in the Alcove 119
The Woman in White 7, 28, 37, 58, 90, 117, 129, 168, 195, 200, 202, 204, 219
"The Woman with the Yellow Hair" 94, 109, 211
"A Woman's Revenge" 173, 220
"Wonderful! When You Come to Think of It!" 146, 163, 217
Wood, Ellen 2, 9, 12, 18, 23, 25, 41, 59–64, 66–67, 87, 90, 94, 96, 100, 115, 135, 145, 199, 201, 206–207, 215; *The Channings* 201; *Dene Hollow* 115; *East Lynne* 12, 25, 41, 59–61, 63–64, 89, 90, 92, 94, 96, 201; "Johnny Ludlow" series 9, 61–64, 67, 199, 201; "Losing Lena" 61; *Mrs Halliburton's Troubles* 60; "Reality or Delusion?" 62; *Roland Yorke* 201, 215
Wood, Mrs. Henry *see* Wood, Ellen
Worthington, Heather 74, 106, 220
"The Writ of Habeas Corpus" 21, 32, 195
The Wrongs of Woman 19
"W.W." *see* Fortune, Mary
Wylder's Hand 18

X.Y.Z. 120

Yates, Edmund Hodgson 170; *Black Sheep!* 170

Zangwill, Israel 123